Art
and Cartography

THE KENNETH NEBENZAHL, JR., LECTURES IN THE HISTORY OF CARTOGRAPHY

PUBLISHED FOR THE HERMON DUNLAP SMITH CENTER

FOR THE HISTORY OF CARTOGRAPHY

THE NEWBERRY LIBRARY

Series Editor, David Buisseret

PREVIOUSLY PUBLISHED
Series Editor, David Woodward

Maps: A Historical Survey of Their Study and Collecting
by R. A. Skelton (1972)

British Maps of Colonial America
by William P. Cumming (1974)

Five Centuries of Map Printing
edited by David Woodward (1975)

Mapping the American Revolutionary War
by J. B. Harley, Barbara Bartz Petchenik, and Lawrence W. Towner
(1978)

Art

and Cartography

SIX

HISTORICAL

ESSAYS

Edited by

David Woodward

The University of Chicago Press ❧ Chicago and London

SVETLANA ALPERS is professor of the history of art at the University of
California, Berkeley

SAMUEL Y. EDGERTON, JR., is professor of art at Williams College,
Williamstown, Massachusetts

ULLA EHRENSVÄRD is keeper of the maps and drawings at the Royal Military
Archives, Stockholm

JUERGEN SCHULZ is professor of the history of art at Brown University,
Providence, Rhode Island

JAMES A. WELU is director of the Worcester Art Museum,
Worcester, Massachusetts

DAVID WOODWARD is professor of geography at the University of Wisconsin,
Madison

THE UNIVERSITY OF CHICAGO PRESS, CHICAGO 60637
The University of Chicago Press, Ltd., London

96 95 94 93 92 91 90 89 88 87 54321

Library of Congress Cataloging in Publication Data

Art and cartography.

 (The Kenneth Nebenzahl, Jr., lectures in the history of
cartography)
 Includes index.
 1. Cartography. 2. Maps—Illustrations.
I. Woodward, David, 1942– II. Series.
GA108.A78 1987 526.8 86-4356
ISBN 0-226-90722-8

Contents

Illustrations

Editor's Note

The essays published here stem from the invited lectures constituting the Sixth Series of Kenneth Nebenzahl, Jr., Lectures in the History of Cartography at the Newberry Library, presented at the library 30 October to 1 November 1980. Two concurrent exhibitions on the theme of the lectures were held at the Newberry Library and at the Prints and Drawings Department of the Art Institute of Chicago from 30 October 1980 to 4 January 1981.

The subject of the lectures was suggested by George Kish some eight years ago. The resulting book does not claim to be a complete study of the relation between art and cartography. This is a vast topic with many facets, and the essays here contain some obvious overlaps and omissions. Nevertheless, the book is offered as a stimulus to further ideas and research.

The lectures were introduced by George Kish in a talk entitled "Maps and the Decorative Arts: A Geographer's View." Since his lecture relied heavily on a large number of colored illustrations and was intended primarily for oral presentation, it has not been possible to publish it. The remaining chapters are enlarged and edited versions of the original papers. Although originally commissioned as a Nebenzahl lecture, Svetlana Alpers's paper was published in a book of her own essays, *The Art of Describing: Dutch Art in the Seventeenth Century* (University of Chicago Press, 1983), by prior arrangement with the editor and publisher. Since her theme is closely related to the other essays in this volume, it has been republished here in slightly modified form.

My thanks are due to the authors for a set of memorable lectures and polished manuscripts, and to the many friends and colleagues who helped with typing, obtaining illustrations, and all the other small but important details of production. Many individuals and libraries lent materials for the accompanying exhibitions; illustrations of many of these items are included here. Although the sources are individually recognized in the captions, I should like to thank them collectively here. My personal thanks are due to Maureen Reilly and Elaine Stroud for typing the manuscript, to my wife Rosalind for help with proofreading,

and to David Buisseret, director of the Hermon Dunlap Smith Center for the History of Cartography, for providing liaison with the University of Chicago Press. Patricia Buisseret undertook the work of obtaining copies of the illustrations and permission to reproduce them.

Once again it is my greatest pleasure also to acknowledge the generosity of Mr. and Mrs. Kenneth Nebenzahl, whose contributions to the Kenneth Nebenzahl, Jr., Fund have made this volume and previous books in the series possible.

Introduction

DAVID WOODWARD

\mathcal{T}he independent appearance in 1980 and 1981 of four major exhibitions on the theme of art and cartography indicates a profound interest in the study of the affinity between these two activities.[1] Many previous exhibitions of old and rare maps had implicitly displayed the ornamental side of mapmaking, but these new exhibitions shared a common feature: their organizers felt impelled to include works of modern art with mapping themes, reflecting a deeper need to explore the complex intermingling of art and science that is found in the map. Three of these exhibitions were organized in two parts—antiquarian maps and modern art—and while this admits to some reluctance to combine the two, the need was obviously felt to see them side by side.

Part of this interest is no doubt due to the growth of interest in the history of cartography as an interdisciplinary field. In its struggle to come of age, broad methodological questions have been raised, including the validity of the concept of maps as language, the art/science dichotomy, and the form/content distinction.[2] But much progress toward a real understanding of these and other issues has yet to be made, and in the face of fundamental technical changes that pose far-reaching philosophical questions for cartographers and map users alike, the art/science matter is of particular importance. On another level, while certainly not dictating the direction of research and interest in the history of cartography as an academic pursuit, the burgeoning of antiquarian map collecting, in which any links between cartographers and master artists or printmakers clearly enhance the value of the artifacts, has certainly played its role.

At the same time, several art historians have been turning their attention to maps, writing major articles that have sparked much interest among historians of cartography.[3] Furthermore, curators of art have widened their definition of what can be justifiably displayed on the walls of art museums, and the traditional distinction between fine and applied art has been breaking down.

A further approach is illustrated by the interest of graphic designers in notions of space and representations of the spatial environ-

ment. Thus some general books and articles on design contain specific references to maps as special design problems.[4] Recent issues of *Arts-Canada* and *Design Quarterly* have explored the affinities between maps and art in both historical and modern contexts.[5]

Finally, among the trends in art since the 1960s, artists have displayed a remarkable interest in maps as subjects for their own paintings, sometimes using the maps themselves as part or all of the work. All these factors have combined to create a favorable climate for studies of the relation between art and cartography and have led directly to the choice of this subject for the Sixth Series of Kenneth Nebenzahl, Jr., Lectures for 1980, and hence this volume of essays.

It has been commonly assumed that the history of cartography can be divided into two distinct phases: a decorative phase, in which geographical information was usually portrayed inaccurately, and a scientific phase, in which decoration gave way to scientific accuracy. Thus Bagrow delimited the subject matter of his general work in this way: "This book ends where maps ceased to be works of art, the products of individual minds, and where craftsmanship was finally superseded by science and the machine; this came in the second half of the eighteenth century."[6] Until very recently *Imago Mundi,* the most representative journal of the field, had in its editorial policy statement a chronological cutoff date of "the dawn of accurate modern survey," clearly reflecting Bagrow's sentiment. The thinking on this matter is rapidly changing; it is now being recognized that, since the past is inextricably linked with the present and can constantly illuminate it, there is little sense in arbitrarily cutting off the historical record. In all but the most narrow definitions of "work of art," it can readily be seen that art and science have coexisted throughout the history of mapmaking, as in the instance of starkly functional portolan charts existing contemporaneously with fanciful and moralistic medieval *mappaemundi*.

The often narrow definition of the term "work of art" has led to another problem: art is frequently equated with maps' ornamental elements and nothing more. The term evokes intricate strapwork on cartouches, robust putti, sailing ships, sea monsters, and other embellishing paraphernalia that account for so much of the decorative appeal of early maps. Such ornamentation is germane, but not central, to the discussion of the place of art in cartography. In these essays we are concerned with more fundamental matters, such as the role of the artist in mapping, the mapping impulse in the artist, the iconographic character of maps, and the sources and development of such cartographic elements as color, lettering, and symbol design.

Several writers, most recently Rees, have remarked on the affinities between cartography and art in history.[7] Of the several themes that Rees and others have raised, this introduction will consider four, providing the semblance of a structure for the subjects of the essays in this volume. These subheadings are of necessity oversimplifications of the whole complex question, but they provide a point of departure.

Since many cartographic elements, such as color, symbols, and lettering, are shared with other visual arts and usually employ similar tools and techniques, we would expect many of the links between art and maps to be revealed particularly through the treatment of those elements. They are also the stuff of iconography, which links them directly to the culture that created them. Ehrensvärd, in her essay on the historical development of color in cartography, shows that the color traditions in maps were taken directly from the medieval miniaturists and that instructions for coloring maps were incorporated into general manuals of limning, or the fashionable art of watercolor tinting, that appeared in the sixteenth century. Again, beginning in the late seventeenth century ascetic tastes were reflected in the use of color on maps only for well-defined purposes, summarized in the purist ideas of Johann Hübner in his *Museum geographicum*.

Similarly, for lettering and typography, Woodward's essay reveals that this graphic element is particularly sensitive to regional and historical trends in style, as well as to calligraphic and typographic technology. Although for some periods in the history of lettering, such as the medieval, the idiosyncrasies and inconsistencies of the scribes make it difficult to generalize about style characteristics, in other cases the lettering or typography is an excellent aid in identifying a map's place and date of creation. Clear examples are the use of local typefaces in the woodcut maps of Bavaria and Switzerland in the sixteenth century and the possible identification of punches used in copperplate engraving in sixteenth-century Italy.

Welu provides a third demonstration of the value of graphic elements as stylistic indicators on maps. He cites many examples of seventeenth-century Dutch maps whose ornamental embellishments were borrowed from graphic arts pattern books and from other maps. Cartographers had extremely eclectic taste, often disregarding the geographical appropriateness of the designs they selected. Thus a cartouche with nude figures drawn for a map of South America might be pirated by another cartographer for a map of the Arctic.

One of the recurring themes in this book, therefore, is that the map constitutes a composite of graphic elements that reveals the cultural context of the map's origin. Treating color, lettering, and ornamentation in separate chapters has made it possible to consider these themes in greater detail, but these aspects of style are actually interdependent. In the last analysis, a full understanding of artistic style in cartography can be obtained only by a holistic, synthetic view that encompasses the total look of the map.

Another indication of the links between art and cartography is seen in the way artists have persistently turned their hand to mapmaking throughout history. Many of these contributions are well known, such as those by Leonardo da Vinci, Albrecht Dürer, Jacopo de' Barbari, Cristoforo Sorte, and other Renaissance figures. The maps these artists

have made, some of which are discussed in the essays by Schulz and Edgerton, are quite clearly products of the artistic method, no matter how structured or conventional the cartographic guise in which they appear. Leonardo's map of Imola, for example, reproduced as color plate 2, not only is an extraordinary scientific document, being an early true orthogonal plan, but is an incredibly sensitive drawing that reveals the artist's full understanding not only of the structure of the city, but also of the riverbed beside it. It is art not in the superficial ornamental sense, but because of the efficiency, clarity, and style with which it communicates the subject.

There is, however, a broader way artists have used maps—the mapping concept as expressed in painting and drawing. This theory of the mapping instinct or impulse in artists is developed in Alpers's essay. She sees seventeenth-century Dutch artists, and perhaps other northern European artists since the Renaissance, as driven by a desire to map things rather than simply to portray them, particularly in topographical views. There was already what she calls a "web of acquaintance between artists and cartographers," but the mapping impulse went deeper. Thus she argues that the whole structure of northern landscape painting was based on pictorial or descriptive aims akin to mapping, with the viewer conceptually within the landscape being mapped; this was quite different from the southern European tradition of picture making, in which she claims the viewer was conceived as being outside the subject looking in.

Edgerton describes another mapping impulse that has extended across cultural and historical boundaries: the apparent need of some groups to organize, and in some cases to dominate, their world on a grid pattern, or what he calls the "mental matrix." Tracing this concept from the earliest times, he takes issue with the often-proposed idea that the Western preoccupation with grids (as in the Roman centuriation) was a simple transfer from its East Asian counterpart. He makes the case that the two were diametrically opposed in concept. The East Asian grid appears to have been centripetal, designed with the aim of enhancing a central focus, as in a rectangular urban plan with avenues leading to a central palace. In the West, however, he shows that the grid was a centrifugal concept, a tool of expansion and domination. The Roman centuriation, he says, almost "turned all Europe into one vast sheet of graph paper."

Both Alpers and Edgerton address themselves to the role that the discovery of linear perspective played in these mapping concepts, but they take opposing positions on the nature of that role. Alpers maintains, for example, that the concepts of map projection described in the *Geography* of Ptolemy were in no way connected with the rediscovery of perspective in early Renaissance Italy. She interprets the Ptolemaic mapping impulse, like the seventeenth-century Dutch equivalent, as conceiving of the mapper within the framework of surveyed points. This was quite different from the *velum* of Leon Battista Alberti, in which the viewer is conceived as being outside the scene looking at it

as if through a curtain. Edgerton, in this essay and in previous work, maintains that there was a direct conceptual link between Ptolemaic projections and Albertian perspective, pointing to a passage in the *Geography* where the reader is asked to conceive of the globe as seen from a distance in order to understand how the curves of meridians will appear to change the farther they are from a straight central meridian. These two essays are presented side by side so that the arguments may be conveniently compared.

In the twentieth century, and particularly in the past decade, the mapping instinct has manifested itself in modern painting to an astonishing degree, as evidenced by the four exhibitions referred to earlier in this Introduction. More recent artists such as M. C. Escher, Jasper Johns, William Wiley, Christo, Claes Oldenburg, Thomas O'Donohue Ros, Misch Kohn, Beth Shadur, Newton and Helen Mayer Harrison, Hundertwasser, Stacey Farley, Martha Glowacki, Michele Turre, Richard Lutzke, Nancy Graves, Masako Miyata, Richard Long, Roger Welch, and many others have used maps as their subjects or as artifacts in their paintings. An example is shown in color plate 1.

Yet another link is the frequent appearance of maps in paintings, the most striking example being in the Dutch interiors of the seventeenth century. Welu's work on this topic has been particularly noteworthy.[8] Alpers takes up this theme here, using it as strong evidence for a distinctive Dutch sensitivity to the map as an artifact and iconographic symbol. The interpretations of the iconography represented by maps in these paintings vary, but they normally include the idea of *vanitas* or worldliness, political or military power and authority, and science or learning. As Alpers shows, they can even be an analogue for the art of painting, as in Vermeer's *Art of Painting,* in which the map is given such prominence in the picture (and rendered in such faithful detail that even its state or edition can be identified) that its meaning is central to the painting's message.

MAPS IN ART

The maps represented by the Dutch painters also reflected the Dutch custom of using maps as wall hangings even in simple homes. This reflects the continuation of a long tradition in Europe, at least from medieval times, and includes not only mural maps, but globes and other cartographic artifacts that have frequently been used as symbols in their own right. Illustrating this fourth and final theme is the essay by Schulz on the map mural cycles of the Italian Renaissance. Maps could certainly be employed as works of art. And as Schulz points out, though in part they were put on walls as decoration, many had much deeper meaning. He traces the meaning of this genre, concluding that many of the maps represent a visual summa of contemporary knowledge, power, and prestige, some of it religious but most of it secular. This recognition of the iconographic meaning of the map as an artifact, quite separate from its function as a carrier of geographical information, reveals an important distinction between the form and content of maps.

MAPS AS ART

* * *

By concentrating on the nature of the artistic method rather than considering art as somehow contained abstractly within an artifact, these essays on the links between art and cartography help to clarify an important distinction. Of the many theories of aesthetics developed in philosophy, that summarized by Thomas Munro may have particular relevance in this question.[9] In company with other writers on aesthetics in the late nineteenth and early twentieth centuries, Munro reacted against the metaphysical idealism of the Neoplatonists that had developed into the "art for art's sake" movement of the late nineteenth century. In the Renaissance this had revived Plato's concern with ultimate beauty, but not without a fundamental misunderstanding: that art could somehow embody this perfection in the artifact itself. In Osborne's words: "To Plato himself, such a theory would have been an absurdity. He talks of beauty in connection with the ultimate reality of the Ideas but it is not the beauty of visual art, not a beauty which can receive sensible form."[10] The Neoplatonist movement found its champion in the seventeenth-century painter Nicolas Poussin, and it grew into a widespread view among art critics that art is nonutilitarian. Munro proposed that this notion be replaced with an empirical science of aesthetics that stressed the social function of art as stimulating satisfactory aesthetic experience. He thus saw form and social function, rather than success or value, as criteria for classing things as art. Based particularly on an earlier theory of George Santayana, Munro sought to show that the difference between the fine (polite or elegant) arts and the useful (practical or industrial) arts that arose with Poussin was no longer valid. Indeed, the value judgment in the term "fine" implied that the aesthetic qualities of a painting or a poem were somehow superior to those of an automobile or a steam engine. Since in his opinion all art seeks aesthetic effects, the prefix "fine" is no longer required. If something is created as a stimulus to satisfactory aesthetic experience, whether made by hand or by machine, whether produced gainfully or otherwise, whether good or bad, whether successful or not, it may be regarded as an artistic activity.

The artistic method is thus thought to be basically synthetic, autographic (revealing the character of the maker), and creative. In contrast, the scientific method may thus be regarded as analytical, independent of the scientist, and reportive in character. The approaches are fundamentally different philosophically and, as theorized in the recent brain lateralization studies of so-called right- and left-brain thinking, may also be so physiologically.[11] In varying degrees of intensity both are necessary in most forms of mental activity, particularly one as complex and interdisciplinary as cartography.

The implications of this view for cartography are several. In the first place, it may be held that if a cartographer makes a map with at least some aim to produce a satisfactory aesthetic experience in the user, whatever else the aims may be, there exists an element of artistic activity. If, among the myriad design options open to the cartographer

(whether typography, color, symbols, layout, or even projection), decisions are made with the user's sensibilities in mind, the artistic method is in action.

Furthermore, there are implications for map criticism or the evaluation of map design. As Munro points out, the terms "good" and "beautiful" are being used less in art criticism, just as their counterpart "true" is vanishing from scientific discussion. They are simply too all encompassing to be useful. Similarly, it is regarded as not enough to use "like" or "dislike" in criticism without explaining why this reaction is evoked.[12] Munro's views could certainly be applied to map criticism as well as general art criticism. But one of the major barriers, as he points out, is the lack of a precise vocabulary for describing the form of an object without evaluating it. In the context of map design, Barbara Petchenik has proposed such a vocabulary for characterizing the desired visual features of maps, and her scheme, or something modeled closely on it, is likely to be used in map and atlas critiques that are becoming more frequent in the scholarly literature of cartography.[13]

Some of these differences between the artistic and the scientific methods in cartography may be demonstrated by regarding cartography as a form of scientific illustration. Rather than the more familiar biological or medical subject matter with which many scientific illustrators make their living, cartography deals with the representation of the physical and social environment. Following Lapage, we may conceive of three main types of scientific illustration: descriptive, interpretive, and imaginative.[14] The descriptive depicts as accurately as possible what the scientist sees and may be photographic or pseudophotographic. The interpretive may leave out details that are not necessary for the immediate purpose of the illustration and involves some subjective judgment by the scientist, who is essential to the process. Finally, the imaginative illustration interprets ideas, hypotheses, and speculations rather than the structure or functions of the subject.

We may cite cartographic examples in each of these three categories. An example of the descriptive map is the orthophotomap, in which a photographic image corrected for tilt and relief displacement is employed with a minimum of subjective input from the cartographer. In the interpretive map, the cartographer's individual knowledge and ability are made manifest in the project, particularly through skill in generalization. An example would be a relief-shaded rendering of complex geological structures in which certain features must be stressed to reveal their true significance; this requires familiarity with what is being mapped. The imaginative map has many examples in history, as a glance at not only the *mappaemundi* but also the many literary other worldly maps will show.

A central theme in the discussion of the artistic nature of scientific illustration is the author's control over the final document. There are, of course, several factors that may interfere with this control: for example, lack of skill or technical limitations such as a particularly resistant medium. But the most significant factors will usually be the pro-

found differences in the kind of authorship involved. For example, at one end of the scale a scientist may employ an artist to create a scientific illustration with little or no direction or supervision; at the other end the scientist may not only prepare the drawing himself but also engrave it or closely control its reproduction. In between, there are many different combinations of personnel and amount of supervision involved.[15]

In general, the more control the author, scientist, or other person familiar with the subject matter being represented has in the creation of the illustration, the more opportunity there is likely to be for the artistic method, because of the more direct link with the potential viewer. On the other hand, where the process has an extreme assembly-line character, so that the individual entrusted with one very small task in the total activity is unlikely to know the purpose of his contribution, the product is likely to be less artistic. Since the nineteenth century, cartography has been undergoing a series of deep technical and philosophical changes affecting each stage of the cartographic process, from data gathering to dissemination; they include the applications of photography, plastics, and now electronics. The increased number of steps required to produce a map, each step calling for a highly specialized technician, has necessitated a complete rethinking of the role of the cartographer and has diminished the creative component within each of these steps.

For the cartographic technician spending his years at a video display unit, with prefabricated software and instructions, the value of the artistic method in cartography is thus not an issue. The subjective is being systematically removed from cartography, with advantages of consistency and predictability but with some major drawbacks. As we break cartography down into more and more logical steps for the purpose of automation, individuals are isolated further and further from both the origin and the meaning of the process.

For cartographic technologists, however, there exist many opportunities for the designers of hardware and software to control the quality of the final output. Indeed, here the links between creator and the product are perhaps more direct than ever before. A broader understanding of the principles of design is therefore required in order to resolve the enormous number of possible variations and combinations of structure, color, lettering, linework, symbols, and so on. Clearly, in this case sensitivity to the aesthetic in cartography is an extremely desirable attribute.

Surprisingly, much programming effort has so far been applied to cosmetic considerations: edge matching to make sure that detail on one sheet matches that on another; automatic contours that "look right"; the avoidance of glitches (idiosyncratic pen movements); and other improvements to counteract quirks of plotted output. While this apparent concern with aesthetics is encouraging, these improvements are intended only to meet the minimally acceptable functional standards of the user.

We cannot ignore the enormous fund of collective experience available to us in existing maps. Artistic criticism, applied to historical maps as well as to contemporary ones, can teach us much. The essays presented here provide examples of how the artistic method has been employed in mapmaking. The collection makes no claim to completeness or consistency, but it provides a taste of the many possible approaches to the study of the historical links between cartography and art. If we can show that the role of art in cartography runs far deeper than the decorative and ornamental, and if we can induce others to plumb these depths, this book will have achieved its aim.

From Mental Matrix to *Mappamundi* to Christian Empire: The Heritage of Ptolemaic Cartography in the Renaissance

SAMUEL Y. EDGERTON, JR.

If the Italian-inspired Renaissance were a modern Madison Avenue corporation and applied to the Patent Office for a registered trademark, it would certainly choose as its letterhead logotype that famous drawing by Leonardo da Vinci entitled *Man in a Circle and a Square* (fig. 1.1).[1] No other design of the period so graphically expresses the essences of the Renaissance: man as the measure of all things, and faith in mathematics as the communications link between heaven and earth. When Leonardo deftly drew this handsome male nude with outstretched finger- and toe-tips just touching the inside edges of superimposed square and circle, he was making a statement about the human and cosmic condition every bit as exalting as in that literary masterpiece by his Florentine contemporary Pico della Mirandola, *De dignitate hominis,* the "Oration on the Dignity of Man," wherein God speaks to Adam thus: "Thou, constrained by no limits, in accordance with thine own free will, . . . shalt ordain . . . the limits of thy nature. We have set thee at the world's center that thou mayest from thence more easily observe whatever is in the world."[2]

Both Pico and Leonardo might have then added what Agrippa of Nettesheim wrote in his *De occulta philosophia* of 1510: "The measures of all the members [of man's body] are proportionate and consonant both to the parts of the world and measures of the Archetype."[3]

Leonardo's drawing and these literary passages have long been regarded as humanistic expressions of man's awakening from the Dark Ages. *Man in a Circle and a Square* is frequently displayed to this day as a symbol of scientific progress. As we admire Leonardo's image, we can almost hear the crescendo timpani of Strauss's *Thus Spake Zarathustra,* the theme music of the twenty-first century.

I shall now argue that Leonardo's inspiration came not from any precocious premonition of modernity but from very ancient lore, even primitive humanoid intelligence, about the form of the cosmos. Furthermore, and this is what the paper will really be about, Leonardo's

This chapter is dedicated to Cyril Stanley Smith.

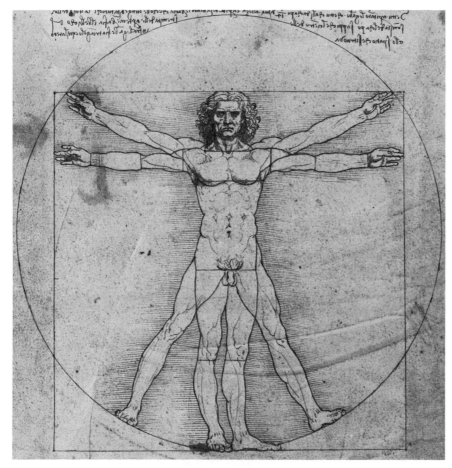

FIG. 1.1 Leonardo da Vinci, drawing, *Man in a Circle and a Square,* Accademia di Belle Arti, Venice. Courtesy of Alinari/Art Resource, Inc.

combination of the human figure with a perfect geometric square and circle is closely connected with cartography, especially the employment of the Ptolemaic grid. Leonardo belonged to a society that, like every human society anywhere in the world since the dawn of mankind, believed that geometric patterns formed in orthogonal relationships not only pleased the eye aesthetically but possessed talismanic power. Even in the Renaissance and well after, certain geometric figures composed of squares, circles, and triangles linked in some sort of grid pattern were considered "magic" because people thought they contained a clue to the power of God and his master plan of the universe.[4] As we shall now see, the arrival of Ptolemaic scientific cartography with its longitude and latitude grid system did not necessarily dispel these primordial beliefs. Instead, the new grid cartography, especially in the hands of the Roman popes, tended to reinforce faith in the divine mission of Christianity to convert the world. That is to say, by Leonardo's time the cartographic grid had become in its own right a talismanic symbol of Christian authority. Whether applied as the abstract direction system on a map, or the actual direction system of an urban site, or even the compositional

system of a picture, the cartographic grid in the Renaissance was believed to exude moral power, as expressing nothing less than the will of the Almighty to bring all human beings to the worship of Christ under European cultural domination.

Leonardo's drawing, of course, was originally intended to illustrate a literary passage from Vitruvius, the pagan Roman author of *De architectura*. This work, written during the reign of Augustus Caesar, had become a basic source of Renaissance ideas about antique architecture and Roman life in the time of Christ himself. Vitruvius had observed that a circle inscribed around a man with arms and legs outstretched would have its center at his navel. In other words, the navel as point of entry for nourishment of the infant in its mother's womb had cosmic significance as center of the form that circumscribed not only man but the whole universe. In Vitruvius's Rome, a certain monument in the Forum was known as *umbilicus mundi,* the "navel of the world."[5] As we shall see, the notion of the human umbilicus or omphalos as metaphor for the center of the universe was hardly unique to ancient Rome. One might even say it has been latent among peoples everywhere during their developmental stage of civilization. Leonardo modified Vitruvius's unillustrated statement by showing that man's figure in a square had the center not at his navel but at his groin, implying that the male phallus has the same symbolic significance as representing the procreative link between earth and heaven.

Leonardo, omnivorously curious, knew another antique treatise that for purposes of this paper had even more far-reaching influence than Vitruvius. This was the *Geography* or *Cosmography* by the second-century A.D. Alexandrian Greek Claudius Ptolemaeus, or Ptolemy, which contained some twenty-five geographical maps of nations known to the ancients plus a double-page gridded *mappamundi* or "map of the world," with which the other detail maps were correlated (fig. 1.2). This abstract grid was fixed to the spherical earth by the same mathematics of longitude and latitude by which the ancient Greeks located the stars in the sky. Strangely, Ptolemy's *Geography* remained unknown in western Europe until about 1400, when it was brought to Florence from Constantinople by humanist scholars seeking original Greek-language texts. When it arrived, it caused an immediate sensation in Roman Catholic Europe. It was quickly translated into Latin and subsequently printed in several editions by the end of the fifteenth century.[6] Leonardo da Vinci owned a printed copy, and he made frequent references to it in his voluminous notebooks. He even promoted the *Cosmography* (as Renaissance scholars preferred to call it) as the ideal model for his own intended treatise on human anatomy, as he acknowledged in his preface:

> Therefore, by my plan you will become acquainted with every part of the human body. . . . There will be revealed to you in fifteen entire figures the cosmography of this *minor mondo* [the "lesser world" of the human body as microcosm of the macrocosm] in the same order as was used by Ptolemy before me in his *Cosmographia*.

And therefore I shall divide the members of the body as he divided the whole world into provinces, and then I shall define the function of the parts in every direction, placing before your eyes the perception of the whole figure.[7]

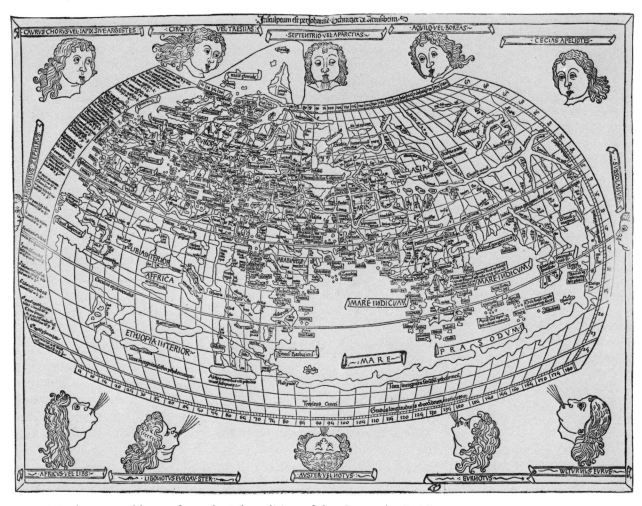

FIG. 1.2 Ptolemy, world map from the Ulm edition of the *Geography* (1482). Courtesy of the Newberry Library, Chicago.

It was hardly Ptolemy's geographical information as such that interested Leonardo. Much of that was wrong or obsolete anyway.[8] Rather, it was the organizing system of the atlas by which Ptolemy coordinated his pictures of the individual lands with their relative positions in the *mappamundi*. This depended on imagining the globe not as amorphous topography but as a homogeneous surface ruled by a uniform geometric grid. Here was the true essence of the world, thought Leonardo, not its wrinkled coastlines and willy-nilly mountains and plains, and indeed he jotted down a number of admiring comments about Ptolemy.[9] The *Cosmography* was proof positive for him that the same forces and organizational systems that operated in the world also pertained to human anatomy. Nor could Leonardo the artist have missed

the analogy Ptolemy drew in the very first paragraph of his *Cosmography,* in which the Alexandrian made a distinction between chorography and geography:

> The end of chorography is to deal separately with a part of the whole, as if one were to paint only the eye or ear by itself. The task of geography is to survey the whole in its just proportion, as one would the entire head. For in an entire painting we must first put in the larger features and afterwards those detailed features which portraits and pictures may require, giving them proportion in relation to one another so that their correct distance apart can be seen by examining them, to note whether they form the whole or part of the picture.[10]

Leonardo's appreciation of the geometric order that Ptolemy indicated must underlie the earth's apparent diversity was not exclusive to Renaissance artists and scientists. It was also for a long time much on the minds of Christian theologians, especially after the Crusaders failed to recapture Jerusalem from the Mohammedans. Many learned churchmen, like the English Roger Bacon and Robert Grosseteste, believed that knowledge of geometric systematization would somehow restore Christian unity and make it possible to regain the Holy Land. As Bacon advised: "Since, therefore, the power of geometry is required for the knowledge of every corporeal creature, there is no doubt but that in an inexpressible manner it is effective for sacred knowledge."[11]

One aspect of Ptolemy's science that appealed to medieval churchmen even before they knew of the *Cosmography* was the study of optics, or *perspectiva,* a branch of geometry systematically researched by the followers of Euclid and transmitted to the West during the twelfth-century "renascence." Ptolemy insisted in his *Cosmography* that the mapmaker first view that part of the world to be mapped as if it were connected at its center to the center of the viewer's eye by an abstract "visual axis"; that is, a line perpendicular to both the earth's surface and the surface of the eye. This followed from an optical theorem stating that only the aspect of an object on axis with the center of the eye could be clearly observed.[12] Medieval theologians like Grosseteste were impressed because ancient Greek optics seemed to explain how God transmitted his divine grace to the human soul. If the human soul were "clean," God's grace would touch it perpendicularly, entering it, as light does transparent glass, undiminished and unrefracted. If, however, the soul were stained with sin, God's grace must strike it obliquely and be refracted or reflected away. Such a parallel between geometric optics and Christian morality was even the subject of a popular treatise of the Middle Ages, *De oculo moralis,* written in the fourteenth century by Pierre de Limoges, printed in 1496 and published in five editions thereafter.[13] The Florentine artist Antonio Pollaiuolo added optical science, personified by the figure of a maiden named Perspectiva, to his imagery of the "Liberal Arts" decorating the tomb of Pope Sixtus IV in Rome in 1493.[14] Leonardo, of course, was determined to compose his own

And therefore I shall divide the members of the body as he divided the whole world into provinces, and then I shall define the function of the parts in every direction, placing before your eyes the perception of the whole figure.[7]

FIG. 1.2 Ptolemy, world map from the Ulm edition of the *Geography* (1482). Courtesy of the Newberry Library, Chicago.

It was hardly Ptolemy's geographical information as such that interested Leonardo. Much of that was wrong or obsolete anyway.[8] Rather, it was the organizing system of the atlas by which Ptolemy coordinated his pictures of the individual lands with their relative positions in the *mappamundi*. This depended on imagining the globe not as amorphous topography but as a homogeneous surface ruled by a uniform geometric grid. Here was the true essence of the world, thought Leonardo, not its wrinkled coastlines and willy-nilly mountains and plains, and indeed he jotted down a number of admiring comments about Ptolemy.[9] The *Cosmography* was proof positive for him that the same forces and organizational systems that operated in the world also pertained to human anatomy. Nor could Leonardo the artist have missed

the analogy Ptolemy drew in the very first paragraph of his *Cosmography,* in which the Alexandrian made a distinction between chorography and geography:

> The end of chorography is to deal separately with a part of the whole, as if one were to paint only the eye or ear by itself. The task of geography is to survey the whole in its just proportion, as one would the entire head. For in an entire painting we must first put in the larger features and afterwards those detailed features which portraits and pictures may require, giving them proportion in relation to one another so that their correct distance apart can be seen by examining them, to note whether they form the whole or part of the picture.[10]

Leonardo's appreciation of the geometric order that Ptolemy indicated must underlie the earth's apparent diversity was not exclusive to Renaissance artists and scientists. It was also for a long time much on the minds of Christian theologians, especially after the Crusaders failed to recapture Jerusalem from the Mohammedans. Many learned churchmen, like the English Roger Bacon and Robert Grosseteste, believed that knowledge of geometric systematization would somehow restore Christian unity and make it possible to regain the Holy Land. As Bacon advised: "Since, therefore, the power of geometry is required for the knowledge of every corporeal creature, there is no doubt but that in an inexpressible manner it is effective for sacred knowledge."[11]

One aspect of Ptolemy's science that appealed to medieval churchmen even before they knew of the *Cosmography* was the study of optics, or *perspectiva,* a branch of geometry systematically researched by the followers of Euclid and transmitted to the West during the twelfth-century "renascence." Ptolemy insisted in his *Cosmography* that the mapmaker first view that part of the world to be mapped as if it were connected at its center to the center of the viewer's eye by an abstract "visual axis"; that is, a line perpendicular to both the earth's surface and the surface of the eye. This followed from an optical theorem stating that only the aspect of an object on axis with the center of the eye could be clearly observed.[12] Medieval theologians like Grosseteste were impressed because ancient Greek optics seemed to explain how God transmitted his divine grace to the human soul. If the human soul were "clean," God's grace would touch it perpendicularly, entering it, as light does transparent glass, undiminished and unrefracted. If, however, the soul were stained with sin, God's grace must strike it obliquely and be refracted or reflected away. Such a parallel between geometric optics and Christian morality was even the subject of a popular treatise of the Middle Ages, *De oculo moralis,* written in the fourteenth century by Pierre de Limoges, printed in 1496 and published in five editions thereafter.[13] The Florentine artist Antonio Pollaiuolo added optical science, personified by the figure of a maiden named Perspectiva, to his imagery of the "Liberal Arts" decorating the tomb of Pope Sixtus IV in Rome in 1493.[14] Leonardo, of course, was determined to compose his own

treatise on the science of vision. "The eye," he wrote, "is the master of astronomy. It makes cosmography. It advises and corrects all human arts. . . . The eye carries men to different parts of the world. It is the prince of mathematics. . . . It has created architecture, and perspective, and divine painting. . . . It has discovered navigation."[15]

<p style="text-align:center">* * *</p>

But let us back up for a moment and consider how these ideas relating geometric to moral rectitude had become so implanted in the Western Christian mind in the first place. As I already mentioned, such associations were not unusual among primitive peoples everywhere. How then did Western civilization during the Renaissance convert these "superstitions" into the service of modern science and make them work for a spectacularly successful system of world organization that lasts to this day?

Modern science has concluded that all human beings possess from birth an innate "orientation preference" for vertical and horizontal lines. This was demonstrated recently by a group of psychologists at Massachusetts Institute of Technology in an experiment that recorded the eye fixations of infants as they were shown patterns of vertical, horizontal, and oblique lines. The children were much more stimulated by the vertical and horizontal compositions than by the oblique.[16] From the anthropological standpoint, moreover, Alexander Marshak has argued that prehistoric hominids, even before *Homo sapiens* evolved, already had a developed mental capacity for measuring time and space.[17] This may have come about after eons of watching what Marshak calls the "vault of the sky." The "fittest" of the early hominids survived because they could apply the movements of sun, moon, and stars to their seasonal preparations for food gathering. Thus the circle, the basic form of shapes and movements in the sky, took on supernatural significance.

Just as the heavens related to the circular form in the mind of early man, so also might the earth have suggested something special about rectilinearity. In ancient Egypt, the hieroglyphic symbol for "land measure" was an orthogonal grid.[18] The oldest known astronomical treatise, from China in the eleventh century B.C., described the heavens as circular and the earth as a square.[19] Among the wall paintings attributed to Cro-Magnon cavemen from Lascaux in southern France, dating some twenty thousand years before Christ, are found a number of grid designs (fig. 1.3) that may also have had some magic intent.[20]

In his book *The Sense of Order,* E. H. Gombrich provides further insights into the innate appeal of the grid (or "hierarchical design") in the visual arts. He goes on to discuss how any such pattern in which one unit is the repeated module for an entire composition presupposes a "framing, filling, and linking" in the viewer's imagination. In other words, the boundaries of the unit module enclose it and simultaneously generate the boundaries of adjacent units. The dynamics of this generation operate both centrifugally and centripetally or, in Gombrich's terminology, are "positional attenuating" and "positional enhancing."[21] These terms refer to the kaleidoscopic effect where shifting patterns in

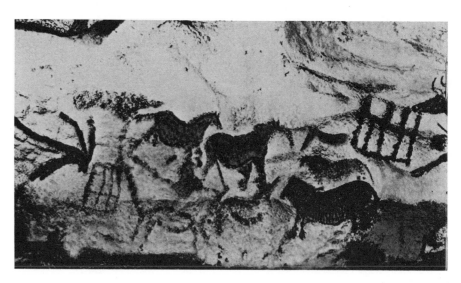

FIG. 1.3 Cro-Magnon cave painting, Lascaux, France, in Fernand Windels, *Lascaux: "Chapelle Sixtine" de la préhistoire* (Dordogne, 1948). Courtesy of the Centre d'Etudes et de Documentation Préhistoriques, Montignac-sur-Végère.

FIG. 1.4 Augustus Welby Pugin, wallpaper design for the British Parliament, in E. H. Gombrich, *The Sense of Order* (Ithaca, N.Y., 1979). Crown copyright Victoria and Albert Museum, London.

the rotating toy seem to fall away from or toward a fixed center. We are more conscious of the latter effect when there is a strongly defined frame around this center. If, however, the boundary is ill defined, we tend to feel the design as "positional attenuating," or flowing outward from whatever center we focus upon.[22] Relative to Gombrich's observations, metallurgist Cyril Stanley Smith of Massachusetts Institute of Technology has been investigating the phenomenon of hierarchical patterning in inorganic crystals and biological cells. Perhaps, he speculates, the universal human aesthetic response to any design formed around a grid derives from the fact that the grid is the basic structural form of matter itself, existing before art was ever invented. He has been especially struck by the ubiquity of the quincunx or five-spot (as on dice or playing cards). The figure is also basic in the structures of cells and atoms and, similarly, an element of decorative style in the arts of peoples at all times and places. As Smith argues, the quincunx is not strictly speaking a design unit but rather is a *specification* of how units must be linked to one another if the whole structure is to achieve uniformity (fig. 1.4). The quincunx, he states, "incorporates the very nature of hierarchy. It is both a recognition of regional differences defined by boundaries, and a recognition that the regions across the boundaries are commonly shared."[23] All these perceptions of the hierarchical grid in nature and in art have given this form special significance as a tool of both magic and science, in religion and in secular politics, as we shall see.

Although ancient civilizations outside Greek influence did not practice cartography in anything like the Ptolemaic sense, many did engage in topographical design—city planning—which for the purposes of this paper I choose to include within the "mental matrix" of cartographic thinking. Indeed, just like the medieval Christian "T-O" map,

many ancient city plans attempted to relate the terrestrial world of the inhabitants to the form of their imagined heavenly paradise. The idea of having one's earthly abode conform in some way to the cosmic will seems almost instinctive, and we have hundreds of archaeological examples from far-flung places: from Egypt, Mesopotamia, India, China, Black Africa, and Europe and among the Indians of North, Central, and South America. There is no prototypical plan for these sites, but some common denominators are apparent: the organization of streets and buildings along orthogonal axes, the placing of the ruler's house or sacred precinct at the axial crossing, and the aligning of streets toward a preferred symbolic direction. Another symbol usually incorporated in ancient urban sites is the omphalos or navel. This takes the shape of a raised monument, such as a tower, complementing the two horizontal axes of the city plan. This monument, usually at the axial crossing, functions to link the community to heaven. We are already familiar with the ziggurats of Babylon and Ur and the altar pyramids of the Aztecs and Mayas. At Angkor Thom in medieval Cambodia, the Khmer king Jayavarman VII built the Bayon, a cluster of masonry towers with the centermost the highest. On each of the faces of the surrounding towers, the king had his portrait carved in the guise of a Buddhist deity. The purpose of the complex was to demonstrate that Jayavarman received his powers directly from heaven (through the central tower) and then transmitted the divine will to the four corners of his kingdom (fig. 1.5). For Mohammedans the Ka'bah in Mecca still represents the "navel of the world." For medieval Christians, Jerusalem was the navel. We are familiar with Dante's description of the tower of purgatory, on an axis with Jerusalem at the opposite side of the world, from which the poet ascended to paradise. Some anthropologists have been so struck by this spontaneous, nearly universal cosmological planning that they have given it a scientific name—"astrobiology."[24]

Anthropologists are generally agreed, however, that astrobiological planning is not spontaneous during the primitive stage of tribal civilization.[25] Instead, it seems to happen only when social consciousness reaches a level where interaction with outside peoples has to be taken into the tribe's consideration. According to urban historian Sibyl Moholy-Nagy, primitive community planning is at first "centripetal," meaning that the spiritual energy of the tribe is inward directed and exclusive, ignoring the outside world and concentrating on the ideological center of the village.[26] During later stages of civilization, Moholy-Nagy finds this dynamic reversed, with the communal energy flowing outward. This is the precondition for orthogonal urban planning. Peoples in this stage, like the Indians of Central and South America, often used their very city plans as aggressive instruments for extending power. They simply pushed their ordered streets outward to include and enclose neighboring tribes. This kind of predatory urban accretion has been called "synoecism" after Synoekia, Greek goddess of civic union.[27]

Urban planning in the Mediterranean world had already reached the developed level of orthogonal, centrifugal sophistication by the fifth

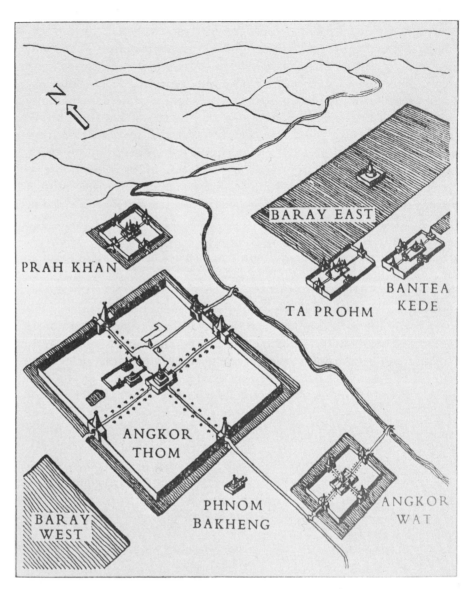

FIG. 1.5 Plan of Angkor Thom, Cambodia, in Benjamin Rowland, *The Art and Architecture of India* (Pelican History of Art, 3d ed rev., 1967). Reprinted by permission of Penguin Books, Ltd.

century B.C. The most ordered of the Greek cities was Miletus, rebuilt on a uniform modular grid plan after the Persian Wars. Aristotle tells us it was the creation of one man, Hippodamus, an eccentric political theorist. However, Hippodamus was probably not even the first Greek to devise a grid city plan, and there is no archaeological evidence that its block pattern was quite so uniform as modern reconstructions suggest (fig. 1.6).[28]

Alexander the Great really deserves the credit for making the Greek urban grid the symbol of Synoekia's power. The Macedonian conqueror dreamed of an ecumenical world empire dominated by Greek

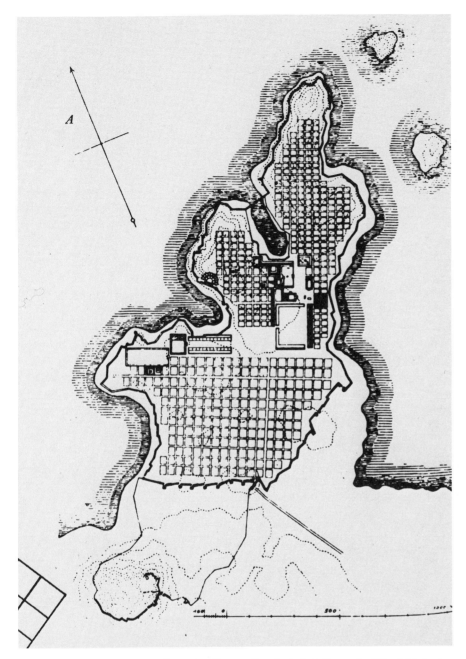

FIG. 1.6 Hippodamus(?), plan of Miletus, Greek Asia Minor, in Sibyl Moholy-Nagy, *Matrix of Man: An Illustrated History of Urban Environment* (New York, 1968). Reprinted by permission of Praeger Publishing Company.

culture. Being Greek, he was nurtured on Pythagorean faith in the transcendant, soothing effects of geometry. Hence he made the grid the trademark of Greek civilization in the inhabited world for centuries thereafter. Alexandria, the emperor's personal city designed by his architect Dinokrates, must have been a masterpiece of orthogonal planning (fig. 1.7). Here the monotony of the modular grid was tastefully

relieved by a succession of open stoas and vistas designed to take advantage of the spectacular harbor view. The city apparently was more inward focusing than most.[29] It was planned so that its privileged inhabitants could enjoy the fruits of empire. Here, of course, was also the Museion, the fabulous institute for advanced study, where worked the fathers of modern scientific cartography: Strabo, Eratosthenes, Hipparchus, and Ptolemy himself. Just as Greek city planners touched a deeper aesthetic when they allowed the urban grid to express the natural landscape, so did the Alexandrian geographers discover a higher truth when they harmonized the cartographic grid with the natural celestial spheres.

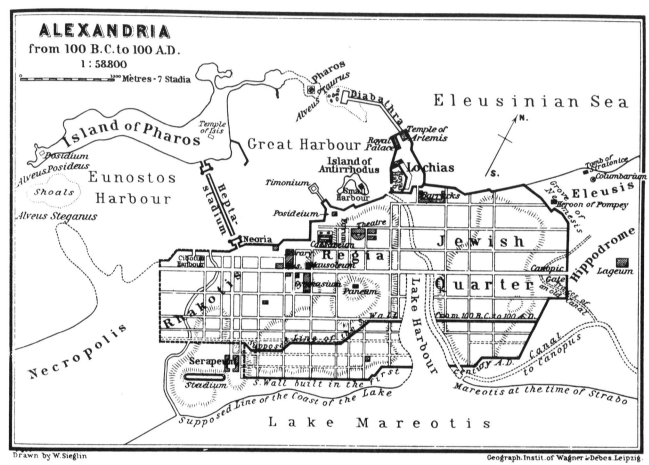

FIG. 1.7 Dinokrates, plan of Alexandria, Egypt, in Sibyl Moholy-Nagy, *Matrix of Man: An Illustrated History of Urban Environment* (New York, 1968). Reprinted by permission of Praeger Publishing Company.

As Bismarck is supposed to have remarked that his fellow Germans could stand a shot of French champagne in their veins, so it might be said that the Romans should have gotten a little drunker on Alexandrian wine. The Romans, of course, took over Greek civilization lock, stock, and barrel. Instead of devising new and interesting variations on the urban grid, they transmogrified it—at least in the colonial

towns outside Rome itself—into an image of regimented dullness. During the six centuries of her empire, Rome established hundreds of settlements from the Atlantic Ocean to the Persian Gulf, from the Sahara to Scotland, monotonously constructed on the same modular grid plan. These communities were all uniformly bisected by two perpendicular avenues, the north-south *cardo* and the east-west *decumanus.* Evidence of this unmitigated orientation is still to be seen in the street patterning of European cities like Florence, where the present Corso defines the ancient *decumanus,* the Via Roma and Via Calimala the *cardo,* and the Piazza della Repubblica the traditional forum, at the intersection of the two main highways.[30] Leonardo da Vinci was sufficiently interested in Roman planning to indicate the ancient grid of the city of Imola in his own plan of 1502 (color plate 2). Leonardo's map is considered the first "ichnographic" or mathematically accurate topographical rendering of a city in all of cartographic history.[31] It was based on the directions of Leon Battista Alberti written a half-century before, which in turn reflected Ptolemy.

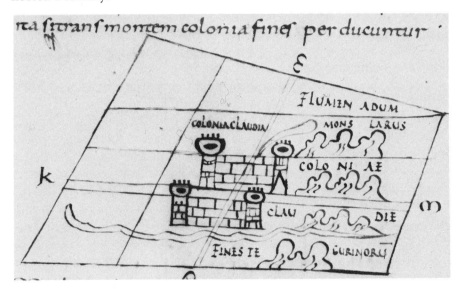

FIG. 1.8 Hyginus Gromaticus, plan of a Roman *colonia,* from the *Corpus Agrimensorum Romanorum.* Courtesy of the Herzog-August Bibliothek, Wolfenbüttel.

The Romans also produced a body of literature on how to measure land according to the modular grid, called the *Corpus Agrimensorum.* One of these treatises, attributed to an author called Hyginus Gromaticus and originally written about A.D. 500, exists today by virtue of a number of illustrated early medieval copies (fig. 1.8).[32] The author's surname, Gromaticus, refers to his surveying profession. His job was to divide up land in the conquered territories into hundred-square units for distribution among Roman colonists. Hence, the name of this land division method has come down to us as "centuriation." Today in rural central Italy one can still see traces of it in the persistent orthogonal layout of roads, fences, and irrigation canals and even in the orientation of houses and barns.

How monotonous must have appeared the centuriated landscape and gridded towns of Europe under Roman occupation! The *mensor* paid little aesthetic attention to relieving variations of topography. Like the imperial ambition it so well symbolized, the grid rolled out relentlessly in all directions from the capital, homogenizing everything in its path. Applying Gombrich's terminology, the unrestricted Roman grid is a good example of "positional attenuating" design. It almost seems that the "aesthetic" attitude of the empire was to implant quincunx-formed *coloniae,* in her conquered provinces, each "linked" to identical communities along the common dendritelike axes of *cardo* and *decumanus* and each "filled" with uniform lattices of perpendicular streets and modular blocks. Such a composition did in fact serve the empire as a surrogate "army of occupation," constantly reminding subject peoples of their conqueror's superior organizing power. Had she not finally been thwarted by the rebellious Goths, Rome might have turned all Europe into one vast sheet of graph paper.

Yet to the lonely Roman traveling in Gaul during, say, the second century A.D., the sight of centuriation was reassuring. It inspired a feeling of security not unlike that of the modern American tourist who suddenly sees, in the wilds of Africa, the familiar facade of a Holiday Inn. Let us imagine further, however, that this same hypothetical Roman had ventured as far as Changan, principal city of Han dynasty China (fig. 1.9). Would he not behold in the Chinese empire perhaps the most persistent orthogonal urban planning in all the ancient world? Would the Chinese city grid, just as commonplace in the East as Roman centuriation was in the West, have communicated to him the same Pax Romana complacency?

At first sight our Roman traveler might be deceived by the appearance of the Chinese city. Not only would he have found its rigidly orthogonal plan familiar, but he would be pleased to note that, like the Roman *cardo,* the Chinese main avenue was always oriented to the north. Nevertheless, he would soon observe that the Chinese grid plan did not encourage him to stand in one spot, as he could at the crossroads of his Roman *urbs,* and from there survey all surrounding space as ordered by a uniform block module. He could not, as he could in Rome itself, stand at one end of a great avenue culminating in a lofty building and from that single viewpoint capture the full iconography of the imposing monument.

As our Roman traveler progressed along the main avenue of the Chinese city, he would pass through a number of gates, each causing him to pause and observe the monument from a different vista, each emphasizing another aspect of the building. Whereas the Roman processional avenue allowed but a single direction from which to fix on one frontal aspect, the Chinese provided a succession of different viewpoints. As Paul Wheatley has pointed out, the experience of walking through a Chinese city is like looking at a Chinese scroll painting. The viewer unrolls it scene by scene, not as if he were following a linear narrative, but to contemplate the depicted story from different angles, no one of which alone tells the whole truth.[33]

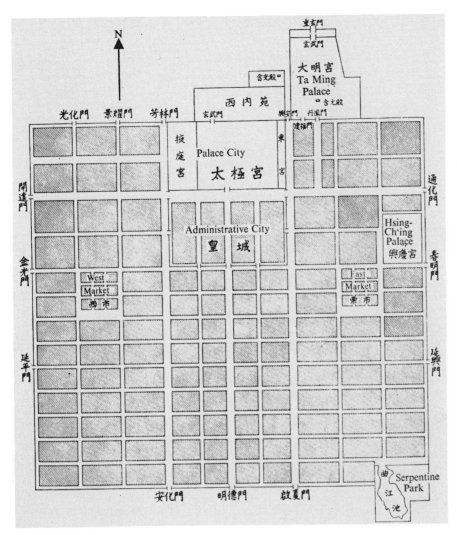

N

童玄門
玄武門

含光殿口
西内苑
大明宮
Ta Ming
Palace
口含元殿

光化門 景耀門 芳林門
玄武門
興安門 丹鳳門
建福門

掖庭宮
Palace City
太極宮

開遠門

東宮

通化門

金光門

Administrative City
皇　城

West
Market
西市

East
Market
東市

Hsing-
Ch'ing
Palace
興慶宮

春明門

延平門

延興門

安化門　　明德門　　啟夏門

曲
江
池
Serpentine
Park

FIG. 1.9 Plan of Changan, China, in Paul Wheatley, *The Pivot of the Four Quarters* (Chicago, 1971).

Joseph Needham, the most respected modern Western historian of Chinese science and civilization, has applied the term "stratified matrix" to the Chinese mental set.[34] He hastens to point out, however, that in the East it is never "mechanical and hierarchical" as in the West. While "pattern" and "order" are key words in Chinese cosmology, the "parts of the whole" remain ever organic and semi-independent. The "parts," in fact, share their interdependence through a system of "mutual courtesy" rather than through hierarchical subordination.[35] Needham likens this "organismic" character of Chinese order to the structure of certain annelids that have nervous systems not centered in a single brain but distributed throughout the body segments in a network of autonomous but mutually tuned ganglia.

Ancient Chinese science thus maintained a bias against the quantitative objectivity of Western thought. Nevertheless, it did manage, about the same time as the Alexandrian school of geography, to come up with an indigenous method for applying the grid as a mapping tool.[36] It would be interesting to speculate that some sort of cartographic

exchange was going on between the Greeks and the Chinese, yet the latter, who knew very well how to determine latitude by measuring the gnomon's shadow and who habitually oriented their orthogonal city plans by astronomical calculation, still did not relate their cartographic grids, as did the Greeks, to the sun's passage over the earth.

With characteristic Sinophilism, Needham takes pride in the fact that the Chinese applied the grid to everything from land measure to gaming boards and that in the Sung and Yuan dynasties, when western Europeans had forgotten Ptolemy, grid cartography flourished in China.[37] He even postulates that Chinese cartographers might first have discovered the usefulness of the grid from the warp and woof of the stretched silk on which the early maps were painted.[38] Whenever the Chinese conceived the grid as a tool of land measure, they thought of it as did the Romans, as a scale of fixed distances with no reference to the size of the whole earth as determined by astronomical calculation. However, the real issue between Chinese and Western concepts of cartography should be not which concept came first but why these two great civilizations understood the gridded map differently; the one as symbol of cultural isolation, the other a symbol of cultural expansion.

<p style="text-align:center">* * *</p>

In ancient China, "space" was not perceived as a uniform *quantum continuum,* as has been taken for granted in the West at least since the Renaissance. Rather, it was understood as a confederation of five directions: north, south, east, west, and middle.[39] Each direction had its own distinction and quality. The Chinese universe was sometimes diagrammed as a grid of nested rectangles with the center occupied by China, whose name means "Middle Kingdom." Figure 1.10 shows such a symbolic, ideological diagram from about the fifth century B.C. The center of this "map" represents the imperial palace. Reading outward, the next rectangle represents the imperial domains; then the lands of the tributary nobles; then the zone of pacification where border peoples are adjusting to Chinese customs; then the land of friendly barbarians; and finally, the outermost rectangle separates Chinese civilization from the lands of savages who have no culture at all.

In this Chinese example we observe an interesting combination of aesthetics and political iconography. The contemporary Chinese viewer not only would appreciate the decorative composition of his "map" with its nested rectangular borders and extraordinary emphasis on a "positional enhancing" center, but was thereby lulled by those very aesthetic qualities into feeling complacent about his national security. Much later, in the sixteenth and early seventeenth centuries, the Jesuit missionary Father Matteo Ricci gained some insight into this peculiar Chinese map mentality. While attempting to convert the gentry of the Ming dynasty, he had published a number of world maps in the Chinese language and artistic style yet still showing the world according to the prevalent European Ortelian cartographic system, with meridians curving toward the north and south poles. His first map (fig. 1.11) had

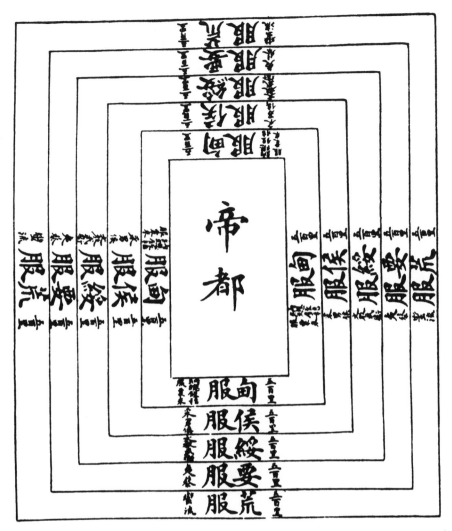

FIG. 1.10 Diagram of the world according to the ancient Chinese, in Joseph Needham and Wang Ling, *Science and Civilisation in China,* vol. 3 (Cambridge, 1959). Reprinted by permission of Cambridge University Press.

China the same size as many other nations and not even in the center (just to the left). In his diary, Ricci recorded the reactions of his mandarin friends upon first seeing this map:

> It was the best and most useful work that could be made at that time for placing China and giving credit to all things of our Holy Faith. But the Chinese had already printed many world maps . . . in which the entire space was filled with the fifteen provinces of China, and around them a little sea in which they indicated certain little islands called by the names of all the kingdoms, as many as they knew, and these united all together made only a small province of China. With this image of the size of

their kingdom, and the smallness of the rest of the world they were proud, and it appeared to them that the rest of the world was barbarian and uncouth in comparison. Nor did they expect to be subject to foreign masters. When they saw the world so large, however, and China appearing so small in a corner, the more ignorant made fun of the map; but the wiser people, seeing the beautiful order of graduation of parallels and meridians . . . could not abandon the belief that all this was true . . . our land so far from their kingdom, and the immense sea that interposes itself between us. With this, they abandon the fear . . . of our people coming to conquer their kingdom. This [fear] is one of the major impediments the Fathers have in converting these people.[40]

FIG. 1.11 Fr. Matteo Ricci, S.J., first Chinese-language *mappamundi* according to the European cartographic system. Reproduced from Pasquale D'Elia, *Fonti Ricciane,* vol. 1, ed. Nazionale delle Opere Edite e Inedite Libraria dello Stato (Rome, 1942).

The omphalos syndrome, where a people believe themselves divinely appointed to the center of the universe, shows its symptoms in the history of cartography as often as in ancient city planning. The oldest extant world map, inscribed on sun-dried brick from sixth-century B.C. Mesopotamia, illustrates a circular cosmos with Babylon in the middle.[41] Both the early Christians and the Mohammedans placed their own holy shrines in the center of similarly circular charts of the cosmos. When the Mohammedans swept over the old Greek world in the seventh century A.D., they lost no time in making their own use of Ptolemy's *Cosmography.* Not only had the Alexandrian inadvertently

blessed Mecca as the "navel of the world" by its proximity to the non-ideological, astronomically determined center of his original *mappa-mundi*, but the longitude/latitude system would make it possible for the most far-flung faithful of Islam to know precisely in which direction to bow toward the sacred Ka'bah.[42] Perhaps the Arabs also felt a certain aesthetic affinity with the Ptolemaic grid, since geometric design has always been the essence of their art. Because of the iconoclastic rule of so many Muslim sects, Islamic cartographers, including the great Idrisi of the twelfth century, sometimes copied Greek drawing conventions without any clear understanding of their illusionary intent—for example, their capacity to show convincingly the three-dimensional curvature of the earth. In general, Mohammedan maps were drawn in the same flat, decorative style that is characteristic of most Islamic art (color plate 3).

From the beginning of Christianity, however, there was no doubt that Jerusalem was the true center of the world. The first Christian map form often has the Holy City as *umbilicus regionis totius* surrounded by Asia, Europe, and Africa, all within a circle or *rota*. This "wheel" map is also known as the "T-O" *mappamundi*, the O being the surrounding ocean and the T, which crosses at Jerusalem, being the rivers and seas that separate the three continents. East, the preferred symbolic direction of the terrestrial paradise, is usually at the top instead of north (or south as in Islamic maps). The most widespread depiction of the "wheel" map was derived from the *Etymologies* of Saint Isidore of Seville, first written in the early seventh century (fig. 1.12).[44]

Early Christians did not begin to express their own brand of cartography until about the fourth century. Except among Greek-speaking Christians in Byzantium, Ptolemy's geographic methodology was rejected as counter to both Scripture and empirical observation.[43] Christians, after their long and bitter struggle for recognition in pagan Rome, had come to reject much of classical learning as sinful, especially the rendering of stereometric forms in art. Like the classical style, Ptolemy's cartography was deemed inappropriate for expressing the true Christian, spiritual reality of the world.

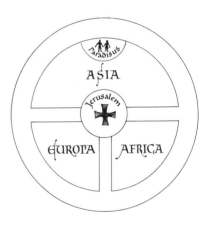

FIG. 1.12 Early Christian T-O map of the world. Author's reconstruction.

As we compare this early Christian map with other ideological diagrams like those from China and Islam, our first glance might deceive us into believing that each communicated the same message to its constituents. All three can be said to be "positional enhancing" in that their common designs, whether based on circle or square, concentrate the viewer's attention upon the center. All three thus imply exclusive, inward-directed worldviews, each with its separate cult center safely buffered within territories populated only by true believers. Such a secure and sanitized Christendom, however, was not a political reality for medieval Europeans, especially after the thirteenth century. In fact the T-O map was a matter of considerable embarrassment to the Christian pope, who could not, like his counterparts in China and Islam, put his finger on the center and say smugly, "There sit I at the shrine of our faith, in the midst of fellow believers."

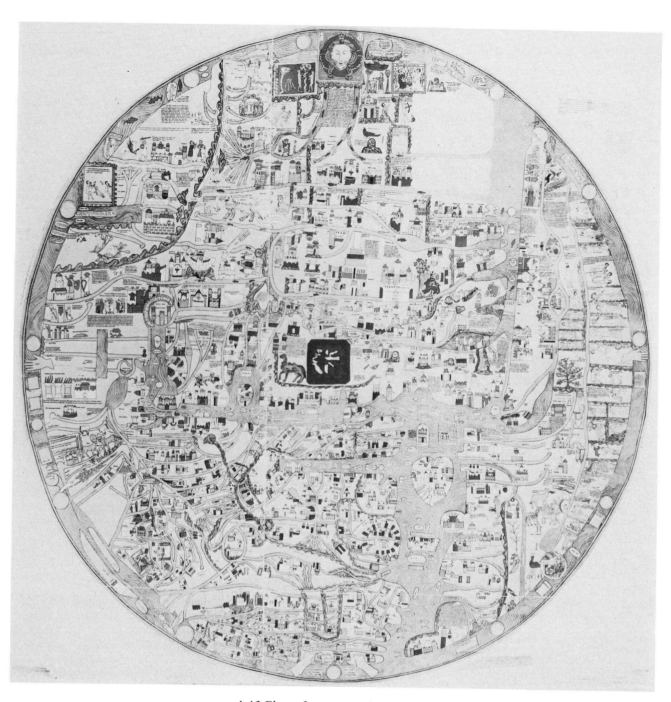

FIG. 1.13 Ebstorf *mappamundi,* ca. 1235, in Leo Bagrow, *History of Cartography,* rev. and enl. by R. A. Skelton (Cambridge, Mass., 1964). Reprinted by permission of Harvard University Press.

Of all the great religions that identified with national sovereignty in premodern times, only Christianity suffered to have its most sacred shrine in territory controlled by infidels. The loss of Jerusalem to the Muslims and the subsequent failure of the Crusaders to recapture it was certainly one of the most wrenching traumas medieval Europeans were forced to endure. To appreciate what Jerusalem meant to the Christian true believer of the thirteenth century, we need only analyze another variant of the "wheel" map, the Ebstorf *mappamundi* (fig. 1.13). This large chart, unfortunately destroyed in World War II, shows Jerusalem in the center, marked by a patch of gold leaf, and east, the terrestrial paradise, at the top. The unique feature is that Jesus's body is then superimposed on the *mappamundi*. We see the Savior's head at the top of the circle; that is, at the farthest east. His pierced hands right and left touch the side edges of the world, north and south. Christ's feet are at Gibraltar, the bottom and the western exit from the Mediterranean. Here the legendary Hercules is supposed to have erected two pillars with the inscription, *Non plus ultra,* "There is nothing beyond." The Ebstorf map thus represented both physically and metaphysically the *Corpus Domini*—microcosm and macrocosm united. Jerusalem is the Savior's sacred umbilicus.[45] The good Christian viewer of this *mappamundi* was reminded of his Christian duty by the circular Eucharistic form of the diagram. He could thus never, as a God-fearing Christian, forget Jerusalem, the very Blood and Body of Christ.

Nor could the good Christian think seriously of sailing away through the Pillars of Hercules, because that too would mean abandoning the Body of Christ. Certainly, here is an important reason why medieval Christians were loath to adventure westward across the ocean before Columbus. In any case, the *Corpus Domini* centered in the Ebstorf *mappamundi* is the Christian iconographic ancestor to Leonardo's *Man in a Circle and a Square.*

In the environment of pessimism in Europe following repeated failures to recapture Jerusalem, the revival of classical learning—the one truly beneficial by-product of the vain Crusades—was a refreshing, optimistic diversion. It seemed even to point the way for restoring Christian unity and resolve. During the 1260s, the learned Franciscan Roger Bacon wrote his *Opus majus* expressly to encourage the pope in his struggle against the Mohammedans. Bacon scornfully recalled how earlier attempts at retaking the Holy Land had been squandered by foolish zealots like Peter the Hermit.[46] Only by arming itself with scientific knowledge derived from the ancients, like mathematics, optics, astronomy, and geography, he averred, could the Christian church regain its primacy. Bacon also presented the pope a now-missing *mappamundi* structured on a grid of astronomically derived longitudes and latitudes. His mapping method was not Ptolemaic, however, for he had never seen the *Cosmography.*[47] In fact, the one surviving drawing that illustrated Bacon's text at this point is remarkably naive (fig. 1.14). The artist wished to indicate the spherical earth with its northern and southern

hemispheres. Lacking any drawing conventions for rendering the illusion of the third dimension, he improvised by showing the earth as two flat circles representing the hemispheres, connected like a barbell by a pair of parallel lines representing the sea between "the beginning of India and the end of Spain."[48]

FIG. 1.14 Roger Bacon, diagram of the spherical earth, in Robert Belle Burke, trans., *The Opus Majus of Roger Bacon,* vol. 1 (Philadelphia, 1928 and 1962). Reprinted by permission of the University of Pennsylvania Press.

In spite of his ignorance of better artistic models, Bacon was quite aware of the power of pictures in communicating ideas, especially those having to do with the new learning he was trying to impress upon the pope in his *Opus majus.* In several passages the author urged that Christians learn the rules of Euclid's geometry:

> Therefore I count nothing more fitting for a man diligent in the study of God's wisdom than the exhibition of geometrical forms of this kind before his eyes. Oh, that the Lord command that these things be done! . . . For without doubt the whole truth of things in the world lies in the literal sense . . . and especially of things relating to geometry, because we can understand nothing fully unless its form is presented before our eyes, and therefore in the Scripture of God the whole knowledge of things to be defined by geometrical forms is contained and far better than mere philosophy could express it.[49]

Pondering the significance of Bacon's statement above, we ought to keep in mind that in Arab Islam, under its iconoclastic laws, the application of geometry to any pictorial subject other than the purely decorative or abstract symbolic was generally forbidden. At the same time the Chinese knew almost nothing of Euclidean geometry until it was introduced to them by the Jesuits in the early seventeenth century, and they therefore never applied it in either art or science.[50]

Although Bacon did not have access to the *Geography,* he certainly knew Ptolemy's *Almagest* or "Handbook of Astronomy" (also known to the Arabs but not the Chinese). From this he would have

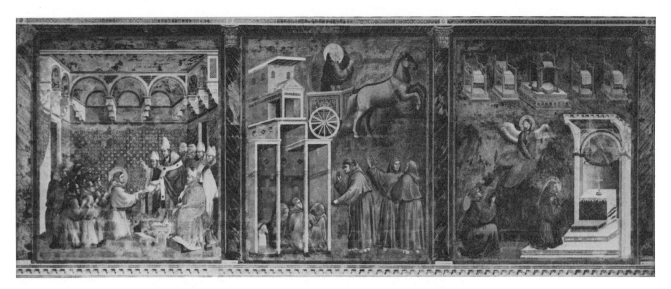

FIG. 1.15 Giotto(?), scenes from the *Life of Saint Francis,* Upper Church, San Francesco, Assisi, Italy. Courtesy of Foto de Giovanni, Assisi.

learned how to determine longitudes and latitudes and may on his own have applied this knowledge to geographical reckoning. Whatever Bacon's classical sources and his limitations as an artist, he clearly appreciated the advantage of having an accurate picture to go along with whatever textual description of the lands and seas of the world was available. "Our sense must be aided by a figure," he wrote, in regard to his own cartographic system: "This is a better and easier method and suffices for a study of the places of the world in a drawing of this kind which appeals to the senses."[51] If the philosophical dictum still holds that if no words exist to express a concept the concept cannot be conceived, then it might well be applied to the illustration of geographical ideas in the Middle Ages. People of that time lacked the pictorial vocabulary with which to express and conceive the overwhelming array of classical Greek and Roman ideas suddenly available in western Europe after the twelfth-century "renascence." The old, more-or-less two-dimensional conventions of medieval artists simply would not do. If the people really wished to "see" what classical knowledge was all about, they would have to devise a brand new or at least quasi-classical pictorial language. It may be no coincidence, then, that Roger Bacon was closely connected with the new Franciscan order whose mother church was just being planned in Assisi in central Italy. Although Bacon lived in far-off England, he may have shared his ideas with many other of his brothers, perhaps the very ones in Italy who were commissioning the program for the artists to decorate the new building. These artists, possibly including Giotto, were the first to come up with a pictorial style suitable for illustrating the very scientific things Bacon was talking about (figs. 1.15 and 1.16).

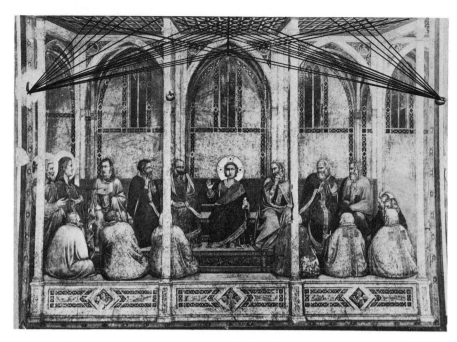

FIG. 1.16 Perspective reconstruction: unknown follower of Giotto, *Jesus among the Doctors,* Lower Church, San Francesco, Assisi, Italy. Photo by the author.

*　　　*　　　*

We are now ready to entertain a hypothesis about how the ancient Greek forerunners of Ptolemy revolutionized cartography and why Ptolemy's method was suddenly so acceptable to western Europeans when it arrived for the first time in Florence in 1400, about a hundred years after the painting of the Franciscan church at Assisi.

The Greeks, like many other ancient peoples, learned early in the history of their civilization how to reckon time and direction by observing the sun in its daily and annual passage through the sky. By the first millennium B.C. they understood the solstices and could locate the maximum north-south rising and setting points of the sun on the earth's horizon in summer and winter. What was truly revolutionary, however, was that about this time some Greek (probably an Ionian from Asia Minor) managed to draw a map of the world organized on this very pattern of the sun's movement between the solstices.[52] We may imagine this enterprising person marking a circle upon the ground with a stick. This represented for him (or her) the surrounding horizon. On the circumference of this, he set out four points denoting where he had observed the solstitial rising and setting of the sun, and he drew horizontal lines connecting each pair. In the center of the circle between the lines (the tropics of Cancer and Capricorn), he drew himself. Through this point he marked another horizontal or "equinoctial" line and crossed it with a perpendicular vertical, the original, prime meridian (fig. 1.17). At some later moment, one of his illustrious successors like Hipparchus worked

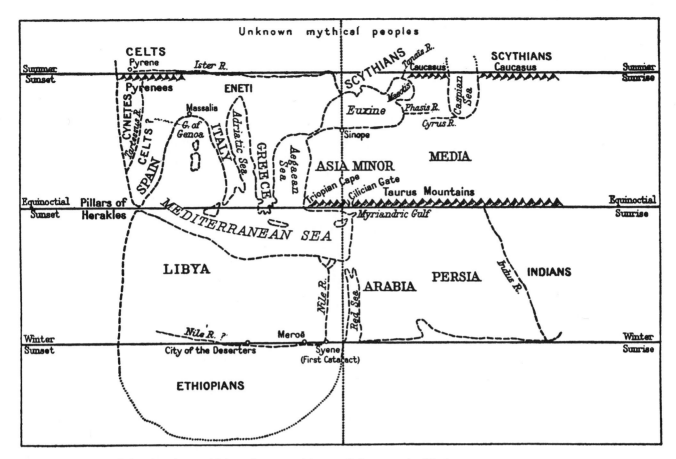

FIG. 1.17 Map of the Greek world based on positions of the sun, in W. A. Heidel, *The Frame of Ancient Greek Maps* (Washington, D.C., 1937; New York, 1976). Courtesy of the Ayer Company, successors to Arno Press.

out the first cartographic grid of longitudes and latitudes that made it theoretically possible to measure distance as well as direction between all places on the earth's curved surface.[53] This could be done not by pacing distances, which is inaccurate or impossible over mountains and water, but by coordinating each location on earth with the local appearance of rising and setting sun and stars. The earth was assumed to be a sphere, and its circumference was divided into degrees, each representing one day's passage of the sun in its ecliptic journey. Thus, if one could only locate his earthly latitude between the poles (by measuring, for example, the altitude of the Pole Star above the horizon), and his longitude between east and west (by measuring the time difference of local noon with noon at other places), he could fix his position precisely on a scaled chart or globe and therefore know exactly how far away and in what direction he was from every other likewise coordinated place in the world. Thus the Greek world map evolved as much more than an ideological or decorative picture of the world. It was the single practical and scientific way of correctly recording geographical locations.

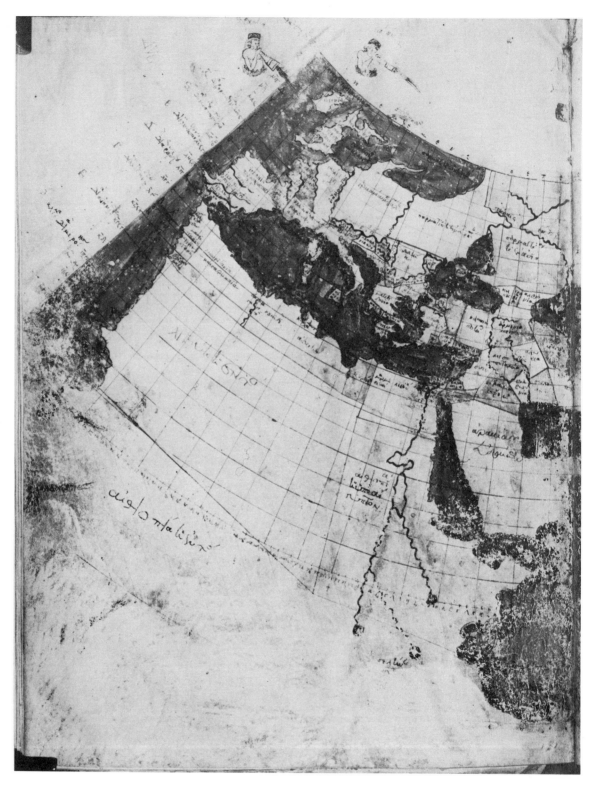

FIG. 1.18 *Mappamundi* showing Ptolemy's *oikoumene* ("first" map method) as represented in a late fourteenth-century Greek edition of the *Geography*. Courtesy of the Biblioteca Medicea Laurenziana, Florence.

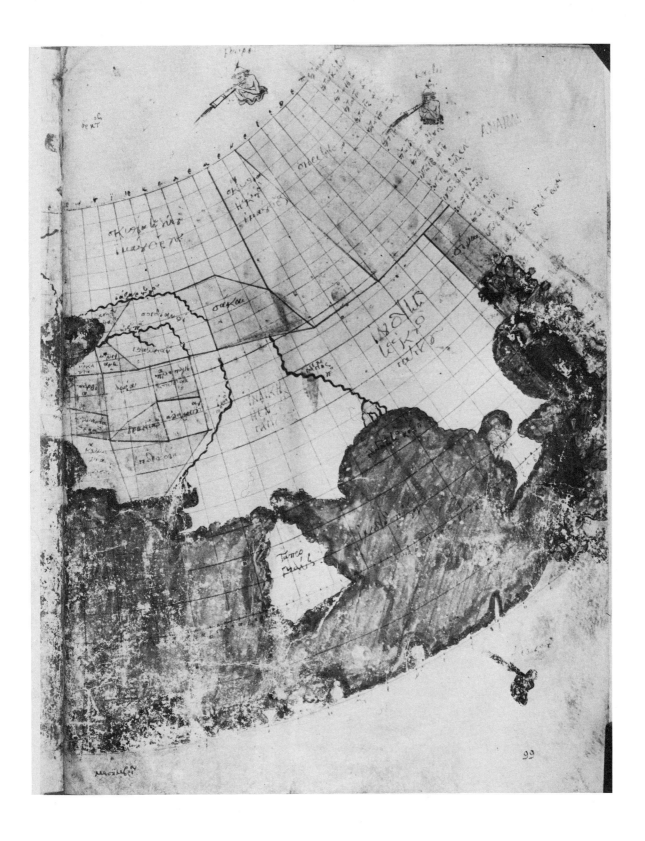

FROM MENTAL MATRIX TO *MAPPAMUNDI* TO CHRISTIAN EMPIRE 35

Ptolemy's system represented the summation of the Alexandrian school of Greek cartography. His original world map is, like most examples of Hellenistic "painting,"[54] no longer extant. We know it only through later interpretations. The subsequent medieval Byzantine approximations first imported into Florence in the fifteenth century (fig. 1.18, for instance), showed only the section of the globe called by the Greeks *oikoumene,* or the "known world," that is, about 180 degrees from Spain through China, and less than 90 degrees from Scotland to just below the equator.[55] Nevertheless, the rest of the globe was clearly implied. Ptolemy wanted his two-dimensional chart to recapitulate the surface curvature of the earth. Hence he selected the conic-sectional shape to suggest that the meridians (longitudes) converged and the parallels (latitudes) continued to curve around a hemisphere behind that of the *oikoumene.* Even though nothing was known of it at the time, terra incognita would be susceptible to the same rational, quantitative measurement as the inhabited world.

No part of Ptolemy's map was emphasized as having ideological significance. It was completely ecumenical and nonmystical. Whereas Ptolemy assumed the central meridian to pass through Syene, in later versions it was moved slightly eastward, though the map center itself remained on the latitude of the Tropic of Cancer, which ran through Syene. One might even say that, aesthetically, Ptolemy's map design is "positional attenuating," since it deemphasizes the center and stresses instead the spreading of the grid in all directions from the perimeter.

Besides his knowledge of astronomy and geography, Ptolemy's special contribution had also to do with profound understanding of the psychology of visual perception. He was the first geometer, optician, or artist from whom we have a written description of linear perspective. This is found in book 7 of the *Cosmography,* where the Alexandrian introduced the third of his three mapping methods.[56] The reader was instructed to draw a picture of the celestial sphere as a kind of circular stage framing the trapezoidal *oikoumene.* Ptolemy imagined the meridians and parallels encircling the celestial sphere as foreshortened perspective ellipses when seen from a fixed viewpoint outside and beyond the celestial sphere. The relative thickness and shape of these ellipses were to be determined according to whether they were seen from above or below and how far they were from the central meridian and parallel. The geometry for this calculation depended on the optical principle of the centric visual ray, the "visual axis" between the center of the viewer's eye and the center of the object seen. According to both Euclid's and Ptolemy's own treatises on optics, the length of this axis (the distance of viewer from object) established the "visual angle," which in turn made it possible to determine the relative distortion of forms according to their distance from the viewer's eye (fig. 1.19).[57] Ptolemy was not interested in illustrating perspective distortion merely for curiosity's sake. He devised his three different projection methods in order to compensate, on his flat map surface, for the effects of illusion in natural vision. He was trying to find a way for the viewer to know that distances be-

tween the latitudes and longitudes are always the same no matter how distorted they appear on the curving globe.

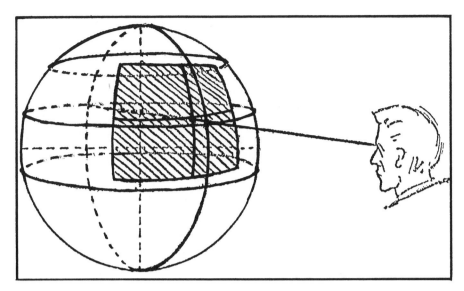

FIG. 1.19 Ptolemy's "third method" for envisioning the universe including the *oikoumene*. Author's drawing.

Ptolemy was perhaps inspired by two other activities concerned with depicting the illusion of the third dimension in his time. One was the study of conic sections (another mathematical science invented in Alexandria)[58]; the other was the theater. Greek artists were frequently called upon to design stage sets for the popular plays, and these often consisted of architectural backdrops that attempted to make the viewer believe he was looking through an open doorway at some farther scene beyond.[59] Similarly, Ptolemy wanted his own viewers to imagine the *oikoumene* as if seen behind and within the "proscenium" of the celestial circles. In projecting his grid of meridians and parallels as a conic section, Ptolemy observed yet another optical illusion that no one had noticed before. This was that the grid, no matter how distorted, can with brief practice be restored in the mind's eye, as Mercator demonstrated even more graphically in modifying Ptolemy in the sixteenth century. Just as one can bend a twisted piece of wire mesh back into its original shape, so can the conditioned human mind look at a Mercator map projection and judge that the apparently wider latitudes near the poles are actually in the same scale and size as the apparently narrower ones near the equator.

$$* \qquad * \qquad *$$

Ptolemy's "visual axis" for projecting his world map followed in the ancient omphalos tradition insofar as it had the effect of linking the celestial to the earthly sphere. While conceived with no ideological prejudice, his map still satisfied that innate human desire to have the visual

image of this world organized according to some higher universal ordering system. Ptolemy's system depended not on divine revelation, however, but on the quantifying eye of the human observer, who was now able to imagine himself detached from the world as if looking at it on a stage. Indeed, the viewer of Ptolemy's map was privileged to see the world as did the gods themselves from their lofty vantage on Mount Olympus!

Already well before Ptolemy's *Geography* arrived in Renaissance Florence, western Europeans both north and south of the Alps were undergoing a metamorphosis of the imagination. Discouraged by their failure to recapture the Holy Land, medieval Christians had begun to lose faith in the efficacy of certain of their visual and pictorial conventions. By the thirteenth century, at any rate, they were demanding a new set of such conventions so that they might better "see" the world, quantitatively this time rather than mystically. Just as Doubting Thomas demanded tactile evidence of Christ's wounds, so medieval Christians demanded to see representations of the holy miracles just as God saw them from his detached viewpoint outside the world.

Let us look again at figures 1.15 and 1.16, two frescoes from the Basilica of Saint Francis at Assisi, attributed respectively to Giotto and a Sienese follower sometime after 1300. In the first, which is a series of three scenes from the *Life of Saint Francis* painted on the lower nave wall in the Upper Church, we see clearly that the artist consciously revived the antique notion of the picture as a window or stage. He even painted an illusionistic architectural proscenium around the scenes in such a way that the viewer should position himself in front of the central fresco and observe each set of three as if the depicted events were actually taking place beyond the wall within the fictive, painted frame. This was a revolutionary way of looking at pictures, quite different from the conventional viewer's attitude toward earlier Christian art, or for that matter Chinese and Islamic art. In those other styles, the artist cared little about the illusion of depth in his picture space. He considered himself not detached and outside the things he was depicting, but rather among them, as if he himself were right "in" the picture surface.[60]

In the second of these Assisi frescoes, we have an early example of a new pictorial convention destined to become perhaps the most widely recognized cliché of the Italian Renaissance, the "perspective grid." To create the illusion of a receding room behind this scene of *Jesus among the Doctors,* the painter designed the ceiling as if it were composed of regular checkerboard squares that appear to get smaller the farther they are from the viewer. Such a device for creating the illusion of depth was well known to Italian artists before they had any knowledge of Ptolemaic cartography. The phenomenon was easy to discern empirically in the tiled floors and coffered ceilings so common in their houses. Even before anyone knew any "rules" about drawing perspective, Italian painters at Assisi may have figured out a device of strings like a cat's cradle that they laid out right on top of their still-wet frescoes. Where the strings crossed determined the intersections of the "perspective"

grid lines in the painting. A reconstruction of this method is shown in figure 1.16 by means of my added overlay.[61] In any case, Italian Trecento painters realized, as had Ptolemy twelve centuries before, that a grid, no matter how distorted or twisted, always springs back to its proper shape in the mind's eye as long as there is some indication of the true form and size of any one of its modules.

After 1400 in Italy, particularly in Florence, where the *Geography* first arrived in western Europe and where also Filippo Brunelleschi first demonstrated the geometric laws of linear perspective in painting, we have good reason to suspect Ptolemy's direct influence on the arts. For example, in the very first extant painting in which linear perspective appears, Masaccio's *Trinity* fresco in Santa Maria Novella of about 1425, we find not only an accurate perspective grid but one that gives the illusion of a curved surface. Similarly, in the *Chalice,* a drawing attributed to Paolo Uccello a few years later, we note how the artist formed hemispherical and cylindrical shapes entirely by means of the curving grid, using the same method Ptolemy suggested for showing the perspective distortion of the celestial circles.[62]

Another example of this revived fascination with cartography is found in the writings of the Florentine humanist Leon Battista Alberti about 1430. While working in Rome as a secretary to the pope, he devised a method of mapping the ancient Holy City, perhaps based on Ptolemy.[63] This same method was later adapted by Leonardo da Vinci (color plate 2) and Raphael.[64] Alberti would have his mapmaker stand on the Capitoline Hill and sight the compass directions of the city all about him with a transitlike instrument of his own invention. These directions would then be entered on a scale map showing the circular "horizon" around his center at the Capitoline. The circumference of the "horizon" was divided into equally spaced "degrees," each connected to the center by a "meridian." The "meridians" in turn were marked off by evenly spaced "parallels," thus creating a grid of nested circles. With his transit on the Capitoline, Alberti would sight the direction of any landmark, note its location at the nearest meridian on his map, then pace its distance from the center and mark it at the nearest parallel. He then had a set of cartographic coordinates for every building and street in Rome. Alberti's original map is no longer extant, but his description, including his list of coordinates, still exists and was reconstructed and checked for accuracy by the late Luigi Vagnetti (fig. 1.20).

Alberti was so obsessed with the cartographic grid as a means even of organizing pictures that he advised painters to set out a *velum* or curtain composed of perpendicular strands stretched across an open window; that is, a grid through which the artist could observe and copy the natural world beyond. The *velum* not only made it easier for the painter to transfer details but, most important, it trained both artist and viewer to "see" the underlying geometry of nature, the truth of visual reality established by God at the Creation. Alberti then went on to describe how pictorial space should be conceived in the mind's eye as framed by four gridded walls in perspective. He always referred to this

FIG. 1.20 Leon Battista Alberti's map of Rome, ca. 1430, according to Luigi Vagnetti in "Lo studio di Roma negli scritti albertiani," *Problemi Attuali di Scienza e di Cultura,* no. 209 (1974). Courtesy of the Accademia Nazionale dei Lincei, Rome.

perspective grid as the *pavimento,* after the checkerboard floors so common in Italian houses.[65]

So helpful was Alberti's grid for conceiving and projecting linear perspective that artists began to employ it almost exclusively during the ensuing Renaissance, both north and south of the Alps. In the early sixteenth century, Albrecht Dürer cut a famous woodblock showing how an artist should use Alberti's *velum*.[66] Subsequently, particularly in Renaissance Germany, many instructional books were published with illustrations on how to apply the perspective grid for drawing anything from landscape to architecture to the human figure.[67] By the seventeenth century, linear perspective in the Italian Renaissance style was the backbone of the pictorial arts everywhere in western Europe. With the exploding of the printed book trade, the exactly repeatable printed picture made it even more possible for everyone to share in this new

Renaissance image of natural order structured on the principles of geometry.[68] In truth, as Erwin Panofsky once argued, geometric linear perspective gave the Renaissance its unique "symbolic form."[69] There was no analogue to this new consciousness in the arts or sciences of Islam or China or anywhere else in the world outside Western civilization.[70]

FIG. 1.21 Jacques Besson, *Théâtre des instruments mathématiques et mécaniques* (Lyons, 1578). By permission of the Houghton Library, Harvard University.

TAB. XXV.

FIG. 1.22 Anatomical figure, designed in 1552, from Bartolomeo Eustachio, *Tabulae anatomicae clarissimi viri* (1714). Courtesy of the Francis A. Countway Library of Medicine, Boston.

Just how deeply this Western consciousness had been penetrated by the cartographic grid is illustrated in two diverse printed pictures from the late sixteenth century. One is an engraving from Jacques Besson's 1578 *Théâtre des instruments mathématiques et mécaniques* (fig. 1.21) demonstrating how to build a masonry wall; the other is from Bartolomeo Eustachio's *Tabulae anatomicae* (fig. 1.22), an engraving cut in 1552 showing details of human anatomy. Both of these illustrations relate to verbal instructions in the text, and to make it easier for the reader to move back and forth from word to picture, the artists adapted the basic system of cartographic coordinates. Around the perimeter of the Besson engraving are printed the standard compass directions; along the borders of the Eustachio anatomy illustration are ruled strips, exactly as on Ptolemaic maps. The authors could then discuss in their texts any pictorial detail simply by referring to its proper "map" location. Cinquecento readers, it seems, were able to "see" meridians and parallels in any visual situation. Alberti's *velum* was impressed in their very optical process.[71]

<p style="text-align:center">* * *</p>

At the same time as this new Renaissance grid consciousness was beginning to affect scientific thought, it was also having political ramifications. The Roman Holy See quickly moved to take advantage. In the 1460s, Pope Pius II awarded Ptolemy's *Cosmography* the official *nihil obstat* sanction of the church. The pope himself wrote a lengthy commentary on it, stressing particularly the importance of its longitude/latitude reckoning system.[72] So fascinated was Pius with Ptolemy that he had a *mappamundi* erected in the garden of his palace in Pienza, his hometown near Siena, which he also remodeled around a gridded square.[73] This gridded piazza, uniting as it did the town cathedral, the local government building, and the pope's palace, served as a model for Renaissance city planning thereafter.

A few years later, in 1481, Pope Sixtus IV had the lower interior walls of his new Sistine Chapel decorated with paintings propagandizing the Petrine Succession. The principal scene of this cycle, by Perugino, shows *Christ Giving the Keys to Saint Peter* (fig. 1.23). It takes place on a grand gridded piazza, whose perspective lines converge upon a classical-style domed temple in the background. This painted edifice was intended to symbolize the church triumphant. All compositional and subject elements focus upon it. The building occupies the center of the gridded piazza, a massive umbilicus with its slightly elliptical dome thrusting skyward as if to link heaven and earth in mystic union.[74]

Perugino's revived grid and navel iconography in this painting clearly touched a popular sentiment, because the composition was borrowed again and again (Raphael's 1504 *Sposalizio* in the Brera Gallery, Milan, is perhaps the best-known example). The composition and its iconography also brought out latent images in the minds of philosophers interested in city planning. Sometime about the end of the century, an unknown artist or artists (perhaps in the circle of Piero della

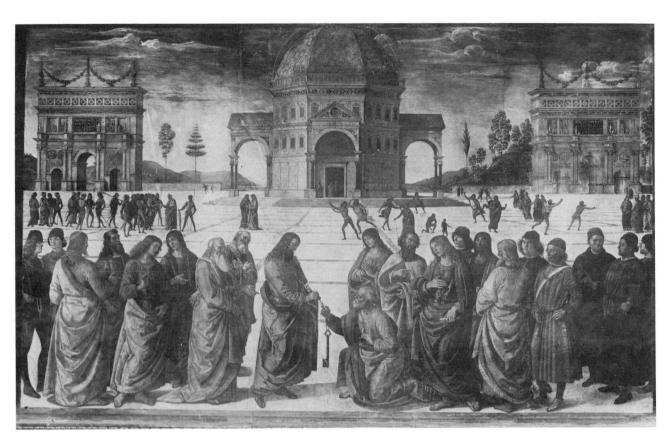

FIG. 1.23 Perugino, *Christ Giving the Keys to Saint Peter.* Courtesy of the Vatican Museums.

Francesca) designed a set of three oblong panels showing ideal city-scapes, all related to Perugino's source. Figure 1.24 illustrates one of these now in the Palazzo Ducale, Urbino. No one knows the exact purpose of these pictures, and they may even have been designed as *modelli* for tragic and comic theater sets.[75] Whatever their original function, they stress, along with many similar designs in Renaissance drawing books and background details in paintings, an almost universal longing felt all over western Christian Europe at this time for a "New Jerusalem," an ideal Christian community where men of goodwill might truly live in peace with justice and prepare for salvation in heaven.[76]

From the thirteenth century on, Europeans became mesmerized by traveler's reports, some wildly apocryphal, about the wonders of the "East," of the terrestrial paradise still in existence out there somewhere just waiting for Christian pilgrims to find it.[77] What is remarkable now is that many of these images of the terrestrial paradise, of the "New Jerusalem" and other utopias that visionaries like Thomas More and Tommaso Campanella began to describe to eager readers in the sixteenth century, followed the general tenets of Perugino's original iconography. That is to say, the ideal city must by definition be symmetrical and orthogonal. Its basic plan must be in the form of a modular grid or

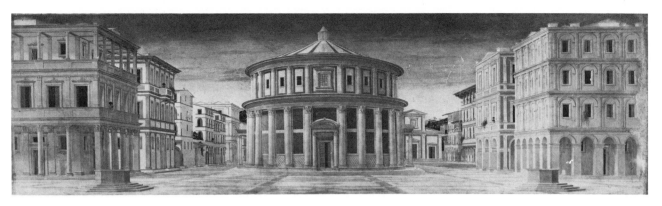

FIG. 1.24 Oblong panel from Perugino's model, in Palazzo Ducale, Urbino. Courtesy of Alinari/Art Resource, Inc.

defined in concentric circles. The old notion of synonymy between geometric and moral rectitude was so ingrained in the Western mind that people simply took for granted that anyone fortunate enough to be raised in a geometrically ordered environment would be morally superior to those living in the twisting cowpaths of amorphous villages. Thomas More believed that such geometric urban planning relieved men of temptation to the sin of pride, since, theoretically, the orthogonal block plan made all living uniform.[78] On the other hand, Gianozzo Manetti, planning an ideal Rome for Pope Nicholas V in the mid-fifteenth century (and perhaps speaking for Leon Battista Alberti), thought the central orthogonal avenue should be reserved for the rich, with the side streets left to the laboring classes.[79]

There are two other contemporary reasons augmenting this Renaissance fascination with the ideal city even before the discovery of America. The first was the accumulated knowledge of classical antiquity, with awareness that the Romans themselves had lived, prospered, and built their incomparable empire while living in essentially grid-planned, orthogonal communities. It was not lost on thinkers like Alberti and Leonardo that the barbarians who overthrew the Roman Empire and aborted its glorious civilization buried the once orderly street plans of the *coloniae* under the detritus of "Gothic" buildings and meandering alleys.

Yet perhaps the most decisive factor favoring the new demand for geometric regularity in city planning had nothing at all to do with Christian morality or classical aesthetics; it concerned military technology. When Charles VIII, king of France, invaded Italy in 1494, the incredible firepower of his mobile artillery proved once and for all the obsolescence of the disorderly if picturesque medieval walled town. Indeed, as it turned out, orthogonal street planning proved the best defense against this awesome new weapon, allowing the defenders' own artillery unimpeded aim and easy mobility within the city. Before the French invasion, Italian engineers like Filarete, Francesco de Giorgio Martini, and Leonardo had already realized on their own this ironic

combination of *teoria* and *pratica*. Not only should geometrical orthogonality be equated with moral rectitude, but it also conferred practical military advantage. By the seventeenth century, all over Europe and in the Americas and the Indies, the gridded garrison, with its radial avenues and star-shaped bastions, stood for the new aggression of Western civilization. It was also a remarkable example of working technology enhanced by ideological symbolism and classical aesthetics.[80]

About the same time as Perugino was painting his ideal gridded cityscape in the Sistine Chapel, an aged Florentine savant named Paolo dal Pozzo Toscanelli opened a correspondence with a Genoese sailor named Cristoforo Colombo. The gist of this propitious exchange was that a western sea route to the East was possible by sailing beyond the Pillars of Hercules. Toscanelli even sent Columbus a gridded map (unfortunately now lost) of the ocean sea in order to make his point more graphically.[81] Columbus, thoroughly convinced, went off to sell the idea to the Spanish, coincidentally at about the same time as Leonardo da Vinci was making his drawing *Man in a Circle and a Square*.

In 1493, after Columbus returned with his stunning news, the Spanish and Portuguese fell to quarreling over who had the prior right to the new lands the Genoese admiral had discovered. Pope Alexander VI then sat down before his *mappamundi* and arbitrarily, in the blank space to the left of the *oikoumene*, drew in a new meridian that he proclaimed to be "one hundred leagues west of the Azores." All the vast terra incognita to the west of this purely abstract "demarcation line" he awarded to the Spanish.[82] Everything east must go to Portugal. Because Renaissance Christians had such faith in the divine authority of geometry, a hundred million Brazilians speak Portuguese instead of Spanish.

Students of cartographic history will hardly need reminding of the role the abstract geometric grid played in the subsequent age of exploration and colonization. The pristine innocence of the American wilds attracted utopian dreams of replacing the Gomorrahs of Europe with Jerusalems in the New World. Once again these visions nearly always began with a grid plan, conceived in the mind of the prophet-adventurer before he set eyes on the actual topography of his promised land. One thinks immediately of William Penn's Philadelphia. Figure 1.25 shows Penn's plan for his new City of Brotherly Love as drawn by his surveyor general Thomas Holme in 1682. The unmitigated gridded blocks between the Delaware and Schuylkill rivers are relieved only by a quincunx of four corner parks and a central square, which still exist in the city.

Indeed, a casual look at almost any seventeenth- or eighteenth-century map of America reveals the absolute faith Europeans of all religious persuasions had in the authority of the cartographic grid. Monarchs laid claim to lands solely on the basis of abstract latitudes and longitudes. Troops were sent to fight and die for boundaries that had no visible landmarks, only abstract mathematical existence (fig. 1.26). In 1844 the United States was ready to go to war with England over an intangible latitude in the wilds of western Canada that the patriots of

neither side could ever have located without complex astronomical instruments.

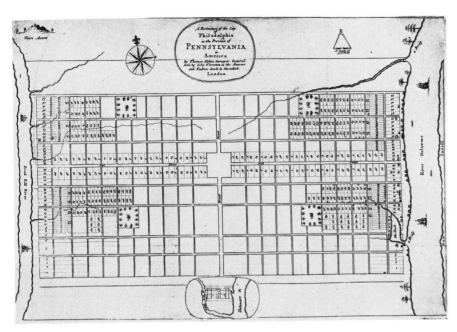

FIG. 1.25 Thomas Holmes, *A Portraiture of the City of Philadelphia*, 1682. Courtesy of the Newberry Library, Chicago.

FIG. 1.26 John Mitchell, *A Map of the Colonies in North America*, first published in 1755. Courtesy of the Chapin Library, Williams College, Williamstown, Massachusetts.

Columbus and the hordes of explorers who quickly followed him to the New World by the mid-sixteenth century made mockery of the fabled warning on the Pillars of Hercules. Leonardo's drawing, *Man in a Circle and a Square,* expresses not only the bravado but the "aesthetic" of the Age of Discovery. The viewer's eye is attracted not so much to the center of Leonardo's drawing as to its periphery. The outstretched hands and feet of Leonardo's *Man* direct our eyes to the edges of the framing circle and square, thus creating a "positional attenuating," quincunx effect that deemphasizes the center, more so than the similar design of the medieval Ebstorf map showing Christ superimposed upon Jerusalem. During the Age of Discovery in the sixteenth century, it seems that the spirit of the ancient roman *mensor* was resurrected with a vengeance, entering into the body of the Christian church. By 1506 Pope Julius II had already commissioned a new Saint Peter's Basilica to be designed by Bramante after the domed temple painted in Perugino's *Christ Giving the Keys* and Raphael's *Sposalizio.* Thus the architectural center of Catholicism should be universally recognized as the nourishing umbilicus of world Christendom (fig. 1.27). From here also, just as the Roman emperors had done from the nearby Forum, the imperial pope would supervise the recenturiation of the earth's unfolding surface and dispense its newly discovered lands, each packaged neatly in a Ptolemaic grid, as reward to His Holiness's loyal legionnaires.

But perhaps the most egregious microcosmic example of Renaissance astrobiology was the Escorial, the massive palace King Philip II ordered in 1563 to be constructed near Madrid by his architects Juan Bautista de Toledo and Juan de Herrera. Behind Kremlinlike walls, the austere monarch gathered together a domed church, a monastery, and the palace headquarters of his secular government, the same threefold arrangement as in the temple of Solomon in biblical Jerusalem.[83] The whole vast complex sat upon a grand gridded plaza (fig. 1.28) that the king dedicated to Saint Lawrence (the patron of his monastery), who was martyred upon an iron grid.

Philip, like his father the emperor Charles V, believed absolutely that it was also his divine mission to extend Christian empire to the farthest corners of the earth. Charles had adopted and passed on to his son as imperial insignia the very emblem of the Pillars of Hercules, but he dropped the word *non* from the original motto, allowing a completely new translation of the old warning. Now the king interpreted the remaining Latin words, *Plus ultra,* as urging "Push ever beyond!" "Adventure westward beyond the Pillars!"[84] One may well imagine him meditating upon this challenge in his great library in the Escorial, filled with manuscripts and printed editions of Ptolemy's atlas. Philip was also an admirer of Abraham Ortelius, the famous Dutch mapmaker, and he must certainly have watched in fascination as more and more new lands found their places in the expanding web of Ptolemaic coordinates. In an age as conscious of visual metaphor as was the Renaissance, the Spanish monarch, as he stood in his vast Escorial plaza, must surely have imag-

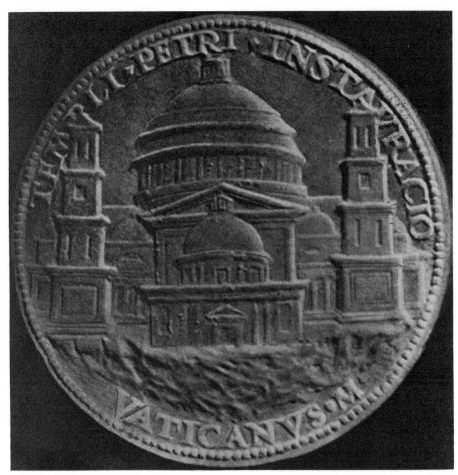

FIG. 1.27 Cardosso medal depicting Bramante's original facade design for Saint Peter's Basilica. Courtesy of the Trustees of the British Museum.

ined himself standing at the umbilicus of the world. Indeed, one of the titles he bore was "King of Jerusalem." Furthermore, King Philip's advising architect, Juan de Herrera, was himself thoroughly steeped in the ancient hermetic lore of astrobiological geometry. The king seems to have planned for his huge palace, including its gridded plaza and cardinal orientation, to be a cosmological symbol. It has recently been demonstrated by René Taylor that the ground plan of the Escorial conforms to the Vitruvian proportions of *Man in a Circle and a Square*. In fact, the architects and their royal patron quite clearly understood the building as no less than the Body of Christ superimposed upon the mystic geometry of Solomon's temple.[85] Thus was Leonardo's famous ideogram Christianized and politicized by the late sixteenth century. The Hapsburg kings of Spain now occupied the ideological if not the geographical center of the Ptolemaic world; the gridded pavement at their feet even established the module for the cartographic grid spreading north, south, east, and west, as carried by their generals, admirals, and priests well beyond the borders of the ancient *oikoumene*.

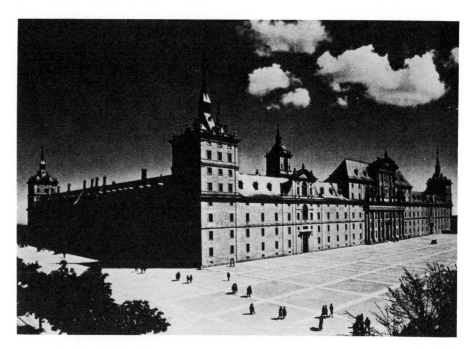

FIG. 1.28 View of the palace of San Lorenzo del Escorial, outside Madrid. Courtesy of Patrimonio Nacional, Madrid.

The Spanish rulers and the Roman popes, of course, were not the only powers of Renaissance Europe who were beguiled by the centrifugal siren music of the Ptolemaic meridians and parallels. In truth, if there was one institution that remained embedded in all European consciousness even after the bitter, divisive religious and nationalistic wars of the sixteenth and subsequent centuries, it was the aesthetic worldview inherent in Ptolemy's classical cartography. Every Western nation that has purported to dominate since, including the United States, has claimed itself to be the New Jerusalem and divinely appointed imposer of this archetypal politico–aesthetic system. One need only visit Washington, D.C., and there experience the domed capitol on its omphalos hill, the center once again of a powerful "positional attenuating" grid-by-implication, pushing out from the Mall, spreading along L'Enfant's radiating avenues, and extending American culture to all corners of the world.

The Mapping Impulse in Dutch Art

SVETLANA ALPERS

In the study of images we are used to treating maps as one kind of thing and pictures as something else. If we exclude the rare occasions when a landscape picture (fig. 2.1) is used in mapping a region—as when the United States Congress in the 1850s commissioned landscape lithographs of the West in preparation for choosing a route for the continental railroad—we can always tell maps and landscapes apart by their look.[1] Maps give us the measure of a place and the relationship between places—quantifiable data (fig. 2.2). While landscape pictures are evocative, they aim rather to give us some quality of a place or of the viewer's sense of it (fig. 2.3). One is closer to science, the other is art. This general, though casually held view—casual because it does not normally seek out the possible philosophical grounding—is upheld professionally. Cartographers are clearly a separate group from artists even as students of cartography are separate from historians of art. Or at least that is how it was until recently. We are witnessing a certain weakening of these divisions and the attitudes they represent. Art historians, less certain that they can stipulate which images count as art, are willing to include more kinds of human artifacts and makings in their field of study. A number have turned to maps.[2] Cartographers and geographers, for their part, in keeping with a related intellectual revolution of our time, are newly conscious of the structure of maps and of their cognitive basis. A distinguished geographer put the change this way: Whereas once it was said "that is not geography which cannot be mapped," now it is thought that "the geography of the land is in the last resort the geography of the mind."[3] Jasper Johns's map of the United States (fig. 2.4) is a painter's version of this very thought. Indeed, the meeting or at least approaching of the different fields is evident today in the work of a number of artists who are making maps.

This paper, originally presented in 1980 as part of the Sixth Series of Kenneth Nebenzahl, Jr., Lectures, appeared in slightly different form in 1983 as chapter 4 of Svetlana Alpers, *The Art of Describing: Dutch Art in the Seventeenth Century*, published by the University of Chicago Press.

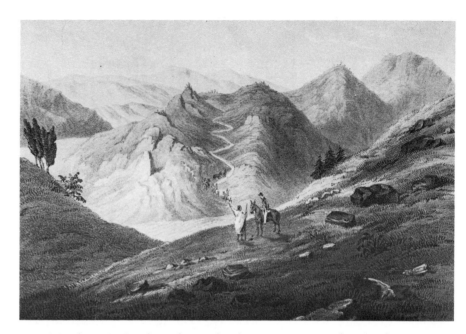

FIG. 2.1 John Mix Stanley, after Richard H. Kern, *View of Sangre de Cristo Pass* (lithograph), in *Reports of Explorations to Ascertain the . . . Means for a Railroad from the Mississippi to the Pacific Ocean* (1853–54), vol. 2, opp. p. 37. Courtesy of the Bancroft Library, Berkeley, California.

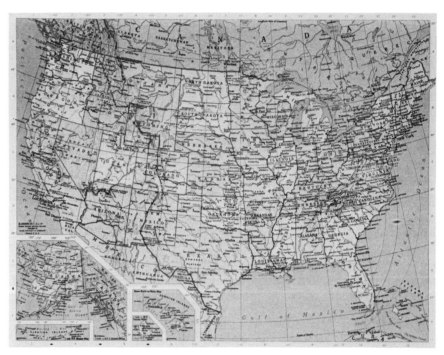

FIG. 2.2 Map of the United States. © Rand McNally and Company, R.L. 82-S-32.

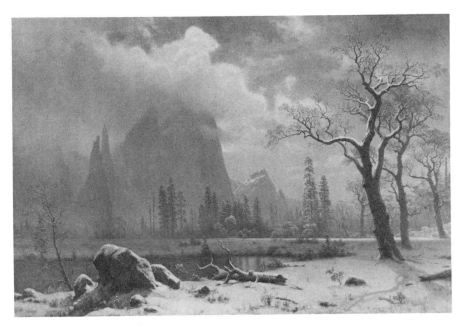

FIG. 2.3 Albert Bierstadt, *Yosemite Winter Scene*. University Art Museum, Berkeley, California. Gift of Henry D. Bacon.

FIG. 2.4 Jasper Johns, *Map,* 1961. Oil on canvas, 6'6" × 10'3⅛". Collection, the Museum of Modern Art. Fractional gift of Mr. and Mrs. Robert C. Scull.

FIG. 2.5 *Map of the Seventeen Provinces,* published by Claes Jansz. Visscher, detail. Courtesy of the Bibliothèque Nationale, Paris.

Students of maps have never denied their artistic component. It is a commonplace of cartographic literature that maps combine art and science, and the great age of Dutch seventeenth-century maps offers a prime example of this. This is illustrated in the cartouche pairing two female figures at the top left corner of the map represented in Vermeer's *Art of Painting* (fig. 2.5): one figure bears a cross-staff and a pair of compasses, while the other has palette, brush, and city view in hand. Decoration—whether in the form of cartouches and other materials such as portraits or city views or whether built into the use of a map as a domestic wall hanging—is acknowledged and studied. "Decorative" maps constitute a specific body of cartographic material. But inevitably such decorative aspects or uses are considered secondary to the real (scientific) aims of mapmaking. There is assumed to be an inverse relation between the amount of art displayed and the amount of information conveyed. Art and science, even when combined, are in some conflict. A recent and interesting study by a geographer dealing with the historical links between cartography and art had this to say: "Mapmaking as a form of decorative art belongs to the informal, prescientific phase of cartography. When cartographers had neither the geographical knowledge nor the cartographic skill to make accurate maps, fancy and artistry had free rein."[4] There is of course some truth to this, but it is stated at the expense of understanding prescientific cartography in its own appropriate terms, in the spirit in which it was done. Whereas cartographers set aside the decorative or picturelike aspect of maps, art historians for their part have done the same with the documentary aspect of art. "Mere topography" (as contrasted with "mere decoration") is the term here. It is used by art historians to classify those landscape pictures or views that sacrifice art (or perhaps never rise to it) in the name of recording place. Cartographers and art historians have been in essential agreement in maintaining boundaries between maps and art, or between knowledge and decoration. They are boundaries that would have puzzled the Dutch. For at a time when maps were considered a kind of picture and when pictures challenged texts as a central way of understanding the world, the distinction was not firm. There was perhaps at no other time or place such a coincidence between mapping and picturing based on a common notion of knowledge and the belief that it is to be gained and asserted through pictures. What should be of interest to students of maps and of pictures is not where the line was drawn between them but precisely the nature of their overlap, the basis of their resemblance.

Vermeer's *Art of Painting* (color plate 4)—a work that illuminates this resemblance—is a promising place to begin. In size and theme this is a unique and ambitious work, and it draws our attention to a splendid representation of a map. We are looking into a painter's studio. The artist has started to render the leaves of the wreath on the head of a young woman, one of Vermeer's familiar models, who here represents (so we have been told) Clio, the muse of history, bedecked with her emblematic accoutrements as described by Ripa, the famous mythographer, in his *Iconologia.* The great map (fig. 2.6), hung so as to fill the back wall

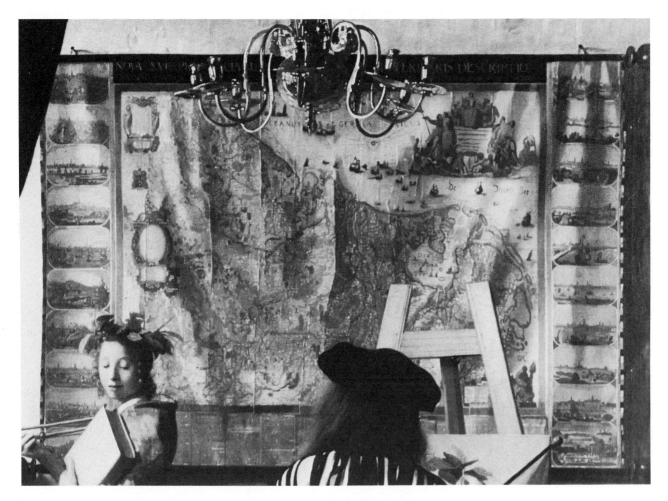

FIG. 2.6 Jan Vermeer, *The Art of Painting,* detail (map). Kunsthistorisches Museum, Vienna.

before which Vermeer has situated painter and model, has not gone unnoticed. It has been plumbed for its moral meanings: its presence interpreted as an image of human vanity, a literal rendering of worldly concerns, and its depiction of the northern and southern Netherlands interpreted as an image of a lost past when all the provinces were one (a historical dimension borne out perhaps in the painter's old-fashioned dress and the Hapsburg eagles on the chandelier). The scrupulous rendering has enabled the map to be identified recently as a particular one otherwise preserved only in a single copy in Paris. Seen this way, Vermeer's map is inadvertently a source for our knowledge of cartographic history.[5]

But these interpretations all overlook the obvious claim that the map makes on us as a piece of painting in its own right. There are, of course, many pictures of the time that remind us that the Dutch were among the first who seriously produced maps as wall hangings—this being only a part of the wide production, dissemination, and use of maps throughout the society. But nowhere else does a map have such

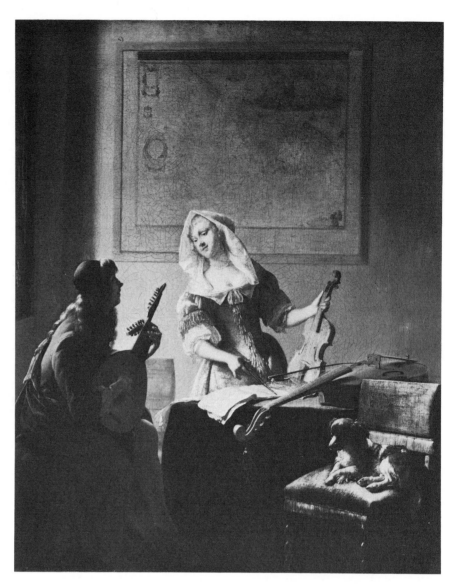

FIG. 2.7 Jacob Ochtervelt, *The Musicians,* ca. 1670. Oil on panel, 31½″ × 25¾″. Mr. and Mrs. Martin A. Ryerson Collection, 33.1088. © The Art Institute of Chicago. All rights reserved.

a powerful pictorial presence. When compared with the maps in the works of other artists, Vermeer's maps might all be said to be distinctive. Whereas Ochtervelt, for example (fig. 2.7), merely indicates that a map is on the wall, testified to by a faint outline on a tawny ground, Vermeer always suggests the material quality of varnished paper, paint, and something of the graphic means by which the land mass is set forth. It is hard to believe that the same map is represented by Ochtervelt and by Vermeer. Each of the maps in Vermeer's works can be precisely identified. But the map in *The Art of Painting* is distinctive in other ways as well. It is the largest map and also the most complex assemblage of any in Vermeer's works. The Netherlands is at the edge of a ship-filled sea,

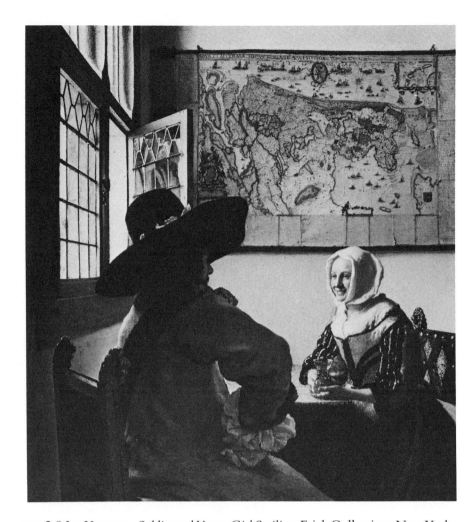

FIG. 2.8 Jan Vermeer, *Soldier and Young Girl Smiling*. Frick Collection, New York.

framed by topographical views of its major cities, emblazoned with several cartouches, explained beneath by a text and elegantly titled in clear letters set across the map's upper edge. What is more, it is a map whose original combined the four kinds of printing then available for use in maps—engraving, etching, woodcut, and movable type for the letters. In size, scope, and graphic ambition it is a summa of the mapping art of the day, represented in paint by Vermeer.

And in this respect—as a representation—it is also different from other maps in Vermeer's paintings. In every other work by Vermeer where there is a map (fig. 2.8), it is cut by the edge of the picture. But here we are meant to see it all because we are meant to see it in a different light. Although it is skimmed by a bit of the tapestry and a small area is hidden by the chandelier, the entire extent of this huge map is made fully visible on the wall. Vermeer combines the richly painted surface of the map in his Frick painting with the weight of the varnished paper of the map behind the *Woman in Blue* in Amsterdam to give this map an astonishing material presence. Other objects in the studio share this

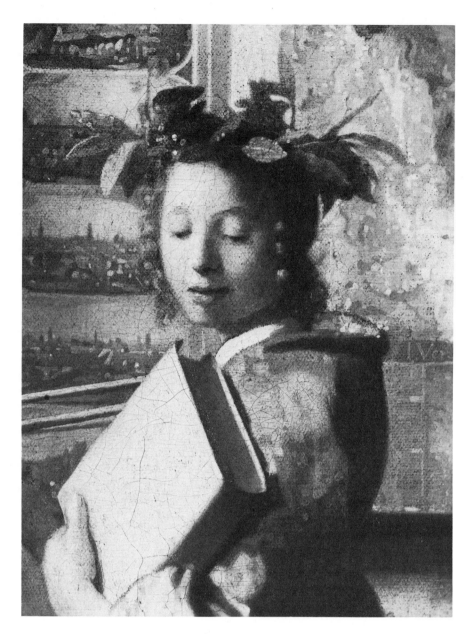

FIG. 2.9 Jan Vermeer, *The Art of Painting,* detail (model's head). Kunsthistorisches Museum, Vienna.

crafted presence—the tapestry, for example, with threads hanging loose from its backside. But the tapestry is located, as its position in the painting suggests, at the edge. It leads us into the painting, whereas the map is itself presented as a painting. (The red tip of the maulstick matches the red paint on the map—but then, as if to caution us against making too much of that, the artist's stockings share the shade.) Vermeer irrevocably binds the map to his art of painting by placing his name on it. "I Ver-Meer" (fig. 2.9) is inscribed in pale letters at the point where the map's inner border meets the blue cloth that stands out stiffly behind the

FIG. 2.10 Jan Vermeer, *The Art of Painting,* detail (map). Kunsthistorisches Museum, Vienna.

model's neck. In no other painting does Vermeer make the claim that the map is of his own making.

The Art of Painting comes late in the day for Dutch painting and late in Vermeer's career. It stands as a kind of summary and assessment of what has been done. The poised yet intense relationship of man and woman, the conjunction of crafted surfaces, the domestic space—this is the stuff of Vermeer's art. But here it all has a paradigmatic status due not only to its historic title but to the formality of its presentation. If this map is presented like a painting, to what notion of painting does it correspond? Vermeer suggests an answer to this question in the form of the word *Descriptio* (fig. 2.10) prominently written on the upper border of the map where it extends to the right of the chandelier over the easel. This was one of the most common titles used to designate the mapping enterprise. Mapmakers or map publishers were referred to as world describers, and their maps or atlases as the world described.[6] Though it was never as far as I know applied to a painting, it is a term we could use of Dutch painters. Their aim also was to capture on a surface a great range of knowledge and information about the world. They too employed words with their images. Like the mappers, they made additive works that could not be taken in from a single viewing point. Theirs was not a window, as in the Italian model of art, but rather, like a map, a surface on which was laid out an assemblage of the world.

But not only is mapping an analogue for the art of painting, it also suggests certain types of images and so engaged Dutch artists in certain tasks to be done. Vermeer confirms this relation between maps

and pictures. Let us consider his *View of Delft* (fig. 2.11), a city viewed as a profile laid out on a surface, seen across the water from a far shore with boats at anchor and small foreground figures. This was a common scheme invented for engraved topographical city views (fig. 2.12) in the sixteenth century. The *View of Delft* is an instance, the most brilliant of all, of the transformation from map to paint that the mapping impulse engendered in Dutch art. And some years later in his *Art of Painting* Vermeer recapitulated the map-to-painting sequence. For the small but carefully executed city views (fig. 2.13) that border the map return his own *View of Delft* to its source. Vermeer puts the painted city view back into the mapping context from which it had emerged as if in acknowledgment of its nature.

I will come back later to both of Vermeer's works. But now let us consider: What are the historical and pictorial conditions under which this transformation and others like it would take place?

THE ARTIST MAPS A great range of people took part in the explosion that geographical illustration underwent in the sixteenth century. A number of reasons can be given for this explosion—military operations and the demand for news, trade, and water control among others. A general feature is the trust in maps as a form of knowledge and an interest in the particular kinds of knowledge to be gained from them. Mapping was a common, even casually acquired skill at the time. Cornelis Drebbel, inventor and experimenter in natural knowledge, mapped his hometown of Alkmaar early in his career, and Comenius, a leading Protestant educational thinker, is reputed to have made the first map of Bohemia before being forced to leave.[7] Each man made only a single map in a lifetime. It seems to have been an accepted way to pay one's respect to one's home while contributing to the knowledge of it.

I am understandably less concerned than a cartographic historian might be to distinguish between the act of surveying (which some draftsmen did themselves) and the act of drafting a map. For my aim is to call attention to the fact that mapping, taken in its broad sense, was a common pastime. On occasion it even offered the possibility of displacing deep human feelings onto the act of describing itself. So it was, for example, that early on the morning of 5 August 1676, just before, as we know from his diary, Constantijn Huygens the Younger was to start the search for the body of his grandnephew killed the day before in battle, he settled down with pen, ink, and paper to describe the besieged city of Maastricht viewed across the river Meuse.[8] In the splendid drawing he made, Huygens dealt with human loss by turning to description, though we cannot with certainty call this drawing a commemoration (fig. 2.14).

It is often said that a fondness for topographical views and topographical details made maps more like what we think of as pictures. A horizon was not uncommon on a map. But the connection is also demonstrated by the surprising number of northern artists who were engaged in some aspect of mapping. Pieter Pourbus (1510–84), even-

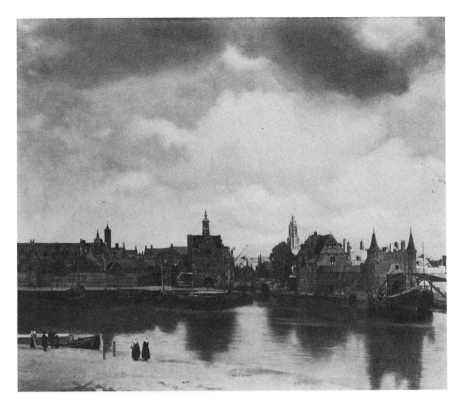

FIG. 2.11 Jan Vermeer, *View of Delft*. Mauritshuis, The Hague.

FIG. 2.13 Jan Vermeer, *The Art of Painting,* detail (map). Kunsthistorisches Museum, Vienna.

FIG. 2.12 Nijmegen, in Georg Braun and Franz Hogenberg, *Civitates orbis terrarum* (Cologne, 1587–1617), 2:29. Courtesy of the Edward E. Ayer Collection, the Newberry Library, Chicago.

FIG. 2.14 Constantijn Huygens III, *A View of Maastricht across the Meuse at Smeermaes* (drawing), 1676. Teylers Museum, Haarlem.

tually to rise to be deacon of the Guild of Saint Luke in Antwerp, was both a painter and a serious mapper, who worked with surveyors and himself used the most modern surveying techniques to produce his essentially topographic maps.[9] In the seventeenth-century Netherlands, from Pieter Saenredam early in the century to Gaspar van Wittel toward the end, artists were employed in executing maps and plans of all kinds. These have tended to be included (though mostly passed over lightly) in the monographs of art historians rather than in the studies of cartographers.[10] An etching after Saenredam's drawing *The Siege of Haarlem* (fig. 2.15) was designed for the commemorative publication on the city. And Van Wittel, later famous as Van Vitelli for his panoramic views of Rome, went to Italy originally to assist a leading Dutch hydraulic engineer by mapping the course of the Tiber as part of a scheme to make it navigable. There is a clear relation between the format of the simple maps for the Tiber project (fig. 2.16) and his later painted views (fig. 2.17).

Nowhere are the professional and also the pictorial links between pictures and maps closer than in the activities of the Visscher family. Claesz Jansz. Visscher, himself responsible for a revival of interest in the topographical views attributed to the old Bruegel, also drew marvelous topographical views of his own in the first decade of the century.[11] A draftsman and engraver, Visscher became a publisher of engravings of landscapes, portraits, and maps and contributed some of the illustrations of towns and local life that appear on his maps. (It is common knowledge that maps in the Netherlands were often sold by the

FIG. 2.15 Anonymous, after Pieter Saenredam, *The Siege of Haarlem* (etching).
Municipal Archives, Haarlem.

same dealers who sold other kinds of prints.) Visscher's son Nicolas
published the map represented in Vermeer's *Art of Painting.*

Journeys for mapping, among other descriptive purposes (in-
cluding the study of foreign flora, fauna, and costumes), were as much
an impetus for northern artists in the sixteenth century to travel abroad
as was the desire to see Rome and learn about antiquity. All attempts to
ferret out some influence of Italy on Bruegel's subsequent figurative art
miss the fact that his Italian trip was probably made for the world scene,
not for Italian art. His famous drawing of the Ripa Grande is close
enough in format to be considered among the type of the city views
collected for Georg Braun and Franz Hogenberg's *Civitates orbis terrarum.*
A picture like his *Bay of Naples* (fig. 2.18) fits right into the category of
topographical harbor views (fig. 2.19) (which, like his painting, some-
times also record naval battles). Mapping projects like these would have
been of interest to his friend Ortelius.

The *Forschungsreisen,* as Ernst Kris called such trips,[12] should
also be invoked when we consider excursions taken closer to home by
certain Dutch artists in the seventeenth century. Pieter Saenredam's
sometimes extended stays to record the churches in various Dutch towns
obviously fit this mapping model, and so do those trips taken by the
popular landscape artist Jan van Goyen, on which he filled pages of his
sketchbook with profile views of various towns (fig. 2.20). The as-
similation of these views into Van Goyen's paintings raises different ques-
tions—combining as they sometimes do elements from different sites.

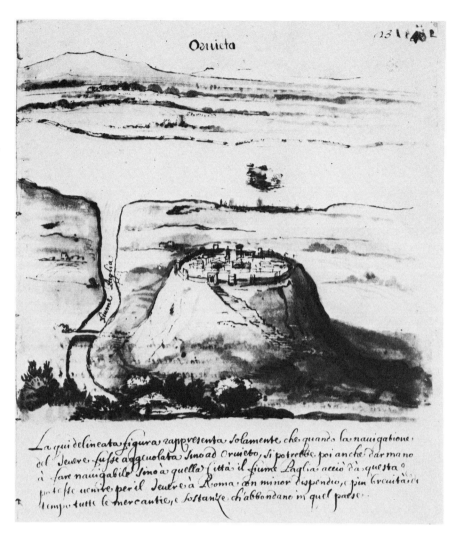

FIG. 2.16 Gaspar van Wittel, *View of the Tiber at Orvieto* (drawing). Meyer Codex (MS 23), Biblioteca Corsini, Rome.

While the form is obviously still a mapped one, the pictures in such cases do not record specific places but rather show what one might call possible ones. They are, however, still usefully placed under the rubric of the mapping mode. From the point of view of the view seen they contrast, for example, with the radical changes wrought on a site combined with the affective handling of Ruisdael's *Jewish Cemetery,* which nears in this regard his quite imaginary representation of swamps. On the other hand, from the point of view of the viewer they contrast with the sense of situating oneself so as to have a particularly picture-worthy view that we find in the nineteenth century. Pissarro reports in his letters to his son that he looked for a room to rent from whose window he could make a pleasing painting. But Dutch draftsmen, by contrast, when they do annotate a drawing (fig. 2.21), note with care the vantage from which they take a view, because recording is inseparable for them from picturing. To distinguish the mapping impulse as in the case of

FIG. 2.17 Gaspar van Wittel, *The Square and the Palace of Montecavallo*. Galleria Nazionale, Rome. Gabinetto Fotografico Nazionale, Rome. Neg. series E. no. 36313.

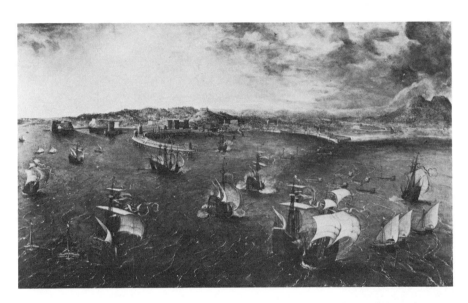

FIG. 2.18 Peter Bruegel, *Bay of Naples*. Galleria Doria, Rome. Gabinetto Fotografico Nazionale, Rome. Neg. series E., no. 41731.

FIG. 2.19 Frontispiece in Willem Barentsz, *Caertboek vande Midlantsche Zee* (Amsterdam, 1595). Vereeniging Nederlandsch Historisch Scheepvaart Museum, Amsterdam.

Ruisdael is not to insist on a single mode but to mark the beginning of an attempt to come to terms with the different Dutch modes of landscape representation.

In the case of maps it seems obvious that the intended function of the image had something to do with the kind of knowledge or information it conveyed and the kind of accuracy that was desirable. According to whether it was used to enable a ship to navigate the seas or enter

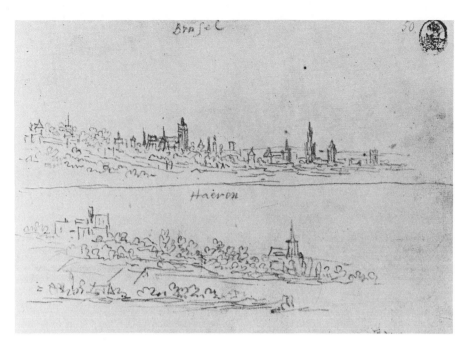

FIG. 2.20 Jan van Goyen, *Views of Brussels and Haeren,* in the Dresden Sketchbook. Staatliche Kunstsammlungen, Dresden.

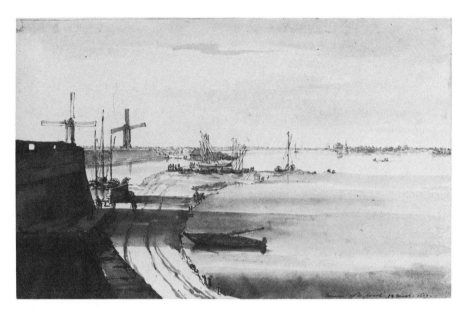

FIG. 2.21 Constantijn Huygens III, *View of the Waal from the Town Gate at Zaltbommel* (ink, brown wash, and some color wash), 1669. Fondation Custodia (coll. Frits Lugt), Institut Néerlandais, Paris.

ports, an army to mount a siege, or a state to tax, different things were demanded. But despite differences in kind it is important not to miss the aura of knowledge possessed by maps as such, regardless of the nature or degree of their accuracy. This aura lent a prestige and power to maps as a kind of image. Their making involved possession of a particular

kind that must not be underestimated in considering the relationship of art to mapping. We cannot help being amused at the claim made by Braun and Hogenberg that they included figures in their city views to prevent the Turks—whose religion forbade images with human figures—from using them for their own military ends. But there is no doubt of the jealous care with which the Dutch trading companies guarded their sea charts against competitors. And a chilling account is given by Isaac Massa—sometime Dutch contact in Russia—of the difficulty he had in obtaining a map of Moscow. Before giving him the map a Russian protested, "My life would be in danger if it were known that I had made a drawing of the town of Moscow and had given it to a foreigner. I would be killed as a traitor."[13] The fear speaks not only to an age-old Russian anxiety about foreigners, but also to a seventeenth-century valuing of knowledge conveyed in map form—it puts great emphasis on the value of a picture. Even for the person on the spot, for the traveler in Moscow, the map allowed one to see something that was otherwise invisible. To put it this way is to call attention to what maps have in common with other Dutch pictures of the time—pictures that were associated with, and used to record, what was seen in a microscope, something that was also otherwise invisible. Like lenses, maps were referred to as glasses to bring objects before the eye.

The link between maps and picture making dates back at least to Ptolemy's *Geography*. With the discovery, translation, and illustration of his text, it became part of the Renaissance verbal and pictorial tradition. Though the first sentence of the *Geography* defines it as a picture of the world[14] (the Greek phrase is "Hē gēographia mimēsis esti dia graphēs tou kateilēmmenou tēs gēs merous holou," and a Latin translation was "Geographia imitatio est picturae totius partis terrae cognitae"), the point of the text that follows is to distinguish between the measuring or mathematical concerns of geography (concerned with the entire world) and the descriptive ones of chorography (concerned with particular places). By way of clarification, Ptolemy invokes the analogy of making a picture: geography is concerned with the depiction of the entire head, chorography with individual features such as an eye or an ear. In his *Cosmography,* a sixteenth-century adaptation of Ptolemy, the Flemish geographer and surveyor Apianus offers illustrations of these points (fig. 2.22). Ptolemy connects the training and skills of the mathematician to geography and those of the artist to chorography. Having made such a distinction, Ptolemy—who seems a modern in this respect—restricts his work to the first category. The maps he produced were various kinds of mathematical projections of large areas of the world rather than detailed pictures of places or regions.

Ptolemy was as careful in his designation of the concerns proper to geography as he was in his designation of the role of the artist. In the Renaissance the situation was different. The explosion of geography in the sixteenth century involved not only a multiplication of images but also an extension of the field itself. One might say that the two were

FIG. 2.22 "Geographia" and "Chorographia," in Petrus Apianus, *Cosmographia* (Paris, 1551). Princeton University Library.

THE MAPPING IMPULSE IN DUTCH ART 67

functions of one another. Mercator's projected five-part *Atlas*—the first to bear the name—was to have started with the Creation and moved on to astronomy, geography, genealogy, and finally chronology. Meanwhile Braun and Hogenberg sent draftsmen all over Europe to record views of cities for their *Civitates orbis terrarum*. The Dutch were surveying their old (and newly made) land and charting the routes overseas to lands such as the Indies and Brazil that were, in turn, theirs to map. Astronomy, world history, city views, costumes, and flora and fauna came to be clustered in images and words around the center offered by the map (fig. 2.23). The reach of mapping was extended along with the role of pictures, and time and again the distinctions between measuring, recording, and picturing were blurred.

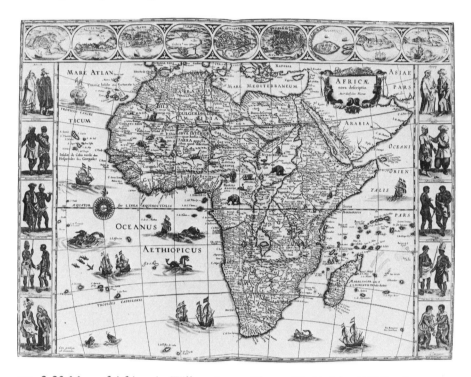

FIG. 2.23 Map of Africa, in Willem Jansz. Blaeu, *World Atlas* (1630). Courtesy of the Edward E. Ayer Collection, the Newberry Library, Chicago.

To what extent do we find this reflected in contemporary texts? How was all this activity proposed or accounted for? To answer this we must go back to Ptolemy himself. The only Greek word available to Ptolemy in referring to a maker of pictures was *graphikōs*. Of particular interest in the context in which Ptolemy used it is that the term (unlike the Latin *pictor*) can suggest and indeed is etymologically related to the group of terms ending in a form of *graphō*—geography, chorography, topography—which in antiquity, as later in the West, was used to define his field of study. The common meaning of this suffix is to write, draw, or record. It is impossible for us today, as it was in the Renaissance, to tell with what examples in mind, and thus with what particular force, Ptolemy invoked *graphikōs*. But how the Renaissance took it is clear

from the translations and adaptations of his work. In general the word picture—*pictura, schilderij,* or the word appropriate for picture in the modern language—was used.[15] I shall postpone until later a consideration of the pictorial presence that came to be suggested by this, the extent to which, in a most unlikely sense, mapped images were said to make the world visually immediate. For now I want to consider the manner in which the Renaissance was not content to invoke Ptolemy's geographic records without also acknowledging their specifically graphic nature. Though the word picture is introduced, it is inevitably modified, accompanied, or replaced by the term description—*descriptio* in Latin, *description* in French, *beschryving* in Dutch.[16] All these words of course depend on the Latin *scribo,* the equivalent of the Greek *graphō.*

To call a picture descriptive at the time was unusual, since description was a term commonly applied to texts. From antiquity on, the Greek term for description, *ekphrasis,* was the rhetorical term used to refer to a verbal evocation of people, places, buildings, or works of art.[17] As a rhetorical device *ekphrasis* depended specifically on the power of words. It was this verbal power that Italian artists in the Renaissance strove to equal in paint when they rivaled the poets. But when the word description is used by Renaissance geographers it calls attention not to the power of words but to the sense in which images are drawn or inscribed like something written. It calls attention, in short, not to the persuasive power of words but to a mode of pictorial representation. The graphic implication of the term is distinguished from the rhetorical one. If we look back at Ptolemy now, we would have to say that his term *graphō* was opened up to suggest both picture and writing.

In the sixteenth and seventeenth centuries description is used equally to title books teaching the new surveying techniques and to title the more general kind of knowledge included in atlases or on maps such as the one in Vermeer's *Art of Painting.* Similarly, the word *landschap* was used to refer to both what the surveyor was to measure and what the artist was to render.[18] Seen from the point of view of the later parting of the ways between maps and other kinds of pictures, description might seem to be a hybrid term that brings together things basically dissimilar in nature. Although the *only* pictorial context in which the word was involved during this later period is the general technical literature of mapping and surveying, I think it suggests a view of picturing that accepted mapping as one of its modes. By employing the term description, the geographical texts accepted the graphic basis of their field while at the same time they related their records to a notion of image making. The graphic use of the term *descriptio* is appropriate not only to maps—which do inscribe the world on a surface—but also to northern pictures that share this interest. With the help of the words used about maps we can suggest that pictures in the north were related to graphic description, rather than to rhetorical persuasion as pictures were in Italy. This map-picture link was confirmed only recently in the definition of a map offered by Robinson and Petchenik: "A map is a graphic representation of the milieu."[19]

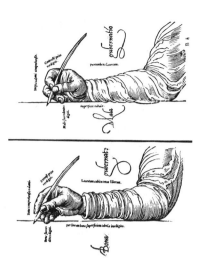

FIG. 2.24 How to hold a pen, in Gerardus Mercator, *Literarum Latinarum* (1549). Courtesy of the John M. Wing Collection, the Newberry Library, Chicago.

Dutch art, like maps, was comfortable with its links to printing and to writing. Not only were Dutch artists often printmakers, accustomed to placing images on the printed page (often a book), but they also felt at home with inscriptions, with labels, and even with calligraphy. Artists and geographers were related not only generally through their interest in describing the world but specifically through their interest in script. Mercator (fig. 2.24) and Hondius among others concerned with maps wrote handbooks for calligraphy, as did people in the circles of Dutch artists.[20] (Indeed, the extraordinary detail in which Mercator set forth the process of cutting the quill, the way the hand rests on the surface, and the forming of the letters analyzed in six moves reveals a graphic attention as great as we find in any draftsmen of the time.) One thing that made this possible was that, in spite of the Renaissance revolution in painting, northern mapmakers and northern artists persisted in conceiving of a picture as a surface on which to set forth or inscribe the world rather than as a stage for significant human actions.

It is implicit in the comparison I am drawing between maps and northern pictures that I take issue with recent work on Renaissance art and geography that has argued for a determining link between Albertian perspective and Ptolemaic recipes for map projections.[21] In this view the picture in Ptolemy is understood to be like the Albertian picture. But despite the great interest Ptolemy's work generated all over Europe, I think the evidence goes against this. Where European Renaissance picturing is concerned it is in the north, not in Italy, that maps and pictures are reconciled, and the results are clear in the great and unprecedented production of mapped pictures, the landscapes and city views with which we will be concerned.

Alberti's great contribution to picture making was not just in binding the picture to vision but in his choice of what to call a picture: not a surfacelike map but a plane serving as a window that assumed a human observer, whose eye level and distance from the plane were essential factors. Though in his third projection Ptolemy did indeed give instructions for making an image based on a projection from a single eye point, he did not invent the Albertian picture. The question whether he did is academic, since no one argues that the Renaissance ever actually took up Ptolemy's construction. To make a long and complicated story very short, Ptolemy's third projection corresponded not to Alberti's vanishing-point perspective but to the so-called distance point method favored in the artists' workshops of the north. Let us look at the diagrams provided by Vignola (figs. 2.25, 2.26). Whereas Albertian perspective posits a viewer at a certain distance looking through a framed window at a putative substitute world, Ptolemy and distance point perspective conceived of the picture as a flat working surface, unframed, on which the world is inscribed. The difference is a matter not of geometry—in basic respects effectively the same—but of pictorial conception.

One might speak of the resulting image as being seen essentially from within or as being surveyed. It is in certain respects much like surveying, with the viewer's position or positions included within the

FIG. 2.25 The first *regola* or the *construzione legittima,* in Giacomo Barozzi da Vignola, *Le due regole della prospettiva practica* (Rome, 1583), p. 55. University of Chicago Library.

FIG. 2.26 The second *regola* or the distance-point method, in Giacomo Barozzi da Vignola, *Le due regole della prospettiva practica* (Rome, 1583), p. 100. University of Chicago Library.

territory he has surveyed. Surveying, however, takes us away from Ptolemy, who was concerned with geography, or the mapping of large areas of the earth. There the issue was not surveying but rather how to project or better transform part of the spherical globe onto a flat surface. What is called a projection in this cartographic context is never visualized by placing a plane between the geographer and the earth; rather it is achieved by transforming, mathematically, from sphere to plane. Although the grid Ptolemy proposed and those Mercator later imposed share the mathematical uniformity of the Renaissance perspective grid, they do not share the positioned viewer, the frame, and the definition of the picture as a window through which an external viewer looks. On these accounts the Ptolemaic grid, indeed cartographic grids in general, must be distinguished from, not confused with, the perspectival grid. The projection is, one might say, viewed from nowhere. Nor is it to be looked through. It assumes a flat working surface. Before the intervention of mathematics, its closest approximation had been the panoramic views of artists—Joachim Patenir's so-called world landscapes—which also lack a positioned viewer.

All this will come as nothing new to cartographers, but it can be of definitive importance for students of art. In discussions of mapping,

distinctions are drawn between systems of projections for dealing with large areas of the globe and for surveying small areas. But whichever case we take, northern painting is like the maps as the Albertian picture is not. The presence on maps of individual structures—buildings, for example—that are "viewed in perspective" does not affect the basic nature of the image. It offered a surface on which to inscribe the world, and this permitted the addition of views—those of cities, for example—as we have seen in *The Art of Painting*. Contrary to what is assumed, such mapped images have a potential flexibility in assembling different kinds of information about or knowledge of the world that is not offered by the Albertian picture.

To sum up: the circumstances were propitious for northern image makers to pursue the pictorial aims that had long been implicit in geography. Their success in this was in turn made possible by a notion of a picture particular to northern Europe.[22] These are factors to bear in mind as we turn to the two major types of images I think are inherently like mapping in source and nature: the panoramic, or what I should prefer to call the mapped landscape view, and the cityscape or topographical city view.

MAPPED LANDSCAPES What are commonly referred to as the first "realistic" Dutch landscape images are some drawings done about 1603 by the great Dutch draftsman Hendrik Goltzius of the dunes near Haarlem (fig. 2.27). Rather than working from his mind or imagination, the artist goes out into nature and tries to capture the great sweep of the flat Dutch land—farms, towns, church towers all marked out on this great expanse. The reason such a description first appears in drawing rather than in paint, it is said, is the "after life" aspect of pen and paper. It was a medium that, unlike brush, paint, and canvas, was taken outside in the seventeenth century. So, the account goes, Goltzius was the first to go out and draw what he saw. This realism is then contrasted with his previous imaginary or so-called mannerist landscapes (fig. 2.28). But indeed surveyors and mappers and artists engaged in such tasks had already gone into the landscape and viewed it for descriptive purposes. Their results differ. Those that are closest to Goltzius's feel for the surface and the land outstretched are the maps that have a high but articulated horizon—Braun and Hogenberg's map of Den Briel (fig. 2.29) or Saenredam's *Siege of Haarlem* (fig. 2.15). Goltzius's landscape marks not the birth of realism (a slippery notion at best) but the transformation of a mapping mode into landscape representation. We see a new attitude toward the land. Both Goltzius's impetus to record landscape and his graphic mode of inscribing it on a surface are accounted for in this way. An entire genre of landscape paintings—a number by Van Goyen, some by Ruisdael, and almost all of Koninck's—commonly known as panoramic and often considered the most important contribution made by the Dutch painters to the image of landscape, are rooted in mapping habits.

FIG. 2.28 (facing page) Hendrik Goltzius, *Couple Viewing a Waterfall* (drawing). Nationalmuseum, Stockholm.

FIG. 2.27 Hendrik Goltzius, *Dune Landscape near Haarlem* (drawing), 1603. Museum Boymans–van Beuningen, Rotterdam.

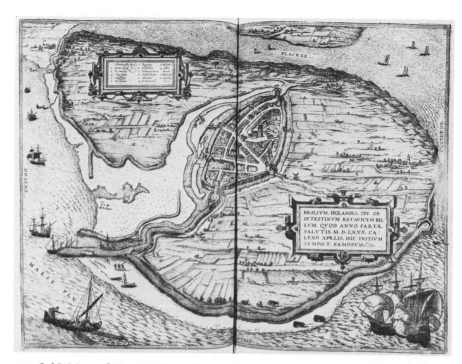

FIG. 2.29 Map of Den Briel, in Georg Braun and Franz Hogenberg, *Civitates orbis terrarum* (Cologne, 1587–1617), 2:27. Courtesy of the Edward E. Ayer Collection, the Newberry Library, Chicago.

It is no discovery, particularly after Gombrich's engaging demonstrations, that even the most illusionistic art employs conventions. What is significant here is that the conventions are like those of some contemporary maps. The artist acknowledges and accepts the working surface—the two-dimensional surface of the page to be worked on. In this drawing, as in the entire tradition of panoramic landscapes to follow, surface and extent are emphasized at the expense of volume and solidity. We note the lack of the usual framing devices familiar in landscape representations which serve to place us and lead us in, so to speak, to the space. We look on from what is normally (and somewhat misleadingly) referred to as a bird's-eye view—a phrase that describes not a real viewer's or artist's position but rather the manner in which the surface of the earth has been transformed onto a flat, two-dimensional surface. It does not suppose a located viewer. And despite the tiny figures just visible at the bottom edge, this landscape can virtually be said to be without people. Goltzius's earlier drawing, on the other hand, is peopled with a couple whose affection for each other is echoed in their joint attraction to the torrent cascading before them. Human wonder at nature, not the recording of the land, is the artist's concern.

"How valuable a good map is," wrote Samuel van Hoogstraten, a contemporary of Vermeer's, in his treatise about art, "in which one views the world as from another world thanks to the art of drawing."[23] Hoogstraten's exclamation applies as well to what I have called mapped (panoramic) landscapes as to the maps they transform. Goltzius *does*

FIG. 2.30 Pieter Saenredam, *Profile Views of Leiden and Haarlem and Two Trees* (pen, wash, and watercolor), 1617 and 1625. Kupferstichkabinett, Staatliche Museen Preussicher Kulturbesitz, West Berlin.

make us feel that we are situated apart from the land, but with a privileged view. It is precisely the curious mixture of distance preserved and access gained that is at the heart of Ruisdael's best works in this mode. Hoogstraten concludes with thanks to the art of drawing for making maps possible. Although his words are usually quoted when maps and Dutch art are at issue, it has not struck anyone to ask why Hoogstraten discusses maps in a section about drawing. The answer lies in his notion of drawing. This is the same chapter of his treatise in which he speaks of drawing as a second kind of writing. It is a chapter dominated, in short, by the spirit of *descriptio*—to recall the word on Vermeer's map—that inscribing of the world to which Goltzius was heir.

Landscapes and mapping are linked in the Netherlands of the seventeenth century by the notion of what it is to draw. In the Italian-dominated theory of the late sixteenth century, drawing (*disegno*) had been exalted to the point where it was synonymous with the idea (*idea* in Italian) of art, and thus with the act of the imagination itself. Hoogstraten by contrast introduces drawing as linked to letters formed in writing, to planning war maneuvers, to medicine, astronomy, natural history, and geography. Drawing is treated as a craft with specific functions, among which are the description on a page of phenomena observed in the world. A beautiful sheet by Saenredam (fig. 2.30) that juxtaposes views of Leiden and Haarlem with their names in a fine calligraphic hand above and with the imprinted silhouettes of two trees below to complete the page is an illustration of drawing understood in this way. It is this

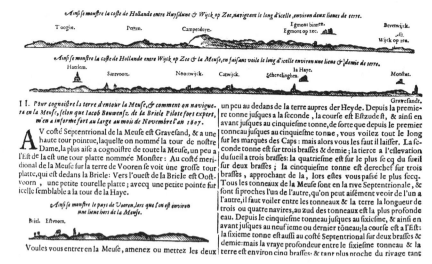

FIG. 2.31 Landmarks, in Willem Jansz. Blaeu, *Le flambeau de la navigation* (Amsterdam, 1625). Courtesy of the Edward E. Ayer Collection, the Newberry Library, Chicago.

impetus to describe that binds the Goltzius landscape drawing and maps. As time goes on this graphic mode is not jettisoned but is in a characteristic Dutch way absorbed into paint. Color already informs the drawing by Saenredam we have just looked at. Paintings do what graphic media had previously done. This is perhaps one of the reasons the relation between maps and Dutch landscape painting has easily been missed.

In many mapped landscapes, as in small area maps, buildings, towns with their church towers, windmills, and clumps of trees appear as landmarks, literally marks on the land (as if to guide travelers), rather than as evocations of particular things. The sources for these are found in maps: in those coastal profiles that illustrate books of navigation (fig. 2.31) and in the notation common on maps of other kinds. Koninck (fig. 2.32) comes particularly close to such landmark notations in the summary nature of his description of the objects in his views. An early seventeenth-century painting (fig. 2.33) by a provincial artist from Enkhuizen (possibly the teacher of Jan van Goyen) reveals a connection to maps in most direct ways—its extremely high horizon, the grid set forth by the polders, and the designation of the landmarks. The horizon alone recalls the mapping connection of many sixteenth-century works such as those by Bruegel, who was no stranger to the geographical activity of his day through his friendship with Ortelius. We might also want to use mapping terms to distinguish the larger *geographical* ambitions of Bruegel's *Season* landscapes from the specific *chorographic* concerns of his drawing *Ripa Grande* or the painting *Bay of Naples*. Establishing Bruegel's engagement with mapping helps us not only to distinguish between his works but also to understand them better. By combining the traditional theme of the seasons with an extensive mapped view of the earth, Bruegel gives to the yearly round a world dimension rather than a local one. In works such as the engravings *Vices* and *Virtues*

or the paintings *Proverbs* and *Children's Games* the mapped view is also used. Though individual proverbs had already been represented in prints and mapped landscapes in painting, Bruegel's great invention was to combine the two. The mapped view suggests an encompassing of the

FIG. 2.32 Philips Koninck, *Landscape with a Hawking Party,* detail. By permission of the Trustees of the National Gallery, London.

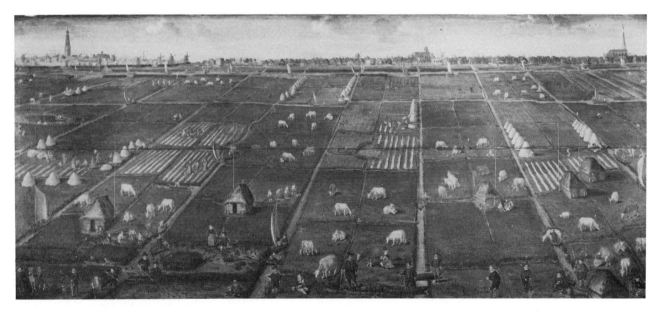

FIG. 2.33 Anonymous Dutch painter, *The Polder "Het Grootslag" near Enkhuizen.* Zuiderzeemuseum, Enkhuizen.

world, yet without asserting the order based on human measure that is offered by perspective pictures. By depicting human behavior in this unlikely setting (though the world is mapped this way, the figures are not like those on a map), Bruegel can suggest the endless repetitiveness of human behavior in an essentially boundless (unframed) space. But the care he takes to distinguish between such essentially repetitious human actions is not dictated by the format. The human community seen under a mapped aspect but attended to with such care has a particular poignancy.

This is not the direction taken in Holland, where the land, not its inhabitants, continues as the major interest. The mapped horizon was not sustained but was lowered to let in first more sky (the Van Goyen monochromatic works of the 1640s) and then clouds and effects of light (as we move on to Ruisdael in the 1650s and 1660s). Philips Koninck (fig. 2.34) is the artist who sustains the format of the mapped landscape the longest in that century. It is not clear to what extent he did or did not detach it from its recording aspect. The enormous size of some of his works, the largest of all Dutch painted landscapes, rivals the dimensions of wall maps. Rather than picturing a geographic world-view as Bruegel did, or the chorographic places of Goltzius, Van Goyen, and Ruisdael, Koninck aims at making the piece of Holland he describes itself seem a part of the larger world. By introducing a gentle curve to the horizon, he lets the earth into what is a mapped view of an area of his native land. Whereas Bruegel expands his neighborhood to be the world, Koninck brings a worldview to Holland.

Many of Jan van Goyen's views are examples of mapped landscape. Although the horizon is lowered, the panel gives the impression of being a worked surface. The extent of the land is scattered with standard landmarks—church towers, hayricks, trees, even cows. A city, which is never far away in Holland and on which this urban society so much depended, is the major landmark. This is true of Ruisdael's views of Haarlem (fig. 2.35), called "Haarlempjes" at the time after the city. Ruisdael, perhaps following the example of the materials added to maps, depicts a major product and economic support of the city—the bleaching of linen in the fields. In these works the mapped landscape approaches the other genre obviously derived from mapping, the topographical city view.

People passing through the country in these works, some inhabitants, some travelers presumably like the artist himself, stop sometimes to look out or, very rarely, to draw. Nothing ever happens. Only rarely is work being done. (Ruisdael's "Haarlempjes" are a signal exception.) The working or the bounty of the land is rarely illustrated. We do not to my knowledge see figures actually engaged in surveying. But the access to the land and the interest in it (people direct their gazes far out, not at things close by) is related to this. There was a tradition among map-makers that one could turn to the natives—to the fisherman or the peas-

FIG. 2.35 (facing page) Jacob van Ruisdael, *View of Haarlem*. Gemäldegalerie, Staatliche Museen Preussicher Kulturbesitz, West Berlin.

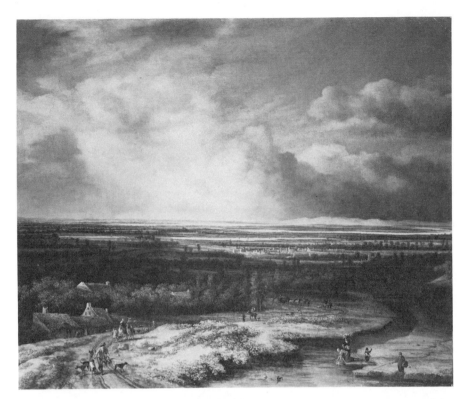

FIG. 2.34 Philips Koninck, *Landscape with a Hawking Party*. By permission of the Trustees of the National Gallery, London.

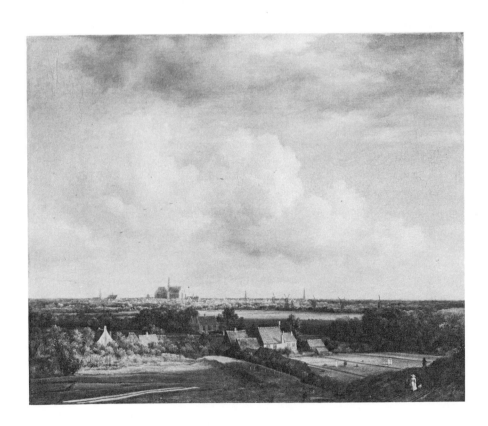

ants—for assistance.[24] Those living on the land or sea share an interest in knowing it—at least that is the assumption. A Cuyp painting of two shepherds looking out and pointing toward Amersfoort (fig. 2.36) renders this.

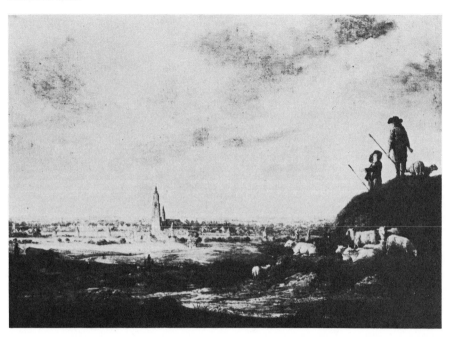

FIG. 2.36 Aelbert Cuyp, *View of Amersfoort*. Von der Heyt-Museum, Wuppertal.

Representative peasants or fishermen turn up on the frontispiece of an atlas or the cartouche of a map. A fisherman with a surveyor's tool is on the Visscher map in Vermeer's *Art of Painting,* though here the mapmaker also intends a play on his own name.

We can, I think, distinguish a narrower and a broader use of the mapping designation. Used narrowly, mapping refers to a combination of pictorial format and descriptive interest that reveals a link between some landscapes and city views and those forms of geography that describe the world in maps and topographical views. Used broadly, mapping characterizes an impulse to record or describe the land in pictures that was shared at the time by surveyors, artists, printers, and the general public in the Netherlands. In the face of this I think we must supplement Gombrich's well-known solution to the problem of how to explain the invention or institution of landscape as a pictorial genre.[25] Gombrich refers us to a telling account from Norgate's *Miniatura* (written ca. 1648–50). An art lover returning from a trip through the mountains, hills, and castles of the Ardennes calls on an artist friend in Antwerp and gives an account of his trip. In the course of the account the artist takes up his brushes and proceeds to paint: "describing his description in a more legible and lasting Character than the other's words," are Norgate's words.[26] Gombrich uses this anecdote to point to the idea or the words, the rhetoric to be more precise, concerning a landscape that preceded its

invention as an image. Following this anecdote he refers us to passages from other contemporaries who also narrated their experience of landscape. This link to a prior human narrator stands us in good stead for the birth of those kinds of landscape images where expression or tone in the rhetorical sense is important. (The heroic and pastoral modes of Poussin and Claude are instanced by Gombrich.) But mapped landscape images and the impetus for making them are not accounted for in this way. They were founded, significantly, by artists on the road looking, artists who were not staying at home listening to travelers' accounts. We can turn Norgate's words back on him. These works are descriptions, but not in the rhetorical sense. For description in these cases is not a rhetorical but a graphic thing. It is description, not narration.

If the great landfill and water projects on the one hand and military activity and news on the other contributed to the demand for detailed maps, the natural features of the Netherlands made it particularly suitable for mapping. The flat, open, relatively treeless country with conspicuous villages and frequent towers made surveying and viewing easy. In fact these very aspects, the condition of its mapping, are some of the favorite motifs in the mapped images. We have many verbal accounts from the seventeenth century of people climbing towers in order to take at least a visual measure of the land. Men such as the scholar-scientist Isaac Beeckman and the doctor Johann van Beverwyck had prospects for their own houses, but foreign visitors, like the Frenchman Balthasar de Monconys, are regularly taken up to get a prospect on the land. Views drawn from the vantage point of specific towers and annotated as such (fig. 2.21) form a special small subgenre of Dutch drawings.

But the mapping and related viewing of the Netherlands were surely also conditional on social and economic factors. All mapping is, in some sense. And in the Netherlands the system of landownership that permitted access to much land that was politically and socially untrammeled is a relevant consideration. The northern Netherlands was unique in the Europe of the time in that over 50 percent of the land was peasant owned. Unlike other countries, seigneurial power was weak to nonexistent.[27] Though I know of no historical account of the matter, it was practically easy to survey the land in a situation in which no threat was presented to tenants or to any others. When we read the history of surveying in England, the social dimension is striking—because of the nature of landownership, surveying was greeted with suspicion by tenant farmers. The first leading seventeenth-century English handbook on the subject, John Norden's *Surveior's Dialogue* (1607), is presented in the form of a dialogue between the surveyor, a bailiff, a farmer, the lord of the manor, and a purchaser. It is the surveyor's task to allay the threat of higher rents that the survey presents to the farmer while at the same time underlining the lord of the manor's obligations to his tenant. I have found nothing similar of Dutch origin. English poetry of the time reflects the sense that a landscape inevitably involved issues of authority and possession. The prospect or view was itself seigneurial in its as-

sumption and assertion of power. Pride in estate was real and was related to the order of the state. As Andrew Marvell said in a Latin poem on his patron's estates:

> See how the heights of Almscliff
> And of Bilbrough mark the plain with huge boundary.
> The former stands untamed with towering stones all about;
> The tall ash tree circles the pleasant summit of the other.
> On the former, the jutting stone stands erect in stiffened ridges:
> On the latter, the soft slopes shake their green manes.
> That cliff supports the heavens on its Atlantean peak:
> But this hill submits its Herculean shoulders.
>
> .
>
> Nature joined dissimilar things under one master;
> And they quake as equals under Fairfaxian sway.[28]

In the Netherlands, on the other hand, as surveyors, travelers, and images testify, the land was there to be mapped and pictured with no issue over seigneurial possession. The informative views taken from Dutch towers contrast with the authority accruing to such views in English life and verse. Though mapping can serve to mark ownership, it does not, by its nature, display pictorial marks of authority. What maps present is not land possessed but land known in certain respects. What has been referred to as the social and political irrelevance of landownership in the Netherlands was, then, an important enabling factor in the freedom to map as well as in the freedom to picture the land as in a map.

It is in this social context that Rembrandt's splendid etching of 1651 known as *The Goldweigher's Field* (fig. 2.37) becomes a particularly interesting example of the Dutch mapping mode. The work was done, we believe, on the occasion (or following the occasion from which a drawing is preserved) of Rembrandt's visit to the country house of one of his unpaid creditors just outside Haarlem. Christoffel Thijsx's country estate, Saxenburg, is visible in the left middle ground of the etching. Rembrandt renders a familiar type of mapped landscape that, however, takes no particular notice of the estate. True to the mode, he shows the great sweep of the land marked by the church at Bloemendaal at the right and the huge Saint Bavo of Haarlem on the horizon to the left. The extensive fields are peopled, as in Ruisdael's paintings, with workers setting linen out to bleach. Rembrandt records the lay of the land, its churches, towns, trees, and grasses, and to a much lesser extent its product—the use being made of good air to set out the linen. Thijsx's estate is incidental to this view. Rubens's depiction of Het Steen (fig. 2.38) offers a fitting contrast to all this. Though its format could lead one to call it a mapped view, it is a view determined by and engaged in the presence of a seigneur. In buying this estate Rubens knew he would acquire the title it bore. The prospect of Flanders stretching out to the right is the view gained from his house. It is suitably graced by a golden light. It is the possession of such a house that gives the authority of this prospect. The owner and family stand before it. Meanwhile the hunter aiming at a bird and the wagon piled with a trussed lamb on the way to market re-

mind us of the uses t[...] [R]ubens as
always acknowle[...]. There
was never, I thin[...] [th]e land.
When Dutch mer[...]s their
portraits and portr[...] [a]nd the
land, that they wa[...] [in] still
lifes. Again these a[...]

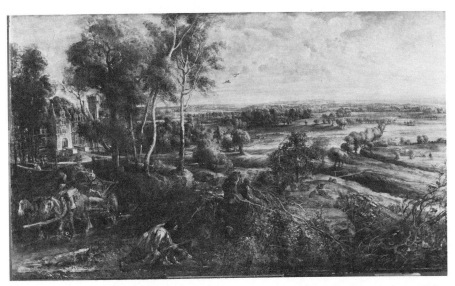

FIG. 2.37 Rembrandt Harmensz van Rijn, *The Goldweigher's Field,* 1651. Etching and drypoint on Japan paper. Buckingham Fund, 53.267. © The Art Institute of Chicago. All rights reserved.

FIG. 2.38 Peter Paul Rubens, *Landscape with Het Steen.* By permission of the Trustees of the National Gallery, London.

There is a further social determinant evident in Rembrandt's etching that conveniently serves to turn our attention to a second major group of mapped images—the topographical city view. A close look at panoramic views will frequently be rewarded with the discovery of a city with its prominent church tower on the horizon. These cities mark not only the visual fact that one was seldom far from an urban center even in seventeenth-century Holland, but also an economic fact. That such mapped landscapes, like Rembrandt's *Goldweigher's Field,* are in a significant respect cityscapes testifies to the importance of the city in the life of the society. Dutch prospects, far from asserting the possession of land and property, rather pay tribute to the cities.

TOPOGRAPHICAL CITY VIEWS The genre of topographical city views is a classic example of the transformation we often find in Dutch art from a graphic medium to the more expensive medium of paint. And the nature of the transformation is of particular interest because Vermeer's *View of Delft* (fig. 2.39) is in this genre.

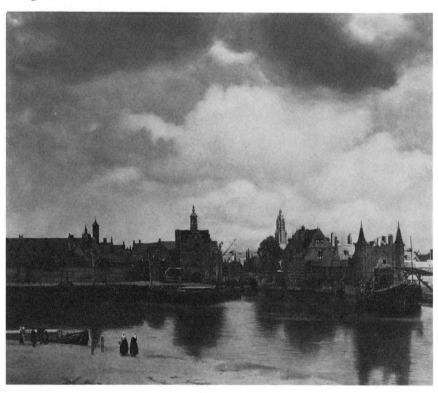

FIG. 2.39 Jan Vermeer, *View of Delft.* Mauritshuis, The Hague.

Art historians who not mistakenly, but certainly far too rigidly, assume that every work must have a source in another have been stumped by Vermeer's *View of Delft.* The only picture that could be found to resemble it at all was a view of Zierikzee (fig. 2.40), by Esias van de Velde painted forty years earlier.[29] The comparison has always seemed reductive, as almost any attempt to compare Vermeer's unique work with an-

other image perhaps does. But here too we find a city spread out in profile against the sky, with boats at anchor and figures perched on a lip of land at the left foreground. A study of map materials, in particular topographical town views (fig. 2.12), makes it clear, however, that, rather than this being a case of influence, both these works belong to a common tradition.

FIG. 2.40 Esias van de Velde, *Zierikzee*, 1618. Gemäldegalerie, Staatliche Museen Preussicher Kulturbesitz, West Berlin.

The interest in city views and their basic models was first presented in Braun and Hogenberg's ambitious *Civitates orbis terrarum,* published between 1572 and 1618. Their stated purpose was to offer the pleasure of travel to those at home. Travel without an interest in business or gain, they asserted, travel just for knowledge, is a virtue.[30] Figures in native dress, flora and fauna, and inscriptions add to the information presented in the views. In the Netherlands the general European interest in cities was supplemented by a civic pride in one's hometown. This is evident in prints of individual cities by Bast and others that start appearing in the 1590s and also in the series of books sponsored by cities in their own honor, often illustrated by native artists. Saenredam designs a profile view of Haarlem for Samuel van Ampzing's *Description and Praise of the Town of Haarlem* (1628). Individual buildings and squares are shown in formats that do not depend at all on Braun and Hogenberg, and trade and gain, contrary to their wish, are very much at issue. In 1606 Visscher has already borrowed Bast's profile view of Amsterdam, expanded it in size, and added four smaller scenes of trade in the city and a panegyric text. The 1649 publication by Blaeu of the first atlas of Netherlandish cities, divided between north and south to commemorate the political division confirmed in the 1648 Treaty of Munster, coincides

with a new burst of interest in cities. The Blaeu atlas, however, consistently uses the vertical or linear grid format for its cities—as far from a picture as it can be.

Of the various formats in which cities are presented by Braun and Hogenberg (four were distinguished by Skelton),[31] a number were popular in separate prints and paintings. One of these is the profile city view—in the case of Dutch cities often seen from across a body of water as in the *View of Nijmegen* or in Hendrick Vroom's 1615 view of the newly built Haarlem Gate at Amsterdam (fig. 2.41). This is the format used by Esias van de Velde and later by Vermeer. On occasion such views were commissioned in a painted form by the cities themselves—like Van Goyen's 1651 *View of the Hague* (fig. 2.42). Rembrandt's etched *View of Amsterdam* (fig. 2.43) of about 1643 was suggested by this established format.

FIG. 2.41 Hendrick Vroom, *The Haarlem Gate, Amsterdam,* 1615. Collection Amsterdam Historical Museum, Amsterdam.

Vermeer's *View of Delft,* then, is dependent on a tradition of topographical prints and is not the first painted view of a Dutch town to take over this design. In the midst of the renewed interest in many kinds of depictions of cities at the midcentury, Vermeer's seems essentially to be a traditional, even a conservative choice of a way to view his hometown.

The accuracy of Vermeer's view has often been remarked. The linear or vertical map of Delft from Joan Blaeu can be marked to indicate which buildings are seen. Vermeer even noted the time—7:10—on the tower clock. But still it seems mistaken to call this picture a topographical view. It is of a different order of rendering than the printed

views or even the other painted ones. It is endowed with an uncommonly seen and felt presence. Vermeer changes the format by lifting the sky high over the strip of the town, which is held to the lower frame by the golden bank. The town so exposed turns in on itself. Ringed by its wall, which encloses trees and crowded roofs, it suggests the intimacy of human habitation—an intimacy preserved in the quiet talk of the figures outside it on the bank. (Vermeer painted out the one person, a man,

FIG. 2.42 Jan van Goyen, *View of The Hague,* 1653. Collection Haags Gemeentemuseum, The Hague.

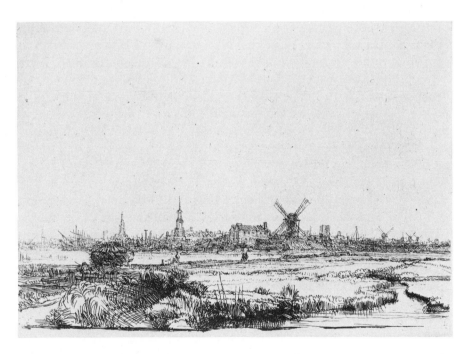

FIG. 2.43 Rembrandt Harmensz van Rijn, *View of Amsterdam,* ca. 1640. Etching. Clarence Buckingham Collection. © The Art Institute of Chicago. All rights reserved.

who would have stood apart.) But the intimacy is internally differentiated. It is contrasted as men and women are in Vermeer's other works. The threatening but protective shadow at the left, which extends the full length of the city wall, is played off against the brilliant light on the right part of the town. Each depends on the other to set it off. This is a fact in the perception of the light, in the painter's art, but also in human experience. Vermeer turns into a city view and its visual values the sense of human experience that informs all his paintings. The two towers that reach into the sky—one in shadow and one in full sunlight—are linked by a bridge where masonry, leaves, sun, and shade all meet at the center of the image.

The transformation from graphic to painted medium was in one respect common in the mapping enterprise. Painters were regularly employed as colorists for maps. The map in Vermeer's *Art of Painting* is a colored one. At a first level such colors have a symbolic value: they distinguish between various aspects of the earth for our eye—sea is blue, land tan. Though they signify, they need not be descriptive. Vermeer's *Soldier and Young Girl Smiling* in the Frick Collection (fig. 2.8), with its pointed reversal of the actual colors of sea (here tan) and land (here blue) clearly makes this point.

But though color conventions were not necessarily descriptive, maps were thought of at the time as being descriptive, as were pictures. In the writings of geographers it was a commonplace to speak of a map as putting the world or a place in it before the viewer's eyes. Apianus calls on the image of the mirror. Cosmography, he says, mirrors the image and appearance of the universal world as a mirror does one's face. In other words, he continues, one sees the picture and image of the earth.[32] Braun and Hogenberg say of the chorographer: "[He] describes each section of the world individually with its cities, villages, islands, rivers, lakes, mountains, springs, and so on, and tells its history, making everything so clear that the reader seems to be seeing the actual town or place before his eyes."[33] (Those copies of the *Civitates* in which the views were hand colored at the time confirm this intent.) Isaac Massa, returning from Russia, refers to the map of Moscow that he replicated for the Dutch as "done by pen with such exactitude that in truth you have the town before your eyes."[34] And Ortelius in the introduction to his *Theatrum orbis terrarum* (London, 1606) writes: "those chartes being placed as it were certaine glasses before our eyes, will the longer be kept in memory and make the deeper impression in us." We could multiply such statements, which occur in almost every geographical text. The terms "mirror," "before our eyes," and "glasses" were applied equally to maps and to pictures at the time. Norgate, for example, continues his passage on the invention of landscape painting with the following characterization: "Landscape is nothing but Deceptive visions, a kind of cousning or cheating your owne Eyes, by our owne consent and assistance, and by a plot of your owne contriving."[35] To speak of maps in this way, however casually, is to assume more similarity between them and pictures than we have yet noted. Not only description but mirroring

FIG. 2.44 Jan Christaensz. Micker, *View of Amsterdam*. Collection Amsterdam Historical Museum, Amsterdam.

presence is held in common. I suggested earlier that it was at this time that pictorial aims long implicit in geography were taken up by northern image makers. But for all the implicit claims about the mirroring presence of a map, how can a map bring something to the eyes in the way a picture can?

We must pause a minute to appreciate the peculiarity of this claim. And the best way to do so is to look at a map—or is it a picture?—by the little-known Dutch painter Jan Micker (fig. 2.44). Basing his work on the famous sixteenth-century painting (or perhaps even the woodcut) of Cornelisz Anthonisz., Micker literally painted the mapped Amsterdam. In this idiosyncratic work he tries to bind the graphic nature of the map to the mirroring qualities of a painting; the list labeling landmarks at the lower right casts a shadow onto the sea, but even more strikingly the city is softly colored and grazed by scattered light and shade cast by unseen clouds. Micker reveals an ambition but poses a pictorial problem. In his Haarlempjes (fig. 2.35), Ruisdael provides a resolution that Micker could not find. He lowers the horizon and extends the sky to include the clouds that leave their mark but have no presence in Micker's painted map. Haarlem is made the object of a pictorial celebration of a sort that no map or topographical view could offer. Vermeer's *View of Delft* is the consummate solution to the problem of placing a topographical view before the viewer's eyes. It cleaves close to the design of an engraved city view, but it is hard to retrace the steps back to this design. The town of Delft is smaller in relation to the large, almost square, canvas, but it commands more: sky, water, light, and

shade appear summoned to grace it. To recall my earlier analysis of the language used of maps, the epideictic eloquence of *descriptio* is transformed from a rhetorical figure and given a uniquely pictorial form. In Vermeer's *View of Delft,* mapping itself becomes a mode of praise.

A central element in the transformation from print to painting is the addition of color. Obviously color was not used only symbolically. Though maps were produced as prints, the application of color often made them hard (it is said) to distinguish from something originally executed in watercolor. Lines in painted maps were taken over by color. Watercolor itself had long been a favored drawing technique in northern Europe.[36] Dürer used it for his *Great Piece of Turf, Rabbit,* and landscapes. In seventeenth-century Holland many of Jacques de Gheyn's drawings of animals or flowers are also in watercolor. (In fact, if one looks at Dutch drawings rather than at reproductions of them it is surprising how many employ color.) Watercolor is a medium that effaces the distinction between drawing and painting, and it was primarily employed in the interest of immediacy of rendering. Conversely, one might say that it is a medium that allows drawings to display at once two normally contradictory aspects: drawing as inscription (the recording on a surface) and drawing as picture (the evocation of something seen). Vermeer's *View of Delft,* though not executed in watercolors, is this kind of work. Whether or not it was painted with the assistance of a camera obscura, it inscribes the world directly in color as did that popular device. It took Vermeer to realize in paint what the geographers say they had in mind.

HISTORY MAPPED In 1663 Blaeu presented his new twelve-volume atlas of the world to Louis XIV, accompanied by some words of introduction and explanation: "Geography is the eye and the light of history. . . . maps enable us to contemplate at home and right before our eyes things that are far away."[37] We have seen that the notion of description was instrumental in tying geography to pictures and in the development of new modes of images. Geography's relationship to history gave it a special authority and encouraged its enlarged scope. Blaeu's remark is an appropriate introduction to an atlas of images recording wide travel and exploration. He wishes to make distant, unseeable things visible. He welcomes and encourages description and validates it as knowledge. The presentation of geography as the eye of history was a commonplace by this time. Apianus, a hundred years earlier, had recommended geography to those interested in the acts and lives of princes.[38] Mercator had embedded history and chronology in his ambitious plans for the first atlas, and his heirs Hondius and Janssonius (Amsterdam, 1636) quite casually introduce their atlas by writing about their concern with actions like war and exploration, which are "described by Geographie and knowne to be true by Historie." History had long lent status to geography. But in the seventeenth century the balance between the pair (Castor and Pollux, as Mercator called them) was subtly changed. As in the realm of natural knowledge, the new testimony of the eye challenged the traditional au-

thority of history. This happened in geography too. A traveler in Holland confirmed that even the houses of shoemakers and tailors displayed wall maps of Dutch seafarers, from which, he commented, they knew the Indies and their history.[39] One kind of map informed the pilot at sea, but another informed the tailor at home. In such a view history is largely based on visual evidence. It suggests the unprecedented ways images at the time were thought to contribute to knowledge.

The relation of images and history was hardly new to European culture, but it was not established in these terms. The highest form of art was history painting, by which was meant not representations of current or even recent events as such, but painting that dealt with significant human actions as they were narrated by the Bible, myth, the historians, and the poets. The great narrative works in the Renaissance tradition are history paintings in this sense. Nothing could be further from the idea of placing strange or distant things immediately before the eyes. The emphasis was on the mediation of tradition. The understanding of the mind, not immediacy to the eye, was the aim.

The record of history that we find on maps and in atlases of the seventeenth century is different in nature. First of all, place, not actions or events, is its basis, and space, not time, is what must be bridged. It is in this sense—if we limit ourselves only to questions of historical representation—that Visscher's simple news map of the siege of Breda (fig. 2.45) can be usefully put beside the great painting by Velázquez (fig. 2.46). The power of the history painter's representation is derived partly from its relationship to a previous interpretation of a meeting. The surrender between gentlemen, which is surprising by its intimacy in the midst of a public occasion, was culled by Velázquez from Rubens's *Meeting of Jacob and Esau*. The gestures of greeting and also the famous lances reveal this. Despite the mapped background (Velázquez's art contained much of what I am considering the northern mode), Velázquez presents a human relationship steeped in artistic tradition, which he further stages on the basis of the account of Breda given in a contemporary play. Visscher's map, with accompanying text, records the site of Breda, shows the lineup of the army, and indicates relevant towns, churches, rivers, and forests. He numbers the places of interest with a verbal key below. To record history in maps and their related illustrations is to emphasize certain aspects rather than others: history is pictured by putting before our eyes an enriched description of place rather than the drama of human events.

This kind of descriptive, mapped history has two notable characteristics (fig. 2.47). First, it presents a surface on which a great variety of information can be collected: a map of the Netherlands features her cities at the side and their coats of arms beneath, with natives displaying their special regional dress arranged above; Brazil is depicted with her settlements surrounding the land on either side and with views of natives at work that seem to extend into the paper. Small items line up around the edges. Portraits appear on sheets layered onto the original surface. Words and images mingle. The profile view of a harbor town in

a typical format abuts the coastal land viewed from above, of which it is part, so that the page holds two contradictory views. Considered as images these maps are inventive and even playful, and as such they are conscious of their craft. It is a playfulness that is not unique. It is in fact almost a feature of Dutch art. The peep box, for example, was a construction that also offered various views adding up to make a single

FIG. 2.45 Claes Jansz. Visscher, *The Siege of Breda* (engraving), 1624. Courtesy of the Rijksmuseum-Stichting, Amsterdam.

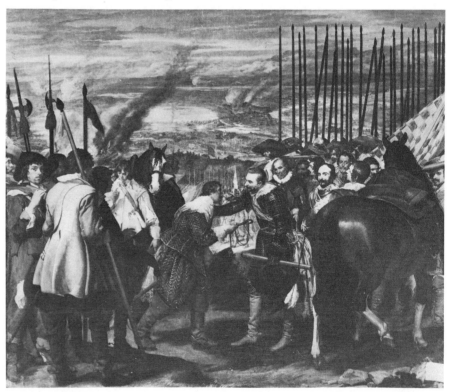

FIG. 2.46 Diego Velázquez, *The Surrender at Breda*. Museo del Prado, Madrid.

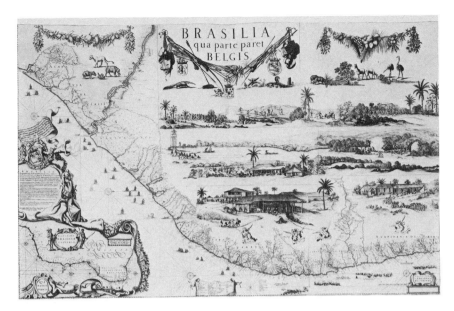

FIG. 2.47 Map of Brazil by Georg Markgraf, published by Joan Blaeu (1647), Klencke Atlas, pl. 38. By permission of the British Library.

world, as do the frequent mirrors or mirroring surfaces; still lifes obsessively topple containers and peel lemons, or cut pies or open watches to expose multiple aspects to view. One could go on. No single view dominates in the interests of this additive way of piecing together the world. In Dutch painting a pleasure is taken in description that is akin to what we find in the world of maps.

Second, the mapped history can offer a detached or (perhaps more relevantly put) a culturally unbiased view of what is to be known in the world. The Dutch record of their short-lived colony in Brazil is an extraordinary case in point. It is the pictorial, not the verbal, records of the Dutch in Brazil that are memorable. They constitute, as a recent writer pointed out, "the most extensive and varied collection of its kind that was formed until the voyages of Captain Cook."[40] The unprecedented team of observers or describers, if we may call them that, which Prince Maurits assembled included men trained in natural knowledge and also in draftsmanship and painting. The skills predictably overlapped and have not yet been sorted out to our satisfaction. They assembled a unique pictorial record of the Brazilian land, its inhabitants, its flora and fauna. The basic mode was portraiture of previously unknown or unprecedented things. Albert Eckhout produced the first full-length paintings of native Brazilians (fig. 2.48). They are unusual not only by virtue of their scale but also because of the care with which he records their bodily proportions, skin color, dress, accoutrements, and social and natural setting. An Eckhout portrait constitutes an ethnography or a human map, as one commentator put it with good reason. Such an interest in description must be set against the fabulous accounts of the New World that were still in vogue. It was these and not the Dutch descriptions that continued to fascinate Europe.

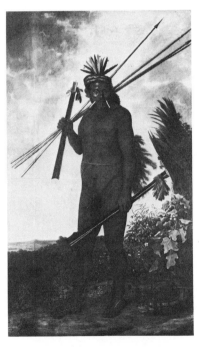

FIG. 2.48 Albert Eckhout, *Tarairiu Man*, 1641. Department of Ethnography, National Museum of Denmark, Copenhagen.

The story of Prince Maurits's descriptive enterprise ends sadly. Aside from Georg Markgraf and Willem Pies Piso's basic handbook on the natural history of Brazil illustrated by new woodcuts, there was no dissemination or absorption of these materials. Maurits himself upon returning home quickly readapted to the international court world in which he had been reared. He devoted himself to building houses and designing gardens, largely in the court mode of the day, using his collection—both of images and of objects—as gifts with which to enhance his social position. He did put some Brazilian natives on the frescoed walls of his new house in The Hague, but the assemblage seems to have been part of the indigenous and lofty European theme of the Four Parts of the World. Eckhout's portraits turn up in the painting *America* by the Antwerp court painter Jan van Kessel (fig. 2.49). What Eckhout had described with such discretion, with such a sense of its difference from what he knew, is here possessed, triply so, by European culture: the interest in mapping the native is absorbed into the allegorical theme of the Four Parts of the World, of which America is one—the world, in other words, as structured by European thought; the Brazilian Indian (a noble savage?) is reshaped in the image of the *David* of Michelangelo; all this in turn is presented in the form of the collectibles of a court, because the room Van Kessel depicts is a *Kunstkammer.*

There is much more to be said about Maurits's pictorial records of Brazil. But even a brief look at their nature and their fate helps us isolate some of the impulses that went into making of images in Holland—impulses that are strongly related to mapping as a basic mode of Dutch picturing.

The images and explanations that crowded the surface of individual maps poured over onto further sheets, the sheets multiplied to fill the volumes of an atlas (which in the case of a wealthy private patron like Van der Hem could grow to as many as forty-eight volumes), and finally they extended so far that they could no longer be bound and so constituted separate collections.[41] There is truly no end to such an encyclopedic gathering of knowledge. We find atlases cataloged under a number of headings in book inventories of the time—as mathematics, geography, art, or history. Though a careful study might suggest a historical sequence, the sum suggests that their nature made their designation at once flexible and uncertain. The historical atlas, as Frederick Muller, who collected a great one himself, remarked, is a Dutch invention.[42] No other culture assembled knowledge through images as the Dutch did. Even today the Muller collection in Amsterdam and the Atlas van Stolk in Rotterdam are unique sources for our knowledge of Dutch history and art. But the historians who so often go to Rotterdam to find illustrations for their texts have not stopped to ask why such useful illustrations are available in the Netherlands.

THE ART OF PAINTING We can now return, with a fuller sense of it, to the splendid wall map to which Vermeer gave a central place in his *Art of Painting* (fig. 2.6, color plate 4). Blaeu's praise for the map that brings knowledge of history into

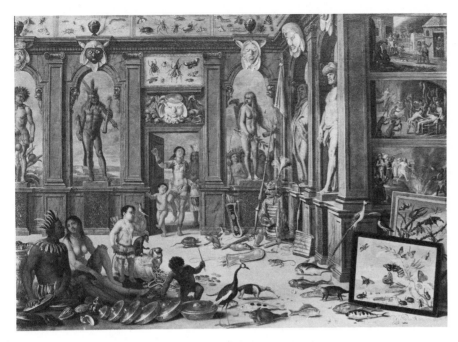

FIG. 2.49 Jan van Kessel, *America*, 1666. Alte Pinakothek, Munich.

the house is realized here before our eyes. This map, which we recognized before to be like a painting, is also a version of history. Vermeer confirms this for us in the female figure he placed just before it, the figure whose image he is beginning to enter on his canvas as the object of his art. Draped, wreathed with bay, bearing a trumpet and book, the young woman is decked out as the figure of History. She serves as an emblematic label placed diagonally across the map from the word "Descriptio": together these two signs, the woman and the word, set forth the nature of the mapped image.

We do not think of Vermeer as a history painter. After his first works he turned away from the tradition of narrative subjects. And the argument that this depiction of Clio, history's muse, shows that despite his own art he still honored the noblest art in the traditional sense is unpersuasive. His concentration on the domestic world of women attended by men excludes the public stage on which history in this sense takes place. The map in *The Art of Painting* confirms this domesticity. Far from threatening the domestic world, this pictured map brings history in to inform it. It is as if History raises her trumpet to praise such descriptive painting.

But to conclude with the map alone is not to do full justice to its place in Vermeer's *Art of Painting,* of which it is only a part, albeit a central one. Consider how Vermeer not only relates but also compares Clio and the map. He has juxtaposed two different kinds of pictorial images—one the figure of a young woman as Clio, an image replete with meaning calling for interpretation, the other the map, an image that functions as a kind of description. How does an image comprehend the world, Vermeer makes us ask, through an association of meanings (art

as emblem) or through description (art as mapping)? As we step back from what is before the painter—the woman and the map—to view the artist and the world of which he is part, we too are suspended between seeking meanings and savoring lifelike descriptions.

The emblematic figure, Vermeer acknowledges, is but one of his familiar models dressed up to represent History. She poses, taking on a role. On the table the fabrics, books, and mask—whatever they might be said to mean—are the very materials out of which an emblematic identity is composed. They are discarded or perhaps waiting to be assumed. Vermeer juxtaposes the face of the woman with the map (fig. 2.9). Her eyes, nose, mouth, her curls are placed beside the bridges, towers, and buildings of one of the small town views, while behind her head lies the Netherlands. The mapping of town and country are compared to the delineation of a human visage. This may be the most extraordinary painterly transformation of all. For it recalls those simple woodcuts (fig. 2.22) with which Apianus illustrated Ptolemy's analogy between describing the world and picturing a face. But Vermeer disclaims any identity. In contrast to Ptolemy and Apianus, Vermeer distinguishes the human presence from map or city. He shows instead that inscription and craft, like emblematic accoutrements, give way before the flesh of a human presence.

But that is not final. For craft is richly present in this painting. A crafted world surrounds both artist and model, who are introduced by a tapestry, backed by a map, crowned by a splendid chandelier, and richly robed. Craft subtly transforms and shapes observation. Observation is in fact revealed to be inseparable from craft. The leaves resting on the model's head are reconstituted by the painter's brush and transformed in threads high on the foreground tapestry. There also they grace a female figure, though one woven in cloth—the only legible human form in the tapestry. The golden band on the woven woman's dark skirt recalls, though in reverse, the pattern and colors of the skirt of the artist's muse. A woman too is subject to fabrication.

Vermeer signed the map and paints the woman. The eroticism of his earlier works—where men wait attentively upon women—is absorbed here into the pleasure of representation itself, which is displayed throughout the painting. Vermeer withdraws to celebrate the world seen. Like a surveyor, the painter is within the very world he represents. He disappears into his task, depicting himself as an anonymous, faceless figure, back turned to the viewer, his head topped by the black hole of his hat at the center of a world saturated with color and filled with light. We cannot tell where his attention is directed at this moment: Is it to the model or to his canvas? Observation is not distinguished from the notation of what is observed. That is the grand illusion that the picture also creates. It represents an *Art of Painting* that contains within itself the impulse to map.

PLATE 1 Jane Lewin, *Rheidol Collage,* a painting depicting meanders in a river valley in map form. Original size 1.01 × 1.37 m. Courtesy of the artist.

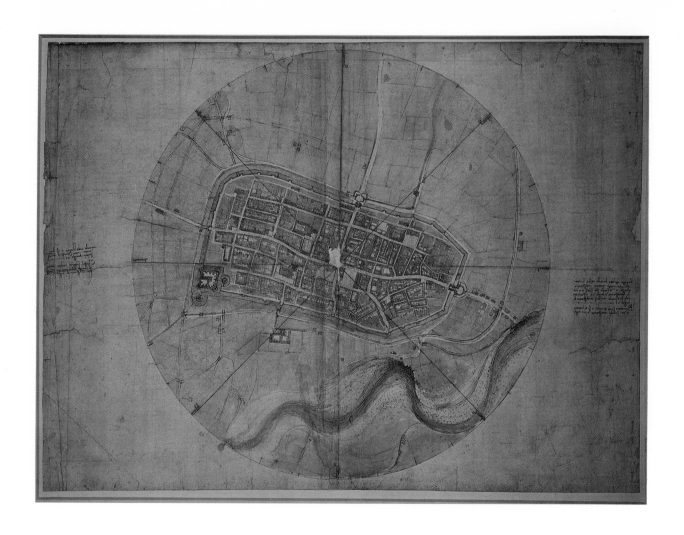

PLATE 2 Leonardo da Vinci, *Pianta della città di Imola,* ca. 1502, in the Royal Library, Windsor Castle, England. Reproduced by gracious permission of Her Majesty Queen Elizabeth II.

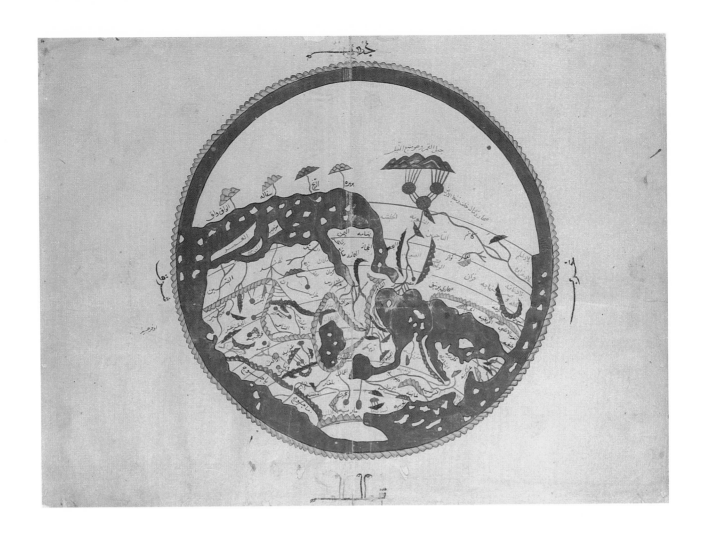

PLATE 3 Mohammedan zonal world map copied from that of al-Idrisi, 1154
(*Pococke* 375, fols. 3v–4r). Courtesy of the Bodleian Library, Oxford.

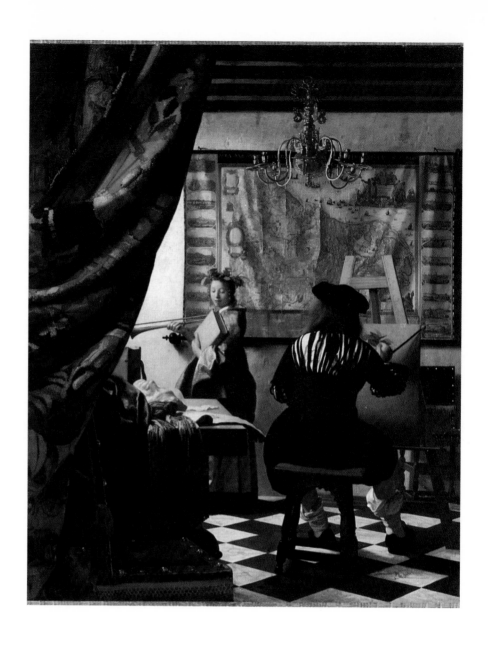

PLATE 4 Jan Vermeer, *The Art of Painting*. Kunsthistorisches Museum, Vienna.

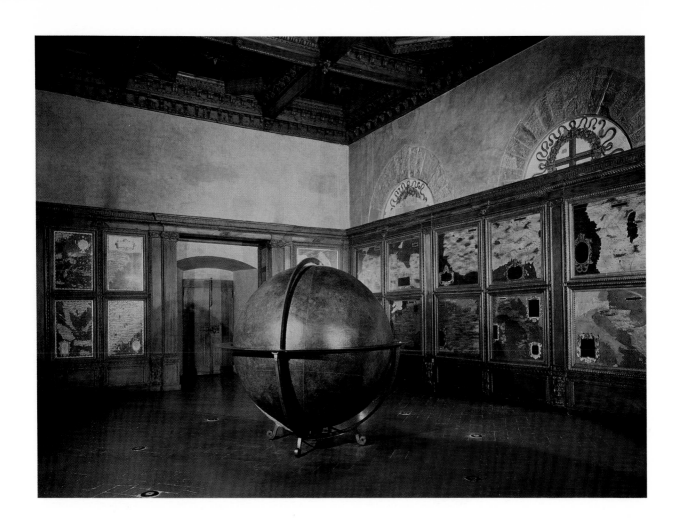

PLATE 5 Sala delle Carte Geografiche (Guardaroba), Palazzo Vecchio, Florence.
Courtesy of Editorial Photocolor Archives, Inc., New York.

PLATE 6 Detail of Han military map, 168 B.C. Courtesy of Professor Mei–ling Hsu, Department of Geography, University of Minnesota, Minneapolis.

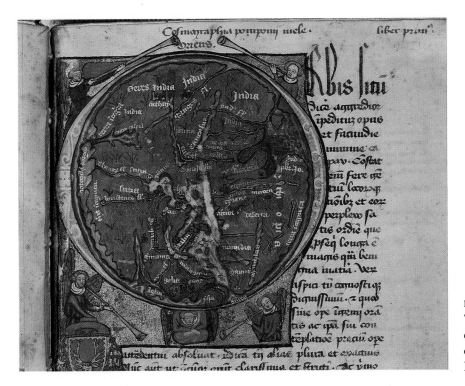

PLATE 7 Map of the world from "Manuscrit de la Cosmographie de Pomponius Mela." Courtesy of the Bibliothèque Municipale, Reims.

PLATE 8 Map of the habitable world by Ranulph Higden, ca. 1350, from the "Polychronicon." By permission of the British Library.

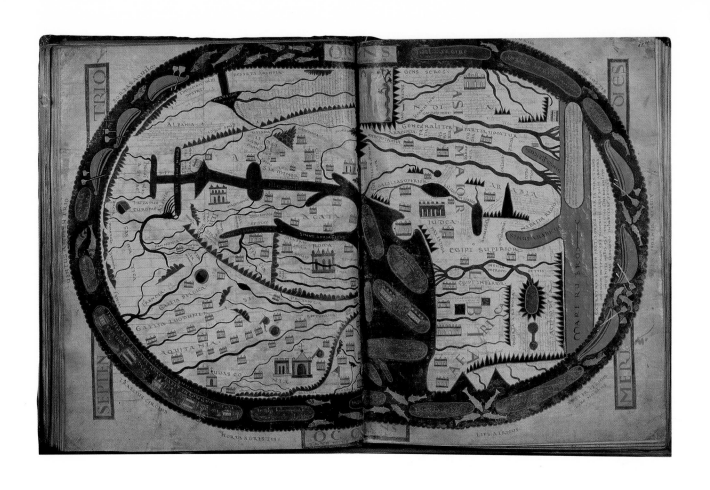

PLATE 9 World map in a manuscript of Beatus, tenth century. Courtesy of the Bibliothèque Nationale, Paris.

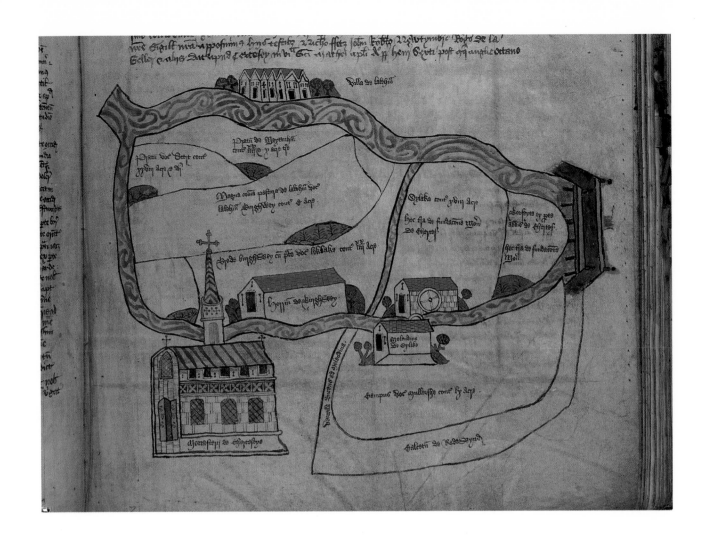

PLATE 10 Manuscript plan of Chertsey Abbey, 1432, from the Cartulary of
Chertsey Abbey. Courtesy of the Public Record Office, London.

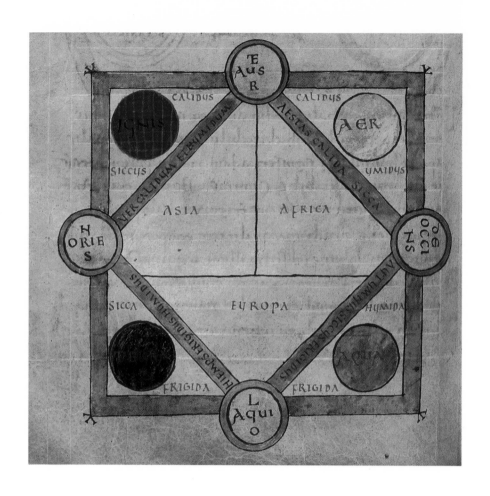

PLATE 11 Square T-O world map, ninth century. Courtesy of the Bavarian State Library, Munich.

BEATLIMITESINCBOARINONPOTERINTTUNCINEX
RECIONEMOUBIADSICNATURIERIMOUSDECIMANU
MAXIMUMETKARDINEMSICCONSTITUEMUS Sed
DECIMANIORDINATIONCORTUSEIOCCASUSTENE
ANTKARDINEMMERIDIANIETSEPTENTRIONIS

LIMITIBUSLATITUDINESSECUNDUMLECEMET
CONSUETUDINEMDIUIAUCUSTIDABIMUS

PLATE 12 Detail from the *Corpus Agrimensorum Romanorum*, codex *Arcerianus A*,
sixth century. Courtesy of the Herzog-August Bibliothek, Wolfenbüttel.

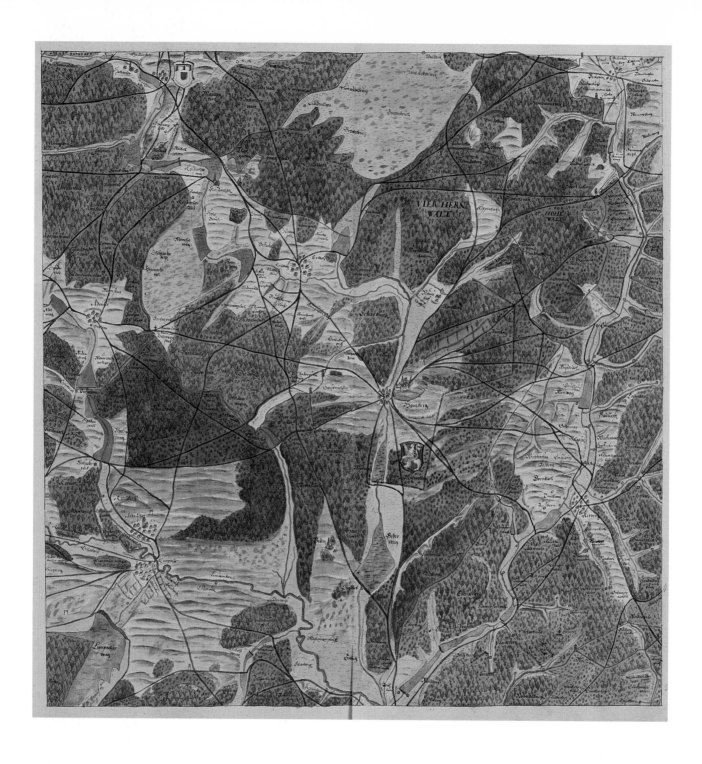

PLATE 13 Tilemann Stella, Manuscript atlas of the duchy of Zweibrücken, 1564.
Courtesy of the Royal Library, Stockholm.

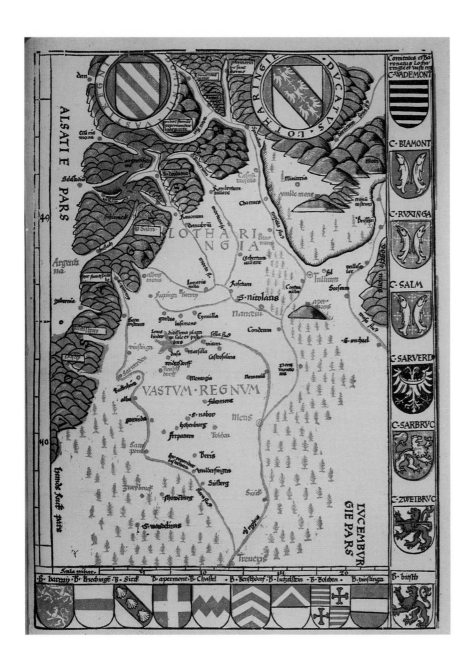

PLATE 14 Map of Lorraine from Ptolemy's *Geography* (Strasbourg, 1513). Courtesy of the Newberry Library, Chicago.

PLATE 15 Peter Weiner, map of Bavaria from the volume dedicated to Duke Albrecht, 1579. Courtesy of the Royal Library, Stockholm.

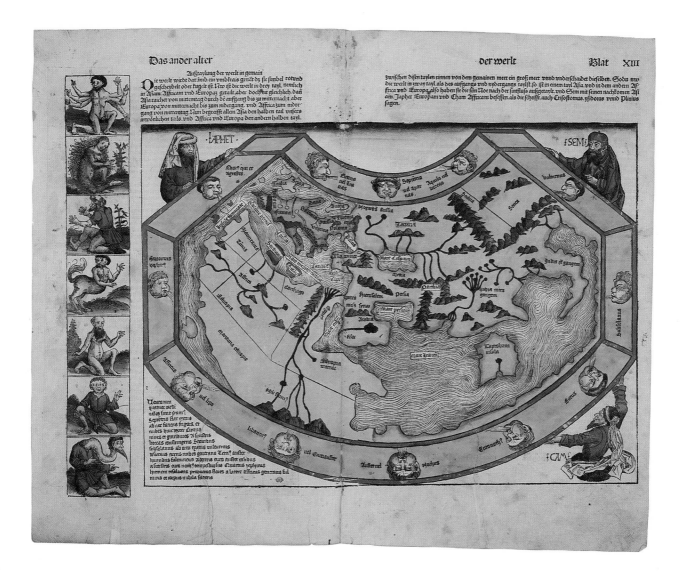

PLATE 17 Caspar Vopel, woodcut map of the Rhine, 1558. Courtesy of the Herzog–August Bibliothek, Wolfenbüttel.

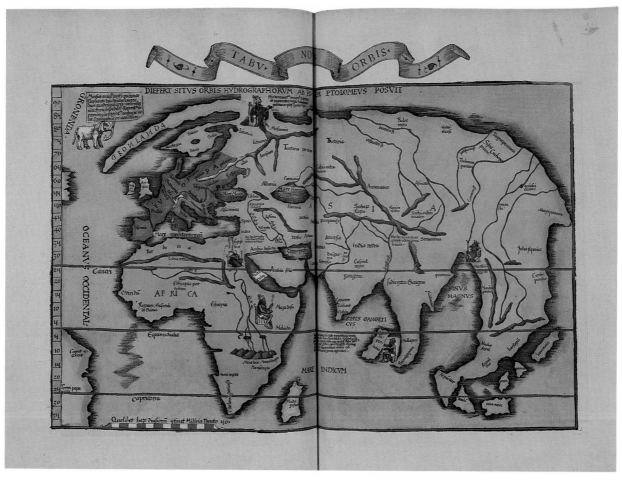

PLATE 18 Ptolemy, *Geography* (Pirckheimer edition, 1535). Courtesy of the Herzog–August Bibliothek, Wolfenbüttel.

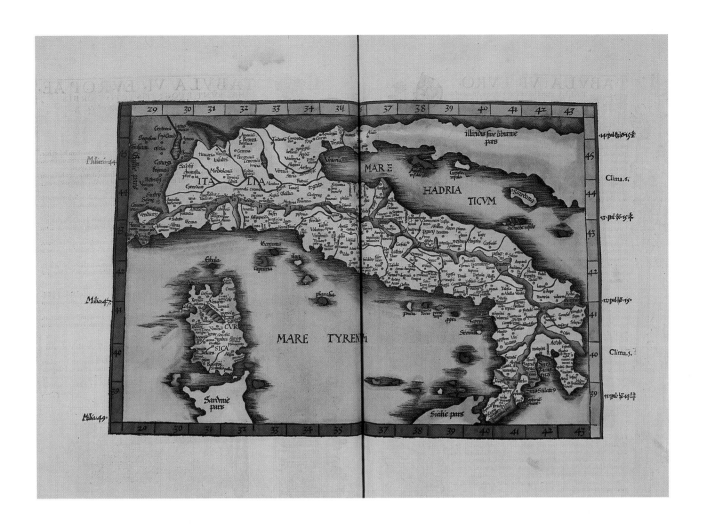

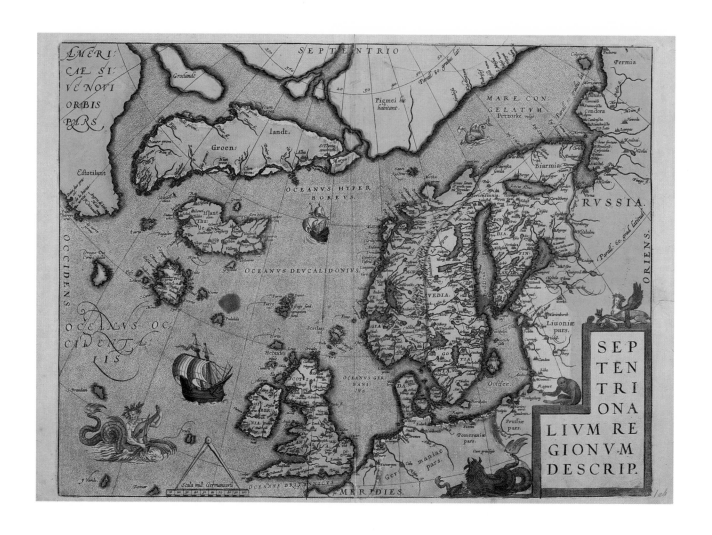

PLATE 20 Abraham Ortelius, map of Scandinavia, from *Theatrum orbis terrarum* (Antwerp, 1570). Courtesy of the Royal Library, Stockholm.

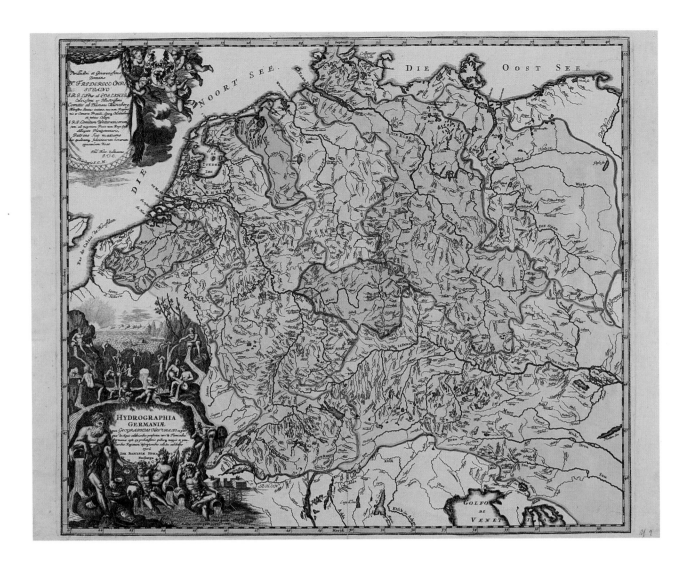

PLATE 21 Johann Baptista Homann, *Hydrographia Germaniae* (Nuremberg, 1710).
Courtesy of the Royal Library, Stockholm.

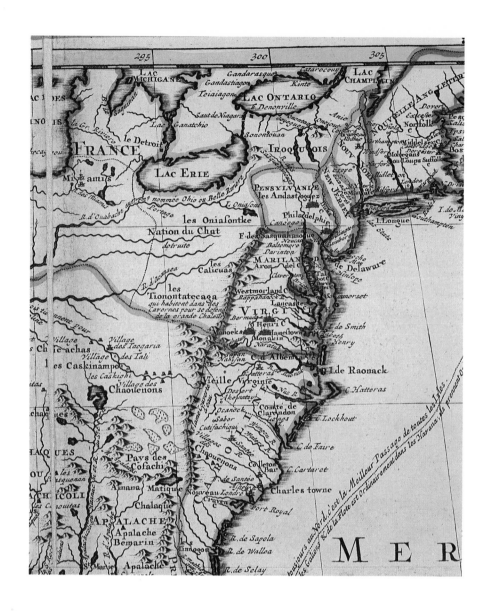

PLATE 22 Guillaume Delisle, detail from the *Carte du Mexique et de la Floride* (1722). Courtesy of the Newberry Library, Chicago.

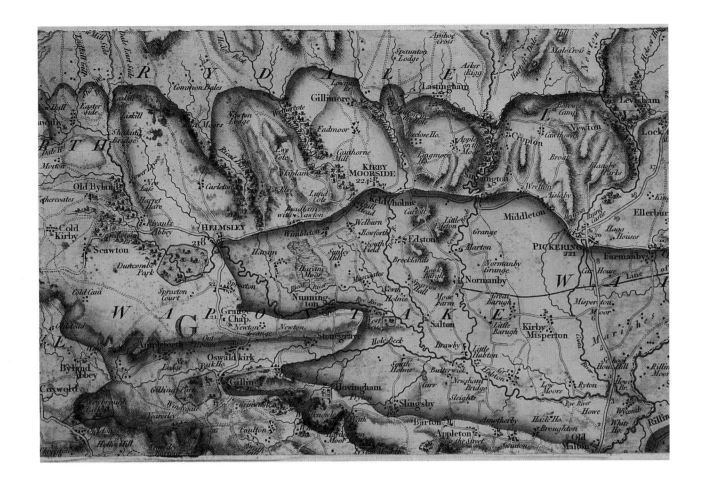

PLATE 23 William Smith, geologic map, 1815, detail. Courtesy of the Geology
Library, University of Illinois, Urbana-Champaign.

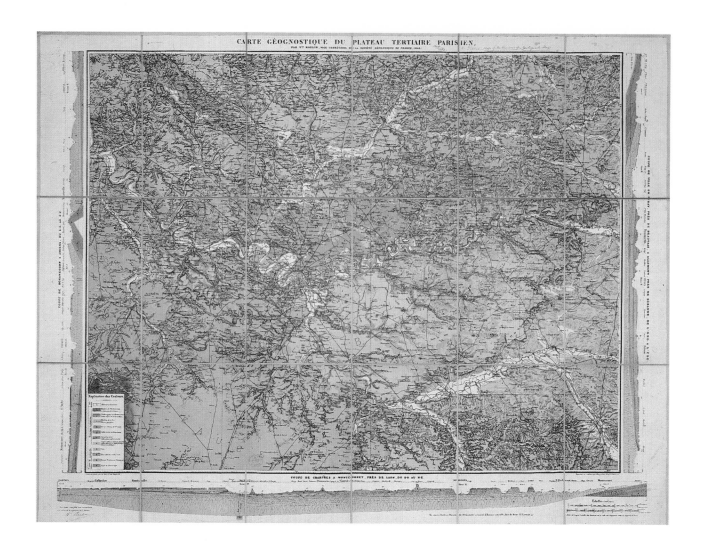

PLATE 24 Victor Raulin, geologic map of Paris, 1842. By permission of the British Library.

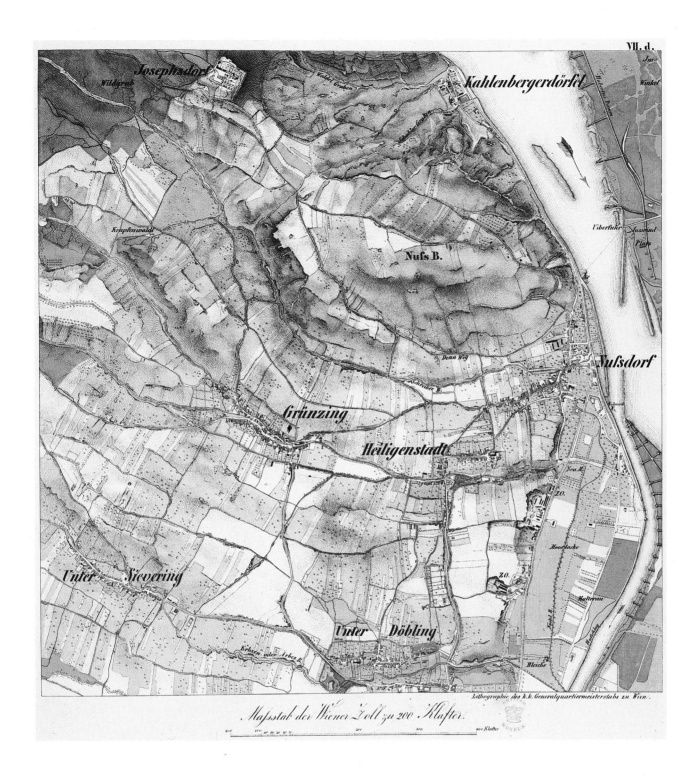

PLATE 25 *Umgebungen von Wien* (1830). By permission of the British Library.

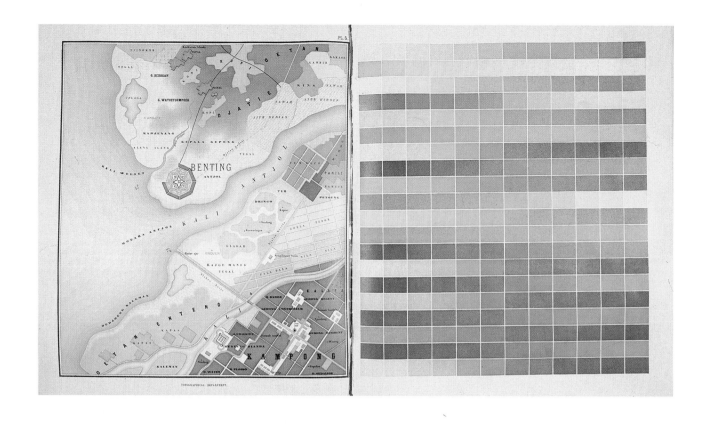

PLATE 26 Eckstein process of color printing, from Charles Eckstein, *New Method for Reproducing Maps and Drawings* (International Exhibition, Philadelphia, 1876).

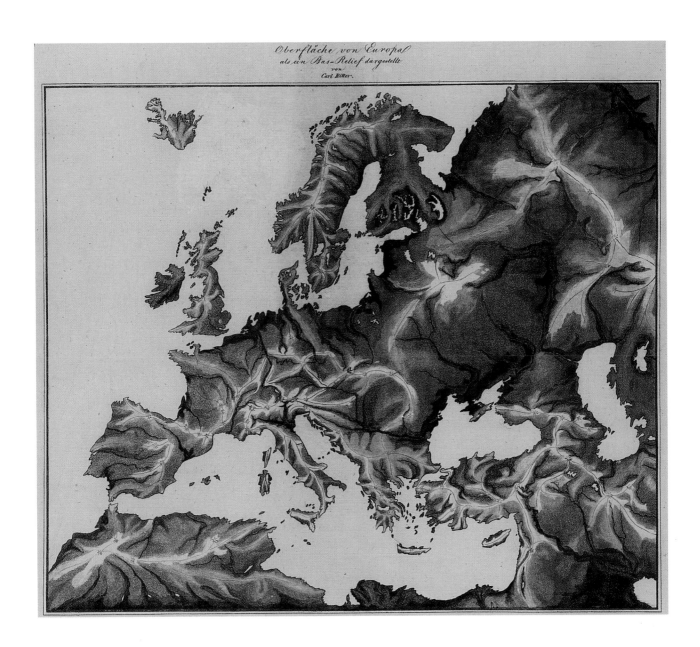

PLATE 27 Carl Ritter, "Oberfläche von Europa als ein Bas-Relief dargestellt," in *Sechs Karten von Europa* (1806). Courtesy of the Royal Library, Copenhagen.

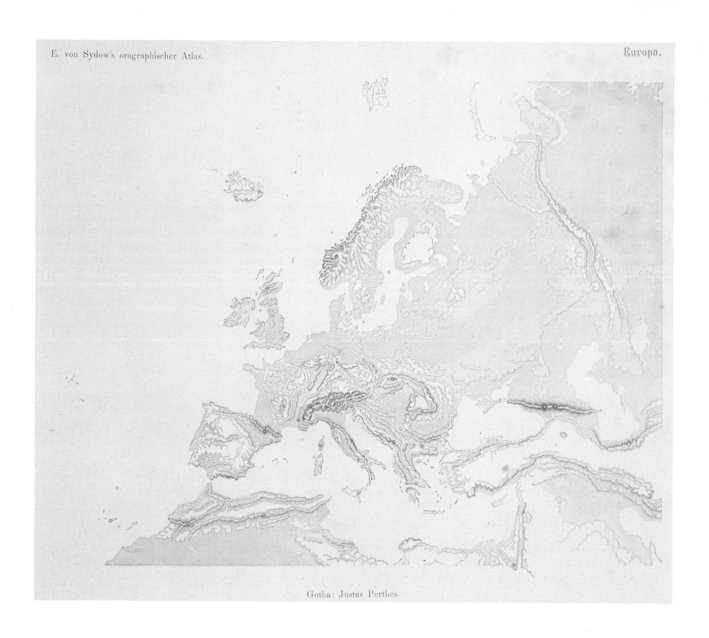

Gotha: Justus Perthes.

PLATE 28 Emil von Sydow, map of Europe in the *Schulatlas* (1847) and included in the *Orographischer Atlas* (1855). By permission of the British Library.

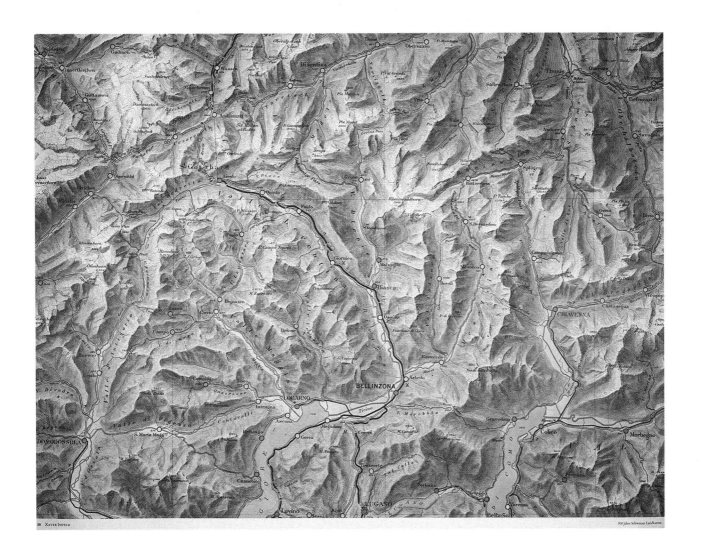

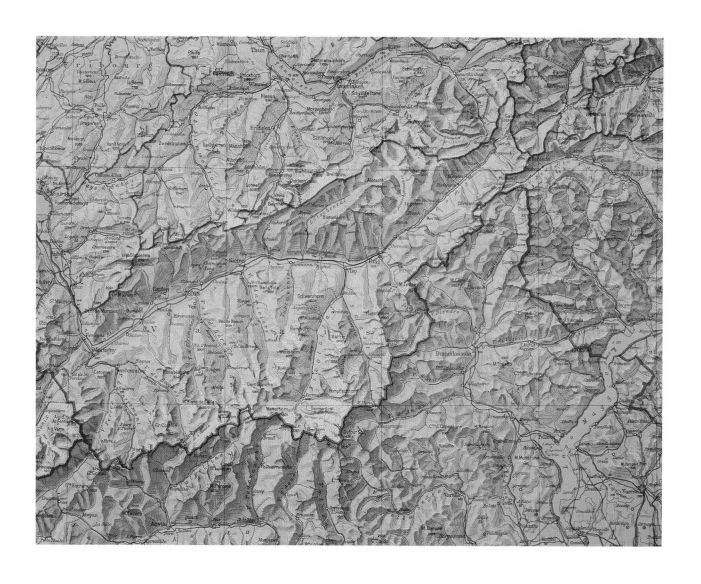

PLATE 30 Eduard Imhof, detail from Swiss topographical sheet. Courtesy of the Map Library, Regenstein Library, University of Chicago.

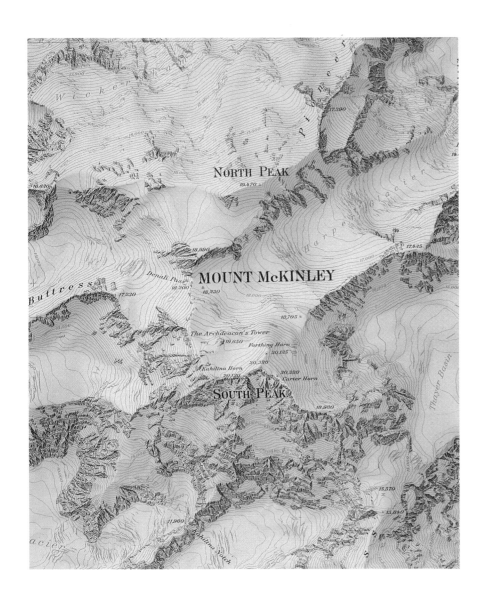

PLATE 31 Detail from the United States Geological Survey topographical map showing Mount McKinley, drawn by Swiss cartographers. Courtesy of the University of Illinois Library, Chicago campus.

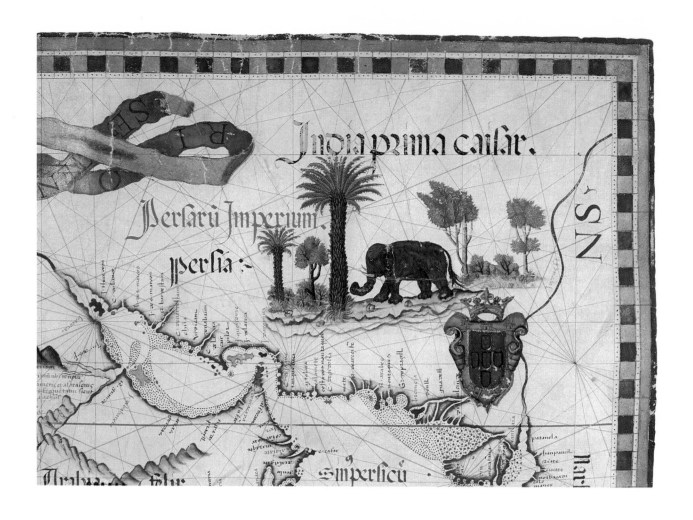

PLATE 32 Diego Homem, detail from a chart of the Indian Ocean, 1558. By permission of the British Library.

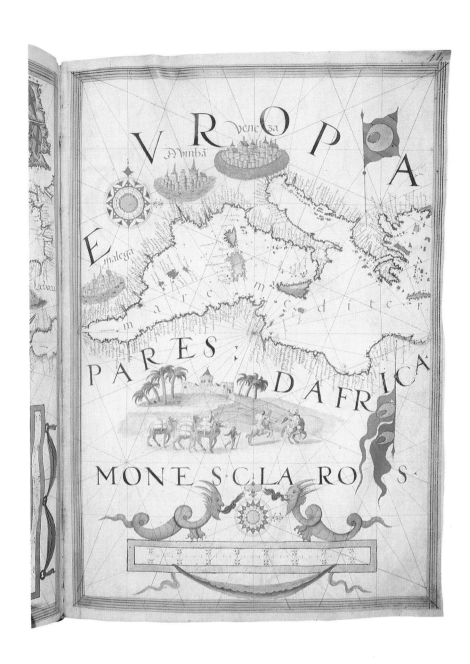

PLATE 33 Chart of the Mediterranean attributed to Sebastião Lopez, from a Portuguese manuscript atlas, ca. 1565. Courtesy of the Newberry Library, Chicago.

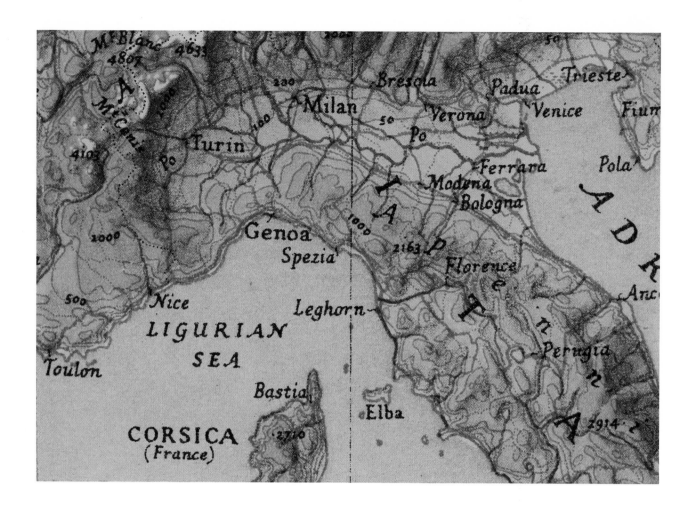

PLATE 34 Detail from "Europe and the Middle East," drawn for the British Council, 1944. Courtesy of the Royal Geographical Society, London.

Maps as Metaphors: Mural Map Cycles of the Italian Renaissance

<div style="text-align: right">THREE ᔣ</div>

JUERGEN SCHULZ

The heroic years of the Age of Exploration—the not quite two centuries that lie between the first Portuguese voyages along the west coast of Africa in the 1430s and the rounding of Cape Horn in 1616—witnessed the discovery of innumerable new lands and a quantum leap in the quality and quantity of map production. It is usual to connect the two developments, if not as cause and effect, certainly as parallel and mutually dependent phenomena. Mapmakers hastened to correct inherited cartographic images and to broadcast new discoveries in their publications, while patrons and explorers were spurred to finance and to undertake new voyages by the implicit contradictions and explicit voids they observed on maps. The output of printed maps leapt from a handful to hundreds per year, and by the end of the sixteenth century the interest in maps had spread to embrace a general public of educated men. For their instruction and diversion there began to be published albums of maps, atlases in the modern sense. In Italy, a leader in cartography as in so much else during the Renaissance, there were painted whole mural cycles of maps.

The best known of these mural cycles are those of the Palazzo Vecchio in Florence, the Vatican Palace at Rome (two cycles), and the Palazzo Farnese at Caprarola, all produced in the two decades between the mid-1560s and mid-1580s. These four by means exhaust the list of known map cycles of the period, but they are the most familiar and most extensively studied, and they are entirely representative of the genre.

Taken as a group, the maps of these mural cycles are quite as "modern" as the broadsheet and atlas maps of the time. They use contemporary projections, indicate scales and other technical cartographic

I am extremely grateful to the Institute for Advanced Study at Princeton, which, by granting me a visiting membership in 1972–73, enabled me to carry out the research reported here. I am also very much indebted to Loren Partridge of the University of California at Berkeley, who gave generously of his time and thought to read and criticize the paper in typescript.

Texts transcribed in the notes reproduce orthography and punctuation of the original document; expansions of abbreviations are printed in *italics*.

information, such as degrees or meridians and parallels, and try to reproduce the new discoveries as fully as possible. They are conventionally regarded, therefore, not as mere decorations, but also as reflections of the new interest in the physical world and the new learning, especially exploration and geography, much as are the contemporary printed maps. Yet in truth this is something of a presumption on our part. I am not aware that, despite all that has been written on these mural map cycles, anyone has ever seriously inquired into their purpose or meaning.

On the face of it, this may seem a superfluous question: a map is a map. But the modern historian of art, raised in the tradition of iconographic inquiry founded by Emile Mâle and Aby Warburg, has been taught to look for the complex of ideas that underlies a given representation. In mural decoration there is usually an organizing program that ties the constituent elements together; it would be odd if there were no such unifying idea in the case of these map cycles. Yet in their studies of them historians of art and cartography have inquired only who made them, when, on what cartographic basis, and as parts of what campaigns of building and decoration. The former have seen them as problems in connoisseurship and building history, the latter as instances of the growing geographical knowledge of the earth that characterized the Renaissance. No one has inquired what the patrons saw in them, and that is what I should like to ask.

THE MAJOR CYCLES The earliest cycle was the one executed for Duke Cosimo I of Florence by the cartographers Egnazio Danti and Stefano Buonsignori to decorate the new Guardaroba of the duke's residence, the Palazzo Vecchio.[1] The maps were begun in 1563 and not yet finished in 1586. We know the room's intended layout from Vasari, who attributes the program's invention to the duke. In his capacity as chief artistic adviser to the duke, however, Vasari no doubt had a large part in its design.[2] The room, which was to hold the duke's "most precious possessions," was to be furnished with cupboards having fifty-seven doors. Upon these doors were to be painted what Vasari calls "the plates of Ptolemy." He lists fourteen maps each for Europe, Asia, and America and eleven for Africa. The count differs from that of the Ptolemaic maps in either of the versions that have come down to us[3] and includes, besides, the New World. Thus the aim was not a reproduction of Ptolemy's plates, but rather a comprehensive representation of the earth in the manner of Ptolemy. In the middle of the room was to be displayed the fifteenth-century armillary sphere made by Lorenzo della Volpaia in the time of Lorenzo the Magnificent. In the twelve compartments of the ceiling were to be painted forty-eight constellations. The two central compartments were to be hinged, so that a terrestrial and a celestial globe could be housed behind them and made to descend at will. On the base, beneath the cupboards, were to be represented the plants and animals native to the countries mapped on the cupboard doors. Above the cupboards were to stand portrait busts of the rulers who had governed them. Also above,

presumably upon the strip of wall between the cupboards and the ceiling, were to hang portraits of three hundred famous men. The criterion for their selection is not explained; one would imagine that, as in the case of the flora, fauna, and rulers, they were to pertain to the various lands represented in the maps.

The purpose of the decoration, reports Vasari, was to assemble "all things relating to heaven and earth in one place, without error, so that one could see and measure them together and by themselves."

In the event, only fifty-three maps were executed (color plate 5). Thirty-two of them were designed by Danti, eighteen by Buonsignori, and the rest we cannot attribute with certainty.[4] Some 280 portraits were produced (chiefly by Cristofano Allori), copied from portraits in the collection of Paolo Giovio at Como.[5] One of the two globes, the terrestrial one, was made by Danti, but for exhibition upon the floor, not in the ceiling, of the room.[6] The armillary sphere of Lorenzo della Volpaia was only briefly exhibited there.[7] A new one, of a size matching Danti's globe, was made by Antonio Santucci delle Pomarance in 1588–93.[8] It was never placed in the Guardaroba, however, because by the time it was completed the then reigning duke, Ferdinando, had decided to transport the scientific exhibits of the Guardaroba to a new Camera delle Matematiche in the Uffizi. Indeed, by 1591 the globe and portraits had all been moved to the Uffizi.[9] Today the globe has been reinstalled in the Guardaroba, the armillary sphere is in the Museo di Storia della Scienza, and the busts and portraits are mostly in storage.

The room, in the form in which it has come down to us, looks like a collection of maps *tout simple*. It has been called the first atlas of modern times, inasmuch as its conception predates by at least seven years the publication of Ortelius's atlas.[10] But as originally designed the room was nothing like an atlas. Typologically, it was a *studiolo*, the Renaissance form of the *Kunst- und Wunderkammer* of the late Middle Ages, itself a descendant of high medieval relic collections.[11] Like the decorations found in many other Renaissance *studioli*, the decoration of the Guardaroba aspired to mirror the sum of wisdom attained by humankind, in the form of a complete representation of the physical cosmos and a selection of the men who had governed it or labored to understand it. The program is notable in one respect: the absence from it of an explicit reference to the organizing principle of God. Among the famous men were men of the church, but they appeared in their capacity as thinkers. God was not shown reigning over the represented cosmos. A theological order was simply implied by the rising tiers of plants, animals, lands, men, and constellations.

The map cycle of the Palazzo Farnese at Caprarola is part of a vast fresco decoration that covers all walls of the principal residential apartments of the building.[12] There are two apartments with an almost identical succession of rooms, leading in single file from a central state room, the Sala dei Fasti d'Ercole (fig. 3.1). On the north is the summer apartment, on the south the winter apartment. Each begins with a public reception room, then a private one, and continues with a bedroom,

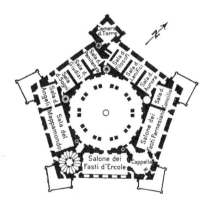

FIG. 3.1 Layout of main floor, Palazzo Farnese, Caprarola. Courtesy of the Istituto Centrale per il Catalogo e la Documentazione, Rome.

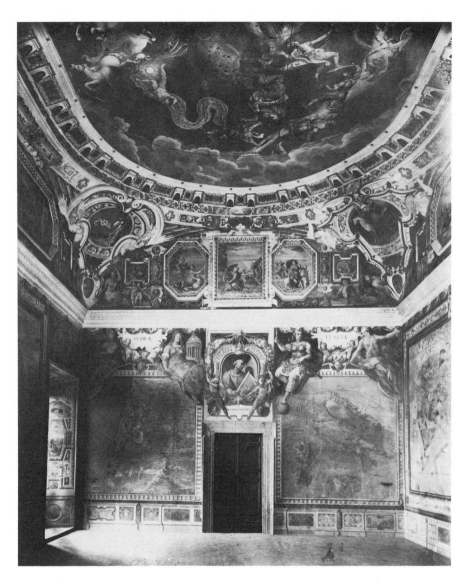

FIG. 3.2 Sala del Mappamondo (looking west), Palazzo Farnese, Caprarola. Courtesy of the Istituto Centrale per il Catalogo e la Documentazione, Rome.

dressing room, and study. The two apartments were frescoed in the 1560s, 1570s, and 1580s by a host of central Italian artists, following carefully framed programs that had been prepared by humanists in the circle of the patron, Cardinal Alessandro Farnese. The organizing theme in the summer apartment is the "vita activa," in the winter apartment, the "vita contemplativa." It is the latter, the "contemplative" apartment, that contains the maps. They decorate the walls of the first reception room, called the Sala del Mappamondo (fig. 3.2), and were executed in 1573–74 by a painter specialized in mural maps, Giovanni Antonio Vanosino of Varese, following a program, now lost, by Fulvio Orsini.

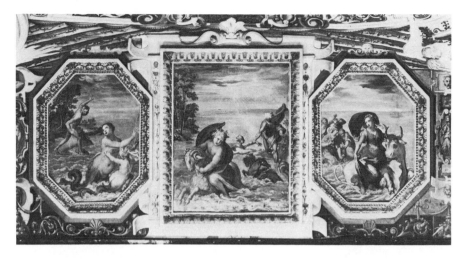

FIG. 3.3 Detail from figure 3.2 (west lunette): myths for Pisces (*Venus and Cupid Change into Fish*), Aries (*Phryxus and Helle Escape on a Ram*), and Taurus (*Rape of Europa*). Courtesy of the Istituto Centrale per il Catalogo e Documentazione, Rome.

In the vault we see the constellations of the zodiac. In the lunettes are mythological scenes in fictive stucco frames, illustrating the myths of the various zodiacal signs (Pisces, Aries, Taurus, etc.; fig. 3.3). Between the mythologies on the long walls, seated as if in the room itself, are prophets (fig. 3.4). On the walls are seven large maps representing the world as a whole, the four known continents, and Italy and Palestine. Flanking the maps are personifications of these lands and portraits of five explorers, from Marco Polo to Magellan (fig. 3.5).

Here again the maps are clearly only a part of a larger whole. The known world, as revealed by the curiosity of men, is governed by the stars that are, literally, superior to it. The whole is a cosmological scheme, not a mere atlas, as was recognized by Montaigne when he saw it in 1581.[13] A Christian element is present: the Holy Land and Italy, represented in separate maps, call to mind the early religious history of man and the paramount role of these two countries in establishing Christianity as a world religion. The prophets in the lunettes allude to the divine principle that rules all and will eventually triumph through Christ. Yet as at Florence, the theological order is not made explicit. In the absence of attributes, for instance, we cannot tell which prophets are represented and what particular form of the prophetic message they articulated. The underlying hierarchy is taken for granted, and the program writer's ingenuity has been applied to illustrating it with as impressive an amalgam as possible of learned references: classical, allegorical, biographical, and scientific.

By contrast, in the map cycles of the Vatican Palace the divine principle is clearly and explicitly exhibited. There are two cycles: one on the top floor of the loggias that form the palace's public facade, the other in a corridor flanking the Belvedere Courtyard.

In the first cycle the maps occupy the inside walls of what was originally a series of open galleries. The western arm of these galleries

FIG. 3.4 Sala del Mappamondo, Palazzo Farnese, Caprarola, detail from the north wall, unidentified *Prophet*. Courtesy of the Istituto Centrale per il Catalogo e Documentazione, Rome.

had been begun under Julius II (1503–13), to form a screen across the congeries of old buildings that composed the residential palace of the popes. Under Pius IV (1559–65) a new arm of the same design as the old one was added at the north end of the latter and at right angles to it. Under Sixtus V (1585–90) still a third arm was added, on the east end of the second and at right angles to it, creating the ∪-shaped court that is the Cortile di San Damaso, familiar today.[14] Here we are concerned with the first two sides or arms.

FERDINANDVS CORTESIVS

FIG. 3.5 Sala del Mappamondo, Palazzo Farnese, Caprarola, detail from the south wall, *Fernando Cortez*. Courtesy of the Istituto Centrale per il Catalogo e Documentazione, Rome.

In the early years of the century only the ground floor and first two upper floors of the original, west arm of the structure had been decorated. They contain the famous frescoes and stuccos by Raphael and his school and are hence called the Logge di Raffaello. When that tract was extended by Pius IV, the system of the Raphaelesque decorations was continued into the new wing. The top floor, however, had not been decorated in Raphael's time. Hence Pius, when he extended the structure, had an altogether new decoration designed to cover both the old and new arms of this third upper floor, or Terza Loggia, as it is now called (fig. 3.6).

Each bay of the vault bears the papal arms of its patron at the center, surrounded by four small fields, two of them historiated, another with inscriptions, and a fourth with, variously, stuccos or inscriptions (fig. 3.7). Along the inside wall, beneath the vaults, runs a frieze of frescoed landscapes and histories. Beneath the frieze, on the main face of the wall, were painted thirty-four maps, of which twenty-four survive. On the socle beneath the maps were painted landscapes, still lifes of fruits and flowers, and city views, of which nothing remains today.

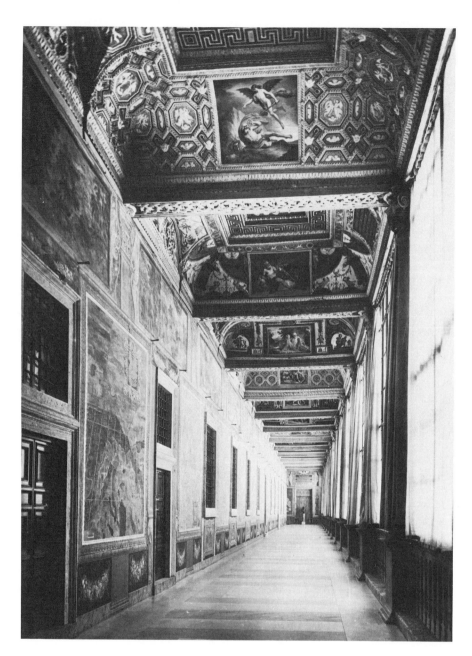

FIG. 3.6 West arm of the Terza Loggia, Palazzo Vaticano, Rome. Courtesy of the Vatican Museums.

The decoration was begun under Pius IV, in the early 1560s, and carried down the whole length of the old wing and into the first three bays of the vaulting of the new one. It followed a program of unknown authorship and was executed by a troop of minor artists of whom almost nothing is known. A certain "Stefano francese" furnished the designs for the maps, which were executed by several muralists working as mere copyists and paid by the day, among them Vanosino, the painter of the maps at Caprarola. After this there was a six-year hiatus, during the pontificate of the saintly Pius V, when no further work was done.

FIG. 3.7 North arm of the Terza Loggia, first vault, Palazzo Vaticano, Rome. Courtesy of the Vatican Museums.

Then, under Gregory XIII (1572–85), the decoration was completed and the portion done under Pius IV, which in the meantime had been damaged by a fire, was restored. The original program was continued with only slight alteration. We do not know who now provided the models for the maps; among the painters who executed them was again Vanosino.[15]

The frescoes were prey to the elements in the open loggia. A restoration was required as early as the pontificate of Urban VIII (1623–44). Nevertheless, by the early eighteenth century, when Agostino Taja composed his description of the Vatican Palace, some of the inscriptions and city views in the north arm of the loggia had become illegible. By the nineteenth century, when the Terza Loggia was finally glazed, all the frescoes in the vaults and on the walls had suffered losses. In the north arm, where the damage was worst, many maps had simply disappeared, while the rest were totally effaced in broad swaths across the middle. All images of which some trace remained were now restored; only those that had entirely disappeared were not renewed. For the partially effaced maps of the north arm this involved reconstructing their missing areas by copying early printed maps in Lafreri atlases. It is in this reduced and falsified state that the decoration survives today.[16]

The maps that form the principal part of the decoration are well known. They comprise the Eastern and Western hemispheres, repre-

sented entire in the two adjoining bays at the corner of the loggia, regional maps of Europe and the Near East in the west arm, and of Africa, Asia, and America in the north arm. By contrast, the other frescoes on the vaults, frieze, and socle, which were an integral part of the program, are generally disregarded. In the older, west arm of the loggia, painted under Pius IV, the vaults show the Trinity and a succession of personifications: Time, Sun, Moon, the Seasons, the Year, Life, Childhood, Youth, Maturity, Old Age (each of these ages shown under two aspects, good and corrupt), and Death. In the first three vaults of the new, north arm, still decorated under Pius IV, we see the end of time (represented by the destruction of a city), the raising and joining of the bones, their clothing in flesh, the resurrection of the dead, and the *Last Judgment* (the first vault in fig. 3.7). In the eight following vaults, painted under Gregory XIII, the cycle continues with representations of the heaven of the blessed: we see Virgins, Bishops, Patriarchs, Popes, Martyrs, Confessors, and other saints, Adam and Eve, Evangelists, Apostles, the nine celestial choirs of angels, the Virgin, and the Trinity, all on clouds. The Trinity appears twice in the entire cycle, at the very beginning and at the end. This is not an unthinking repetition; rather, God is shown under two of his aspects, once as the *primum mobile,* a governing force of the physical and moral universe, like the seasons, sun and moon, vice and virtue, and once again as the supreme judge and deity of the coming days of glory. The shift from a depiction of abstract entities to one of the last days of time occurs within that portion of the decoration executed under Pius IV and must therefore have been envisaged from the start. The vault frescoes executed under Gregory XIII simply continue the theme begun under Pius.

This is not the case in the frieze. Here there is a change directly attributable to Gregory's patronage. In the older, western tract of the loggia are represented land- and seascapes. Many are lost and the rest are damaged, but they were described in the eighteenth century by Taja, who also noticed that two of them bore still legible legends. One text, in the third bay, came from the Book of Psalms and read: "Thou has set a bound that they may not pass."[17] The other, in the fourth bay, came from Zechariah and read: "His dominion shall be from sea even to sea."[18] When we turn the corner into the northern tract, we find the subject of the frieze has changed to a representation of a procession in contemporary dress, passing through the streets and squares of sixteenth-century Rome. An inscription identifies it as the procession that accompanied the translation in 1580 of the relics of Saint Gregory of Nazianzus from the church of Santa Maria in Campo Marzio to Saint Peter's.[19] The body of the saint was moved to the magnificent chapel built in Saint Peter's (in 1572–79) at Gregory XIII's behest and named after him the Capella Gregoriana. Gregory showed a special veneration for this saint, who was not only his namesake, but also one of the Greek fathers of the church and a champion of the doctrine of the Trinity.

There are numerous inscriptions throughout the loggia.[20] Those on the walls name the popes who undertook these works. Those on the

vaults list the various achievements of Pius IV and Gregory XIII. The legends give no hint as to the program of the decoration as a whole, but an enumeration of its various parts makes clear enough that there was a syncretistic concept at the back of it. In the vaults we see the life forces that govern the globe, and the heavenly glory of which creation is only a weak reflection and for which it is a preparation. In the frieze we see, first, an endless prospect of lands and seas, presented as a reflection of an immanent and omnipotent God, then an exaltation of Saint Gregory of Nazianzus, defender of the Trinity, which rules in heaven and on earth. On the walls we see the geography of the earth. Clearly, within this context, the geographical maps are meant to show the vastness and universality of God's creation, as do the frieze landscapes, only they show it under its physical rather than its spiritual aspect.

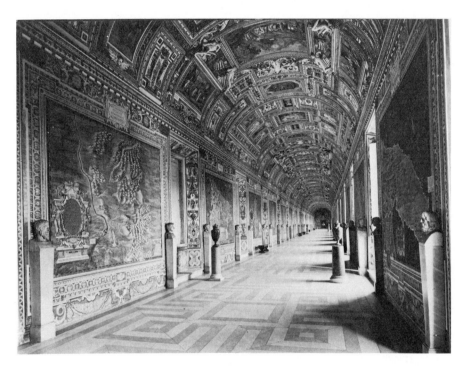

FIG. 3.8 Galleria delle Carte Geografiche, Palazzo Vaticano, Rome. Courtesy of the Vatican Museums.

The other cycle in the Vatican, the Galleria delle Carte Geografiche, painted in 1580–81, is a creation of the same pope who saw to the completion of the Terza Loggia, Gregory XIII.[21] It contains, on the walls, maps of the provinces and major cities of Italy, plus one of the papal domain in France, the county of Avignon (fig. 3.8). The maps are arranged topographically: western provinces on the west wall, eastern provinces on the east, unfolding from the top of the peninsula and continuing down to its tip when the gallery is entered from the papal apartment. They were designed by Egnazio Danti, the same cartographer who began the maps of the Guardaroba in the Palazzo Vecchio, and executed by a company of minor artists. Several restorations are recorded,

of which the most far-reaching was that of Lukas Holstein in the 1630s, when many of the maps were brought up to date.[22] But no parts of the series have been lost outright, as in the Terza Loggia. The vault, also a collaborative work of a troop of undistinguished painters, is covered by a dense network of historiated scenes in stucco frames and fields of painted ornament. The histories, seventy-two in all, show episodes from the Old and New Testaments, church history, and the lives of various saints. We do not need to speculate on the relationship of vault and walls. An inscription over the north portal of the gallery, facing the entering observer, announces the organizing principle:

> Italy, the most noble region of the entire globe, is divided into two parts by this gallery, just as by nature it is cut by the Apennines. . . . The vault shows pious deeds of holy men, the maps exhibit the places where they were done. Lest from pleasure be absent the utility of knowledge of things and places, Gregory XIII wished this to be finished with art and magnificence. . . .[23]

Italy is exhibited to our eyes, in other words, not as a geographical curiosity, but as a theater of pious deeds. Indeed, the vault scenes are broader in scope than the inscription suggests. They encompass the whole religious history of the world, beginning with Adam and Eve and Cain and Abel (fig. 3.9), continuing through Noah, Abraham, and Jacob to Moses. There follow scenes of Jewish sacrifices and rites, showing God's workings through his First Covenant with mankind. In the exact center of the long vault we see the scene of Christ instructing the apostles to feed his sheep (fig. 3.10), that is, speaking those words on which the Catholic church rested its claim to be the Lord's keeper of the New Covenant between man and God. Interspersed among these scenes are representations of early church history (the deeds of Constantine, the donation of Countess Matilda), and of miracles of later saints, the instruments of God under the New Covenant. The latter are arranged so as to fall always above the maps that represent the lands where these saints worked: scenes of Saint Paul are above Malta, Ambrose above the territory of Milan, Francis above the territory of Umbria (fig. 3.11), the donation of Countess Matilda above the States of the Church, and so forth. The thought is clear. Italy, the country represented in the maps, is the new Holy Land, the land of the church, which, by the decree of Christ, became heir to the Synagogue as mediator between man and God and brought the peninsula to blossom into a land of pious men and deeds. The maps supply still one other kind of information for our edification: they contain vignettes, always at the appropriate geographical site, of famous battles of antiquity (fig. 3.12), the Middle Ages, and modern times. Between the narrative scenes on the vault and the military exploits on the maps, the gallery presents us with a digest of world history, *ante legem, sub lege,* and *sub gratia,* the last chapter of which, so we are given to believe, is being played out in Italy under the Holy Roman Catholic church.

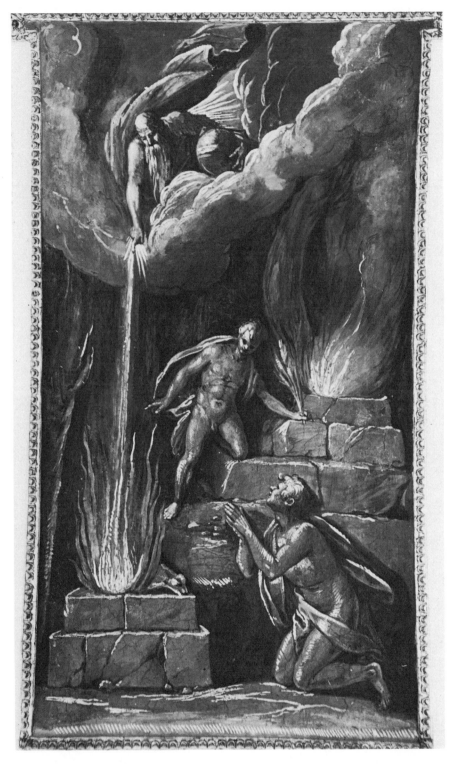

FIG. 3.9 Vault scene showing *Cain and Abel*, Galleria delle Carte Geografiche (see fig. 3.8).

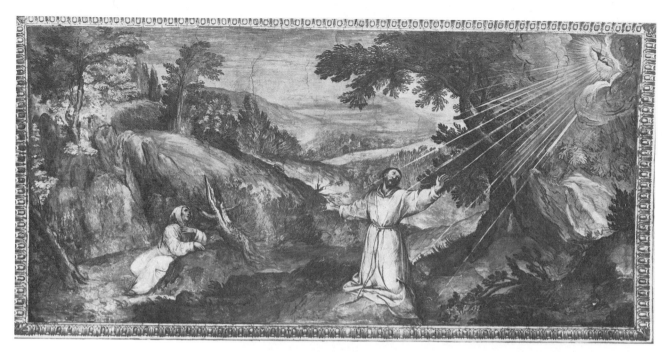

FIG. 3.10 *Pasce Ove Meas*,Galleria delle Carte Geografiche(see fig. 3.8).

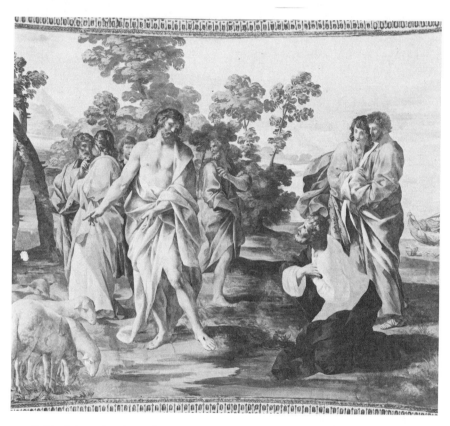

FIG. 3.11 *Stigmatization of Saint Francis*, Galleria delle Carte Geografiche (see fig. 3.8).

110 JUERGEN SCHULZ

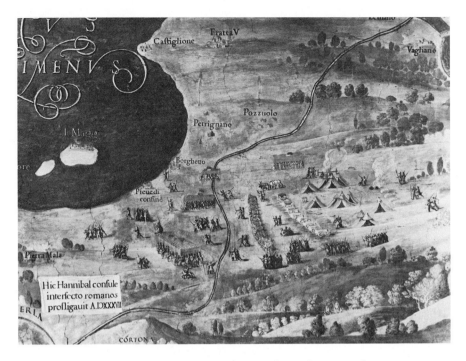

FIG. 3.12 *Hannibal's Victory at Lake Trasimeno*, from the map of *Perusinus ac Tifernas*, Galleria delle Carte Geografiche (see fig. 3.8).

In all four cycles, to the extent the maps have not been disfigured by restoration, we can recognize that they were drawn as accurately as Renaissance cartographic practice permitted. Yet setting the maps of each cycle in the context of the decoration as a whole shows that, accurate though they are, they address broad philosophical ideas rather than mere geographical curiosity. How are we to understand such a use of cartography, in an age supposedly characterized by the pursuit of value-free geographical truths?

All four cycles recall the kind of moralized geography that was practiced during the Middle Ages. Then, in the millennium between the triumph of Christianity and the beginning of the Italian Renaissance, maps as often as not had served a didactic rather than a reporting function. Alongside the value-free maps drawn by medieval surveyors, architects, and illustrators of factual texts—maps that we may call technical maps to distinguish them from the others—there had been produced, chiefly by artists, a mass of ideal maps, maps that were not an end in themselves but vehicles for higher ideas. They illustrate religious verities, moral and political conceits, and other matters; in them the map is the medium, not the message.[24]

Some ideal maps illustrate the reach of a supposed temporal or religious power. For instance, an unknown eleventh-century writer composed a description of the Latin emperor's vestments, in which the imperial sash is described as embroidered at both ends with a planisphere that shows the three continents and is encircled by the motto, "The Round Orb's Reins Are Held by Rome, Head of the World."[25]

Some illustrate vanity, like a recently excavated twelfth-century floor mosaic in Turin's cathedral which shows a planisphere with the wheel of fortune at its center, characterizing the earth as a place of vain pursuits.[26] By far the greatest number of medieval ideal maps, however, are philosophical rather than allegorical in meaning. This is the content of innumerable *mappaemundi,* world maps large and small, meant to illustrate the unity and diversity of creation, not the exact shapes of, and relationships between, ground features. They show, in greater or lesser detail depending on the availability of space, the continents, seas, and rivers of the *oikoumene,* the flora, fauna, and human races of its different regions, the events of biblical and ancient history that took place in them, the missionary travels and martyrdoms of saints, and still more. The purpose was to exhibit in one synoptic image the firmly rooted and universally held idea that the events, features, and phenomena of the created world are infinitely many and yet all one, for they are all emanations of one divine principle, links in one great chain of being.

Occasionally a *mappamundi* was used to signify other ideas as well. The large thirteenth-century world map in Hereford cathedral in England, for instance, shows the *Last Judgment* above the map proper, together with inscriptions announcing the Day of Judgment and imploring mercy.[27] Around the planisphere itself are inscribed the letters M-O-R-S, characterizing the earth as the realm of death. The map expresses the transitoriness of earthly existence and thereby reinforces our understanding of the finality and universality of the Last Judgment.

The now destroyed world map of the monastery of Ebstorf in Lower Saxony, also of the thirteenth century, showed joined to the planisphere the head of Christ at the top, his hands at the sides, and his feet below.[28] Early Christian and medieval texts yield an explanation of this strange image. Bishop Eucherius of Lyons and, following him, Hugh of Saint Victor and Honorius of Autun tell us that the head of God signifies his divine essence whence creation sprang; his hands signify his divine power by which creation is ruled; his feet signify his incarnation in the flesh by which he joined the life of men. His body, finally, signifies the created world itself. The Ebstorf map, in short, was a picture of God!

Both the Hereford and the Ebstorf maps also describe the location of all the features conventionally identified in *mappaemundi:* lands and seas, men and monsters, beasts and plants, saints and heroes. The metaphorical use of world maps to express religious ideas did not exclude the conventional syncretistic content, for the two were not contradictory.

We may take the all-pervasive use during the Middle Ages of cartographic images to express metaphysical and other ideas as a manifestation of the profound idealism of the period. Physical essences were conceived as the reflections of ideas, of ideal essences that represented a truer and more important order of existence than the real objects of this world. Now in the nineteenth-century view of the Italian Renaissance, as formulated by Michelet, and especially Burckhardt and Dilthey, the fundamental contribution of the new age was held to have been the re-

placement of such idealism by a new realism.[29] Led by the example of the ancients, Italian artists and thinkers began to turn from the metaphysical to the physical world, developed a new confidence in their own rational faculties, and pursued with an increasing lack of constraint the unprejudiced observation of themselves and their environment. In Burckhardt's famous formula, the Italian Renaissance rediscovered the individual and nature. This view colored our understanding of the Italian Renaissance down to the Second World War. Modern Renaissance studies were dominated by it, as a model to follow or to rebel against. In the history of art and ideas, it was the rebels who were ascendant during the 1930s and 1940s. They emphasized the continuity between Renaissance and Middle Ages; some even called into doubt the very existence of the Renaissance as a distinct new epoch in Western culture. Eventually, some thirty years ago, a compromise was reached. Historians agreed that in fifteenth-century Italy there was a birth of new, rational ideas and methods and of individualistic modes and codes of behavior, but that there also survived a wealth of deeply ingrained metaphysical convictions and aspirations which took many centuries more to lose their hold on men. Current studies are concerned to illustrate both continuity and change; we now see the Renaissance as an age of conflict rather than rebirth.

The debate left the appreciation of maps relatively untouched. Studying maps, we are still likely to conceive of the Renaissance as an age that moved quite simply from darkness to light, Scholastic compilation to rational inquiry, credulity to skepticism, and so forth. And yet common sense suggests that cartography could not have been immune from the uncertainties that everywhere attended the advance of understanding. One need only look closely at a fifteenth-century *mappamundi,* one that has usually been taken as a manifestation of the new skepticism, to see that it was not so. I am thinking of Fra Mauro's famous planisphere of 1459–60 in the Biblioteca Marciana at Venice (fig. 3.13).[30]

Fra Mauro's map does depend in large degree on ancient learning (namely Ptolemy's *Geography*) and on unprejudiced observation (namely travel reports from actual voyagers and portolan charts, a product of practical navigation during the late Middle Ages). It maps the shorelines of the Mediterranean and Black seas and the Atlantic coast of southern Europe and northern Africa with considerable accuracy and even shows a rather good understanding of Southeast Asia. In its annotations the author criticizes again and again the traditions handed down by old authorities. Even Ptolemy is declared to have been fallible. An inscription just above the wind rose at the bottom of the map declares that fuller knowledge has been gained with the passage of time than was available to Ptolemy, and that the writer, Fra Mauro, therefore has sought to verify the Greek's assertions by the testimony of eyewitnesses.[31] The principle is carried out throughout the map. Old beliefs are questioned in many places. Below Africa, for instance, Fra Mauro wrote that though some authorities deny the continent is completely encircled by water, Portuguese explorers have demonstrated that it is so;

thus, unless one wishes to contradict witnesses who have seen things with their own eyes, one cannot always believe or follow what is written.[32] A thoroughly modern skepticism and reliance on one's own reason speak from such lines.

At the same time the map is filled with fictions. There in the Indian Ocean lie the fabled islands of Nebila and Mangla, whose existence was vouchsafed by numerous authors but never observed, the one inhabited only by men, the other only by women, who meet to have commerce with one another three months of every year.[33] Some of the annotations are equally revealing. They not only describe geographical matters, like the natural wealth, fauna, and native races of different regions, sources of rivers, and travel routes of merchants, but also rehearse the histories of nations, cities and toponyms; the deeds of Alexander, Roman heroes, and Tamerlane; and events in religious history associated with particular places. Even when a tradition is reported together with a critical gloss, there remains a residual credulity. The giants Gog and Magog, for instance, are explained as a probable corruption of the names of local tribes (Huns and Mongols), rather than as monsters that will out at the coming of the Antichrist.[34] Nevertheless Fra Mauro does not desist from locating them in the Asian heartland. Other traditions no sounder than that of Gog and Magog are repeated without glosses: cannibals in Mauritania; ants larger than dogs in India; the phoenix in Arabia; a valley of jewels guarded by spirits and monsters in mid-Asia; the Old Man of the Mountain in Persia; and many more.[35] Again we can look to an inscription for an explanation of this seemingly paradoxical credulity. In a *cartellino* beside the Iberian Peninsula Fra Mauro wrote:

> If someone considers incredible the unheard-of things I have set down here, let him do homage to the secrets of nature rather than consult his intellect. For nature conceives of innumerable things, of which those known to us are fewer than those not known . . . , and this is so because nature exceeds the understanding, and those who have not grasped this cannot admit unusual things . . . ; thus, let those who wish to understand first believe, so that they may understand.[36]

The thought expresses an important aspect of the age-old idea of the great chain of being, namely, the notion that nothing the divine mind can conceive does not exist. There is no vacant step in the endless scale of things, and God's omnipotence exceeds our petty human understanding.[37]

Thus, taken as a whole, Fra Mauro's map is not a document of a new, value-free cartography but a visual summa as of old: an encyclopedia of knowledge geographical, natural, historical, religious, and philosophical. It exhibits, albeit in a more carefully considered fashion than earlier world maps, the abounding richness and varied history of creation, and at the same time the unity of that creation.

Fra Mauro's map was no exception in its conservatism. Other surviving *mappaemundi* of the fifteenth century show a similar mixture

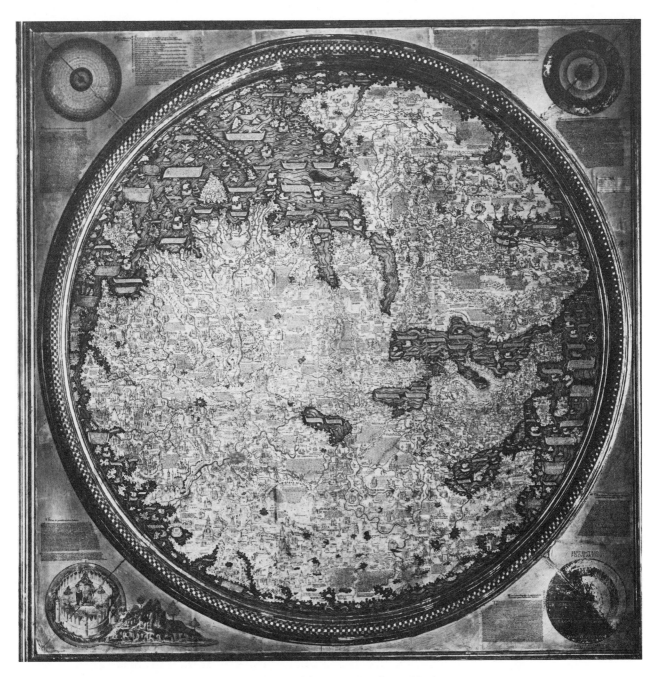

FIG. 3.13 *Mappamundi* of Fra Mauro, 1459–60, Biblioteca Marciana, Venice.
Courtesy of Alinari/Art Resource, Inc.

of fact and fiction that can be explained only if we consider their aim to
have been a synoptic representation of creation.[38] *Mappaemundi* con-
tinued to be exhibited in churches and residences, as they had been
throughout the Middle Ages. About 1443 a world map was made for
the ducal apartment in the doge's palace at Venice.[39] In 1463 Pope Pius II
sent one to the cathedral of his native town, Pienza, which he was then
rebuilding into a full-fledged city with all the appurtenances of a princely

seat.[40] Another was painted between 1464 and 1469 for the main reception room of Pope Paul II's city palace at Rome, Palazzo Venezia.[41] All of these maps are lost, but their purpose in these sites cannot have been geographical reportage; it must have been, instead, the exhibition in a traditional, diagrammatic form of the created world within which, and under the rule of whose creator, these various princes governed.

Likewise, the use of maps as vehicles for political and moral ideas rather than metaphysical ones continued in the early Renaissance. The *mappamundi* of the doge's palace was actually one of two maps in the same room; the other represented Italy. The fact is that now, in the early Renaissance, we begin to encounter the use of maps in cycles of mural decoration. Three fifteenth-century cycles are known to me, and each of them expresses some idea or conceit that is nongeographical.

The first is the just mentioned pair of maps in the doge's palace, a *mappamundi* and a map of Italy.[42] Both were made about 1443 by Antonio Leonardi, destroyed in a fire forty years later, made anew by Leonardi, and destroyed again in a fire of 1574. They hung in the anteroom of the doge's audience chamber, where envoys and other callers waited to be received by the doge. They could not serve any informational purpose there: in this room no councils of policy took place. Here waiting visitors and their escorts prepared to meet the most serene prince of the most enduring and prosperous state of the peninsula. The maps can only have served to impress upon them the extent of the state's dominion and the wholeness of the cosmos of which this state was a seemingly immutable part.

The other two cycles represented cities rather than regions, in bird's-eye view rather than orthogonal projection, but by the categories of the Renaissance such representations were considered maps. In the Villa Belvedere of Pope Innocent VIII at the Vatican, there was frescoed in the mid-1480s a series of views of capitals of Italian states.[43] The frescoes were ruined when the room was rebuilt in the eighteenth century as a sculpture gallery, but we can reconstruct the cycle. The thought behind it seems to have been to exhibit by their natural aspect the six Italian states that supported the expansive policies of the pope.

The final example is found in the private villa of Francesco II Gonzaga, marquis of Mantua, at the town of Gonzaga, where there were frescoed in the mid-1490s city views representing in strict alternation four each of the chief European harbor and inland cities.[44] These frescoes were totally destroyed, but we can see that in their schematic way they projected an orderliness of political geography that was ideal, not real. They also flattered the marquis. The chief reason these states of land and sea were fitting company for the lord of Mantua was that Mantua shared the nature of both—maritime and terrestrial. Lying in the middle of the fertile Lombard plain, on an island in a vast lake that connected with all the region's waterways, Mantua was superior to one and all.

We can infer the continuing appreciation of maps as instruments of nongeographical edification from yet another source. The treatise on

the cardinalate by Paolo Cortesi, published in 1510, includes an entire chapter on the kind of residence appropriate to the cardinal's office and the sort of decorations it should contain.[45] In the reception room of the cardinal's summer apartment, Cortesi prescribes representation of what he calls "learned" matter. He instances paintings of engineering works, such as the irrigation system his family had built on their estate near San Gimignano and—more to the point for our inquiry—geographical subjects. He writes:

> nor is there less of learned enjoyment in a picture representing the world, or a depiction of its regions, now known through the audacious circumnavigation of moderns, like that lately done for King Manuel of Portugal in the exploration of India. And the same holds true for paintings exhibiting the remarkable nature of diverse creatures, in which the diligence of observation is the more praiseworthy the less familiar are the species portrayed. And in this kind of depiction of curiosities and truths is found that which sharpens the intellect and stocks the mind with learning.[46]

The passage recalls Fra Mauro's justification for the inclusion in his *mappamundi* of what he called "unheard-of things." Whereas Fra Mauro wrote in the familiar terms of conventional piety and used colloquial Venetian as his language, Cortesi expresses himself in the ingeniously obscure vocabulary and artful syntax of a humanist bent on writing for the learned. These differences notwithstanding, the basic idea stated by each man is similar: contemplation of nature's vastness and diversity improves the mind. However, Cortesi makes no allusion to the ineffable creative power that lies behind the world's diversity as did Fra Mauro. His conception of the edifying character of geography reformulates in secular terms what Christian pietism expressed religiously. We have not left the realm of spiritualized geography; we have only substituted one spirit for another.

There is no doubt that geographical curiosity spread more and more widely with the beginning of the sixteenth century, nurturing a publishing industry for printed maps that catered to this taste. But the taste was slow to avow itself frankly. At the beginning of the century the inscriptions found on printed maps still make reference to contemporary events or abstract ideas, as if maps must be justified as the illustrations of topical subjects or ideal concepts. Only with the 1540s was this need to attribute a "higher" function to maps overcome. Broadsheet maps were now published frankly for their intrinsic interest as maps; amateurs began to form collections of maps; and publishers began to issue ready-made collections—atlases. However, these were all maps meant for private consumption, to be enjoyed alone in the seclusion of one's study or in the company of a few like-minded spirits.[47]

In the realm of publicly exhibited maps, the feeling endured that a higher idea should be expressed. We find, for instance, that during

MORALIZED GEOGRAPHY IN
THE LATER RENAISSANCE

1535–44 another cycle of maps was painted for the doge's palace at Venice, this one by Domenico Zorzi of Modon.[48] It consisted of maps of the Holy Land and Greece and was exhibited in the private chapel of the Senate. These were the lands where the principal events of the New Testament had taken place, which gave them religious meaning. Previously, in 1531, Zorzi had made a *mappamundi* for the Sala del Collegio, the meeting chamber of the collective executive body of the republic, the Signoria. At the small scale required to represent the world as a whole, the map could not have had any informational value for the Signoria's deliberations; rather, it must have been meant to exhibit to the members and their attendant noblemen the divine order of which Venice was but a small part, which the Signoria would do well to bear in mind in transacting the business of the state.

The nearest we come to plain reportage in Italian mural maps of the Renaissance is in still another cycle formerly at Venice. This was a pair of mural maps made in 1549–53 by Giacomo Gastaldi for the audience chamber of the doge.[49] One showed Africa with the Mediterranean Sea and the opposite coasts of America, that is, Brazil and the West Indies. The other showed Asia with the opposite part of the New World, that is, North America. Gastaldi's contracts make it clear that both maps were to show all the new discoveries known at the time.[50] Thus one motive in their making indubitably was curiosity. But the acts also show that the emphasis was to be placed on the discoveries of Venetians: Marco Polo, Giovanni Caboto, Alvise da Mosto, and others. On the one hand we may look on the cycle as a display of the actual world, as sixteenth-century men had discovered it to be. But on the other hand the maps had a political significance as well, for they were a glorification of Venice, whose sons had been leaders in the Age of Exploration.

In the third quarter of the century, at the more conservative, even orthodox courts of Duke Cosimo I and Cardinal Alessandro Farnese, we find the taste for ordered, cosmological schemes as strongly entrenched as ever. The duke's Guardaroba and the cardinal's winter reception room are not value-free displays of geographical curiosities but programmatic exhibitions of all that is. Only, they do not spell out the place of God and revealed religion in the hierarchy. Like Cortesi's prescription for decoration of a cardinal's palace, they are secularized versions of the medieval chain of being.

By comparison with them, the religious programs of the cycles in the Vatican seem a throwback to the more explicit formulations of medieval images. In this they reflect the evolution of Italian, even European, culture in the later sixteenth century. The reaction to the increasing secularism of the Renaissance, as we well know, took the form of a religious revival: the Protestant revolt in the North, the Catholic reform in the South. In Italy a growing religiosity is discernible as a weak and diffuse phenomenon in the 1530s, gains force in the 1540s, 1550s, and 1560s—the decades of the Council of Trent—and reaches maturity in the Counter-Reformation that begins with the last quarter of the century. All aspects of life and culture were affected, especially the arts.[51]

Choice of subject matter, conception of decorative programs, even the manner of narrating or presenting a given subject were all newly purified, returned to an expressly religious, doctrinally orthodox, functionally instructive mode. It is as a manifestation of this reviving, more explicit religiosity that we must understand the map cycles of the Vatican.

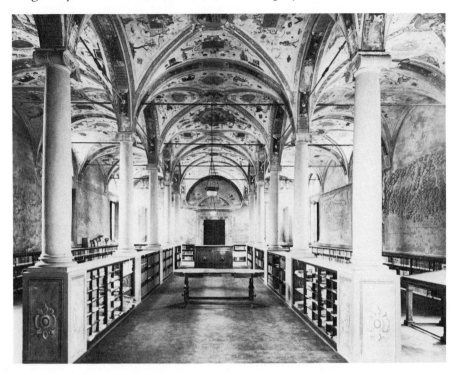

FIG. 3.14 Monastery of San Giovanni Evangelista, Parma: library (looking north). Photo by the author.

Indeed, the entire genre of ideal maps experienced a sort of revival in later sixteenth-century Italy, at least in the realm of mural painting. An elaborate cycle at Parma, for instance, painted in 1574–75 to decorate the monastic library of San Giovanni Evangelista (fig. 3.14), exhibits maps of the Holy Land before and after the coming of the Israelites, Greece, Italy, and the Duchy of Parma, surrounded by a farrago of texts and images that set these regions within the context of the larger, divinely governed orb.[52] There are, to begin with, four chronological tables giving the names and dates of the successive kings of Israel, ancestors of Christ, popes, and Roman emperors. Then there are large representations of Noah's ark, the ark of the covenant, the high priest of the Jews, the temple of Solomon, the city of Jerusalem, and the Battle of Lepanto (fig. 3.15). The program is meant to repeat the history of civilization *sub specie religionis Christianae,* from the occupation of Canaan by the Jews and the first covenant of God with man through the rise of classical culture in Greece, the birth of Christianity in Jerusalem, its spread in Italy, to the divinely sanctioned order of the 1570s, which witnessed the triumph of Christians over Muslims at Lepanto. As is appropriate in a monastery beholden to the patronage of an autocratic

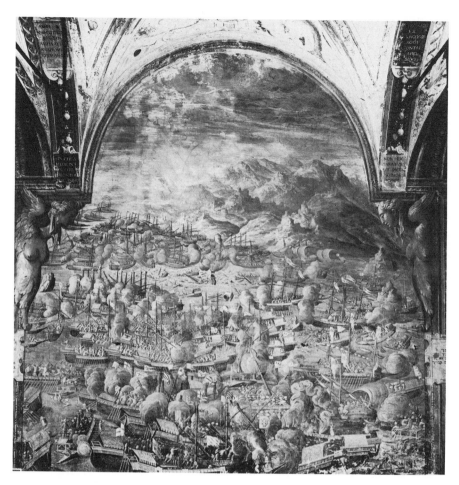

FIG. 3.15 *Battle of Lepanto,* Monastery of San Giovanni Evangelista (see fig. 3.14).

duke, the membership of the Duchy of Parma in this comity is broadly displayed. Also, the Battle of Lepanto had local as well as general significance. Alessandro Farnese, the young son of the reigning duke, had been present somewhere belowdecks during the great engagement.

Mural *mappaemundi,* exhibiting the whole created world in one image, reappeared in the last quarter of the century. The maps of the Eastern and Western hemispheres painted under Gregory XIII during the second campaign of work in the Terza Loggia of the Vatican are referred to as "mappamondi" in the documents and are indeed modernized forms of the medieval type. Two other *mappaemundi* were painted for the same pope in the papal palace on the Quirinal in 1585.[53]

The exhibition of a prince's or government's reach of power was an especially common subject in later sixteenth-century maps. One instance was, of course, the Galleria delle Carte Geografiche, which illustrates Italy as a land of faith in the pastoral care of Christ's vicar, the pope. But secular power was similarly illustrated, as it had been repeatedly in the Middle Ages. When Duke Alfonso II d'Este visited Venice in 1562, the entrance hall of the palace where he was staying was hung with tapestries showing detailed bird's-eye views of the cities he

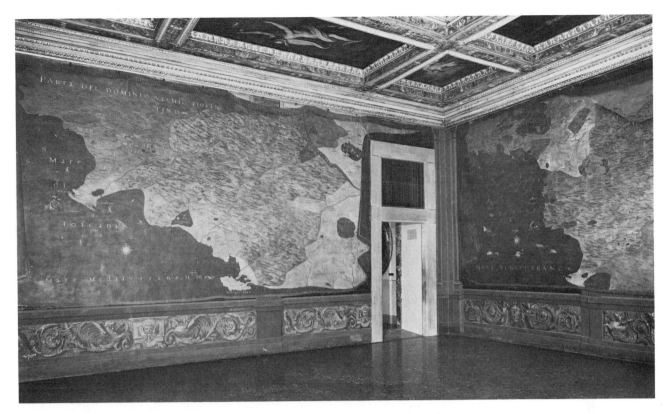

FIG. 3.16 Camera delle Matematiche (looking east), Palazzo degli Uffizi, Florence. Courtesy of Gabinetto Fotografico, Soprintendenza per i Beni Artistici e Storici, Florence.

ruled: Brescello, Carpi, Ferrara, Modena, and Reggio Emilia.[54] When Francesco I de' Medici returned in 1564 to make his entry into Florence with his new bride Joanna of Austria, the Salone dei Cinquecento of the Palazzo Vecchio was decorated with ten canvases showing cities of the Medici domain, and the courtyard with fourteen frescoed views of Austria.[55] A map of the Vicentine territory hung in the Camera dei Deputati of Vicenza in 1573, and a map of the territory of Siena was put up that same year in the Sienese town hall.[56] Gregory XIII had a plan of Bologna (his hometown) and a map of the province of Bologna (one of the chief states of the patrimony of Saint Peter) painted in 1575 in a room at the Vatican called, thereafter, the Sala di Bologna.[57] Egnazio Danti painted a map of the Perugino for the Perugian town hall in 1577.[58] Ludovico Buti painted maps of the provinces of Florence and Siena in the Uffizi, in 1588–89, for Duke Ferdinando de' Medici (fig. 3.16).[59] Only the maps of the Sala di Bologna and the Uffizi survive. They are fairly accurate cartographically but quite general in their topographical detail. They do not look like maps meant for the orientation of government officials, such as the maps seen nowadays in the offices of municipal and county assessors.

The history of still another sixteenth-century territorial map will drive home the point that the display of exact geographical information

was not the chief purpose of such publicly exhibited maps. This is the map of the Venetian state planned for the Senate chamber of the doge's palace in 1578.[60] The sequence of events is known from the copious notes kept by the cartographer, Cristoforo Sorte. The map was to show the entire mainland state of the republic and to measure over 13 by 35 feet (4.17 by 10.78 meters), covering the inside wall of the Senate chamber. Sorte, an excellent cartographer, set to work as soon as he received the commission, riding the countryside and taking compass fixes. But a year later, in 1579, the project was stopped by one of its overseers, a senator, on grounds of security. The map would show any prospective enemy all Venice's fortifications, defenses, roads, and passes. Accordingly, its format and destination were changed. The map was now to be divided into six sheets, one showing the state as a whole, the other five its several provinces, and was to be kept under lock and key in specially built cupboards in a private room. In the event, the general map was not locked away after all. A seventeenth-century guidebook records it as hanging in a vestibule between the Senate chamber, the Senate chapel, and the state archive. The five detailed maps, on the other hand, seem never to have been exhibited. They were certainly made, because they still survive and state their destination in the inscriptions. But neither the guidebook that noticed the general map nor any other guide to the doge's palace of the seventeenth and eighteenth centuries mentions them. We can only conclude that during the life of the republic they were, in fact, treated as classified material, either hung inside locked cupboards as planned or, possibly, kept in the state archive, rolled up. The different treatment of the two classes of maps—the general map and the detailed maps—is most revealing. The first, which gave visual expression to the extent of the republic's dominion but was short on geographical facts by virtue of its scale, was publicly exhibited. The latter, crammed with detailed information, were hidden away. As detailed maps, they were not edifying but merely informative.

The story confirms that even in Renaissance Italy a map was not always a map. Often it was the vehicle for elaborate nongeographical ideas. In some branches of cartography curiosity did overcome metaphysics before the end of the century, as in broadsheet maps and atlases. But in others, mural maps, for instance, the contest between a rational and a mystical view of the world that dominated the period's intellectual life was never resolved. Even the seemingly rational discipline of geography continued to be colored by the tenacious propensity of educated men to see ideal notions reflected in real facts. In short, it was only after the Renaissance that the map in Italy came entirely out of the closet.

Color in Cartography: A Historical Survey

ULLA EHRENSVÄRD

*A*lthough its importance as a map element has been acknowledged repeatedly by historians of cartography, the role color plays on maps has yet to receive thorough historical scrutiny. Among those who have devoted attention to the subject, R. A. Skelton takes the approach of distinguishing the decorative aspect of color on maps from its information-bearing function: "From the late Middle Ages mapmakers have used colours to enhance the decorative quality of their work. . . . The functional use of colour to supplement and distinguish the mapmaker's symbols is at least as old as its decorative use, and has outlived it."[1]

The implication here is that the decorative aspect of color is nonfunctional. But, as Werner Horn has pointed out, decoration on maps has been closely allied with map content throughout the history of cartography. This was especially the case in early maps, because the imprecise information then available lent itself to pictorial depiction; the modern cartographer can choose between pictorial and abstract representation of more accurate data.[2] The hand-colored portrayals of natives parading around Willem Blaeu's 1630 map of Africa are no less informative in intent than the colored layer tints showing the density of African population in the 1974 edition of *Goode's World Atlas*.[3]

To fully appreciate the historical significance of color in cartography, it is essential to treat the aesthetic aspect as inextricably bound up with function, a situation Lewis Mumford describes as characterizing the practical arts (technics), whether handcrafts or machine craft, throughout history. According to Mumford, art represents mankind's uniquely human ability to "abstract and represent parts of his environment, parts of his experience, parts of himself, in the detachable and durable form of symbols."[4] Maps, as symbolic graphic representations of the spatial environment reduced to human scale, certainly fit this definition of art.

I gratefully acknowledge the assistance of Karen Severud Pearson in revising and amplifying this essay, particularly the introductory and concluding sections. I have also written an article on the subject in Swedish with an English summary: "Färg på gamla kartor" (Color on old maps), *Biblis: Årsbok utgiven av Föreninigen för Bokhantverk* (1982), 9–56.

123

Mumford adds that the functional role of the symbol has followed a typical sequence of development in mankind's general cultural evolution: "It is only at a very late stage of history that the symbol becomes useful as a device of abstract thought, in the service of science and eventually of technics. The mythic and poetic functions of the symbol . . . antedated its rational and practical uses."[5] This functional evolution has been strongly evident in the changing symbolic vocabulary of the map. For example, the introduction to a recent exhibition catalog points out how the increasing polarity between pictorial decoration and the map body reflected the conflict between traditional religious and philosophical concepts and advancing scientific understanding of the world, a conflict that was to end in the disappearance of traditional decorative imagery from maps.[6] When cartography is viewed thus, as a culturally based means of mediating environmental experience through symbolism, any map feature, including color, can serve as a revealing indicator of cultural change.

The mapmaker's creation of color has always been dependent on available techniques, tools, and materials, and the evolution of map printing has operated as a controlling factor on the look of maps throughout the history of cartography. Over time, the trend has been from a craft in which the mapmaker exerted a direct and very personal control over the product to mechanization. Mechanical means of reproduction have brought gains in production speed and economy as well as image accuracy and repeatability, but at the price of increasing separation of the cartographer from the end product. This change has occurred more slowly for colored maps than for monochrome maps because the greater difficulty of mechanizing multicolor reproduction has resulted in a technological lag. Between the era of hand color on manuscript maps and the shift to printed color there thus intervened a stage of hand coloring on printed maps, a situation that had a marked effect on the cartographer's approach to the design and use of colored symbols.

The first stage can be characterized as the era of the hand-colored manuscript map, although other techniques and materials were used to make maps as well. This stage ended in Europe with the introduction of printing to cartography in the third quarter of the fifteenth century. Although manuscript maps have continued to be produced and used through the present day (both at intermediate steps in the map production process and as end products), they are outnumbered by the vast quantities of printed maps. During the manuscript era, the technical limitations on the hand colorist were the cost and range of materials and tools that could be made or obtained, the time available for creating the desired effects, and of course the colorist's own skill.

The second stage in color technology, following the introduction of map printing, was a period in which it remained difficult to create and register multicolored images. This technological lag meant that color was generally added to the printed map by hand until the mid-nineteenth century. Despite the use of semimechanical aids such as stencils, the continuing use of hand coloring had the effect of severely restricting the number and types of colored symbols employed on maps.

Technological improvements in the mid-nineteenth century finally enabled the color printing of maps, although hand coloring continued in use into the early twentieth century. Continuing improvements in reproduction have greatly expanded the role of color, and though cost is still a factor in color reproduction, virtually any color effect is now technically achievable.

Modern color printing is thus fully capable of expressing the coloristic intent of the mapmaker, but this facility comes at a time when the trend toward automation is increasingly limiting the routine cartographer's direct control over the map as an artifact. According to Mumford, this progressive limitation of the designer's influence is an inevitable consequence of mechanization and necessitates a rethinking of the traditional role of creativity in the practical arts:

> One of the effects of the machine arts is to restrict the area of choice, on the part of the designer, and to extend the area of influence, with respect to the product. In some sense, man must forego his purely personal preference and submit to the machine before he can achieve good results in the limited province of choice that remains to him. . . . What is peculiar to the machine is that choice, freedom, esthetic evaluation, are transferred from the process as a whole, where it might take place at every moment, to the initial stage of design. Once choice is made here, any further human interference, any effort to leave the human imprint, can only give impurity to the form and defeat the final result. So it is by a fine sense of formal relationships, by proportion, by rhythm, by delicate modulation of the utilitarian function that good form is achieved in the machine arts.[7]

Following this warning, it is critical at the present stage in the development of cartographic technology that the cartographer continue to exercise control over map design and to do so effectively. One of the ways to accomplish this is to seek out the root of cartographic design traditions in the craft era of mapmaking, just as Edward Johnston advocated doing for calligraphy at the turn of the century. At present, for example, the rapid expansion of computer technology for the production of multicolor graphic images calls out for creative cartographic input. An understanding of the way cartographers of the past have adapted their use of color to technological change is needed. Recent books by cartographers on cartographic history reflect a growing sense of the need for historical self-evaluation during an era when the role of the cartographer is rapidly changing.[8] This brief survey is intended to summarize this theme.

THE CRAFT TRADITION: HAND COLOR ON MANUSCRIPT MAPS

Direct evidence about the appearance and production of the earliest colored maps is lacking because the maps have not survived. If we exclude earlier carved or painted examples, such as the *Forma Urbis Romae* or the town plan at Çatal-Hüyük, the oldest extant European manuscript

maps date only from the seventh century. Color appears on medieval European maps as well as on recently discovered Chinese maps from the second century B.C. (Han dynasty) (color plate 6) and on the oldest Egyptian maps from about 1250 B.C. The very early use of color on maps can safely be assumed.

The examples that do survive present research problems, because pigments have frequently altered over time in response to poor treatment and environmental conditions. Color may also have been added centuries later by a map dealer or collector wishing to enhance the map's salability, oblivious to its value as a historical document. Consequently, generalizations about colors observed on old maps must be made with extreme caution, drawing upon the conservator's knowledge of the chemical composition of pigments and their behavior under different conditions.

Comparison of colors on maps is further complicated when, as is often the case, they are in different locations. Color photography is a valuable aid to the researcher, but it is not totally reliable when photographs are made with different films under various lighting conditions. Identification of colors by comparison with standard color chips is also essential, particularly when the researcher is interested in subtle variations in color.[9]

Instructional treatises can provide useful information about coloring techniques, although literary evidence about the preparation and application of colors before the medieval period is scanty. Because the coloring methods described in later technical compilations represent to a large extent the recording of oral tradition, much of the information can be assumed to apply to earlier centuries. The interpretation of pre-1800 literature on color is hindered by the differing color terminology as well as by the general lack of actual color samples.[10] Modern color science employs a three-dimensional color solid coordinating three variable characteristics (hue, brightness or value, and saturation or purity) to describe and specify colors.[11] The descriptive color models of the present day did not exist in antiquity and the Middle Ages, and the color terms employed often varied in meaning.

Despite the limited information about color on early maps, it is possible to make some useful observations about the influence of manual techniques on map production starting with the medieval period. During the preprinting era, maps in Europe were primarily drawn or painted using the tools, materials, and techniques of the book illuminator. Most medieval maps were manuscript illustrations, and book illumination occupied a significant position in the arts.[12] Map illustrations were produced in artistic workshops along with other types of manuscript illustrations (color plate 7).

The surface on which such maps were created was usually what may generically be called parchment. Papermaking had been introduced to Spain by the Moors by the tenth century and to Italy by the eleventh century, and it became known in the rest of Europe by the twelfth to fifteenth centuries. To a lesser extent, maps of the preprinting era were

also produced on other surfaces such as clay, metal, and wood.

The pigments for manuscript illustration were prepared, as for medieval book illumination in general, with binders of glair (beaten and settled egg white), gum, and starch. Colors were applied with pen or brush, using the techniques of the illuminator. Most color pigments were mixed with white lead to lighten them, a step that also rendered the pigments more opaque. The coarseness of pigments (compared with modern ones) also increased opacity. This coarseness was due partly to manual grinding techniques but often was a deliberate means of retaining richer color in mineral pigments. Coarse azurite, for example, yielded a dark, handsome blue, while finer particles resulted in a pale greenish blue relegated chiefly to the addition of pen flourishes around lettering.[13] Although many of the pigments of medieval book illumination had been in use since antiquity, the types of pigments and their sources of supply were not static. The Moorish heyday of influence in mid-tenth-century Spain, for example, brought new knowledge about pigments to Europe. Their relative cost affected their use, particularly in the case of ultramarine (powdered lapis lazuli) and gold. Gold could be laid on before painting as thin sheets of gold leaf or added later with pen or brush in the form of gold powder mixed with ox bile or gum arabic. The high cost of gold spurred efforts to produce cheaper alternative pigments, such as orpiment (sulfide of arsenic) and in the thirteenth century mosaic gold (yellow sulfide of tin).

In addition to the cost of the materials, the time needed to color maps effectively limited their clientele to the church and the nobility. Although rote copying of existing models often occurred, manual production by individual craftsmen resulted in inevitable variation from one copy to the next and also provided the opportunity for individual creativity with each map.

Although there is limited information about design ideas during the manuscript era, some observations and speculations about the cartographic approach to color are possible. Early manuscript maps frequently reveal the use of different hues to create visual contrast among map features. Bright colors such as red and gold often highlight important line and point symbols, as well as lettering (color plate 8). The use of color to emphasize selected map labels has been linked to the copyist's practice of rubricating manuscript text. In medieval arts, the general use of more brilliant colors for book illumination than for panel and wall paintings has been attributed to the graphic need for greater visual contrast in the smaller context, as well as to the sense of the craftsman's product as an item of value.[14] It is clear that brilliance and luster were greatly prized characteristics of pigments employed in rubrication and illumination; technical literature from the late Greek period through the medieval period often points out how to enhance these qualities.[15]

In addition to contrasting colors for line and point symbols and lettering, flat and graded colors often cover areas on medieval maps. Stylized color gradations often appear on terrain features; similar color variations (although more systematic and refined) are still used in mod-

ern cartography to create the visual impression of an undulating three-dimensional surface.

Ideas about the relation of different hues varied, but the medieval European artist, echoing ideas passed down from the Greeks, generally viewed colors as progressing along a scale from light to dark. Hues were regarded as mutable rather than fixed, a point of view that may have stemmed partly from the practical observation that differing preparation of certain common pigments produced contrasting hues. Such related though contrasting hues (i.e., red and green) were frequently associated or even used interchangeably in medieval painting.[16] The possible influence of medieval color theory on manuscript map illumination should be explored.

In contrast to the subject of color and cartographic design, there is considerably more historical evidence about the symbolic association of particular categories of map features with certain hues. Although there was some variation, von den Brincken's study identified groups of hues commonly associated with land and water features on medieval world maps.[17] The clothing of religious figures in medieval painting similarly displays marked consistency of symbolic color associations within families of related hues. The cartographic expression of symbolic color associations apparently has its roots far back in antiquity. An especially interesting example is the use of red for the Red Sea, characteristic on medieval maps (color plate 9).

The names Black Sea and Red Sea were used by Asiatic peoples in antiquity, but these place-names were traditionally credited with an older origin. The name Pontos Euxeinos (Black Sea) was interpreted by the Greeks without any color association to mean friendly sea, because the common Greek word for black (*melas*) could not be connected with water in the Greek mind, since water was for the ancient Greeks shining, bright (white) *leukon*, while something like blood could be *melas*.[18] Pindar, writing in the fifth century B.C., explained Pontos Euxeinos as a euphemistic modification of the former name Pontos Axeinos (unfriendly sea). The latter name certainly corresponds better to the sufferings of Odysseus on that cold, rough sea with no protecting islands. Since the 1920s, however, linguists have pointed out that Pindar did not go far enough in his interpretation. The Greek word *axeinos* could be a distortion of an old Persian word, *aχšaēna,* meaning dark, black, or obscure, derived from the fact that people related to the Persians lived around the borders of the Black Sea—say 2000 B.C., before the Greeks invaded the Balkan area. The name Black Sea was not used commonly until the Turkish influence overruled in the twelfth and thirteenth centuries.[19]

It seems that the Mediterranean Sea did not bear a color name until the Arabs named it. Its present name stems from Roman times, when it was called the Mare Intestinum, Mare Internum, or even Mare Nostrum (Our Sea). However, the traditional name for this sea among Arabic-speaking peoples is al-Baḥr al-Abyad (White Sea), and the Turkish name is Akdeniz (White Sea).

The suggestion of an Asiatic origin for the names Black Sea and White Sea is reinforced and explained by the evidence associated with the Greek name Erythra Thalassa or Red Sea.[20] The Bible gives the Hebrew name for the Red Sea as Jam Suf (Sea of Reed), while the Arabs called it al-Baḥr al-Hidjas (Sea along the Barriers), so these sources provide no clues. However, the Greeks had a number of theories about the origin of the name Erythra Thalassa. The Greek geographer Strabo (ca. 63 B.C. to ca. A.D. 25) ascribed the name to the Egyptians, who had used it about five hundred years previously and passed it on to the Greeks. He cited old sources, which gave various reasons for the name. One mentioned the red color acquired by rainwater running down the mountain slopes to the sea. It is true that *erythron* does occur in Greek place-names, such as Erythraia in Ionia, where reddish rocks predominate. Another of Strabo's sources associated the name with the color of dawn mirrored by the calm sea. Homer had similarly described the surface of the sea touched by rosy-fingered Eos. Still another theory was presented by Deinon, an Argive historian, who told how Perseus (son of Zeus and Danaë) had gone to the eastern countries, named Persia after him, and left behind a son, Erythras. Boxos, a Persian living in Athens, added that the Persian Erythras's ownership of much land along the sea had led to the name Erythra Thalassa.[21]

A far more likely source for the name did indeed lie in the direction of Persia, but it consisted rather of deep-rooted symbolic connections between colors and the cardinal points.[22] Documents found in Ashurbanipal's library in Nineveh (founded in the seventh century B.C.) tell that the Babylonians identified black with north, white with south, red with east, and yellow with west. The area where they lived was symbolized by brown.[23] In antiquity the land of Persia stretched across Asia to the borders of China, and other Asiatic peoples had similar ideas relating colors to cardinal points. In ancient Israel red represented east, black north, green south, and white west.[24] The ancient Chinese symbolized the earth of the area where they lived by yellow; their earliest settlements were concentrated near the Huang Ho (Yellow River).[25] In contrast, the Mongols called the upper reaches of the same river to the northwest the Karamuran (Black River). The word *kara* is very common in Asiatic place-names and always signifies north, as in Karakorum and the Kara Sea.[26] The Chinese, Indonesians, and Central Asian peoples associated red with the south or southwest. The Chinese word *hung* means both red and south; it also connotes something vast and extended. In addition, the Chinese characterized east as blue and west as white.[27]

The red applied to the Red Sea on some medieval manuscripts is thus a vestigial symbolic association of color with direction, a relic of an earlier age when mankind's conception of the environment was more mystical than rational.[28] The symbolic association of colors with cardinal points seems to reflect a high degree of civilization. In a linguistic study, social anthropologists Brent Berlin and Paul Kay compared color terms in ninety-eight different cultures throughout the world. They

found the basic hues entering the languages according to a fixed pattern: white, black, red, yellow or green, blue, brown, and all other colors afterward. In most societies the first two or three colors also symbolized certain ethical values.[29] When the color symbology passed on from the ancient to the medieval world is examined further, there emerges a pattern of overlapping, sometimes even contradictory symbolic meaning.

A brief consideration of the colors assigned to land and water features on medieval maps will make evident the complicated nature of the symbolic relationships involved. With the occasional exception of red for the Red Sea, von den Brincken found that water features on medieval world maps were usually blue or green, with one instance of violet (color plate 10). Mountains, although more varied in color, were predominantly brown, green, or red. The land area on which mountains were placed was usually left the natural color of the parchment, though sometimes it was colored green (on such maps the water is blue) or brown.[30] While the selection of colors may have stemmed in part from observation of natural phenomena, long-standing symbolic association of colors with the four elements and seasons as well as with cardinal directions was also clearly involved. Although brown was too dull a hue to be popular in other types of manuscript illumination, its frequent use for mountains on maps also suggests the power of color symbolism to outweigh the graphic preference for bright colors.

Over the centuries, the Greek philosophers had sought to establish connections between colors and various natural phenomena. Empedocles, writing in the fifth century B.C., formulated a doctrine associating the colors white, black, red, and ocher yellow with the four elements (air, earth, fire, and water) (color plate 11). This scheme may have been Asiatic in origin, like that for the cardinal directions.[31] The number four represented an equilibrium, and all material conditions on earth were viewed as produced by the interaction of the four elements. The Greeks were aware of the volcanic origin of mountains, for example, and the association of red (the color of fire) with mountain features may have had its source here. The Greek philosophical schools varied in opinion on colors, but all linked the earth with the color black.[32] The four seasons were also fitted into the system in various ways. Ptolemy, for instance, associated the seasons and cardinal points with color: winter with northeast and black, spring with southeast and red, summer with southwest and white, and autumn with northwest and yellow (color plate 11). The seasonal association with colors was also an important feature of Roman chariot races of the early Christian era. The circus represented the solar system, and the race symbolized the sun's orbit through the course of a year. Each chariot was dedicated to one of the four seasons. The driver of the quadriga dedicated to spring and the earth was dressed in green; red represented summer and Mars; blue stood for autumn, the sea, and Neptune; and white was the color of winter, the air, and Jupiter.[33] Isidore of Seville described the color symbolism of the circus in his seventh-century *Etymologies,* which

remained an important reference work for centuries. Elsewhere, however, Isidore associated water with purple and, following Greek tradition, assigned black to the earth.[34] The connection of water with the color purple had its origin in antiquity and derived from the use of tiny murex shellfish as a source of purple dye.

Medieval Christian writers took over the assorted color symbology inherited from the pre-Christian era, disguising heathen associations by transforming them into the symbology of Christianity. Whereas some authors, such as Tertullian (second to third century A.D.) and Isidore (sixth to seventh century A.D.), warned against the dangers of pagan color symbology, Saint Jerome (third to fourth century A.D.) interpreted the elemental colors of the Jewish high priest's vestments (white for earth, purple for water, blue for air, and scarlet for fire) in a positive light, as representing man's ascension to heaven.[35] The classical association of blue with the heavens (Pliny had referred to a blue pigment as *caerulum*) was transformed into a mystical association with Christ's divinity.[36] In the Christian era, the different colors became imbued with various spiritual qualities, which could sometimes be dual in nature. Green, for example, became a symbol of Christian hope and faith, but in other contexts it could also represent Satan.[37]

This complex of symbolic ideas obviously influenced the coloring of features on the medieval world maps surveyed by von den Brincken, whether the colorist was actively making the symbolic connection or simply following a model or familiar convention. After the discovery of the New World, the idea of four continents was to be incorporated into the existing quadripartite symbolic scheme of directions, seasons, and elements. Personifications of these concepts, in various combinations, commonly appeared as decorative features on maps and persisted well into the era of the printed map. Although some attention has been given to the thematic iconography of such representations, the possible associated use of symbolic colors has yet to be explored.[38]

To some extent the selection of colors on the medieval world maps surveyed by von den Brincken may also have stemmed from the desire to create a realistic impression of the landscape. On the map in the fourteenth-century manuscript of Brunetto Latini's *Livres du trésor,* in the Bodleian Library, for example, the blending of colors where the light gray rivers empty out into the deep blue oceans reflects observation of this natural phenomenon.[39] Realistic treatment of perspective, light and shade, draperies, and color had been characteristic of classical art. The Greeks had associated blue with air partly because of the observation that the sky appeared blue and that intervening air turned distant objects blue.[40] Although visual realism in art had largely given way to symbolic treatment in the early Christian era, there were some lingering tendencies toward realism. A hint of classical realism is apparent in the treatment of mountains in the sixth-century *Corpus Agrimensorum Romanorum.* The mountains are painted gray-violet, shaded on the west (sunset) side with lampblack or ultramarine, and some are illuminated on the east by a luminous brazilwood pink suggesting the dawn (color

plate 12). The realistic appearance of features represented on maps was to become a major concern again in the Renaissance, when artists and scientists turned away from the medieval symbolic view of the environment and sought to develop a new one based on study of natural phenomena. This new concern is apparent in Leonardo da Vinci's observation in 1511 that "the surface of rivers is of three colours, namely light, medium and dark. The light part is the foam which is generated, the medium is when the water reflects the air and the dark is in the shadows of the waves. This dark part appears green. . . . If the water takes on the blue of the air in its high lights then the shadows appear green and to a certain extent dark blue."[41] Summing up these natural observations in symbol form, Leonardo employed an azure blue to represent the sea on his topographical drawings and maps. His treatment of landscape also reflects a new understanding of landforms.

Mapmakers after the fifteenth century would continue to develop techniques for representing the three-dimensional landscape and also would master the realistic use of color to depict and differentiate various types of terrain. The intent of the distinctive coloring of cultivated and uncultivated land in Tilemann Stella's 1564 manuscript atlas of the duchy of Zweibrücken in the Royal Library, Stockholm, is clarified by reference to a treatise published a century later by H. Gautier of Nîmes (color plate 13). An alphabetical appendix at the end of *L'art de laver; ou, Nouvelle manière de peindre sur le papier* explains how maps and plans sent to the French royal court were washed. The entry under "T" reads: "terre labouré, terre non labouré or inculte, terre plain."[42] Gautier goes on to recommend that cultivated land be washed in colors of yellow-green to dark green to distinguish it from other types of land. Alternate stripes of dark red and reddish green would convey the impression of plowed furrows. Fallow land should be painted with grayish ocher to give the impression that the grayish surface of the unplowed land could be lifted up by the farmer. Land without agricultural significance should be left white or painted black with india ink.

During the fifteenth century the centuries-old system of laborious manual production of maps was to be challenged by the introduction of woodcut printing. The use of color on the printed maps that followed would reflect not only an adjustment to the new technology but also the changing world view developing out of the Renaissance period.

THE TECHNOLOGICAL LAG: HAND COLOR ON THE PRINTED MAP

The introduction of woodcut printing for maps made it possible to reproduce multiple copies of the same map by means of the mechanically repeatable printing image. Although hand-drawn maps continued to be produced, the number of maps duplicated by printing rose steadily. Printed maps circulated to an ever wider audience, and their contribution to the spread of geographical knowledge paralleled the profound impact of book printing on literature.

The technical constraints of the woodcut process affected the use of color on maps. Whereas the manuscript copyist had been free to

render any symbol or label in any color available, the difficulties of color printing strongly inclined the cartographer to print as much as possible of the map image from a single woodblock. Some attempts at color printing maps were made in early sixteenth-century Germany, paralleling the more successful contemporary production of chiaroscuro woodcuts. The three-color map of Lorraine in the 1513 Strasbourg edition of Ptolemy's *Geography* displayed the shortcomings of color registration, a severe problem in cartography, where precise location of marks is more critical than in artistic printing (color plate 14). Cutting the small tree symbols and route lines obviously presented a challenge for the engraver and illustrates the difficulties of executing small detailed features. The capacity of the woodcut method to print areas of solid color is evident in the mountains, but the area color partially obscures the underlying black lines and lettering. On the other hand, the red and golden brown printing inks are bold enough to allow the colored point and line symbols and lettering to stand on their own. The technical drawbacks to printing the different parts of the map image in color were not to be removed until the nineteenth century, and hand color remained almost the exclusive method of coloring printed maps through the intervening centuries. Early in the development of printing with movable type, printed rubrication of the text had similarly been tried and then dropped for practical reasons.

Woodcut printing thus brought with it a change in the approach to color on maps. Instead of being an option as part of the hand copying process, color became a supplementary map element, to be added after printing if desired. Maps, like books, were commonly sold both uncolored and colored. A purchaser might take an uncolored printed map to an illuminator's shop for coloring or even color it at home, but color definitely came to be regarded as an optional addition to an essentially complete black image.

The shift to copper engraving for map reproduction in the mid-sixteenth century solved some of the problem of image quality, but the continuing technical barriers to accurate color registration perpetuated the "color as addition" approach to cartography. The fineness and precision of the lines that could be engraved in the copper plate allowed the creation of a much more detailed black image. This advantage over woodcut compensated somewhat for the decreased importance of color. The production of the intaglio image by incision with sharp-pointed tools or by stamping inclined the character of the symbols toward dots and linear marks. Combinations of such marks made up any area symbols; the copper engraving process was not suited to the production of solid area images, even when the occasional map was printed in color. Hand color continued to be employed on copper-engraved maps, but the delicate and detailed map image could not support such strong colors as the woodcut image (color plate 15). Copper engravings presented definite technological incentives for the use of subtler, more transparent watercolors and, indeed, for the reduced use of color. Although other factors were involved, such as changing artistic color preferences and

the evolving nature of the maps, the trend toward less and lighter color in the seventeenth and eighteenth centuries meant that the black printed image was usurping some of the information-bearing functions performed by color in the manuscript era.

As map publishing developed further in the seventeenth century, hand coloring became a common adjunct to the cartographic enterprise, a situation that continued through the end of the nineteenth century. In the seventeenth century coloring maps also became an accepted genteel pastime, as indicated by the numerous treatises intended for the instruction of amateurs. Treatises on the art of coloring (first published in Italy and later in England, Holland, and France) had traditionally included chapters on coloring fortification plans and maps. Whereas professional painters learned about materials and techniques by training in a studio, amateurs were taught by private teachers and books. A typical publication of this time was *The Compleat Gentleman* by Henry Peacham, a teacher by profession. A very popular book, it was first printed in London in 1622, reprinted in 1626 and 1627, and enlarged in 1634 and 1661. Peacham recommends the coloring of maps as an educational pursuit:

> I could wish you, now and then, to exercise your Pen in Drawing and imitating Cards and Mappes; as also your Pencill in washing and colouring small Tables of Countries and places, which at your leasure you may in one fortnight easily learne to doe; for the practice of the hand doth speedily instruct the minde, and strongly confirme the memory beyond any thing else; nor thinke it any disgrace unto you, since in other Countries it is the practice of Princes, as I have shewed heretofore; also many of our young Nobilitie in England exercise the same with great felicitie.[43]

A similar point of view is expressed in the third edition of John Smith's treatise *The Art of Painting in Oyl* (1701), where a chapter is devoted to "The Whole Art and Mystery of Colouring Maps, and Other Prints, in Water Colours." Smith states that this information is intended

> for the sake of those that are inclined to Ingenuity, to set forth the way and manner of doing this Work, it being an excellent Recreation for those Gentry, and others, who delight in the Knowledge of Maps; who by being Coloured, and the several Divisions distinguished one from the other by Colours of different kinds, do give a better Idea of the Countries they describe, than they can possibly do uncoloured.[44]

The title of another popular treatise by the London "professor of physick" William Salmon illustrates how the practice of map coloring was grouped with various other artistic pursuits:

> Polygraphice: or the Arts of Drawing, Engraving, Etching, Limning, Painting, Washing, Varnishing, Gilding,

Colouring, Dying, Beautifying and Perfuming. In four books. Exemplified in the Drawing of Men, Women, Landskips, Countries, and Figures of various forms; The way of Engraving, Etching, and Limning, with all their Requisites and Ornaments; The Depicting of the most eminent Pieces of Antiquities; The Paintings of the Antients; Washing of Maps, Globes, or Pictures; The Dying of Cloth, Silk, Horns, Bones, Wood, Glass Stones, and Metals; The Varnishing, Colouring and Gilding thereof, according to any purpose or intent; The Painting, Colouring and Beautifying of the Face, Skin and Hair; The whole Doctrine of Perfumes (never published till now), together with the Original, Advancement and Perfection of the Art of Painting. To which is added, A Discourse of Perspective and Chiromanty.[45]

In addition to recommending the best pigments for map coloring and describing their preparation, Smith's treatise stresses the importance of paper quality: "But if the paper be not good and strong, no Art can make the Colours lie well; therefor in buying Maps, chuse those that are Printed on the strongest or thickest Paper."[46] Smith then proceeds to describe how to use a fine brush to apply watercolors that will highlight line and point symbols:

First with a small Camel Hair Pensil in a Ducks Quill, colour over all the Hills within the large prick Line that divides [one province from another] with the Tincture of Myrrh very thin; then if there be any Woods, dab every Tree with the point of a very fine Pencil dipt in Grass Green, made of Copper Green tempered up with Gum-Boge. . . . Then with another Pencil dipt in Red Lead, tempered thinly with Gum-Water, let the Principal Cities and Towns be done over that the Eye may more readily perceive them.[47]

The boundaries of provinces and the seacoast are to be emphasized by graded area washes, darkest along the line symbol.

Lastly, with a Ducks Quill Pencil dipt in Copper Green, trace out the Bounds of one of the Provinces, keeping the outmost Edge of the Pencil close to the Pricks, and be careful to lay your Colours all alike, and not thick in one place and thin in another, or too deep in some places and too light in others; and when 'tis almost dry, take another clean Pencil of the same Size, and dip it in Water, stroaking the Water out well, and therewith rub upon the inside of the coloured Line, till it take away most of the Colour on the edge, and make it grow faint and lose it self by degrees, and continue so to do till you have gone quite round; then take Yellow made of Gum-Boge, and go round the inside of the Pricks that divide the next Province, sweetning over the innermost Side of it; when almost dry, with a Pencil dipt in Water, as you did be-

fore, do over the next to that with the Crimson Tincture made with Cochinele, and the next do round with Red Lead, and the next to that with Grass Green, and the next to that with any of the former Colours that will so agree with the Work, that two joining Provinces may not be coloured with the same Colour, for then you could not distinguish them.

And when you have coloured over or divided all the Counties, then colour the Sea-shoar, and all Lakes of Water, if there be any, with thin Indico, working of that side of the Colour which is from the Land faint, with a wet Pencil as before was taught.[48]

Coloring a map by hand was a slow process. Although a colored model generally was followed, the application of the colors could vary considerably from one copy of a map to the next. Stencils were often used to speed the application of colors to maps and to increase the consistency of their placement. Stencil coloring had been common on playing cards in the fifteenth and sixteenth centuries and on popular broadsides in the sixteenth century.[49] As late as the 1870s and 1880s, the adoption of stencils for area color in *Petermanns Geographische Mitteilungen* was viewed as a means of enabling hand-applied color to compete a little longer against printed color.[50]

On the other hand, hand color could be added to qualify or amend the information presented on the printed map. This practice dates to the beginnings of map printing in Europe and had its artistic parallel in early stock woodcuts representing various pictorial subjects. The woodcut outlines were apparently intended as guides for the colorist, with variation to be achieved by different application of colors.[51] Woodcut blocks for maps represented a considerable investment but were difficult to revise; examination of fifteenth- and sixteenth-century German woodcut maps repeatedly reveals the use of hand color to supplement the printed information. The old-fashioned Ptolemaic map in the Wolfenbüttel copy of Hartmann Schedel's 1493 *Liber chronicarum* does not show the New World, but the colorist may well have been updating the map when he colored the large island west of Africa with the orange-pink used for Asia rather than the same yellow as Africa (color plate 16).[52] On the Wolfenbüttel copy of Caspar Vopel's 1558 woodcut map of the Rhine, selected regions (presumably political) have been denoted by a flat gray-green wash; the area color adds substantially to the original printed information, since it sometimes departs from the printed river lines and dotted boundaries (color plate 17).[53] Wilcomb Washburn's study of the representation of unknown lands also points out the use of variations in coloring to indicate cartographic uncertainty about portions of a map.[54]

Color on woodcut maps in late fifteenth- and early sixteenth-century German books varies from the sloppy to the superb, in terms of both execution and design. Because each colored work of that period is very much an individual creation, it is difficult to make generalizations

about graphic design. Consideration of one outstanding example will help to indicate how hand color, at its best, could heighten both the communicative power of the printed map image and its aesthetic quality.

The example is a copy of the 1535 Pirckheimer edition of Ptolemy's *Geography,* preserved in the Herzog-August Bibliothek, Wolfenbüttel (color plate 18).[55] The use of color on the three world maps in this volume is similar. The continents are colored with strong, flat area washes of gold, rose-pink, orange-pink, and green that set off and distinguish the continents. The generally warm colors of the continents contrast with the surrounding pale green oceans and blue sky, which grades from pale blue near the map body outward to a rich dark blue at the map border. The rectangular border, colored with full-strength red and gold, effectively separates the map from the paper on which it is printed. Although the overall color palette is identical, the color designs of the numerous regional maps in this volume are quite different. Countries are distinguished by graded washes of rose-pink, orange-pink, and gold, a technique that effectively accents the boundary lines with darker color while leaving the central area light so lettering and symbols show up well (color plate 19). The density of detail on the world maps and the regional maps is about the same; whereas the world maps are colored to present a stronger and more immediate graphic picture, the softer coloring of the land area on the regional maps is better suited to lengthier close-up study. The more intense but related red and gold colors of the map border both harmonize and contrast with the land colors. Contrast results from differences in value and intensity as well as from frequent placement so the red section of a border falls next to gold land, and so on. The stronger colors used for the red towns, green mountains, and blue rivers also stand out well against the pale area tints on the land. Such use of contrasting colors had been traditional in German art as well as cartography and is apparent in the work of artists, such as Albrecht Dürer, active about the time the Pirckheimer edition of Ptolemy was published.[56]

In the mid-sixteenth century the focus of European map production shifted to Italy and the Netherlands. The predominantly copper-engraved Italian maps display a classical restraint in the use of color. Although bright colors continued to be employed on many maps, the prevailing trend over time was toward more subdued color. The fashionable soft pink and violet hues are evident in a map of Scandinavia published in Antwerp by Abraham Ortelius in 1570 (color plate 20). It was quite natural that Ortelius, a leader among successful Dutch cartographers, should follow the modern trend in color set by the Italians. His use of color was also influenced by the growing public demand for beautiful maps: map coloring became almost an industry in itself in the seventeenth century.[57]

One of the passages already quoted from John Smith's treatise has shown how color was employed to distinguish different map features as well as in decoration. By the end of the seventeenth century, several mapmakers reacted against the distracting use of excessive color on

maps and advocated reducing color to the practical minimum. Although the engraver might continue to beautify maps with decorative detail, the addition of color was to be strictly functional. Principal Johann Hübner of Hamburg was very successful in his propaganda campaign for coloristic purism. He wrote several geography manuals and guidebooks for map collecting. In the introduction to his *Museum geographicum* (1726) he recommended that the cartouches and decorative details be left uncolored. Color should serve only the informative purpose of emphasizing the administrative, religious, ethnic, and other divisions of a country.[58] Hübner's recommendations were widely received, among others by the most prolific cartographer of the early eighteenth century, Johann Baptista Homann of Nuremberg. For instance, on Homann's maps from the 1710 *Hydrographia Germaniae,* the coloring is concentrated on the network of rivers and lakes (color plate 21). Homann's stance on coloring was relatively moderate; some members of the French cartographic school (Sanson, Delisle, and others) were more severe, permitting only the coloring of boundary lines (color plate 22). The German geographer and theologian Eberhard David Hauber followed Homann's practice of systematically illuminating the same features with the same color on different maps as the best aid to memory.[59] In his 1713 book *Curieuse Gedancken von den vornemsten und accuratesten Alten und Neuen Land-Charten . . . ,* Johann Gottfried Gregorii also stressed the importance of carefully executed coloring and said that this task should hardly be left to unskilled women and children.[60]

The restrained and purposeful use of hand color to distinguish and harmonize the elements of the printed map image became an ideal goal in cartographic design. This outlook influenced the cartographic taste of mapmakers into the late nineteenth century, as was often expressed in reviews of new maps and of map displays at international expositions. August Petermann's shift from printed to stencil color for maps in the 1870s in *Petermanns Geographische Mitteilungen* was made partly for economic reasons but also reflected Petermann's decided aesthetic preference for the subtleness and transparency of watercolor washes.[61]

At the same time, the rapid growth in mappable data about the physical and cultural environment placed increasing strain on the limited informational capacity of the black printed image. The refinement of intaglio techniques for hatching and stippling to create an increasingly detailed portrayal of the earth's surface, as exemplified in the superbly executed Dufour series of Switzerland in 1844–64, posed difficulties in map design. Point and line symbols and labels tended to lose discriminability and legibility when they had to be integrated with densely textured terrain representation. New symbols for thematic mapping presented particular challenges; attempts to show continuous variation in areal data by means of aquatint shading on the black intaglio plate or later with lithographic crayon shading also tended to overwhelm other symbols, as well as being frustratingly inconsistent and incommensurable.

The obvious solution to many representational difficulties was

to expand the role of color in map symbolization. As one of the earliest branches of thematic mapping, geologic cartography demonstrates growing use of hand color to supplement the black plate. Until the mid-eighteenth century, mineral locations were primarily indicated on maps by various point symbols. When eighteenth-century geologists began to show rock types extending over areas, black stippled and ruled patterns proved inadequate to the task. A solution was found in the combination of watercolor washes with printed patterns. Graded washes, similar to those long employed by hand colorists to show political areas and outline coasts, were employed at first but soon abandoned in favor of flat washes that were easier to apply. The systems for geologic hand coloring that developed combined transparent coloring with the principle of associative coloring, in which the colors selected matched the typical color of the rock as closely as possible. During the first half of the nineteenth century, flat colors were applied by hand in combination with line and stipple patterns on increasingly elaborate geologic maps (color plate 23). The French geologist Jules Marcou complained that variations in colors from one map to the next, and even in different portions of the same map, as well as the frequent careless application of colors detracted from the quality of geologic maps. Despite the use of stencil color, machine-ruled printed patterns in black, and more systematic map explanations, hand color was recognized as being inadequate for the needs of geologic map printing by the 1840s. This spurred experimentation with new methods of color printing in this and many other areas of cartography.[62]

By now, the end of the era of hand color on printed maps, the lingering traces of mystical color symbolism, so important in the cartography of the preprinting period, have dwindled to the merest vestigial remnants. High standardized associative symbolism (blue for water, red for towns, green for trees, etc.) has come to characterize the representation of the most common map features. As I mentioned above, the attempt at realistic portrayal through associative color also influenced the development of hand-coloring schemes for geologic maps. At the same time, the increasing amount and complexity of the information to be combined in the cartographic image has aroused a growing sense of the need to create effects with color that are not possible with hand color.

Particular drawbacks that made hand coloring an increasing liability in map reproduction were the expense and the inconsistency of the results. The lack of exact repeatability detracted considerably from the scientific accuracy and general utility of the maps, while the high cost of professional hand coloring limited the production and distribution of maps. It should be pointed out, however, that hand coloring was a very important source of income for those with seasonal work such as farming, so that its cost was a relative item. It very seldom contributed more than a quarter of the cost of an uncolored map, even in the seventeenth century when heavy coloring was used.

MECHANIZATION:
COLOR-PRINTED MAPS

During the nineteenth century, the introduction of new printing techniques and the associated development of mechanical aids for creating and registering the colored printing image made the shift to printed color feasible. First of the new printing techniques was wood engraving, actually an older process that became popular for renditions of artistic subjects in eighteenth-century England with the adoption of smoother-surfaced wove papers capable of reproducing the fine wood-engraved lines. Similar to woodcut relief printing in mechanical principle (but engraved on the end grain with a burin rather than on the plank of the wood with a gouge or knife), wood engravings could be printed along with typeset text. This gave wood an advantage over copper engravings (which had to be printed separately) for small simple maps and pictorial illustrations to be included in newspapers, atlases, and textbooks.

Another new method of printing, lithography, was launched in Germany by Alois Senefelder about 1796. Unlike existing intaglio and relief printing processes, lithography was a planographic process with an essentially flat printing surface, dependent on the mutually repellent chemical qualities of the greasy printing image and the dampened non-image areas. Despite the poor quality of early lithographs, the relative ease of creating the image gave lithography an early advantage over copper engraving.

During the nineteenth century, major improvements were made in lithographic techniques, and other new relief processes, such as wax engraving and chemotypy, succeeded wood engraving. The overall trend in both relief and planographic printing was away from direct work on the printing surface toward preparation of an image on a convenient surface before mechanical transfer to the printing plate. Although efforts were also made to develop intaglio methods along the same lines, the continuing high cost of intaglio printing gradually reduced its role in map reproduction. By the late nineteenth century, the application of photomechanical methods in printing had made it possible to reproduce an ink drawing without having it recopied by an engraver or a lithographic artist. For the first time since the advent of printing this placed the cartographer in direct control of the final manual stages of production.

In color printing, various transfer methods could be used to make accurate guide images for the registration of color plates. Other significant improvements in color registration resulted from the development of mechanical devices. Early breakthroughs were Godefroy Engelmann's registration frame for lithography (1836) and Charles Knight's system for wood engraving (British patent 1838).[63] Since then increasing mechanization has made accurate registration much easier, although it is still a step requiring great care and skill on the part of the printer.

Nineteenth-century color printing of maps displayed an early technological bias toward printing area symbols in color. For example, a survey of lithographic maps in geographic journals of that period re-

vealed a marked increase in colored area symbols with the transition from hand to printed color, although color printing of point and line symbols also became common. Unlike hand color, which was easiest to apply to point and line symbols, printed color worked better for area symbols, for which accurate registration was less critical. Wood engraving and lithography were both capable of printing solid areas in color, something impossible in copper engraving except in small areas. The wood engraver could simply leave a raised area on the woodblock, while the lithographic draftsman could fill in the designated area with ink.

This was not such an advantage as it might appear. The relative opacity of the oil-based printing inks compared with the transparency of watercolors was a major problem in color printing. When Victor Raulin's geologic map of the Paris area was lithographed in color by Kaeppelin in 1842 by overprinting four plates to produce eleven tints, it was heavily criticized for the colors' lack of transparency (color plate 24).[64] The solution soon found was to employ a variety of methods for breaking up the solid color surface into patterns of small dots, lines, or other marks whose cumulative visual effect was that of a "transparent" color surface.

One of the earliest lithographic techniques, crayon drawing on a grained (toothed) stone, permitted a pattern of irregular-shaped dots. The size of the dots and the darkness of the overall pattern varied with the pressure and number of repeated strokes used to apply the crayon. The "Umgebungen von Wien" series of maps, whose production was begun at the Militär-Geographisches Institut in Vienna in 1830, is an outstanding example of the early use of crayon shading on four color plates keyed to a black base plate (color plate 25).[65] However, crayon shading executed directly on the lithographic stone lent itself more to the reproduction of artistic prints than to maps. The delicate crayon-shaded image could not withstand the longer press runs required for maps. A technological breakthrough came in the 1860s when shading on grained transfer paper (coarser in texture than the grained stone) made it possible to transfer crayon to the long-wearing smooth-surfaced stones used in printing lithographic ink drawings and lithographic engravings.[66] Color-printed crayon shading became more common on lithographic maps during the last quarter of the nineteenth century. A frequent use was for a graded area image printed in a single color, such as brown terrain shading.

For the flat area image, it was the ruling machine that represented the first great advance for both relief printing and lithography, when it was adapted from its initial use in copper engraving. A variety of patterns could be created by varying line width and spacing, then overprinted to form crosshatching. Colored area patterns of this sort give a characteristic look to both the wax-engraved and the lithographic maps of the nineteenth century.[67] Maps reproduced by the Besier-Eckstein process at the Dutch Topographical Department during the period 1864–1910 represent the peak of technical perfection in applying machine ruling to lithographic color printing. This method yielded a com-

plex array of color combinations by selectively etching line patterns ruled on three color stones (red, yellow, and blue) and then overprinting them together with the black stone (color plate 26).[68] As with crayon shading, the combination of the transfer process with machine ruling in the second half of the nineteenth century began a shift away from working directly on the final printing surface. Since direct ruling of patterns was both tedious and exacting, Eckstein and others saved labor costs by transferring line patterns from master ruled plates. Although the transfer of patterns was not adaptable to wood engraving or wax engraving, other relief printing processes based on relief etching of the printing image could employ it. From the late 1880s, the Ben Day machine and similar devices used flexible gelatine sheets on which the pattern appeared as a raised inked image that could be transferred to the printing surface by pressure.

Major changes in color printing since the late nineteenth century have largely been due to the development of photographic techniques, both for making high-contrast line images and for screening tonal images. For area patterns to be printed in color, the production of adhesive-backed pattern films has meant that the mapmaker can conveniently include mechanical area images on positive ink-drafted artwork intended for photography. More recently, tint screens have been employed in combination with open-window negatives to create flat tint screens or patterns that can be overprinted in precise register to produce different colors. Negative scribing and the introduction of photosensitive material for the preparation of open-window negatives have also contributed to greater accuracy in register. Halftone screens have been used most in the reproduction of colored terrain shading, but process color separation by photomechanical means or by laser scanning to reproduce full-color originals composed of flat color areas is now feasible. Accompanying the development of the photographic tint and halftone screen has been the evolution of a systematic approach to the overprinting of process colors (magenta, cyan, yellow, and black) to achieve virtually any desired color effect. Although topographical maps, for example, are still printed with each feature assigned a separate color of ink and separate press run, the overall trend is toward increased use of process color. In geologic mapping, the detailed topographical base is often printed in solid gray or brown, but the wide variety of hues for geologic unit areas are created by process color combinations.

An additional contribution of modern technology to color printing has been the development of various color proofing methods that allow prepress checking of colored maps.[69] Not only does this facilitate editing for production accuracy, but it also allows the cartographer to refine the design by trying out various screen and color combinations.

The ongoing expansion of computer graphics technology into the field of color map production indicates that the cartographer's relationship to the final cartographic product will increasingly become one of remote control. The possibility of creating colored maps with little or no manual intervention at the production stage makes the contribu-

tion of the cartographer at the initial design stage even more important.

Like color reproduction technology, concepts of graphic design in cartography have changed markedly since the introduction of printed color. Initial attempts at printed color during the nineteenth century were made by cartographers familiar with hand coloring, who sometimes tended to treat printed color similarly as a supplement to an essentially complete black base. Although printed color had been common in European geographical journals since the 1860s, it was not until the 1880s that it finally achieved independent status there. This occurred when the map image began to be separated into colors in such a way that the base image could no longer stand alone if color were removed.[70] In geologic cartography, by contrast, printed color played an integral information-bearing role from its introduction in the 1840s; of course, color had been treated as an independent graphic element on hand-colored geologic maps, where frustration with the limitations of the black base image had already led to greater reliance on color.

One general objection to the graphic quality of printed color by nineteenth-century cartographers, as in the case of early color-printed geologic maps, was based on the practical observation that the opaque printing inks tended to obscure underlying map information.

A number of nineteenth-century cartographers also criticized the garish crazy-quilt appearance of color-printed maps. Josef von Hauslab observed that several German maps of the 1850s made use of "the harshest, most contrasting colors in the effort to make impossible any confusion or misidentification of layer tints in opposite corners of the maps, without consideration for the art of creating the appearance of a plastic form. They desire too much clarity and produce a harlequin-like patchwork, and they have imitators. In this manner, maps become mere schematic representations instead of pictures."[71]

While his criticism of the tasteless use of color has lasting validity, his comments also reflect opinions formed during the era of subtle hand coloring. Eventually the need was recognized for boldness in printed color so it could stand on its own, independent of the black image. This shift to stronger colors also paralleled a general change in artistic style during the late nineteenth century. In cartography as in art, an important aspect of the development of new tastes was the application of scientific color theory in design.

The application of theories about the physical mixing of colors to the overprinting of colors, first mentioned by Leonardo da Vinci and widely discussed after Newton's *Optics,* led to four-color process printing. Experiments using mezzotints were made in the 1730s by Gautier d'Agoty, among others.

Another area of concern in cartographic design since the early nineteenth century has been the development of a sequence of colored layer tints, suited to conveying the visual impression of varying degrees of some phenomenon. The initial focus of experimentation was with the representation of the terrain surface.[72] Since Ptolemy's day, the general rule had been that mountains should be colored darker as they in-

creased in height.[73] This rule was based on the observation of aerial perspective; the lightening effect of atmospheric humidity close to the earth made distant mountains seem to become darker toward their peaks. However, the contrast between the dark upper slopes of mountains and their snow-covered tips created representational problems. During the nineteenth century, some cartographers began to experiment with coloring mountains the other way around, the higher the lighter.[74] For example, Carl Ritter employed this approach on some 1806 maps, where mountainous areas were dark brown in the lower portions and became lighter in shade upward (color plate 27). In 1838 the Prussian cartographer Emil von Sydow introduced a scheme for school wall maps by which the lowlands were printed green up to two hundred meters, the highlands to five hundred meters were colorless, and mountainous country to two thousand meters was brown; this was an early example of lithographic color printing in cartography (color plate 28). In 1864 field ordnance officer Josef von Hauslab proposed a scheme with darker colors for higher elevations.[75] The controversy continued into the twentieth century. Instead of layer tints by elevations, some cartographers recommended plastic shading. Here there were proponents of oblique versus vertical lighting. Austrian cartographer Karl Peucker broke new ground in this field in 1898 when he published his investigations under the title *Schattenplastik und Farbenplastik*.[76] According to Peucker, colored layer tints for terrain should start from below with a blue-green shade and progress through gray-green, green, and yellow-green to a greenish yellow for the intermediate elevation; the progression continues upward through a light brownish yellow to orange-yellow, yellow-orange, orange, red-orange, orange-red, and finally red. This *"adaptive-perspektivische Farbenplastik"* rested, of course, on the spectral progression observed in the physical separation of white light into its components of different wavelengths. Peucker's ideas were challenged by Swiss cartographers, among them Xavier Imfeld, who employed a sequence of colors from brownish violet to olive green for his entry to a competition for a new school map of Switzerland in 1896 (color plate 29).[77] Although the design principles employed have varied, the colored layer tint has held a lasting place in twentieth-century terrain representation on atlas and wall maps and standard worldwide cooperative projects such as the International Map of the World at 1 : 1,000,000. Red, being an advancing color, was proposed for higher elevations, while the receding blues, besides conforming to the convention for water, were used for the lower levels.

Overall in modern cartography there has been increased exploitation of graphic concepts of artistic design, scientific observations about depth perception, and the figure ground relationships of Gestalt psychology. The design-conscious cartographer approaches a map project with the goal of creating a visual hierarchy of symbols that corresponds to the relative importance of their content as part of the cartographic message. Ideas about advancing and receding colors, for example, have been incorporated into a stacking of visual layers that characterizes the best modern atlas design.[78]

Clearly, there is still much to be learned about the possible applications of color in graphic design; at the same time, changes in conventional color symbolism are rapidly occurring. At first, the advent of printed color in the nineteenth century made it possible to increase the conventional association of certain hues with particular map features. Instead of adding hand color to black printed symbols, the entire symbol could be printed in color. Typical instances of such color separation on a nineteenth-century map were route lines in red, hachures or terrain shading in brown, vegetation in green, water in blue, and so on. This practice continues, with the change that accurate registration of process colors now often eliminates the need for a separate press run for each color.

In thematic mapping the development of fixed symbolic color associations has also taken place. For geologic color, a chart organized according to stratigraphy has become standard for United States Geological Survey and USGS-based maps. Each age has a characteristic hue, which is subdivided with the older rocks appearing lighter in value and intensity. Lithology is commonly indicated by patterned overprints or blockouts, although igneous rocks are shown in reds, oranges, and pinks (an example of associative color—the lighter the older). Although each geologic map requires individual design choices, general adherence to the standard color chart and body of lithologic patterns results in consistency and ready comparability of different geologic maps.

In terrain shading, the use of color has also become very sophisticated and elaborate. The progress is evident when one compares the simple brown crayon shading on a late nineteenth-century lithographic map with a modern Swiss topographical map on which subtle shades of yellow, violet, and blue may be combined to convey the effect of aerial perspective, sunlight, and clarity of the Swiss mountain air—that is, the overall coloristic character of the Swiss landscape. This approach to terrain shading reflects the influence of Eduard Imhof, who began his work in the 1920s inspired by intimate knowledge of the Swiss landscape (color plate 30).[79] When Swiss cartographers took on the task of reproducing a terrain-shaded map of Mount McKinley, the traditional Swiss colors were replaced by stronger ones they felt better conveyed the visual feel of the North American terrain (color plate 31).

The use of color on maps has always reflected the character of the time and place in which the map was produced. This is no less true in modern cartography, even when cartographic advances are communicated worldwide through international cartographic meetings and publications. An American printer continuing a series of aeromagnetic maps whose publication was begun in Sweden recently commented on the effort to match the subtler colors characterizing the Swedish maps. There is certainly room for consideration of the influence of cultural characteristics on colored maps of the present era. Studies using contrasting pairs of adjectives to characterize maps might serve as useful models.[80] Of course, maps vary so much in type that it is hard to generalize about national stylistic characteristics; a consideration of variations in the use of color on particular types of maps might be more rewarding.

Modern cartography is technologically both sophisticated and crude in its use of color. Whereas the introduction of printing in the fifteenth century constituted a single major advance, technological advances since the early nineteenth century have come so quickly that they overlap temporally and spatially. Copper-engraved master plates at USGS and wax-engraved plates at Rand McNally were still being used fifty years after the introduction of scribing and various photographic techniques in the mid-nineteenth century. Today a map designed by a skilled cartographer using scribing and separations for process color can represent the ultimate in color sophistication, while a computer-generated map on a color video display screen looks crude by comparison. As this current technological disparity in types of color reproduction is met in the future, there will be opportunity for innovative yet tradition-conscious cartographic design.

CONCLUSION

In the history of map reproduction, color technology has tended to lag behind that of monochromatic cartography. Although color-printed maps did not appear until almost five hundred years after the invention of printing, modern color technology is now able to handle almost every color problem in maps. The removal of the cartographer from direct participation in map reproduction began with the introduction of printing, when design ideas had to be channeled through the engraver and hand colorist. Although modern technology has eliminated the need for human intermediaries to create the printing image, the return of manual control to the cartographer (through production of a pre-printing image) may be only temporary. As continued advances in computer technology free them from the need to participate manually in the production of maps, cartographers will have to exert influence through design decisions. Traditional distinctions between "realistic" associative and pictorial symbolism on the one hand and abstract symbolism on the other are being challenged in an age when mechanical sensing devices can record both visible and nonvisible phenomena for display on maps in instantly changeable color combinations. The blind transference of tradition-bound conventions for color symbols to the new technology should be avoided. The choice of color in modern cartography should accord with the contemporary understanding of the map's function as a graphic communication device. While information about the process of color perception can be used to understand the needs of the map user, consideration of the historical bases of conventional types of color symbolism may also assist in the evaluation of their continuing validity. An active, open-minded participation in color design will do much to ensure cartographers' continuing ability to control the aesthetic quality of maps, even if they are totally machine produced.

The Sources and Development of Cartographic Ornamentation in the Netherlands

FIVE

JAMES A. WELU

For roughly a century, from 1570 to 1670, mapmakers working in the Low Countries brought about unprecedented advances in the art of cartography. The maps, charts, and globes issued during this period, at first mainly in Antwerp and later in Amsterdam, are distinguished not only by their accuracy according to the knowledge of the time, but also by their richness of ornamentation, a combination of science and art that has rarely been surpassed in the history of mapmaking.

Just as maps of this period document the most recent geographical findings, they also exhibit the latest styles of ornamentation, from the semiabstract mannerist designs of the late sixteenth century to the more naturalistic baroque imagery of the following century. The ornament on these maps has often attracted as much attention as the maps' geographical content. This interest in the decorative aspect of cartography is not characteristic only of our own time, when we have come to appreciate maps, particularly older maps, as works of art. As paintings and other documents indicate, it was from the very beginning an important aspect of the making and collecting of maps in the Netherlands.[1]

This study will investigate the variety of sources that Dutch and Flemish cartographers used to decorate their maps in the late sixteenth century and the seventeenth century. More specifically, it will demonstrate that much of the ornamentation was not invented by the mapmakers themselves but was taken from contemporary, and in some cases much earlier, engravings and etchings. Looking at how these sources were used can add to our appreciation of the significance and overall development of cartographic ornamentation during the golden age of Dutch and Flemish mapmaking. Borrowing ornament for maps was so common during this period that it would be a Herculean task to cite every example, but I will cover a range of cartographic forms including atlas maps, loose-leaf maps, wall maps, sea charts, and globes, touching upon most of the major cartographers of the time and a number of minor ones.

I would like to thank Timothy A. Riggs, who read over the manuscript and offered several helpful suggestions, and Hans Mielke, who provided material on Hans Vredeman de Vries.

147

First published in Antwerp in 1570, the *Theatrum orbis terrarum* of Abraham Ortelius is considered the first modern atlas or the first systematic collection of maps based on contemporary knowledge since the days of Ptolemy.[2] Ortelius's *Theatrum* is also known for its numerous decorative cartouches, which undoubtedly added to the atlas's long popularity. As I will show, most of the cartouches in the *Theatrum* were taken from ornament prints published in Antwerp during the 1550s and 1560s.

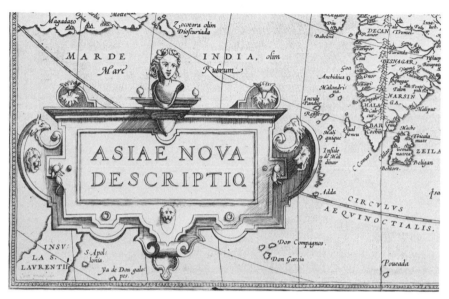

FIG. 5.1 Abraham Ortelius, detail from *Asiae nova descriptio* (1570), in *Theatrum orbis terrarum*. Courtesy of Universiteitsbibliotheek, Amsterdam.

FIG. 5.2 Jacob Floris, engraving from *Veelderhande cierlycke compertementen* (Antwerp, 1564). Courtesy of the Metropolitan Museum of Art, the Elisha Whittelsey Collection, the Elisha Whittelsey Fund, 1948.

Ortelius borrowed the designs for his cartouches from numerous sources. He copied from at least two series of ornament prints designed by Jacob Floris and published in Antwerp during the 1560s. The title cartouche on Ortelius's map of Asia (fig. 5.1), which appeared in the first edition of his atlas, comes from a Floris print of 1564 (fig. 5.2).[3] Here Ortelius used only the main part of the original design, eliminating many of the peripheral elements. Ortelius's design is a mirror image of the original, the light coming from the upper right instead of the upper left. This reversal, probably the result of the printing process, suggests that the engraver of the map traced his design directly from an original ornament print.[4] Ortelius, who drew the manuscripts for all the maps in the first edition of his atlas, states in his preface that almost all the plates were engraved by Frans Hogenberg and his assistants. Who was actually responsible for selecting the ornament—Ortelius, Hogenberg, or a third person—remains unknown.

By the mid-sixteenth century the publication of ornament prints designed specifically to be used by craftsmen in decorating objects was a well-established tradition. The designs Ortelius used were also intended to be used by woodcarvers, stonemasons, silversmiths, and a host of other craftsmen. By this time most ornament prints were issued in sets. A set might range from five prints to as many as thirty-five; the ornament designers seemed to have prided themselves on the number of variations that could be made on a particular theme. A set of prints would frequently be issued with a title page and might well be sewn or bound into book form. The fate of these albums, however, was usually to be broken up and scattered, and doubtless thousands of them were destroyed by the craftsmen who used them.

Ortelius was certainly not the only mapmaker to use contemporary ornament prints. In fact the same design that appears on his map of Asia can be found on the map of Flanders (fig. 5.3) in Gerard de Jode's *Speculum orbis terrarum* (1578), the first atlas to appear after Ortelius's. De Jode's map includes more of Floris's original design, although part of it is cut off at the right. The space inside the cartouche is made larger than the original to accommodate the inscription, and a bear holding a flag is added at the top.

Another series of seventeen ornament prints by Jacob Floris, published in Antwerp in 1566, inspired the ornamentation on at least half a dozen other maps in the *Theatrum*.[5] One cartouche containing a depiction of Apollo and Daphne (fig. 5.4) was used on the maps of Brandenburg (1588) and of New Spain (1579) (fig. 5.5). On both maps the cartouche appears at the lower left, its mythological image replaced by an inscription. The ship on the map of New Spain, just to the right of the Floris cartouche, was also taken from an earlier engraving, a view of sixteen ships (fig. 5.6), which traditionally has been associated with Pieter Bruegel the Elder. Although this print is now rejected from Bruegel's oeuvre, it appeared with a set of naval prints designed by him and issued in 1565.[6] As van Beylen has already noted, many of the ships on Ortelius's atlas maps were taken from the prints in this series.[7] The

same prints were used by other mapmakers such as Gerard de Jode, who also drew from the view of sixteen ships for the large vessel on his map of Flanders (fig. 5.3). Van Beylen notes that because of their mixed accuracy the ships on these maps are of little value for the study of naval vessels.

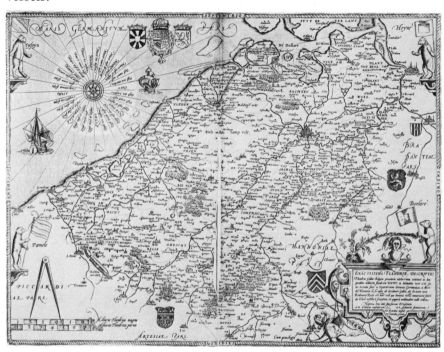

FIG. 5.3 Gerard de Jode, *Exactissima Flandriae descriptio* (1578), in *Speculum orbis terrarum*. Courtesy of Leiden University Library, Bodel Nijenhuis Collection.

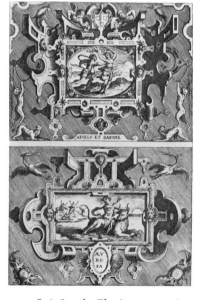

FIG. 5.4 Jacob Floris, engraving from *Compertimentorum* (Antwerp, 1566). Courtesy of the Rijksmuseum, Amsterdam.

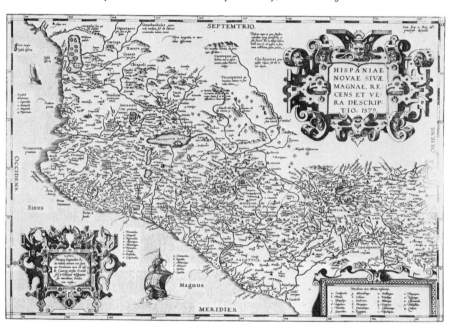

FIG. 5.5 Abraham Ortelius, *Hispaniae novae* . . . (1579), in *Theatrum orbis terrarum*. Courtesy of the Newberry Library, Chicago.

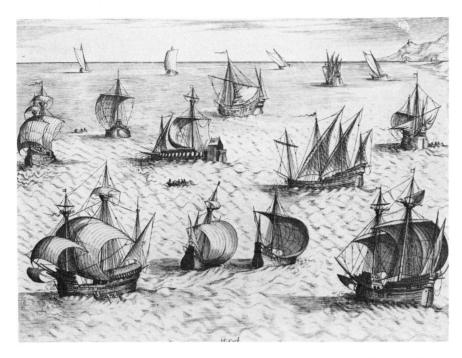

FIG. 5.6 Anonymous, *View of Sixteen Ships* (1565?). Courtesy of the Graphische Sammlung Albertina, Vienna.

The title cartouche on Ortelius's map of New Spain was taken from yet a third source (fig. 5.7), one of a series of ornament prints by the Flemish artist Hans Vredeman de Vries. This set, which consists of thirteen prints, was engraved by Frans Huys and published in Antwerp in 1555 by de Jode.[8]

In borrowing from ornament prints, mapmakers did not hesitate to adapt them to their own particular needs. Designs were sometimes reproduced with few changes, as we have seen in the two cartouches on the map of New Spain, but more often the cartographer used only part of the design, as seen in Ortelius's map of Asia (fig. 5.1). Mapmakers also cropped ornament designs in various ways. One cartouche by Vredeman (fig. 5.8) appears on three of Ortelius's maps that were added to the *Theatrum* at different times: Bavaria (1573, fig. 5.9), Le Maine (1594, fig. 5.10), and ancient Egypt (1595, fig. 5.11), and in each case the cartouche was cropped differently.[9] On the map of Bavaria, the design was cut off on the right side and placed along the right border to serve as the title cartouche; on the Le Maine map only the top part of the design was used, placed at the bottom right to form the cartouche containing the graphic scale; and finally, on the map of ancient Egypt the lower half of the design was used, placed along the upper left-hand border to again serve as the title cartouche. Fragmented cartouches are found throughout the *Theatrum*. This style of ornamentation, which enjoyed a vogue in mapmaking during the second half of the sixteenth century, is typical of mannerist art, in which forms are often fragmented or seek the edge of the overall composition.

FIG. 5.7 Hans Vredeman de Vries, engraving from *Variarum protractionum* . . . (Antwerp, 1555). Courtesy of the Royal Library, Stockholm, Map Section.

FIG. 5.8 Hans Vredeman de Vries, engraving from *Multarum variarum que protractionum* (Antwerp, 1555). Courtesy of the Royal Library, Stockholm, Map Section.

FIG. 5.9 Abraham Ortelius, detail from *Bavariae* (1573), in *Theatrum orbis terrarum*. Courtesy of Leiden University Library, Bodel Nijenhuis Collection.

FIG. 5.10 Abraham Ortelius, detail from *Cenomanorum* (1594), in *Theatrum orbis terrarum*. Courtesy of the Geography and Map Division, Library of Congress.

FIG. 5.11 Abraham Ortelius, detail from *Aegyptus antiqua* (1595), in *Theatrum orbis terrarum*. Courtesy of the Newberry Library, Chicago.

FIG. 5.12 Hans Vredeman de Vries, engraving from untitled set of ornament prints (Antwerp, 1560–63). Courtesy of the Graphische Sammlung Albertina, Vienna.

FIG. 5.13 Hans Vredeman de Vries, engraving from untitled set of ornament prints (Antwerp, 1560–63). Courtesy of the Graphische Sammlung Albertina, Vienna.

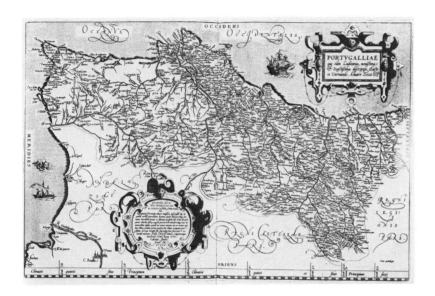

FIG. 5.14 Abraham Ortelius, *Portugalliae* (1570), in *Theatrum orbis terrarum*. Courtesy of the Newberry Library, Chicago.

The ornament prints designed by Vredeman were by far the most popular source for the cartouche work in the *Theatrum*. Ortelius borrowed from at least four series of prints by Vredeman. He was especially dependent on two sets, one including twenty cartouches, the other sixteen, that date from about 1560–63, both published in Antwerp by Hieronymus Cock.[10] Ortelius managed to incorporate almost all thirty-six cartouches into his atlas in one way or another, many of them more than once. For example, two designs from the series of twenty (figs. 5.12, 5.13) were used on Ortelius's map of Portugal (fig. 5.14), which appeared in the first edition of the *Theatrum*. Both cartouches on this map are exact copies of the central portion of Vredeman's designs, the only differences being that, as we have seen before, both are mirror images of the originals. These same two cartouches were used again by

FIG. 5.15 Hans Vredeman de Vries, engraving from untitled set of ornament prints (Antwerp, 1560–63). Courtesy of the Graphische Sammlung Albertina, Vienna.

FIG. 5.16 Hans Vredeman de Vries, engraving from untitled set of ornament prints, (Antwerp, 1560–63). Courtesy of the Graphische Sammlung Albertina, Vienna.

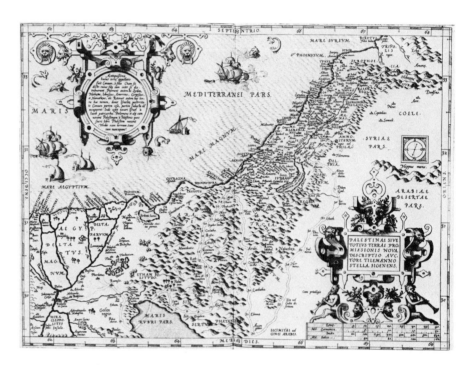

FIG. 5.17 Abraham Ortelius, *Palestinae* (1570), in *Theatrum orbis terrarum*. Courtesy of the Newberry Library, Chicago.

Ortelius. The upper half of the rectangular cartouche frames the graphic scale on his map of Provence (1594), and parts of the other cartouche appear on his maps of ancient Thrace (1585) and of the area around Florence (1595). These two cartouches, like much of Vredeman's work, continued to serve as a model for cartographic ornament well into the seventeenth century. For example, the round cartouche appears on Jodocus Hondius's maps of Valencia and Africa, both added to the Mercator-Hondius atlas in 1606, and the rectangular cartouche appears on Hondius's atlas map of France dated 1622,[11] his terrestrial globe of

FIG. 5.18 Abraham Ortelius, detail from *Monasteriensis et osnaburgensis episcopatus descriptio* (1570), in *Theatrum orbis terrarum*. Courtesy of Leiden University Library, Bodel Nijenhuis Collection.

FIG. 5.19 Hans Vredeman de Vries, engraving from untitled set of ornament prints (Antwerp, 1560–63). Courtesy of the Graphische Sammlung Albertina, Vienna.

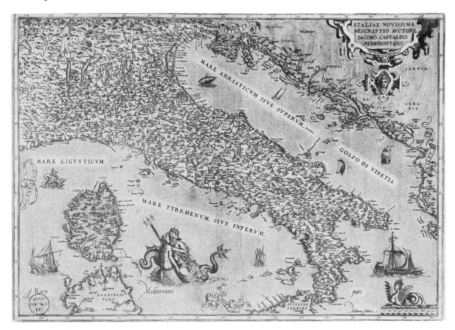

FIG. 5.20 Abraham Ortelius, *Italiae novissima descriptio* (1570), in *Theatrum orbis terrarum*. Courtesy of the Leiden University Library, Bodel Nijenhuis Collection.

1592,[12] and finally a wall map of the Seventeen Provinces issued in 1630 by Henricus Hondius of The Hague.[13]

From the same series of cartouches used on his map of Portugal, Ortelius borrowed two more designs (fig. 5.15 and 5.16)[14] for his map of the Holy Land (fig. 5.17), which also appeared in the first edition of the *Theatrum*. Here, in both cases, most of Vredeman's original ornament print was used. Filling up large areas of both land and sea, Vredeman's designs transform the map into an extremely decorative object. Ortelius

also took the liberty of reworking borrowed designs, as may be seen in his map of the diocese of Münster (1570). The title cartouche on this map (fig. 5.18) was taken from a design by Vredeman (fig. 5.19),[15] but on Ortelius's map the area inside the cartouche was reduced by inserting a square frame and additional shading.

A variation of a different sort appears on the title cartouche for Ortelius's map of Italy (1570) (fig. 5.20). Here the design is made up of parts from two different ornament prints, both by Vredeman. The upper part was taken from one print, while the pendant form at the bottom containing a human head was taken from another.[16] The sphinx seated on the graphic scale at the lower right also comes from an ornament print by Vredeman,[17] and as might be expected, most of the naval vessels on the map can be traced to an earlier source, the view of sixteen ships (fig. 5.6), which as we have seen was in common use among mapmakers of this period. The representation of Triton and a Nereid in the Tyrrhenian Sea is also not original; it was taken from an earlier map of Italy by Giacomo Gastaldi, which Ortelius used as a source for most of the map's geographical content. It is interesting that Gastaldi also borrowed the pair of sea figures; they are taken from a Jacopo de' Barbari engraving of about 1503.[18] Ortelius apparently later felt de' Barbari's image was old-fashioned, for in 1584, when it became necessary to replace the worn copperplate for his map of Italy, the only major change he made was to replace the original Triton and Nereid with more modern figures. Gastaldi's map of Italy was not the only map from which Ortelius borrowed ornament. Diego Gutierrez's large map of America, published posthumously in Antwerp in 1562, served Ortelius for many of the ships, sea animals, and even mermaids on his atlas maps.[19]

FIG. 5.22 Benedetto Battini, engraving from untitled set of ornament prints (Antwerp, 1553). Courtesy of the Royal Library, Stockholm, Map Section.

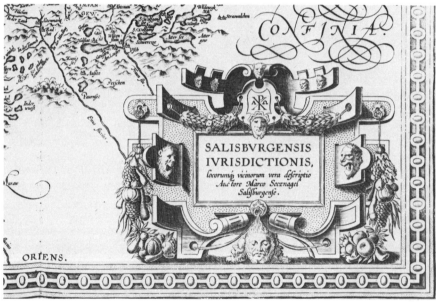

FIG. 5.21 Abraham Ortelius, detail from *Salisburgensis jurisdictionis* (1570), in *Theatrum orbis terrarum*. Courtesy of the Newberry Library, Chicago.

A series of designs by the obscure Italian artist Benedetto Battini, issued in Antwerp in 1553 by Hieronymus Cock,[20] served as a model for cartouches on at least a dozen of Ortelius's maps, many of which were added to the *Theatrum* during the 1590s. The title cartouche on Ortelius's map of Salzburg (fig. 5.21) almost exactly reproduces one of Battini's original designs (fig. 5.22). Here Battini's cartouche is joined by two others taken from designs by Vredeman.[21]

Many of the sixteenth-century designs that were published as ornament prints have become better known through the maps they appear on than through the original prints. For example, when the nineteenth-century publisher Charles Claesen issued a collection of about eighty cartouches to be used by "stone and wood carvers, cabinet-makers, decorative painters, glass painters, art-metal workers and architects,"[22] his main source was Ortelius's *Theatrum*.[23] Claesen, who credited all the cartouches to Ortelius, was apparently unaware that most were taken from earlier sources. Plate 24 (fig. 5.23) from this nineteenth-century pattern book shows two cartouches, both of which can be attributed to Battini, one being taken from Ortelius's map of Salzburg (fig. 5.21).[24]

Ortelius copied from at least eight different sets of ornament prints for the ornamentation in his *Theatrum orbis terrarum*. It seems likely that a further investigation of the atlas's ornamentation will show that except for specially designed title pages very little is original.[25] Ortelius was primarily a compiler rather than an innovator in terms of not only his maps' ornamentation but also their geographical content.[26] Yet through his skillful handling of eclectic elements, both geographic and decorative, he succeeded in producing one of the most important and attractive publications of the sixteenth century, a work that was to have a long influence, both cartographically and artistically, on the many maps and atlases that were to follow.

FIG. 5.23 Charles Claesen, plate 24 from *Kartuschen im Style der flamischen Renaissance* (Berlin, 1886). Courtesy of the Trustees of the Boston Public Library.

SEVENTEENTH-CENTURY EXAMPLES

During the seventeenth century cartographic ornamentation became increasingly elaborate, and its content increasingly specific. The strapwork cartouches of the previous century, characterized by their abstract designs and anonymous figures, soon gave way to more naturalistic imagery, often centered on a particular theme. As a result many cartographers had designs made specially for their maps. On some maps the designer of the ornament is given, and in some rare cases preparatory drawings have survived. There exists, for example, a preparatory drawing for part of one of the major cartouches on Willem Jansz. Blaeu's large world map of 1605. This drawing, attributed to David Vinckeboons, is preserved in the Staatliche Graphische Sammlung in Munich.[27] Another well-known Dutch painter and engraver, Nicolaes Berchem, provided several drawings for the decoration on two atlas maps, both published during the second half of the seventeenth century by Nicolas Visscher.[28] As one might expect, the printed designs are mirror images of the preparatory drawings.

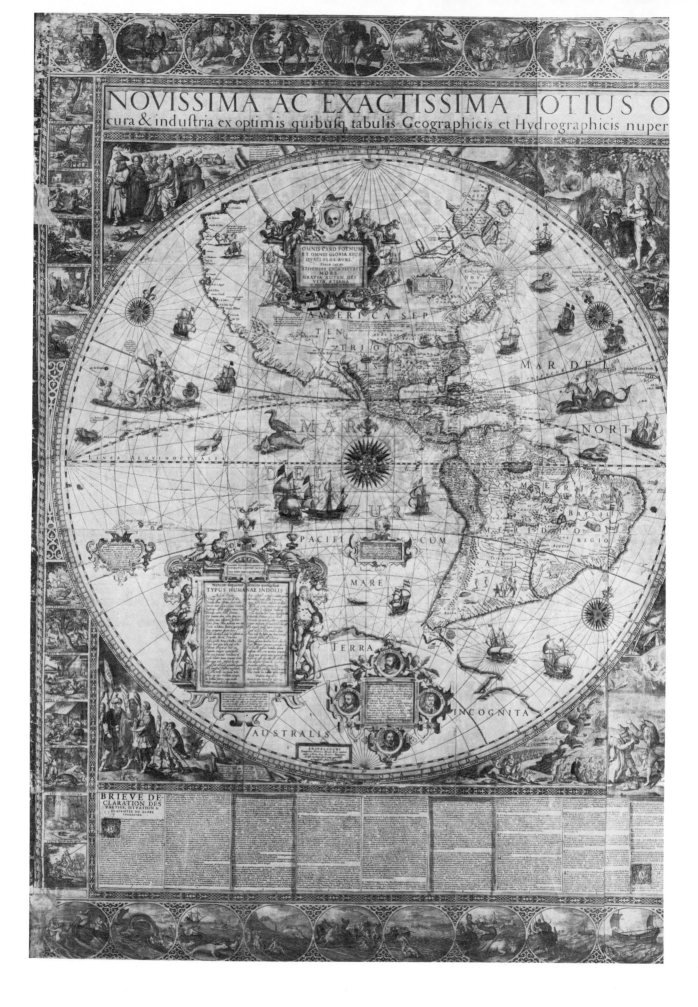

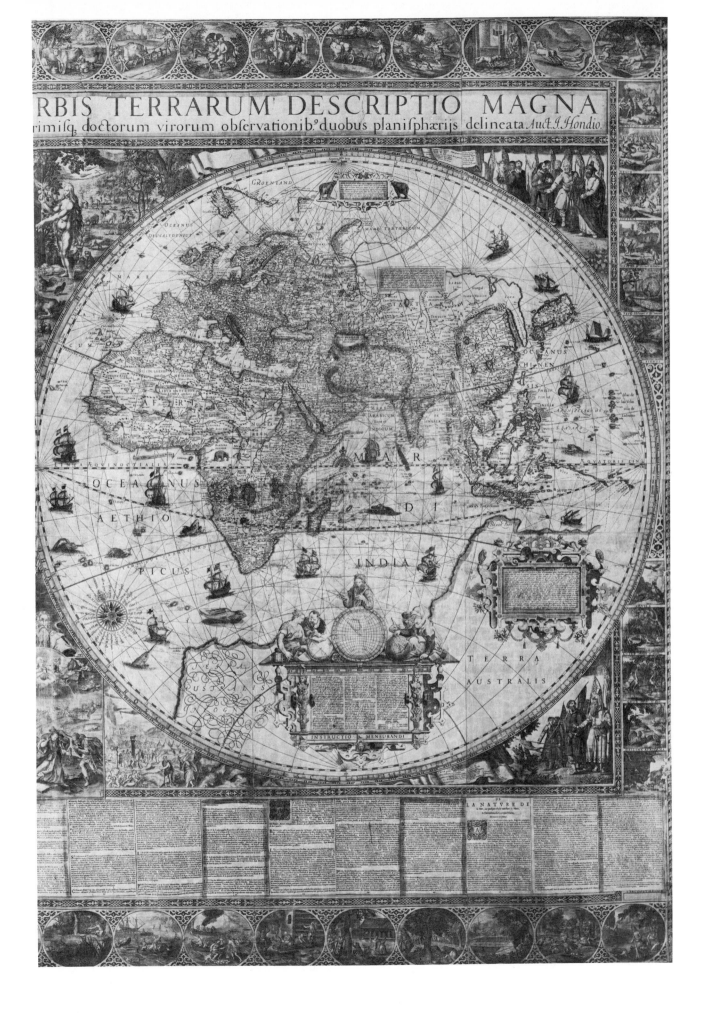

FIG. 5.25 Jan Saenredam after Cornelis Ketel, *Allegory of Gratitude and Ingratitude*. Courtesy of the Rijksmuseum, Amsterdam.

FIG. 5.26 Johannes Sadeler I after Marten de Vos, *Bonorum et Malorum consensio . . .* (1586). Courtesy of the Rijksmuseum, Amsterdam.

Even with the more elaborate cartographic ornamentation of the seventeenth century, many Dutch mapmakers still managed to copy from other works. But in contrast to sixteenth-century cartographers, who borrowed mainly from ornament prints, those of the following century relied more heavily on figurative prints. Some of the most elaborate cartographic cartouches of this period are found on wall maps. One example, Jodocus Hondius's large world map of 1611, can be best appreciated in a well-preserved later copy in the Bibliothèque Nationale, Paris (fig. 5.24).[29] This copy was issued in 1634 by Hondius's son Henricus. One of the main cartouches on Hondius's map, in the lower half of the Western Hemisphere, was taken from an allegorical print engraved by Jan Saenredam after Cornelis Ketel sometime before 1604 (fig. 5.25). Hondius eliminated the main allegorical image and replaced it with a passage from Pindar that complements the theme of the original print: good and evil nature. Hondius also changed the attributes of the two male figures on the sides. Whereas in the original cartouche they are pagan gods, Apollo and Saturn, in the Hondius cartouche they have been given Christian attributes. The figure on the right places his foot on a serpent while the figure on the left is shown holding a placard inscribed LEX DEI (law of God) and rests his foot on a rock inscribed *Christus,* which crushes a serpent. The full meaning of Hondius's cartouche has yet to be explained.

Hondius's wall map includes another large, allegorical cartouche in the upper half of the Western Hemisphere. This cartouche was taken from a print designed by Marten de Vos and engraved by Johannes Sadeler I (fig. 5.26). Dated 1586, Sadeler's print forms the title page for a suite of fourteen prints on the history of the family of Seth.[30] Hondius reproduced most of Sadeler's design and reinforced its *vanitas* theme both by replacing the coat of arms at the top with a large skull and by adding burning candles at the sides and in the hands of the two figures at the top. The two inscriptions on Hondius's cartouche also relate to *vanitas;* the one, taken from Isaiah, appears on the print by Sadeler. *Vanitas* imagery was not uncommon in sixteenth- and seventeenth-century cartography, particularly on world maps.[31] On Hondius's map, however, the moralistic cartouche appears in an unusual place, in the area of North America, a spot usually given over to imagery relating specifically to the New World.[32]

Part of the large cartouche in the Eastern Hemisphere was also taken from another source. This cartouche includes five figures shown working with cartographic materials. The man on the left, next to the woman surrounded by scientific instruments, is thought to be a portrait of Hondius. Both this figure and the woman were taken from Hendrik Goltzius's representation of Geometry (fig. 5.27), which was part of a series on the Seven Liberal Arts engraved by Cornelis Drebbel.[33]

FIG. 5.24 (preceding pages) Jodocus Hondius, *Novissima ac exactissima totius orbis terrarum . . . ,* published by Henricus Hondius (Amsterdam, 1634). Courtesy of the Bibliothèque Nationale, Paris.

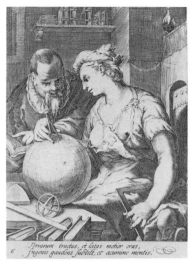

FIG. 5.27 Cornelis Drebbel after Hendrik Goltzius, *Geomtery*. Courtesy of the Prentenkabinet, Leiden.

FIG. 5.28 Pieter Plancius, detail from *Universi orbis tabula . . .* (1607), published by Cornelis Danckerts (Amsterdam, 1651). Courtesy of the Royal Library, Copenhagen.

FIG. 5.29 Herman Hugo, *Obsidio Bredana . . .* (Antwerp, 1626). Courtesy of the Department of Rare Books and Special Collections, University of Michigan Library, Ann Arbor.

All three of Hondius's large cartouches demonstrate the complexity and highly symbolic nature of seventeenth-century map ornamentation. Hondius combined these figurative cartouches with other cartouches that consist mainly of strapwork. Like Ortelius, Hondius undoubtedly took some of the strapwork designs from ornament prints. The small cartouche to the left of the large cartouche on good and evil nature also appears on a terrestrial globe published in 1613 by Hondius's son Jodocus, Jr., and Adriaan Veen.[34]

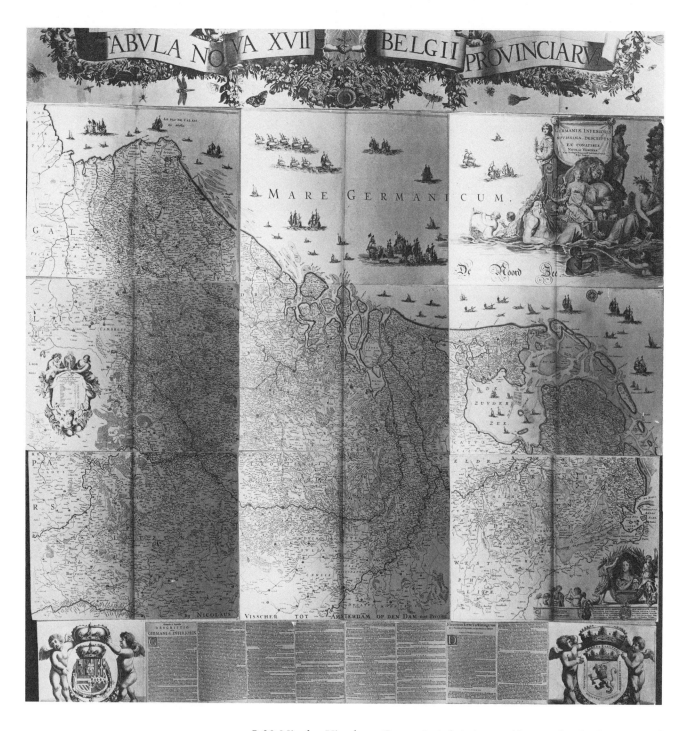

FIG. 5.30 Nicolas Visscher, *Germania inferioris . . .* (Amsterdam). Courtesy of the Board of Trinity College, Dublin.

Title prints like the one by Sadeler that Hondius used were a convenient source for the more elaborate cartouches that came into vogue during the seventeenth century. This source of ornament continued to be used throughout the period. In 1651 when Cornelis Danckerts reissued Pieter Plancius's large world map of 1607, he added a large cartouche (fig. 5.28), the main part of which was taken from a title page designed by the Flemish master Peter Paul Rubens (fig. 5.29). This title page, which appears in a book dated 1625,[35] includes a pair of putti and the mythological figures Hercules and Minerva. To adapt Rubens's design Danckerts made a few changes, replacing the coat of arms at the top and substituting a different base.

Another elaborate title page was used for the main cartouche on a nine-sheet map of the Seventeen Provinces that was published at least twice during the second half of the century, by both Hugo Allart and Nicolas Visscher. A copy of the Visscher edition, shown here (fig. 5.30), is preserved in book form in the Trinity College Library, Dublin;[36] it includes the additions of a decorative title band, two large coats of arms, and a descriptive text.[37] The title page (fig. 5.31) used for the main part of the map's title cartouche comes from a series of portraits of Dutch rulers published in 1650 by Pieter Soutman. Its allegorical imagery, which relates specifically to the Netherlands, made it a logical choice for a map of the Seventeen Provinces.[38] The same map includes on the left side another cartouche that was also borrowed. Here the maker of the map continued the sixteenth-century tradition of using ornament prints. The entire cartouche, which features three satyrs, was taken from a print by Stefano della Bella (fig. 5.32). Reflective of the seventeenth century's more naturalistic style of ornament, this cartouche belongs to a series of eighteen decorative prints published in Paris in 1646.[39]

It is not surprising to find a mapmaker like Allart borrowing ornament, for he often borrowed his geographical information as well. But even one of the Netherland's most accomplished cartographers, Willem Jansz. Blaeu, produced maps with ornament that can be traced to earlier sources. Several examples are found in his very successful pilot book *Het Licht der Zee-vaert,* the earliest known copies of which are dated 1608.[40] One of the most attractive designs in Blaeu's pilot book, the title cartouche for the coastal chart of Picardy and Normandy (fig. 5.33), includes figures of Bacchus and Ceres taken from two separate prints by Jan Saenredam (figs. 5.34, 5.35). Saenredam's two prints, published together in 1596, are both after drawings by Hendrik Goltzius.[41] The grotesque mask at the top of Blaeu's cartouche comes from a third print that Goltzius himself engraved.[42] The engraver of Blaeu's sea chart copied the figures and mask closely but took the liberty of denuding Bacchus by removing one of the god's grape leaves.

Another map in Blaeu's pilot book, a coastal chart of northwestern Africa, includes a cartouche flanked by two seated putti (fig. 5.36), a design that was also taken from an earlier mannerist print, Nicolas de Bruyn's *The Golden Age* (fig. 5.37), made in 1604 after a drawing by Abraham Bloemaert.[43] In addition to reversing the image,

FIG. 5.31 Cornelis Visscher, title page to *Principes Hollandiae, Zelandiae, et Frisiae* . . . (Haarlem, 1650). Courtesy of the Worcester Art Museum.

FIG. 5.32 Stefano della Bella, ornament design from *Raccolta di varii cappriccii et nove inventioni de cartelle et ornamenti* (Paris, 1646). Courtesy of the Metropolitan Museum of Art, Harris Brisbane Dick Fund, 1937.

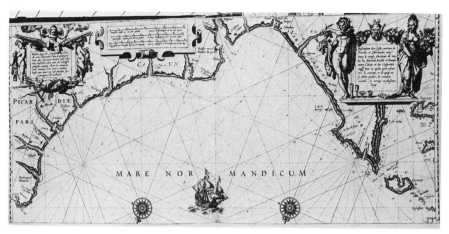

FIG. 5.33 Willem Jansz. Blaeu, coastal chart of Picardy and Normandy from *Het Licht der Zee-vaert* (1608). Courtesy of the Maritiem Museum "Prins Hendrik," Rotterdam.

FIG. 5.34 Jan Saenredam, after Hendrik Goltzius, *Homage Paid to Bacchus* (1596). Courtesy of the Metropolitan Museum of Art, the Elisha Whittelsey Collection, the Elisha Whittelsey Fund, 1951.

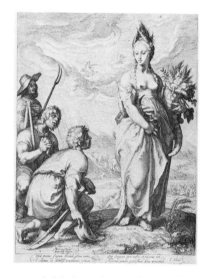

FIG. 5.35 Jan Saenredam, after Hendrik Goltzius, *Homage Paid to Ceres* (1596). Courtesy of the Metropolitan Museum of Art, the Elisha Whittelsey Collection, the Elisha Whittelsey Fund, 1951.

Blaeu eliminated the drapery around one of the putti and slightly altered the shape of the cartouche at the bottom.

Blaeu's maps in turn served as a source for other cartographers like Pieter van den Keere, whose map of the Seventeen Provinces, dated 1617, was derived mainly from Blaeu's 1608 map of the same subject.[44] Van den Keere's map was included in his atlas *Germania inferior,* published the same year. The two major cartouches, all the naval vessels, and even the two sea animals on van den Keere's map were taken from Blaeu. Van den Keere was not the only cartographer to use Blaeu's ornamentation. The title cartouche and some of the ships from Blaeu's map are also found on another map of the Netherlands issued by Justus Danckerts in 1628.[45] But small variations on Danckerts's title cartouche indicate that the borrowing was indirect and that Danckerts referred not to Blaeu's map, but to van den Keere's.[46]

For his *Germania inferior,* the first atlas of the Netherlands, van den Keere depended almost exclusively on ornament from earlier maps. The source he referred to most often was another work by Blaeu that I have already mentioned, *Het Licht der Zee-vaert.* Most of the cartouches in van den Keere's atlas can be traced to this important pilot book.[47] One of the designs from *Het Licht der Zee-vaert* (fig. 5.36), which as I noted was taken from a print after Bloemaert, was used as the title cartouche on van den Keere's atlas map of Groningen (fig. 5.38), where it is surmounted by the coat of arms of the province. Van den Keere used the same cartouche on a map of Africa that he published separately in 1614 (fig. 5.39). Here the presence of the drapery next to the putti and the shape of the cartouche indicate that he referred to the print after Bloemaert and not the variant in Blaeu's *Het Licht der Zee-vaert.* In this case van den Keere added his own personal *vanitas* motif, a skull-faced clock.[48] Bloemaert's design was used yet a fourth time on another loose-leaf map of Africa (fig. 5.40), dated 1623, issued by Jodocus Hondius.

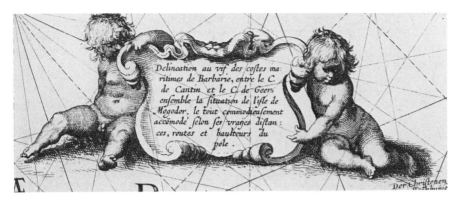

FIG. 5.37 Nicolas de Bruyn after Abraham Bloemaert, detail from *The Golden Age* (1604). From the Collection of Mr. and Mrs. David Tunick.

FIG. 5.36 Willem Jansz. Blaeu, detail from coastal chart of northwestern Africa in *Het Licht der Zee-vaert* (1608). Courtesy of Maritiem Museum "Prins Hendrik," Rotterdam.

FIG. 5.38 Pieter van den Keere, detail from *Groninga*. Courtesy of Leiden University Library, Bodel Nijenhuis Collection.

FIG. 5.39 Pieter van den Keere, detail from *Africae nova descriptio* (1614). Courtesy of the Staatliche Bibliothek Regensburg.

FIG. 5.40 Jodocus Hondius, detail from *Africae nova tabula* (1623). Courtesy of Leiden University Library, Bodel Nijenhuis Collection.

FIG. 5.41 Jodocus Hondius, detail from *Galliae* (1617). Courtesy of Badische Landesbibliothek, Karlsruhe.

The cartouche on the Hondius map is the same as Blaeu's variant but includes van den Keere's personal emblem, the skull-faced clock. This motif suggests that van den Keere, who was the uncle of Jodocus Hondius, engraved the map.

Van den Keere, who distinguished himself as one of the most prolific map engravers of the seventeenth century, frequently used other maps as sources for his ornament. Like most engravers of this period, he worked for a variety of publishers throughout his career. The mobility of engravers contributed to the repetition of cartographic ornament, even among publishers who were in competition with each other. One of the most celebrated rivalries of this period was between the publishing house of Blaeu and the partnership of Henricus Hondius and Joannes Janssonius. The two firms competed for the lead in atlas production, and yet, because of earlier exchanges of copperplates and subsequent mutual borrowing, the same cartographic ornament frequently appears on the maps of both. For example, many of the maps that were added to the Hondius-Janssonius atlas in the early 1630s (when the competition began) contain ornament that can be traced back to maps by Blaeu. A particularly interesting example appears in the Hondius-Janssonius atlas of 1633, the title cartouche on a map of France dated 1631 (fig. 5.41). This map was first issued in 1617 with a decorative border by Henricus Hondius's brother, Jodocus.[49] The title cartouche was taken from Blaeu's sea chart of Picardy and Normandy that I have already discussed (fig. 5.33). The figures of Bacchus and Ceres from Blaeu's title cartouche at the right are combined with one of the putti from Blaeu's other title cartouche, at the left. On the Hondius map the putto receives a crown with three large lilies to make him a symbol of France. The fox and rabbit that appear on either side of the Hondius cartouche are also taken from two other sea charts in Blaeu's pilot book.[50] The Hondius cartouche is truly eclectic, composed of parts from four different cartouches, one of which—that with the figures of Bacchus and Ceres—was itself dependent on earlier sources. Considering its origins, it seems likely that the cartouche on the map of France was composed by van den Keere. In the same year that this cartouche first appeared, 1617, van den Keere published his *Germania inferior,* which includes many similar eclectic designs, the bulk of which were also drawn from Blaeu's *Het Licht der Zee-vaert.*

Blaeu's maps continued to be a popular source of ornament throughout the century. Justus Danckerts, who headed one of the leading cartographic firms during the second half of the century, also copied freely from him. One example of his plagiarism, which appears on a sea chart of Europe (fig. 5.42), resulted in some strange juxtapositions. The figurative cartouche at the top, taken from Blaeu's atlas map of China (fig. 5.43), includes six figures, all of which are oriental and have nothing to do with the subject of Danckerts's sea chart. Since Blaeu's map did not appear until 1655,[51] we can assume that the sea chart was issued sometime afterward and not earlier as has been suggested.[52] Even more amusing than Danckerts's title cartouche are the three figures added to the

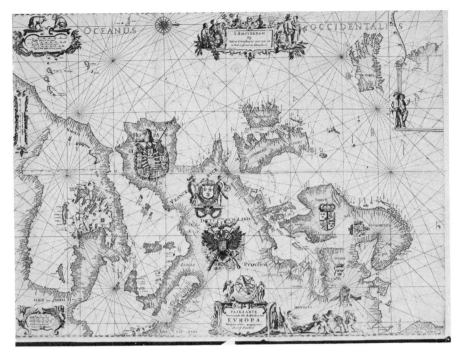

FIG. 5.43 Willem Jansz. Blaeu, detail from *Imperii Sinarum nova descriptio* (1655). By permission of the British Library.

FIG. 5.42 Justus Danckerts, *Paskaarte . . . Europa* (ca. 1650). By permission of the British Library.

framework between Iceland and Greenland, which come from Blaeu's sea chart of the West Indies published about 1630.[53] Taken from their original setting in South America, these three nude figures are certainly unprepared for the frigid climate in which the mapmaker has placed them.[54] Most of the other ornamentation on Danckerts's chart comes from a sea chart of Europe by Blaeu of about 1625.[55] Blaeu's chart influenced not only Danckerts's, but a whole series of decorative sea charts of Europe issued by various mapmakers throughout the seventeenth century. Danckerts, however, even went so far as to borrow Blaeu's printer's mark,[56] which he used in the title cartouche at the bottom. Next to the cartouche are several putti carrying a garland of flowers, a design that can also be traced to an earlier source, the title band on Claes Jansz. Visscher's wall map of Germany.[57]

Danckerts's wholesale borrowing of ornament from other maps is indicative of the seventeenth-century mapmakers' push to make their works more decorative. In spite of their often derivative designs, Danckerts's maps seem to have had great appeal; as the early eighteenth-century scholar Gregorii wrote, "his clear engraving and illumination attracted many collectors who bought all his maps whether they were accurate or inaccurate."[58] In the case of Danckerts's sea chart of Europe, even the ornamentation is inaccurate.

The eclecticism in cartographic ornamentation was frequently carried further by subsequent publications of the same map, particularly wall maps, which during the seventeenth century were often furnished with

CLAES JANSZ. VISSCHER

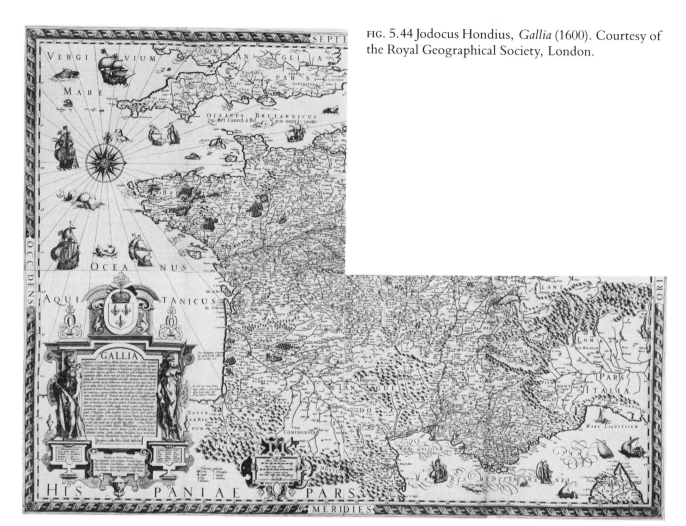

FIG. 5.44 Jodocus Hondius, *Gallia* (1600). Courtesy of the Royal Geographical Society, London.

additional ornament borders. An interesting example is Claes Jansz. Visscher's revision of Jodocus Hondius's four-sheet map of France. A rare copy of the first edition of this map is preserved at the Royal Geographical Society, London.[59] Bound in an atlas with a variety of maps from the sixteenth and seventeenth centuries,[60] this copy, which lacks one of its four sheets, measures overall 74 by 100 centimeters (fig. 5.44).[61] Although it bears no date of publication, Hondius's map of France appears to have been printed about the beginning of the seventeenth century,[62] when the same Amsterdam publisher produced several other wall maps in four sheets, all of which are today extremely rare. In fact, each of the other maps, which include Europe, America, Africa, and the Seventeen Provinces, is also known by only one surviving copy.[63]

The large cartouche at the lower left containing the map's title and descriptive legend features Apollo on the left and Minerva on the right.[64] The cartouche's architectural framework appears to have been designed by Hondius, while both mythological figures were taken from Hendrik Goltzius's portrait print of the French classical scholar Julius Caesar Scaliger, dated 1588 (fig. 5.45).[65] As we have seen, this was not the only time Hondius borrowed from Goltzius; he also used figures

from the pendant to this print, a portrait of Scaliger's son Joseph Justus (1575), to decorate two of his other four-sheet maps.[66]

The small cartouche containing the map's graphic scale was also taken from an earlier source, one of the cartouches on an ornament print by Jacob Floris, published in 1566 (fig. 5.4). This cartouche is the other half of the same print that Ortelius used in decorating two of his atlas maps (fig. 5.5).[67] On Hondius's map, both the graphic scale cartouche and the two figures on the title cartouche are identical in size to their original source; reproduced as mirror images, they appear to have been traced directly from the original prints.

A comparison of the title and graphic scale cartouches shows that the chiaroscuro or lighting on these two designs is not the same. On the larger design the light comes from the upper right, whereas on the smaller one it comes from the upper left. Such inconsistency in the chiaroscuro, which also appears among the ships and sea animals, is indicative of the eclecticism of the map's ornamentation. The sea animals, many of which appear on other maps by Hondius,[68] seem for the most part to be imaginary. On the other hand, the ships, which range from several single-masted galleys on the Mediterranean Sea to a British ship and a Spanish ship engaged in combat in the English Channel,[69] suggest the variety of naval vessels that could be seen in the waters around Europe at the time the map was made.[70]

It was in 1650, about a half-century after the Hondius map first appeared, that Visscher reissued it in a revised state. For this edition Visscher engraved two additional plates, one of costumed figures and the other of town views. As with the original edition, only one copy of Visscher's map is known. Preserved in the Bibliothèque Nationale, Paris,[71] this map consists of six separate sheets, whose contents are assembled as intended in figure 5.46. The present rarity of Visscher's revised map is no measure of its availability during the second half of the seventeenth century, for as late as 1682, long after the map was reissued by Visscher, his grandson, Nicolas Visscher II, applied for privileges to publish a long list of works that included a map of "France of four map [sheets] and two ornamentation sheets."[72]

When Visscher revised Hondius's map, he eliminated all the sea animals and replaced the late sixteenth-century ships with more contemporary models, each bearing the Dutch flag. The large compass rose in the Atlantic Ocean was replaced by a smaller design. A second compass rose with directional lines was added to the Mediterranean Sea, the Latin name of which now appears in roman lettering instead of sixteenth-century italic script. To update the title cartouche, Visscher heightened the relief by adding deeper shading, a technique common among baroque engravers. The upper part of the cartouche was completely reworked; here Visscher substituted another coat of arms of France and replaced the decorative architectural designs with naturalistic elements: fruit, foliage, and two large fish. In replacing the graphic scale cartouche immediately to the right of the title cartouche, Visscher again favored a naturalistic motif: a simple pedestal with two men, a fishing

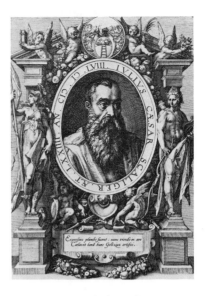

FIG. 5.45 Hendrik Goltzius, *Portrait of Julius Caesar Scaliger* (1588). Courtesy of the Staatliche Kunstsammlungen, Dresden.

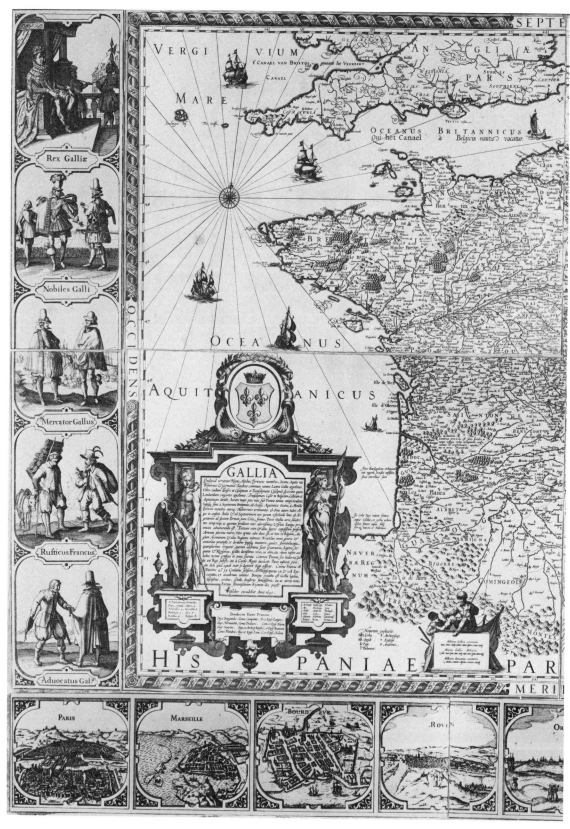

FIG. 5.46 Claes Jansz. Visscher, *Gallia* (1650). Courtesy of the Bibliothèque Nationale, Paris.

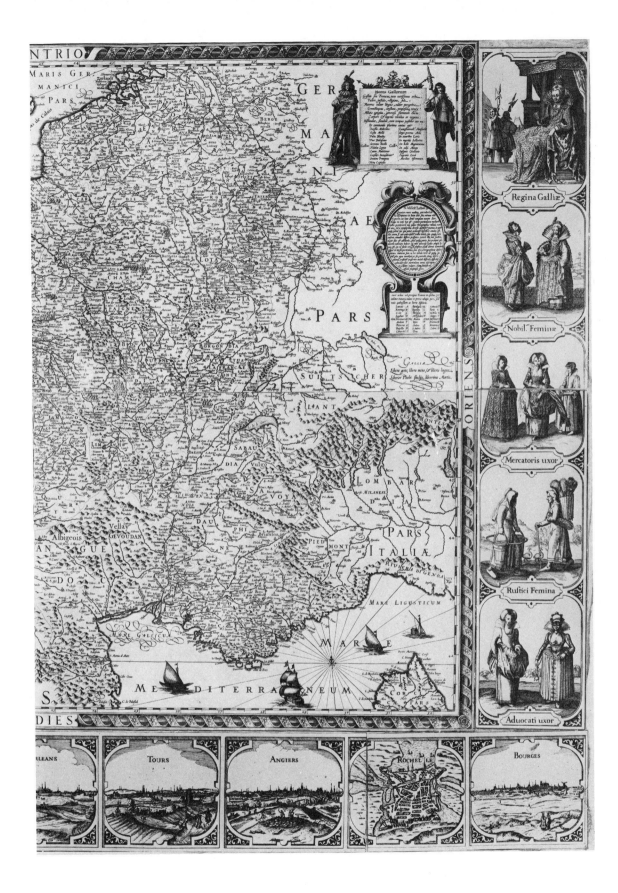

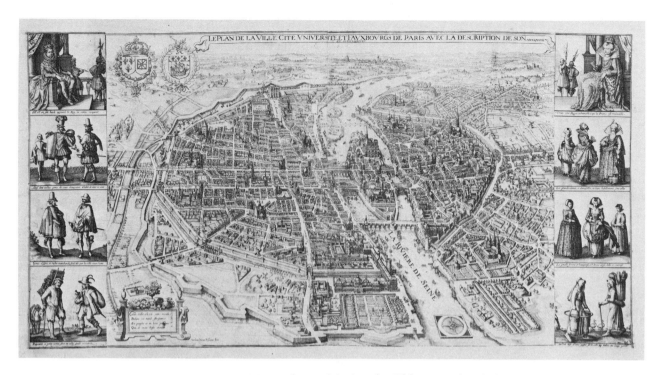

FIG. 5.47 Matthaeus Merian the Elder, *Le plan de la ville . . . de Paris* (1615). Courtesy of the Kunstmuseum, Basel.

net, a large book, and some cartographic instruments. The main figure seated on top of the pedestal holding a pair of dividers and a fishing pole refers to Visscher himself, whose personal emblem was a fisherman. It can be shown that, except for the map's decorative outside edge, Visscher reworked all of the map's ornamentation, even though his only geographical contribution was adding a single name.[73]

Visscher did not stop with the decoration on the map itself but, as we have seen, also designed a border of figures and town views, which increased the map's size from 74 by 100 centimeters to 87 by 126 centimeters. The figures Visscher engraved for the sides of the map include men and women of the various levels of society, from royalty to the peasant class. Most of these figures were taken from the border for a plan of Paris (fig. 5.47) by the Swiss engraver and draftsman Matthaeus Merian the Elder.[74] First published by Merian in 1615, this plan was reissued by Visscher as early as 1618. For his map of France, Visscher added to Merian's four levels of French society the lawyer class, represented by two men and two women. One of the women from this group was also taken from the series by Merian, where she appears with the noble class. To account for the succession in the monarchy between 1615, the date of Merian's original engraving, and 1650, when Visscher copied from it, Visscher simply altered the features of the two royal figures, making Louis XIII into his successor Louis XIV and Marie de' Medici into her successor Anne of Austria.

The views that appear at the bottom of Visscher's map of France were also derived from an earlier source. All but one, the view of Paris, appear to have been taken from Georg Braun and Franz Hogenberg's *Civitates orbis terrarum,* published in several volumes between 1572 and 1618.[75] To unite the town views with the series of figures, Visscher placed each in the same style of frame. All the frames are given a three-dimensional, windowlike effect by the addition of a recessed inside edge. Since the frames are drawn according to a single system of perspective, the vanishing point of which is approximately the center of the map, they confirm the order in which the figures and views are to be arranged around it. To complete the border, Visscher probably also designed a title band for the top. Such inscriptions, printed from woodcuts or engravings, appear on many of his wall maps published about the middle of the century.

By enlarging and embellishing Hondius's early seventeenth-century map, Visscher produced a more appealing item for the contemporary market. His extensive revision clearly demonstrates the attention given during this period to the updating of cartographic ornamentation, and his use of a variety of sources to do so was in keeping with the eclectic nature of the map's original ornamentation.

As we have seen, the borrowing of ornament was an important aspect of Dutch and Flemish mapmaking during the sixteenth and seventeenth centuries. The role of this eclecticism in the overall development of cartographic decoration should not be overlooked. Tailoring this borrowed imagery to their individual needs, these cartographers produced maps that must be considered among the most beautiful from the golden age of decorative mapmaking. Moreover, as I have demonstrated, a study of the sources of this ornament can help in attributing and dating certain maps.[76] The oeuvres of most, if not all, cartographers from this period include eclectic ornament, much of which can be traced back to designs by some of the Netherlands' foremost artists, thus providing yet another link between cartography and the graphic arts.

❧ SIX The Manuscript, Engraved, and Typographic Traditions of Map Lettering

DAVID WOODWARD

INTRODUCTION *T*he ingenuity with which mapmakers have overcome the mechanical problems of lettering on manuscript and printed maps, together with the many links between cartography and other arts, makes this element particularly worthy of study. We can recognize three major eras in the history of map lettering: manuscript, engraved, and typographic, and my purpose in this study is to explain these developments in a historical context and to demonstrate that the arts of calligraphy, typography, and cartography have many things in common.

But singling out lettering from the total graphic field does not imply that this element is not related to others such as color, symbolization, and mathematical structure. The graphic appreciation of maps must, in the last analysis, consider the design holistically and explain the connections between the elements and their context. But sometimes it is useful to isolate and exaggerate one element by looking at the map as if using both filter and magnifying glass together so that the detailed structure of the element can be understood.

The importance of lettering as a graphic element on maps shows itself in several ways. Manuscript lettering frequently reflects the character and skill of its maker as transparently as a signature. As experience with the Vinland map suggests, any map forger worth his salt must first be an expert paleographer and calligrapher.[1] Similarly, where type or punches have been used, the map literally bears the stamp of the engraver or printer, revealing by the idiosyncrasies of particular characters the identity of a unique set of punches or font of type and permitting an approach to map analysis analogous to that of forensic science.

The prominence of lettering in the visual hierarchy of a map may explain why it is so frequently the first object of criticism: it is described variously as too big, too small, too crowded, too sparse, too bold, too weak, badly positioned, stylistically inappropriate, and so on. Some authors have gone so far as to suggest that since lettering is a foreign element that does not appear on a conventionalized picture of the

I would like to thank Arthur S. Osley and James M. Wells for kindly reading the manuscript and making many helpful suggestions.

174

earth, and since its inevitable bulk tends to prevent the reader from appreciating the topography beneath, the ideal map should contain none. Indeed, a class of maps known as *Stummekarten* arose in the eighteenth century reflecting this concern.[2] It is now generally held that some form of identification not only is necessary but is an integral part of the map. And while modern advances in automated mapping have made it possible to separate the graphic from the denotative elements of the map, so that the name and even a full description of a place can be displayed at the touch of a light pen on a graphic display, the necessity for identification remains.

Even granting the integral nature of map lettering, it is quite another matter to achieve a practical combination of linework and lettering, and most cartographers would agree that despite the enormous advances in cartography in the past fifty years or so the problem still needs to be solved and will continue to be significant as long as the conventional map remains in use. The technical difficulty results from the fundamentally different ways lettering and linework have been produced throughout the history of cartography. Even in the era of manuscript maps, where perhaps more harmony could be expected, lettering was produced with the edged pen whereas point, line, or area symbols were drawn with the pointed pen, stylus, or brush. With typography, which has usually been designed by someone other than the map engraver or draftsman, the stylistic gap has widened even further, and the harmony between linework and lettering has been progressively undermined.

The attention paid to map lettering certainly has not reflected its fundamental importance. Each of the familiar manuals and texts, to be sure, devotes a section to the subject, and these describe the major methods with their advantages and drawbacks. In almost every case the authors lament the intractable nature of the problem,[3] but only a few studies have attempted to explain the technical and stylistic development of map lettering in a positive way.[4] To supplement these sources it is necessary to consult the extensive general literature in the history of calligraphy, typography, and paleography, which only rarely alludes to cartography.[5]

In recognition of the importance of the instruments and techniques for molding lettering style on maps, this chapter is divided into three parts dealing with the main lettering tools available to the cartographer: the pen, the engraving tool (whether burin, stylus, chisel, or gouge), and type. Clearly these are not simple chronological subdivisions that conform to the preprinting and postprinting eras, for manuscript maps never intended to be printed were still being produced centuries after the invention of printing (fig. 6.1).

The first part deals with the stylistic characteristics of manuscript lettering from early medieval times to the vestigial use of calligraphy in modern decorative cartography. The second treats the hand-engraved styles based on the Roman and Gothic models from the fifteenth to the seventeenth century and demonstrates the emergence of an independent engraved lettering style for maps that appears in the late seventeenth

century. Finally, the application of typography to cartography is broadly discussed, including such techniques as the direct use of metal type, stereotyping, hand-driven punches on copper plates, typometry, various transfer processes, and finally the form we are familiar with today: preprinted lettering. For each of the three sections the styles and techniques of the period are related to their specific uses in cartography.

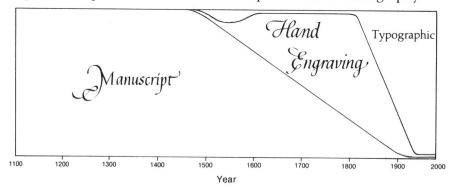

FIG. 6.1 The three traditions of map lettering in the West.

MANUSCRIPT CALLIGRAPHY
ON MAPS

The styles of lettering found on maps before the era of printing closely followed those prevailing in manuscript books. In many cases medieval maps, especially small world maps or diagrams, were found well integrated into the text, and often they blend effortlessly into each other.[6] To appreciate the changing character of map lettering of this early period, some familiarity with the general history of calligraphy is desirable. But so complex is the crossbreeding between styles that it is usually not possible to classify them in discrete categories. In addition, the relation between mapping centers may be so complex that precise dating cannot be achieved. At a general level, therefore, we are usually content to place a document in a given century and a broad area. Anything more precise will almost certainly require the help of a paleographer specializing in documents of the period, using the specific stylistic idiosyncrasies of a certain scribe or scriptorium.

After the fall of the Roman Empire in the sixth century A.D., the indigenous cultures adopted the Roman cursive minuscule, the everyday current rapid writing that had evolved from the Roman capitals over the previous five centuries. Based on this style, national hands developed from the sixth to the eighth century, and the styles became increasingly complex, with superfluous strokes and strange idiosyncratic contractions.[7] Toward the end of the eighth century a new, beautifully formed minuscule was being used near Amiens by the scribe Godesscalc; it was the precursor of a simple, clear, and dignified script that won the approval of Charlemagne and was propagated though his reform of the Benedictine Rule, the Vulgate, and the liturgy. The new script became known as the Carolingian minuscule. It took a generation or so to be adopted throughout France and gained acceptance in England during the tenth century, but it did not reach the more resistant areas of Spain and southern Italy, where the vernacular scripts were more entrenched, until the twelfth and thirteenth centuries, respectively.[8]

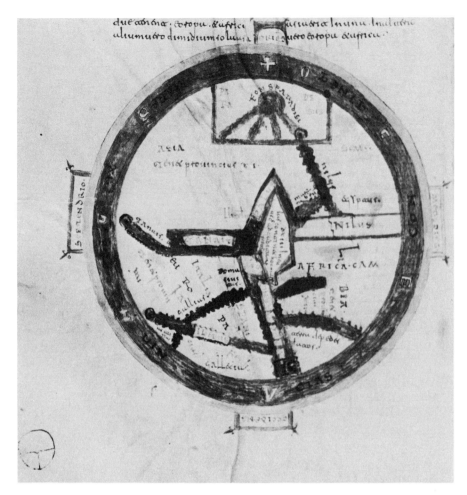

FIG. 6.2 World map from tenth-century manuscript copy of Saint Isidore's *Etymologies*. Courtesy of the Real Academia de la Historia, Madrid.

Few medieval maps survive from before the era of the Carolingian minuscule. Destombes lists only eight from the eighth century and none earlier.[9] These, and those dating up to 1200, are mainly small world diagrams by Isidore, Sallust, or Macrobius. In addition, no manuscript portolan charts have yet been found that predate the end of the thirteenth century. Of the remaining category, the medium- and large-scale topographical maps to which Harvey has recently drawn our attention, there are many more examples in small public and private archives than had previously been thought.[10] It is perhaps here that a knowledge of lettering styles can be of most use for identification in this early medieval period. It would immeasurably aid our understanding of the cartography of this era if we had more catalogues raisonnés and facsimiles of these little-known documents, and without such tools the study of their lettering styles is clearly premature.

Although few examples of pre-Carolingian styles exist on maps, the Carolingian itself, in one variation or other, was the characteristic lettering style of medieval world maps from the eighth to the twelfth century (fig. 6.2). Starting as a rounded, simplified style, it evolved into a more angular form in the eleventh century. Along with this angularity

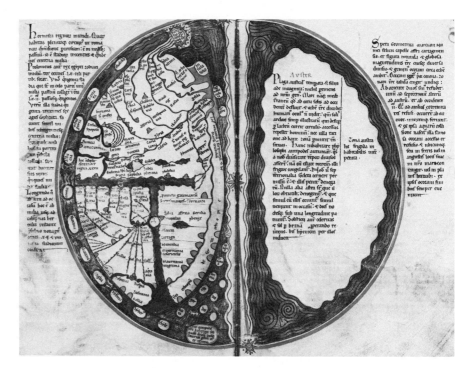

FIG. 6.3 Lambert of Saint-Omer, world map from *Liber Floridus* (ca. 1200). Courtesy of the Herzog-August Bibliothek, Wolfenbüttel.

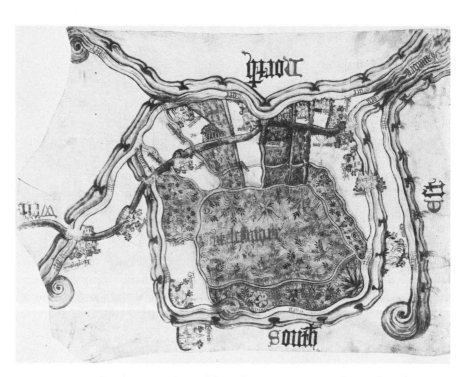

FIG. 6.4 Map of Inclesmoor; later fifteenth-century copy of map first drawn in 1405–8. Courtesy of the Public Record Office, London.

came a trend toward condensation and thickening of downstrokes, contributing to a denser look.[11] After 1200 it developed rapidly into what has been variously called Gothic or black letter in its various forms.[12] The two main types were the *textus prescisus* and the *textus quadratus*. The *textus prescisus* or *abscisus* was characterized by having the main downstrokes cut off level with the bottom line (fig. 6.3).[13] The *textus quadratus* had well-developed square feet and a distinctly more angular look, particularly at the height of its use in the fifteenth century (fig. 6.4).

Transitional styles between the *prescisus* and the *quadratus* can be recognized primarily by the degree of truncation of the main strokes. Other variations, usually regional, were in the degree of roundness. The Italian scribes, for example, found the severe angularity of the northern styles unpalatable and preferred the *rotunda,* which preserved the cutoff look of the downstrokes but was far more rounded and less rigid than the *prescisus*. It was the style frequently used for the large manuscript world maps that survive from the early sixteenth century, such as the Cantino map, the Ribeiro map of 1529, and the maps of Lopo and Diego Homem and the Reinels, to name a few (color plate 32).

Much more common are the semiformal crossbred current styles known as *littera bastarda,* combinations of the everyday cursive secretary hands and the more formal black letter. Precisely because they were less formal and less prone to convention, regional and chronological variations abound, but with careful study this is an advantage in pinpointing the origin of a document, since the styles are highly individual. Though less popular for the formal world maps, the *littera bastarda* appears with characteristic frequency on portolan charts of the Mediterranean from the end of the thirteenth century to the Renaissance (fig. 6.5).

Between about 1200 and the early fifteenth century, therefore, the Gothic styles in their various forms were dominant, and stylistically they clearly evoke the late Middle Ages. At the beginning of the fifteenth century a new trend was seen. Whether as part of the general revival of the classical forms or because of a practical desire to read the classical authors in a clearer script, the secular humanists of Italy revived the Carolingian minuscule and developed it into what is known as the humanistic script. Ullman has made a convincing case for tracing the beginnings of this script to Poggio Bracciolini, specifically to two manuscripts, one dated 1408 and the other undated but assigned a date of 1402 or 1403.[14] Poggio's style was widely adopted and developed throughout the fifteenth century and became the foundation for the lower-case roman type designs of Nicholas Jenson in 1470 and Francesco Griffo in 1495. It is also found on several fifteenth- and sixteenth-century manuscript maps, such as the various versions of Leonardo Dati's *La Sfera* (fig. 6.6) and the manuscript maps of Battista Agnese.

A parallel development of the majuscules (or capitals) was the rediscovery of the exquisite proportions of the Roman inscriptions of the first and second centuries A.D. While there are hundreds of such inscriptions of varying quality, that on the base of the Trajan column (ca. A.D. 150) has been held up as a particularly fine example. The Re-

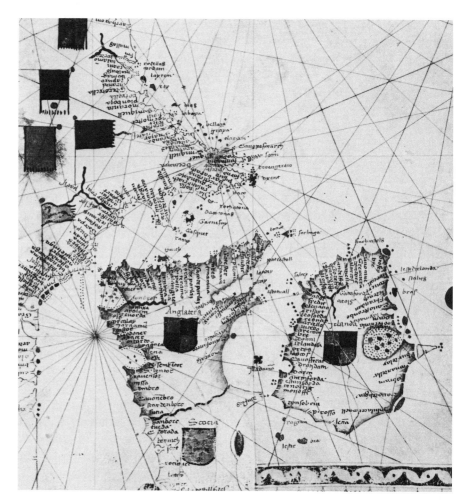

FIG. 6.5 Petrus Rosselli, detail from a portolan chart. South is at the top. Courtesy of the Newberry Library, Chicago.

naissance taste quickly adopted these models for calligraphy and typography.[15] Not surprisingly, we find them liberally used on manuscript maps from the sixteenth century on, usually as titles, band headings, or large continental names (color plate 33).

A third development was a cursive style, no doubt derived from the upright humanistic script as a natural consequence of writing more rapidly. One of its earliest exponents was Niccolò Niccolì, in the 1420s. This compact, semiformal hand was adopted in the Vatican chancery, whence it derives its name of cancellaresca corsiva, chancery cursive, or the italic hand. It formed the basis for the first italic type cut in 1500 for Aldus Manutius and the printed copybooks of Ludovico degli Arrighi Vicentino (ca. 1522) and Giovanniantonio Tagliente (1524) (fig. 6.7). The style became popular throughout Europe in the sixteenth century for the semiformal writing of official documents and then went through the inevitable accretion of complications and ornateness that debased its original clarity and balance.[16]

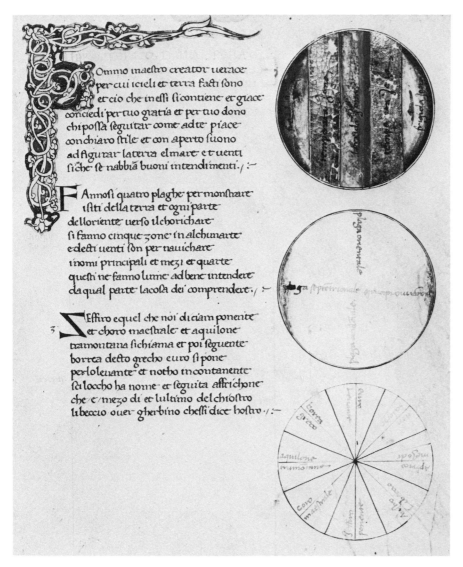

FIG. 6.6 Leonardo Dati, page from *La Sfera*. Courtesy of the Newberry Library, Chicago.

FIG. 6.7 Handwriting of Giacomo Gastaldi. Courtesy of the Archivio di Stato, Venice. Senato Terra, filza 29, 29 July 1559.

There has been a second revival of the Carolingian hand in the twentieth century with the work of Edward Johnston. Johnston's main thesis was that to understand the history of writing and lettering one needed to reconstruct how it was done.[17] He heralded a new school of calligraphers whose work has been the basis of the recent upsurge of popular interest in calligraphy. The map of Europe made for the British Council by the Royal Geographical Society in 1944 is an excellent example of the harmony that can be achieved with hand lettering (color plate 34), and the use of calligraphy for small maps in books, while having few practitioners, has been revived in recent years[18] (fig. 6.8). It is likely to be reserved, however, for custom-made maps that do not require detailed specifications for a team of cartographers; for maps that do, the consistency of typography is usually an overriding consideration.

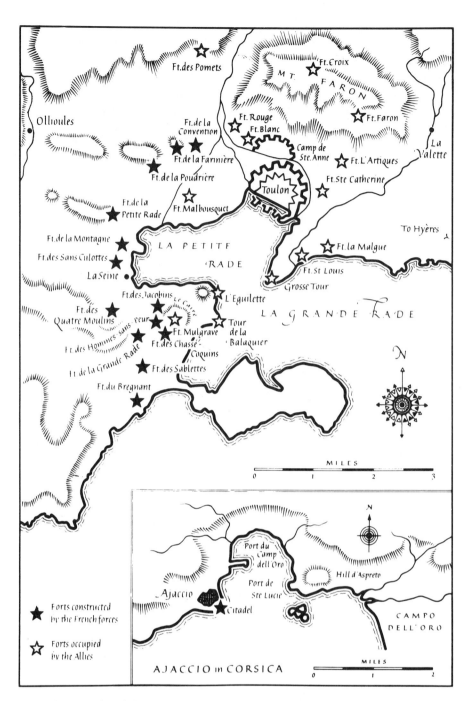

FIG. 6.8 Example of the use of calligraphy (by Sheila Waters) in maps for book illustrations. From Heather Child, *Calligraphy Today* (New York: Taplinger, 1976), 76.

ENGRAVED LETTERING ON MAPS

In the manuscript era of cartography the media and tools of the trade remained basically unchanged. True, small variations in style could be attributed to differences in the cutting of the quill, the angle at which it

was held, or the speed of writing, but the major shifts in style—national hands, Carolingian, Gothic, humanistic—were results of fundamental upheavals in ways of thinking and general changes in fashion and practice. With the introduction of graphic printing, the technical constraints placed on style by the various tools and techniques of the engraver's trade became far more significant, to the extent that prints were described by their manner of reproduction: the terms woodcut and copper engraving immediately elicited images in the mind of the viewer, and they still do today.

When looking at hand-engraved lettering styles on maps, therefore, at least until the introduction of lithography about 1800, we cannot ignore the tools and techniques by which they were fashioned: the knife and gouge in the woodcut technique, the graver or burin in copperplate engraving, and, more rarely, the stylus in etching. As illustrated in figure 6.9, these three types of tools are fundamentally responsible for three entirely different letter characters: the knives and gouges tend to produce an angular, stylized letter; the burin is able to accommodate more graceful lines and subtle variations in line width; and the etcher's stylus tends to a more rounded, limp-looking style.

Etching is less known than the woodcut and copperplate engraving techniques and worthy of further research in its map context. It may have been used for lettering and ornamental work on maps far more than has been supposed. In 1609 Matthias Quad reported that about 1570 the brothers Jan and Lucas van Doetecum had invented a new method of etching for "pictures and maps with all the writing and lettering in them done so neatly and smoothly, and with such gentle gradations, that it was long considered by many connoisseurs not to be etching, but pure engraving. The art remained a secret between the two of them."[19]

In addition to the technical factors, there were also at least three stylistic sources from which these letters were derived, as was the case with manuscript lettering: the Roman capitals and lower-case letters, the Gothic, and the cursive (which later evolved into an independent engraved style). The hand-engraved Roman capitals and lower-case letters were at first imitated with difficulty, as is shown in the 1477 Bologna edition of Ptolemy's *Geography* and the Berlinghieri edition engraved about 1480. Indeed, all the samples of fifteenth-century copper engraving where map lettering is engraved by hand reveal a notable lack of lettering skill. The same is true even for the celebrated engraver Francesco Rosselli, working into the early sixteenth century.

After the more widespread popularization of Roman lettering in the published treatises and manuals of Luca Pacioli (1509), Sigismondo Fanti (1514), Francesco Torniello (1519), Albrecht Dürer (1525), and Geofroy Tory (1529), and by several excellent Roman type styles, there were certainly enough models to follow, and by the second quarter of the sixteenth century the Italian and Flemish map engravers had become masters of the art, as illustrated by the work of Sebastiano da Re and Gerardus Mercator (fig. 6.10).[20]

(a) *America*

(b) Ingolstadt

(c) America

FIG. 6.9 Effect of three main types of engraving tools on lettering style: (*a*) engraver's burin, (*b*) etcher's stylus, and (*c*) woodcutter's knife. Author's drawing.

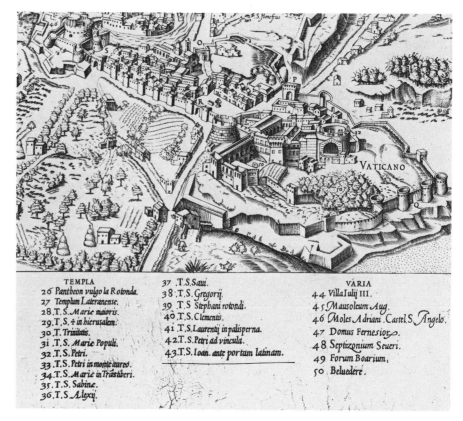

TEMPLA		VARIA

26 Pantheon vulgo la Rotonda.
27 Templum Lateranense.
28 T.S. Marie maioris.
29 T.S. † in hierusalem.
30 T. Trinitatis.
31 T.S. Marie Populi.
32 T.S. Petri.
33 T.S. Petri in monte aureo.
34 T.S. Marie in Trastiberi.
35 T.S. Sabine.
36 T.S. Alexij.

37 .T.S. Saui.
38 T.S. Gregorij.
39 .T.S. Stephani rotondi.
40 T.S. Clementis.
41 T.S. Laurentij in palisperna.
42 T.S. Petri ad vincula.
43 T.S. Ioan. ante portam latinam.

44 Villa Iulij III.
45 Mausoleum Aug.
46 Moles Adriani. Castel. S. Angelo.
47 Domus Fernesioꝛ.
48 Septizonium Seueri.
49 Forum Boarium.
50 Beluedere.

FIG. 6.10 Sebastiano da Re, detail from a map of Rome, 1561. Courtesy of the Newberry Library, Chicago.

The attempts to emulate small Roman capitals and lower-case letters in woodcut were even less successful than the fifteenth-century attempts in copper. The rounded, subtle forms of the traditional Roman letter presented a great challenge to the *Formschneider* (woodcutter) faced with engraving several hundred small names on a map. Curves were straightened and flourishes truncated, so that the look of woodcut lettering is characteristically primitive, naive, and even crude. It is no wonder, therefore, that the angular Gothic styles of lettering gained favor with the woodcutters, and this might help explain why woodcuts were used far more often for maps north of the Alps, where the Gothic styles were more popular.[21]

The difficulty of rendering the Roman letter may be seen by comparing details from the 1482 (Ulm) edition of Ptolemy's *Geography* with the corresponding detail from the 1513 edition of the same work printed in Strasbourg. In the 1482 edition, though the model has in the main been Roman, we see occasional lapses into Gothic, as in the rendering of the *r* in "Gorgona" or the lower-case *d* in "Garibaldo" (fig. 6.11). By the time of the 1513 edition, on the other hand, there is no pretense of following the classical letterforms, and the general character is clearly Gothic, as is best shown in the rendering of the capital G in "Gorgonis" (fig. 6.12). In both cases the medium molds the style.

FIG. 6.11 Ptolemy, *Geography,* detail from the map of Italy in the Ulm edition (1482). Courtesy of the Newberry Library, Chicago.

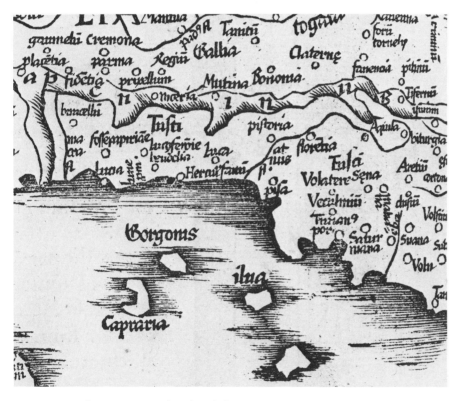

FIG. 6.12 Ptolemy, *Geography,* detail from the map of Italy in the Strasbourg edition (1513). Courtesy of the Newberry Library, Chicago.

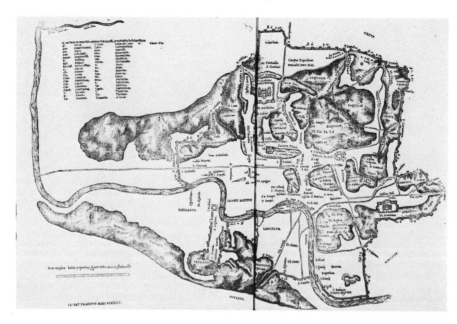

FIG. 6.13 Giovambattista Palatino, map of Rome from Giovanni Bartolomeo Marlianus, *Urbis Romae topographia* (Rome, 1544). Courtesy of the Newberry Library, Chicago.

It is wise, however, to point out that the penchant of the wood-cutter's knife for Gothic styles or the adaptability of the copper engraver's burin to the rounded Roman forms was not universal; the dominance of technique over style was not overwhelming, and the resistance of a medium could be overcome by a good craftsman. Thus the first published copybooks of the chancery cursive—Arrighi, Tagliente, Palatino, Mercator—were all in wood, and the first copybook with engraved models devoted to Gothic, *Ein gute Ordnung . . .* by Johann Neudörffer the Elder in 1538, was engraved in copper, though it is not altogether clear why.[22]

It was in the chancery cursive that the sixteenth-century map engravers found their forte, and it is this style that has been best documented. We have already seen how the chancery cursive originated. After the printed copybooks of Arrighi and Tagliente, the form became popular in engraved work. The island books of Benedetto Bordone (1528 and later editions) were to become one of the first cartographic uses of the script. Giovambattista Palatino, one of the most popular and accomplished Renaissance scribes and author of an influential writing manual first published in 1540, signed two maps in Giovanni Bartolomeo Marlianus, *Urbis Romae topographia* (1544) (fig. 6.13). Giacomo Gastaldi, perhaps the leading Italian geographer and cartographer of the sixteenth century, who had a finely developed chancery hand, may also have engraved his first published map, *La Spaña* (1544), himself.

The foremost figure was the incomparable Gerardus Mercator, instrument maker, globe maker, engraver, geographer, cosmographer, cartographer, astronomer, philosopher, and mathematician. Mercator

FIG. 6.14 Gerardus Mercator, lettering on the Gemma Frisius terrestrial globe, ca. 1536, from A. S. Osley, *Mercator* (London, 1969). By permission of the British Library.

was also a skilled calligrapher and the author of a popular writing manual, *Literarum Latinarum,* first published in 1540 and with four later editions (the last in 1557). The purpose of Mercator's manual was not geographic or even cartographic; it was meant to promote the use of the Latin hand for the Latin language. But in Osley's words, his pioneer work "led to the widespread adoption of italic lettering in the making of maps."[23] His earliest work, done in his early twenties, largely follows the forms recommended in the *Literarum,* as illustrated in figure 6.14. A second period may be identified between his move to Duisburg in 1552 and the engraving of his world map of 1569. The original style was modified to be less flamboyant, and he shortened the long curved ends of the ascenders and descenders into neat serifs. After 1569 his business had become so large that it became impossible for him to engrave everything himself, and we can also detect the hands of other engravers working from his manuscripts.

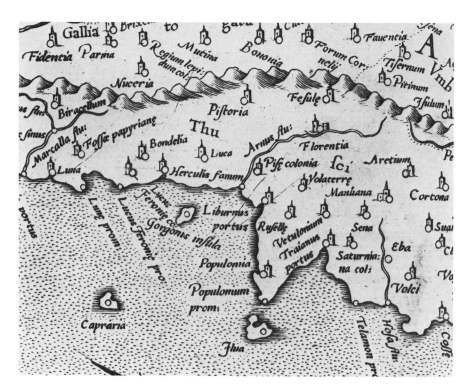

FIG. 6.15 Ptolemy, *Geography,* Mercator edition (1578). Courtesy of the Newberry Library, Chicago.

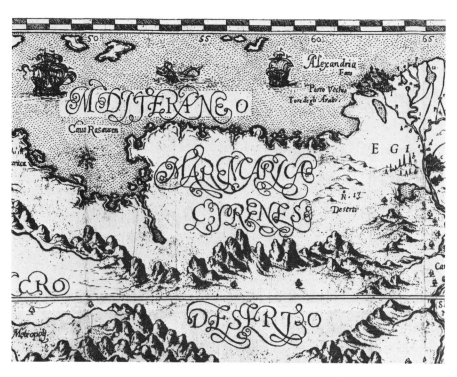

FIG. 6.16 Natale Bonifacio, detail of map from Antonio Pigafetta, *Relatione del reame di Congo* (1591). Courtesy of the Newberry Library, Chicago.

FIG. 6.17 Detail of an engraving by the Van Doetecum brothers from Waghenaer, *Spieghel der Zeevaerdt* (Leyden, 1584–85). Courtesy of the Newberry Library, Chicago.

In 1594, the year of Mercator's death, another well-known cartographer, Jodocus Hondius, published a writing manual containing some of the basic chancery style of Mercator but combined with the clubbed serifs promoted by Giovanni Francesco Cresci in his writing manual of 1560. Cresci had criticized the early chancery hand as too old-fashioned, slow, pointed, and angular. This style heralded the baroque deterioration of letterforms in which the spare and beautiful chancery became overbearingly ornate and fussy. Compare, for example, the work of Mercator in figure 6.15 with the late style of Natale Bonifacio in 1591 (fig. 6.16). See also the contrast between the early style of the van Doetecum brothers in the maps of de Jode or Waghenaer (fig. 6.17) with the later work for the Linschoten voyages in 1599 (fig. 6.18).

A third engraver who at the end of the sixteenth century was engaged not only in map engraving but in compiling a writing book was Giacomo Franco.[24] Well known as an artist and as one of the best copper engravers of the day, he signed several copper-engraved maps commonly included in the Italian composite atlases. In 1595 he published *Il modo di scrivere cancellaresca moderna,* followed by at least two other editions in 1596 and 1600.

The Dutch atlas trade, based mostly on the genius of Mercator and Ortelius in the sixteenth century, flourished and became consolidated in the seventeenth century, to dominate European map engraving in the well-known publishing families of Hondius, Jansson, and Blaeu.[25]

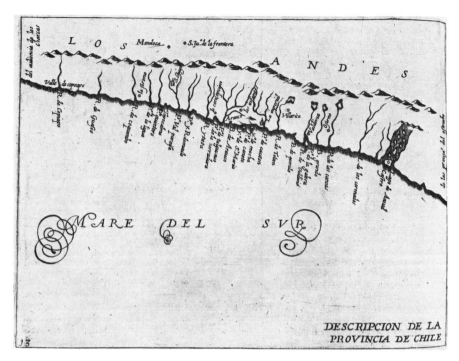

FIG. 6.18 Detail of an engraving by the Van Doetecum brothers, from Jan Huygen Van Linschoten, *Zwolffte Schiffahrt* (Frankfurt am Main, 1608). Courtesy of the Newberry Library, Chicago.

For lettering it was a homogeneous, almost monolithic stylistic period in which the routines of copper engraving for maps had become well established (fig. 6.15). The characteristic lettering style of the monumental twelve-volume *Atlas maior* of Joan Blaeu (1663), for example, had its roots in the Mercator-Hondius style for naming towns and small topographical features; Roman capitals for titles and regional names, with an occasional sprinkling of delicate rounded Gothics for titles, sea names, and so forth, whenever a touch of nationalistic flavor was required. So routine had the engraving become, indeed, that despite the vast output of copper plates of the period, very few of their engravers are known. The names—H. Coeck, N. and N. Peters, A. Z. and Chr. L. Rodtgiesser—occur very infrequently. In the *Atlas maior* over five hundred of the copper plates bear no indication of the engraver, though the output is so large that it is doubtful they are all the work of one person. Yet the appearance of these plates is extremely consistent, suggesting either a set of precise specifications or perhaps a division of labor in the engraving, in which the lettering was one specialized task assigned to one individual. This line of thought needs further investigation.

In the last quarter of the seventeenth century a subtle but important change overcame the style of hand-engraved lettering on maps. This is the threshold between what Fournier a century later was to call the *ancien* and the *moderne*. The general change in look between seventeenth- and eighteenth-century maps—the more restrained use of color and the more precise, scientific character—has been pointed out in the

cartographic literature.[26] The equally important change in lettering style has attracted the same attention in the typographic literature, but the links between the two have not been noted.[27]

The difference between the two styles, "old style" and "modern," illustrated in figure 6.19, concerns the general distribution of weight of the letters and a fundamental change in the design of the serifs. In modern we see a far greater contrast between thick and thin strokes and an upright rather than a slanted stress to the counters of the letters. There is also a trend away from the angled, bracketed serif toward horizontal straight, unbracketed serifs. If we compare typical maps from the *Atlas maior* (1663) (fig. 6.20) and the *Atlante veneto* of Vincenzo Coronelli (ca. 1690) (fig. 6.21), it is clear that a fundamental change took place between those two dates.

dd e ff j ll o p p i

dd e ff j ll o p p i

FIG. 6.19 Major characteristics of modern (above) and old style (below) typefaces.

FIG. 6.20 Joan Blaeu, detail from *Atlas maior* (Amsterdam, 1663). Courtesy of the Newberry Library, Chicago.

The transition from old style to modern was institutionalized in the "Romain du Roi" with the "Paris serif" authorized by Louis XIV in 1692 for the use of the Imprimerie Royale.[28] Some features of the modern style (such as the vertical stress of the counters) were taken up by the English typefounders William Caslon and John Baskerville and the Frenchman Pierre-Simon Fournier le Jeune, but the first modern faces

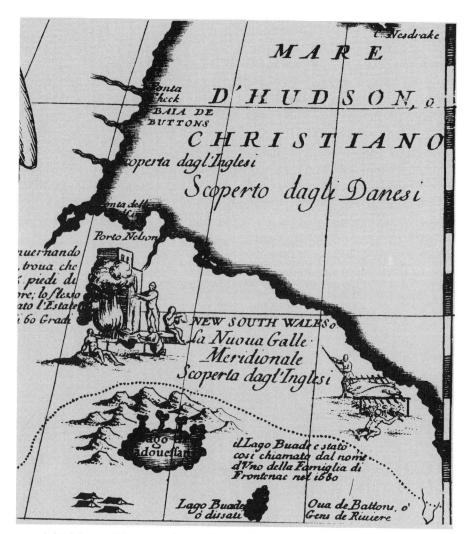

FIG. 6.21 Marco Vincenzo Coronelli, detail from *Atlante veneto* (Venice, ca. 1690). Courtesy of the Newberry Library, Chicago.

proper were designed by François-Ambroise Didot, Johann Fleischmann, John Bell, and Giambattista Bodoni in the latter part of the eighteenth century.

The roots of the "modern" typefaces may well have been in the work of copper engravers, and we see the beginnings of the trend in the maps of the late seventeenth century. It is true that the handwriting manuals of the time tended to stress the cursive hands developed from the chancery, such as in the writing book of Lucas Materot (1608), which hints at the much later English round hand of Charles Snell or George Bickham.[29] This copperplate style, as it was called, is the basis of most modern western European and American handwriting. There was, however, a more formal engraver's roman, known as draftsman's italic or stump roman, that became standard for cartographic engravers and is reflected in a whole succession of engravers' style sheets for national mapping agencies in western Europe from the late eighteenth century. Examples are seen in the official style manuals of the Ordnance

Romana diritta

abcdefghijklmnopqrstuvxyz&, æ œ ff w.

Cifre pella Romana diritta *Cifre per la Capitale diritta*

1234567 8 9 10. 1 2 3 4 5 6 7 8 9 10.

Romana inclinata

abcdefghijklmnopqrstuvxyz&, æ œ ff w.

Cifre pella Romana inclinata *Cifre per la Capitale inclinata*

1234567 8 9 10. 1 2 3 4 5 6 7 8 9 10.

Italica

abcdefghijklmnopqrstuvxyz &, æ œ ff w.

MODELLI DI LETTERE ORNATE

A B C D E F G H I J K L

M N O P Q R S T U V X Y

Z. Æ Œ

FIG. 6.22 Engraver's roman. From *Norme e modelli pel rilievo del terreno, pel disegno topografico, e per la scrittura delle carte e dei piani, ad uso del Real Corpo di Stato-Maggiore Generale* (Turin: Tipografia Chiro, 1844).

Survey of England and Wales, the Istituto Geografico Militare, the Institut Géographique Nationale, and their equivalents in Germany, Belgium, Switzerland, and elsewhere. The style changed very little until the use of typography gained acceptance in modern topographical mapping agencies (fig. 6.22). The development of what in 1935 was called the normal engraved cursive alphabet has been traced by Wilhelm

Bonacker.[30] It is still in use today in some central European mapping establishments.

Thus, between the sixteenth and nineteenth centuries engraved lettering showed an increasing independence from the writing books or type styles of the day. Though closely tied to the copybooks of Palatino and Mercator for the Renaissance chancery and its subsequent modifications by Cresci and Hondius at the beginning of this period, an independent engraved cursive style arose in the late seventeenth century that may even have had an influence on the "modern" type styles introduced at the end of the eighteenth century.

TYPOGRAPHY ON MAPS
The difficulties of engraving hundreds of names in a small area of copper or wood stimulated the use of alternative methods of lettering. It was not surprising that this should take some mechanical form, especially after the invention of movable type for printing in the mid-fifteenth century, based on the technology of casting metal type from soft copper matrices fashioned with hardened steel or brass punches. Since the fifteenth century, therefore, the means to combine typography and cartography has always been present but not always exploited. In this section we shall explore the options open to the map printer and try to explain why almost five centuries passed before typography became the routine method of lettering maps, despite almost constant experimentation since 1478.

Identifying period or place of origin of a map is easier if its typography can be traced. Types tend to be standard, with fewer categories of style, size, and idiosyncrasies of individual engravers or draftsmen. This applies more to the earlier period, of course, when fewer fonts were available; with the present revolution in phototypography, when new alphabets can be produced at whim, we have entered an era of almost unlimited typographic variety.

The repetitive, consistent nature of dies or type sorts also provides clues. Where minor idiosyncrasies in shape or style or possibly even damage to characters can be identified, it may be possible to discover not only the engraver but also the chronological order in which certain map plates or blocks were created. The method is analogous to tracing the author of a typewritten letter through a broken character on the typewriter.

Type was employed on maps in many ways. Punches or dies could be stamped into intaglio copper plates letter by letter. Movable type could be used in conjunction with woodblocks or as specially cast map characters, as in typometry. Plates of type could be cast from molds created by printer's type, or impressions from it could be transferred to a lithographic stone, zinc plate, or map manuscript in a variety of ways. Lately, photomechanical and electronic methods of typesetting have been applied to cartography. In every case, however, we are dealing with type—an artificial but highly consistent product—whose fundamental characteristics are different from manuscript or engraved letterforms. The stylistic implications of this application of typography have been profound.

The 1478 Rome edition of Ptolemy's *Geography* must rank as one of the most remarkable achievements in map printing. As with the Gutenberg Bible or the Mainz Psalter, we can marvel that something produced so early in the lifetime of a technique can be so brilliantly executed (fig. 6.23). The look is almost modern and, compared with the Bologna edition of the same work published one year earlier, seems centuries later in the sophistication of its production. We know that the Bologna edition was hastily prepared, but there is a more obvious, but usually overlooked, difference. Whereas the Bologna Ptolemy contains hand-engraved lettering crudely attempting to imitate Roman capitals, the engraver of the Rome edition has employed well-cut dies or punches, a technique similar to that used in bookbinding or, much later, in music engraving. This point apparently was not recognized until Joseph Sabin drew attention to it in passing when he described the book in his catalogue,[31] and it seems then to have been forgotten until a short note by Arthur Hinks in the *Geographical Journal* in 1943. In response to a reader who claimed that the lettering of the Rome Ptolemy was not punched or stamped at all, Hinks pointed out the regularity of the impressions and supported his opinion with that of the typographer Stanley Morison.[32] To us now the debate seems unnecessary; it is quite obvious that these letters are stamped or punched, and the difference in our reaction perhaps reveals that we have become more sensitive to the look of maps and to the role physical evidence plays in their study.

The plates for the Rome Ptolemy of 1478 were used again for the 1490, 1507, and 1508 editions of the *Geography*. At least one of the plates was also issued several decades later.[33] But in the 1507 and 1508 editions new maps were added, the *tabulae modernae,* reflecting the updating of geographical information both in the New World and in Europe. They were engraved in the style of the earlier editions, and the lettering even used the same dies, with one notable exception: the capital *O* used for the 1478 edition appears to have been lost in the intervening years and replaced with the die used for zero (fig. 6.24). Thus the presence or absence of the capital *O* might be of considerable help in dating.

Punches were also used on the single-sheet Ptolemaic world map of about 1480, sometimes wrongly attributed to Taddeo Crivelli (whose style it is far from resembling) (fig. 6.25); the Nicolaus Cusanus map of Germany dated 1491 (fig. 6.26); possibly the *Tabula nova d'Italia* (1536) engraved by Agostino Musi (Veneziano); and three maps of about 1540 by an engraver known as G. A. or the Master of the Caltrop, two of which have been identified from the evidence of the punches. More examples abound in the sixteenth century, including some lettering on the 1546 world map of Gastaldi, the Ruscelli editions of Ptolemy's *Geography* (1561 and later), and an Italian map of Great Britain of about 1550 by M. R. (fig. 6.27), and the globe gore described by Almagià and tentatively attributed to Livio Sanuto—a simple comparison of the styles of the punches might support this attribution.[34] Other topics for research might include a close examination of the possible ties between the Contarini map of the world (1506) and the Ruysch map. In its hierarchical

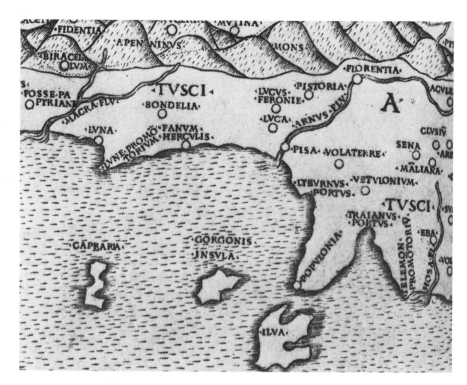

FIG. 6.23 Ptolemy, *Geography,* detail from the map of Italy in the Rome edition (1478). Courtesy of the Newberry Library, Chicago.

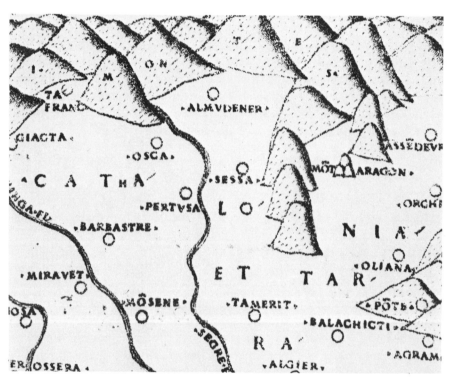

FIG. 6.24 Ptolemy, detail from *tabula moderna* in the *Geography* (Rome, 1507). Courtesy of the Newberry Library, Chicago.

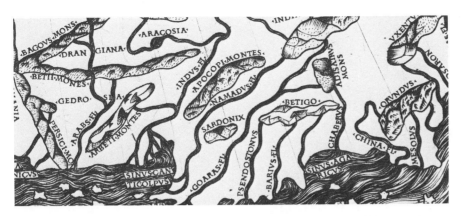

FIG. 6.25 Detail from a map of the world, ca. 1480. Courtesy of the Newberry Library, Chicago.

FIG. 6.26 Nicolaus Cusanus, detail from a map of Germany, 1491. By permission of the British Library.

nature, the lettering on the Contarini map, though hand engraved, bears some relation to the punched lettering of the Ruysch map, and the five letters *S E P T E* in the Contarini map (fig. 6.28) resemble the style of the Ruysch punches.

In the sixteenth century dies were used not only in engraving copper plates for printing, but also in making scientific instruments and metal globes. These punches differed fundamentally from the printing punches in that they were wrong-reading instead of right-reading; they thus were similar to the punches used in fashioning typographic matrices (fig. 6.29). If stylistic links can be found, it might be possible to establish associations between instrument engravers and map engravers in the sixteenth century.

In the seventeenth century, the use of punches for lettering maps was far less common, though they were used for stamping symbols such as town circles in some maps for the *Atlas maior*. Skelton refers to their being used in an experimental way by Robert Hooke. This needs further investigation.[35] The method seems to have been revived at the end of the eighteenth century, as in the multisheet map of London by

FIG. 6.27 Detail from an Italian map of Great Britain, ca. 1550, by M. R. Courtesy of Biblioteca Nazionale Braidense, Milan.

FIG. 6.28 Giovanni Matteo Contarini, detail from a map of the world, 1506. By permission of the British Library.

FIG. 6.30 Richard Horwood, detail from a map of London, 1792–99. By permission of the British Library.

FIG. 6.29 Punches used in making scientific instruments. From M. L. Righini Bonelli and T. Settle, *The Antique Instruments of the Museum of the History of Science in Florence* (Florence: Arnaud, n.d.), 95.

Richard Horwood (1799) (fig. 6.30), and for systematic topographical and hydrographic maps and charts in the nineteenth century. In the Hydrographic Office in Taunton until very recently specially manufactured punches were used to stamp copper plates.

MOVABLE TYPE

The difficulty of carving small names was even more severe with the woodcut technique, and most maps printed by this process used movable metal type either inserted through specially mortised slots in the wood block or printed in a separate impression overlapping the woodcut detail[36] (fig. 6.31). In addition to the general characteristics of consistency shown by all typographic impressions, inserted metal type can also be identified by vertical shifts between individual letters, dropped spaces, type damage of various kinds, inking of type shoulders, upsidedown type, overinking, and a host of other clues.[37]

The earliest known use of type on maps is in the *Rudimentum novitiorum* (Lübeck, 1475). For setting titles, legends, and text in cartouches it was also widely used in the fifteenth and sixteenth centuries, and though it fell into disuse during the dominant era of copper engraving, it was revived in the nineteenth century for wood-engraved maps in Victorian textbooks, encyclopedias, and popular journals.

In addition to the method of lettering by inserting type through the wood block, the names were occasionally set up in a separate form and printed as a second impression over the woodcut detail. This was a forerunner of the technique known as typometry, a process in which the map types were composed on glass laid over the worksheet. Early experiments were made in 1773 by August G. Preuschen, and the method

FIG. 6.31 Detail from a map of Italy in Ptolemy's *Geography* (Venice, 1511). Courtesy of the Newberry Library, Chicago.

was developed by Johann Gottlieb Immanuel Brietkopf, a printer and typefounder of Leipzig, and by Wilhelm Haas (father and son), Basel typefounders. Except for the efforts of the Haas family, which amounted to at least twenty-one examples of the technique, the method never progressed beyond the experimental stage and finally had to compete, unsuccessfully, with the many other relief printing processes developed in the nineteenth century, to say nothing of lithography.[38] Although the typometric technique was touted as a rapid method of producing military maps in the field, a note in the corner of one such map reveals that it took fourteen days' work, which seems excessive for the amount of detail involved (fig. 6.32).

STEREOTYPING Among the indirect methods of reproducing type on maps is the method of stereotyping, introduced early in the sixteenth century. Stereotyping is a method of casting whole pages of movable type in one plate, usually thought to have been developed at the end of the eighteenth century for reprinting multiedition books. Its earlier use for maps involved setting the required names in type, impressing a matrix in damp paper or some other molding material, and creating a plate from metal alloy poured on the mold. The individual names were then cut out and glued to the wood block.

FIG. 6.32 Detail from a typometric map. From E. Hoffmann-Feer, *Die Typographie im Dienste der Landkarten* (Basel, 1969).

Since stereotyping was one step removed from the original movable type, there was usually some loss in clarity, and since the alloys used for stereotyping were softer than type metal, there was also more tendency for damage, which shows up clearly in the impression. Despite previous descriptions of the method, it is worth reiterating that its use enables the cartobibliographer to identify variant states of wood blocks to a very precise degree.[39] The examples shown in figures 6.33 to 6.35 are from the 1540, 1542, and 1545 editions of Ptolemy's *Geography,* and we can discern minor shifts between the different states of the block. Note, for example, the differences in angle of *Arnus fl.* and the capital *I* in the peninsula below *Florentia.* In addition, the stark difference in style between these examples and the copper-engraved maps of the same area illustrated earlier should be readily apparent.

WAX ENGRAVING

The use of type in its various forms on woodcut maps illustrates the lengths to which printers went to combine the advantages of the relief printing surface and the consistency of typography. In the early nineteenth century, when steam power was first applied to printing, a relief printing process became even more desirable. But the particular problems of lettering these blocks still had not been solved, and among the many attempts to invent a satisfactory process, wax engraving became the most popular commercial relief printing technique for maps from about 1870 until the 1930s, particularly in America.[40]

FIG. 6.33 Detail from a map of Italy in Ptolemy's *Geography* (Basel, 1540). Courtesy of the Newberry Library, Chicago.

FIG. 6.34 Detail from a map of Italy in Ptolemy's *Geography* (Basel, 1542). Courtesy of the Newberry Library, Chicago.

FIG. 6.35 Detail from a map of Italy in Ptolemy's *Geography* (Basel, 1545). Courtesy of the Newberry Library, Chicago.

An essential ingredient of wax engraving was the use of printer's type for the lettering. As with stereotyping, the impression was not taken directly from the type but went through an intermediate molding stage. The type was stamped into a mold made of beeswax, from which an electrotype relief plate was cast. The resulting electrotype, backed with type metal, provided a rigid and long-wearing plate that could be used for hundreds of thousands of impressions before showing signs of deterioration. The type on wax-engraved maps had the usual characteristics of mechanical lettering, to which we may add the tendency—since the use of small type was quick and easy—to overcrowd and to position names not where they looked right but where they fitted. In addition, since the type styles available to the wax engraver included a remarkably mediocre series of commercial type designs current in America in the early twentieth century, the maps automatically took on a mediocre look. So ingrained was this look of maps in the minds of the American atlas-buying public that it continued even after the demise of wax engraving in the 1950s, and traces of the style can be seen in the design of commercial atlases even today.

In Europe, meanwhile, a solid tradition of lithography had built up through the nineteenth century, gradually gaining ground from the copper engravers. But the search for a satisfactory method of lettering by mechanical or artificial means was present here as well. Karen Severud Pearson has shown in her detailed documentation of nineteenth-century lithographic techniques in cartography that the experiments were numerous and for the most part successful.[41] Two main methods were tried: one was to transfer the image of the type to the lithographic stone by means of transfer paper, and the other was to print names on paper that could be cut out and stuck to the artwork for subsequent photography.

The idea of typographic transfer map lettering was mentioned as early as 1827 and involved a process by which type could be set in its final position (as in the typometic map) and printed on autographic transfer paper, with the rest of the map added in ink and then transferred to the stone. The French Société d'Encouragement pour l'Industrie Nationale offered a prize in 1828 for the best combination of typography and lithography to be employed in the production of maps, but the prize went for a method of etching a lithographic image in relief that did not solve the problem posed. In 1840 *Le Lithographe* concluded that, despite numerous attempts to transfer type onto stone, all techniques had so far failed.[42]

It was not in France but in the Netherlands that the breakthrough occurred, in the 1860s when Charles Eckstein developed his typoautography. An impression of the map to be lettered was taken on transfer paper, and the necessary words were set in type and stamped on the paper using straight or curved stamping tools. The linework and lettering were then transferred to the stone together. This process was used in the topographical map series of Java by the Topographical Bureau of the Netherlands.[43]

The origins of what is now inelegantly but appropriately called "stickup lettering" lie in the transfer system just described. But one very important ingredient was added: photography could now be used to transfer the image from the map manuscript to the stone, and reductions or enlargements were possible. In 1878 José Julio Rodrigues in Lisbon was one of the earliest exponents. After printing the names from movable type on a band of special paper, he placed them in convenient places on the map manuscript, which was then reduced photographically.[44] The technique has not changed radically since then; the medium on which the names are printed has changed from paper to film, and the means of preparing the type image has undergone a revolution from metal to filmsetting, but the principle has remained the same.[45]

With experiments in the 1920s, and especially since the Second World War, photocomposition has been making steady inroads into the traditional "hot metal" methods of typesetting, such as foundry type, Monotype, Ludlow, and Linotype, in all facets of the printing industry, and map printing is no exception. The devices used to produce this "cold type" can be classified into three groups, appearing broadly in the

FIG. 6.36 National Geographic Society typesetting machine. From Wellman Chamberlin, *The Round Earth on Flat Paper* (Washington, D.C.: National Geographic Society, 1950).

following order: the manual devices by which film characters were arranged into words and then photographed; the mechanical devices by which the letters are projected one by one onto the film; and the electronic methods by which replicas of the letters stored digitally are either exposed to the film with flying spot scanners or printed directly with computer–directed ink jets.

Patents for photocomposition had been taken out as early as 1856 by A. E. Bawtree, but the first working prototype did not appear until 1915.[46] In 1929 an American machine called the Luminotype was introduced that, it was claimed, could set seven thousand characters an hour (considerably slower than an average typist). One of the earliest successful photocompositors in use was designed specifically for maps by the National Geographic Society. Matrices of letters reproduced on film were placed in a holder to produce the individual names, which were then photographically reduced to the required size[47] (fig. 6.36). The first map produced by this method was the *United States,* appearing as a supplement to *National Geographic* magazine for May 1933. These devices were the forerunners of the Hadego manual photocompositor, a Dutch-built machine introduced in 1948; the Nomaphot/Bibette used for the Michelin maps in the 1950s; and the Staphograph.[48]

The keyboard and disk devices that developed at about the same time, such as the Intertype Fotosetter (1946), the Rotofoto (1948), and the Photon-Lumitype (1949), had distinct advantages of speed for book typesetting but lacked the versatility of the hand-set photocompositors

in that names could not be curved as is frequently required in map work. Names set on these machines therefore had to be curved when stuck to the map manuscript. Nevertheless, despite this minor inconvenience, most map typography is produced this way today, either photographically or digitally.

The production of automated map typography is well developed and here to stay. But the automatic placement of names on maps has given the programmers far more difficulty. As Imhof has shown, the decisions involved in type positioning are constantly modified as new names are added to the map.[49] The cartographer usually starts in the middle and moves outward, constantly shifting names that have already been tentatively placed. The number of choices at each step is so vast that at the present stage of technology the cost of the procedure would exceed that for the existing manual methods. Nonetheless, it seems reasonable to suppose that an efficient and satisfactory algorithm could be worked out, as has been done with automatic spacing in computer typesetting.[50]

As it became clear in the 1920s that the transition from engraving to photolithography was inevitable, concern was voiced regarding the design and use of appropriate lettering styles for national topographical map series. In England, as the Ordnance Survey undertook the revision of the one-inch map of England and Wales, a new set of alphabets by Ellis Martin was presented to a meeting of the Royal Geographical Society in a paper by Capt. J. G. Withycombe of the Survey.[51] The published discussion following Withycombe's paper, longer than the paper itself, reveals a concern for well-designed lettering, particularly as it affected the image of the Ordnance Survey map, about which there was a great deal of national pride. Among the contributors was Arthur Hinks, secretary of the Royal Geographical Society and a talented cartographer who combined an aesthetic flair with a solid training in mathematics, and Emery Walker, a well-known graphic artist who had taken a major part in the arts and crafts movement led by William Morris. The gist of their comments was that it made sense to use the best historical models for lettering, such as the Trajan inscription or the great Hondius wall map that the society had acquired some years before.[52]

Speaking for the opposition were E. A. Reeves and a Major Boulnois, who questioned the propriety of using these models and advocated the democratization of the whole process. Boulnois:

> In a way, the worst man to choose to design letters for maps is an artist. The man I should like to see put to design the lettering on maps is just the "average sort of bloke" who is a poor map reader, constantly losing his way, and if possible a somewhat short-sighted fellow! . . . I think that if there is to be a re-design of lettering the main points should be entirely those of legibility and simplicity. A map is, after all, an expression, not of art, but of jolly hard work in the field.[53]

As if following Boulnois's lead, another paper on the subject was read to the society a decade later.[54] Col. C. B. Fawcett (who had contributed to the discussion on Withycombe's paper) had designed an alphabet for cartographic use based entirely on the principle of distinguishability of characters (fig. 6.37). The discussion was as heated as that of a decade before. Eva G. R. Taylor remarked:

> A large part of the alphabet really is hideous . . . a draughtsman called upon to make such lettering might well refuse to do so, for if the ordinary map-user were given a map with such lettering . . . the draughtsman or publisher of the map would have to bear the blame for this, in part at least, extremely ugly alphabet. I cannot but emphasize the ugliness.[55]

These polarized viewpoints, one relying solely on efficiency and the other on individual taste, are both valid to a degree. But one can take issue with each. The pragmatic view, by isolating the design of individual characters, fails to appreciate the importance of the graphic context of the lettering and the need to design the map as a holistic unit rather than a patchwork of individual elements.

With the more recent efforts in the United Kingdom and the United States to create new topographical map series based on metric elevations and simpler scale ratios, the problems of choosing lettering arose once more. In the United States, after conversion from copper engraving to lithography about the turn of the century, all type on United States Geological Survey (USGS) topographical maps was hand-set until 1955, when an Intertype Fotosetter was made available. Although it was one of the heaviest users, the topographical division did not control the selection of typefaces for the machine, placing severe restraints on map design. The introduction in 1976 of a Mergenthaler Variable Input Phototypesetter (VIP), which allowed significant increase in speed and quality and for which the division could choose its own typefaces, was therefore hailed as a major improvement.[56]

At about the same time, new metric series of topographical maps at scales of 1:25,000 and 1:100,000 were being planned; two experimental quadrangles of San Juan, Puerto Rico, and "Norwich" had already been prepared, and the former was published. It was recommended that three typefaces be used—Clearface Italic, the Univers family, and the Souvenir family—and the recommendations were substantially accepted. The Mergenthaler VIP was accordingly fitted with Souvenir as the main roman typeface for the entire metric series.

Such a decision, with its far-ranging impact on the look of USGS maps for decades, was not made lightly. Souvenir was commercially available in four weights with matching italics, reduced well without breaking down or filling in the counters, and was in common use throughout the graphic arts industry.

But there are also severe problems with the style. It was designed in 1914 by Morris Fuller Benton, a type designer for American

FIG. 6.37 Plate from C. B. Fawcett, "Formal Writing on Maps," *Geographical Journal* 95 (1940): 19–29.

Typefounders Company. Benton was a prolific type designer who adapted many standard typefaces such as Baskerville and Garamond for ATF; the latter is a particularly fine version of that face. Most of his original designs, however, such as Hobo, Broadway, and Chic, popular in the 1920s, have now become dated and are used to evoke that era. As part of the resurgence of art nouveau taste, they (and Souvenir) have once again become popular. In particular Souvenir, which was adapted for filmsetting by the International Typeface Corporation in 1974, has become widely used in book or advertising typography, especially where an informal atmosphere is desired.

It is questionable whether it is appropriate to choose a typeface of such informal character or transitory quality for the official topographical maps of the country for the next several decades (fig. 6.38). The Souvenir typeface, being weakly constructed at the outset, requires bolder forms to hold its own. In addition, its rounded character (particularly in the lower-case letters *y*, *g*, and *w* and the capitals *A, U, W, Y,* etc.) may be distinctive, but the forms are also intrusive and do not blend well with Univers, the sans-serif face chosen for the series. The conclusion is that the designers at USGS might have been better advised to choose a typeface that had already been well tested in cartographic situations rather than committing themselves to an excessively distinctive and probably transitory style.

It was in the private sector that strides were made to develop a series of map faces that were both effective and attractive. The experience of the National Geographic Society over the past sixty years is instructive because it illustrates a cross section of the adaptation of a commercial map publisher to the changing reproduction processes. The company is also unique in that it developed and patented a series of typefaces specifically for cartographic use. At the outset, the company employed the services of commercial wax engravers such as Matthews-Northrup Company of Buffalo, which had one of the finest map-engraving departments in the United States at the turn of the twentieth century (fig. 6.39). But since the process was wax engraving, commercially available typefaces were used, lending the clarity but sterility characteristic of the technique. In the 1920s the National Geographic Society experimented with lithography, and for a brief period hand lettering was used on their maps. But it became increasingly difficult to find craftsmen trained in the art, and the quality of the product reflects the difficulty (fig. 6.40).

Albert H. Bumstead, the first chief cartographer of the society, believed the answer lay in photocomposition, and he began building a photolettering machine in his home workshop. As he progressed, he discovered that existing typefaces did not lend themselves to the required wide range of photographic enlargement and reduction; the hairlines broke down and the counters filled up. Charles E. Riddiford, staff cartographer and an accomplished designer, was given the assignment of designing typefaces that could stand reduction without loss of clarity. He came up with original typefaces for which the society was able

FIG. 6.38 Use of Souvenir typeface on United States Geological Survey maps. From David Woodward, "Map Design and the National Consciousness: Typography and the Look of Topographic Maps," in *Technical Papers of the American Congress on Surveying and Mapping,* annual meeting March 1982 (Falls Church, Va.: American Congress on Surveying and Mapping, 1982), 343.

FIG. 6.39 Detail from a map of the United States prepared especially for *National Geographic* (National Geographic Society, 1923).

FIG. 6.40 Detail from a map of Louisiana prepared for *National Geographic* (National Geographic Society, 1930).

1946	*Washington : abcdefghijklmnopqrs*
	tuvwxyz:áàâäåÅéèêëæïîìíóôöøØü
	ùûüç§ñłŁ¢$%()°'‴"-?,.1234567890
	WASHINGTON :&ABCDEFG
	HIJKLMNOPQRSTUVWXYZ
	Washington : abcdefghijklmnop
	WASHINGTON : & BCDE
	Philadelphia : abcdefghijklm
1945	*PHILADELPHIA : & BC*
1946	Philadelphia :abcdefghijklmnopr
	PHILADELPHIA: ABCDEF
1945	Philadelphia : abcdefghijklmo
	PHILADELPHIA : &ONA
	Rochester : abcdefghijklmno
	ROCHESTER : ABCDE
	RICHMOND : ABCDE
1946	Sassafras:abcdefghijklmnop : bdfhkl
	SASSAFRAS:ABCDEFGHIJKL
1945	Alleghenies: abcdefghijklmnop
	ALLEGHENIES: &BEFGH
1945	Laurentians : abcdefghijklmn
1945	LAURENTIANS: &BCDE
	ROCKY MTS : ABCDEF
	Mississippi : abcdefghijklmn
	MISSISSIPPI : & ABCD
	Potomac:abcdefghijklmn
	POTOMAC:&.ABDEF
	Edinburgh: abcdefghijklmnopqrs
	Pacific Ocean : m.u.e aceimnors
	PACIFIC SMALL CAPS *& fghjklpq* LONG ASCENDERS
	ATLANTIC: BDEGH
	EUROPE:ABCDEFG
1946	⑫₅ₑ ㉕₇ ⑫ ⑫ₙ ⑦ EWNSA 1234567890

FIG. 6.41 Typefaces designed by Charles E. Riddiford for the National Geographic Society, in Wellman Chamberlin, *The Round Earth on Flat Paper* (Washington, D.C.: National Geographic Society, 1950).

to obtain patents because of their clarity, legibility, and typographic excellence (fig. 6.41). They were first used on the 1933 map already mentioned.[57]

Riddiford continued to improve the typefaces, so that none of those appearing on the 1933 map are precisely the same today, but in the period from the 1930s to the 1960s the basic Riddiford styles were used consistently on National Geographic Society maps and created an iconographic trademark that the map-reading public not only recognized but preferred. It was a classic example of the commercial value of a distinctive and familiar product (fig. 6.42).

FIG. 6.42 Detail from a map of California, with descriptive notes, from *National Geographic* (June 1954).

In the 1970s the use of this typeface was challenged. For the Close Up series of maps, probably out of a desire to change to a more up-to-date image, the society decided to use commercially available typefaces in addition to the Riddiford styles, often as many as eight on one map. In figure 6.43, for example, one can identify the following: Albertus, Copperplate Gothic, Joanna, Optima, Plantin, Schadow Antiqua, Times Roman, and Univers—all perfectly satisfactory styles in themselves but losing much of their value when competing for attention in a small area. The appearance was now stiff, confused, and reminiscent of the wax-engraving era. Fortunately this decision was reversed when it was realized that the change was not an improvement, and the society stopped using most of these typefaces. Furthermore, as if to endorse the original designs, it went to the considerable capital expense of converting the Riddiford alphabets into digital form so they could be used with Mergenthaler computer typesetting equipment without loss of quality.

FIG. 6.43 Detail from a map of California and Nevada in the Close Up series, *National Geographic* (June 1974).

The history of lettering on maps in the Western world from medieval times to the present reveals a constant attempt to combine two basically incompatible graphic elements: the lettering and the rest of the map detail. Three main traditions may be recognized based on the method of producing the lettering: manuscript, hand engraving, and typography. Although these traditions overlap in time and thus cannot be assigned to historical eras, manuscript maps not intended to be printed existed from earliest times until the introduction of photography and other short-run duplicating methods; there are few maps today that are not intended for reproduction of some kind. Hand engraving was introduced in the fifteenth century and extended to the beginning of the twentieth. The final tradition, the typographic, can be traced from the fifteenth century, with experimental uses until the late nineteenth century, whereupon it became the dominant method of lettering maps and is likely to remain so as long as typography and cartography exist in their present forms.

The various attempts to solve the problem of map lettering are closely related to the tools and media available. In the era of manuscript cartography it is doubtful much thought was given to the problem, for there were no other options. It was perhaps during the period of dominance of copper engraving that the greatest harmony was achieved. In that era the burin was equally well adapted to the engraving of linework and the subtle variation in width of lettering strokes; in addition, the same engraver controlled both linework and lettering, making possible a unified stylistic effect.

The use of typography marks a fundamental change in how map lettering was produced and created. Whether in its early sporadic use with woodcuts or as punches in copper plates, or in the later routine use, the typographic image was not created by the engraver or cartographer, who had no control over the basic design. The influence the cartographer can now exert is related to the choice of typefaces, their size, and their placement on the map. We might think that with the multiplicity of typefaces now commercially available, choosing one or two for cartographic use would be a simple matter. But when the decision has to be made, especially a long-range decision as in the case of the USGS metric maps, the choice is not easy. Frequently some undesirable elements or characters are present in the alphabet, or the right weights are not available at a given size. The logical solution is to design or modify a series of typefaces for cartographic use, and this was done successfully by the National Geographic Society in its patented designs.

Lettering has been a prominent and ubiquitous element on maps. Its style is so sensitive to regional and historical differences in taste that it can be used, along with other cartographic elements such as symbolization, color, and iconography, as a period guide in identifying maps. But the historical study of map lettering can provide an additional service. If the quality of maps is to improve, their designers will need to develop a feeling for what is appropriate to the purposes of their time, given the various constraints. One way of achieving this is to immerse themselves in the history of cartography and see what has been found appropriate in the past.

Notes

1. Catalogs issued were "Art and Cartography: Two Exhibitions, 30 October 1980–4 January 1981," *Mapline,* special number 5 (October 1980); Roberta Smith, *Four Artists and the Map: Image, Process, Data, Place* (Lawrence, Kans.: Spencer Museum of Art, University of Kansas, 1981) (a concurrent exhibition in Lawrence was "A Delightful View: Pictures as Maps," 6 April–31 August 1981). "cARTography" was the title of a two-part exhibition at the John Michael Kohler Arts Center, Sheboygan, Wisconsin, 16 November 1980–11 January 1981; part 1, "An Historical Selection of Maps, Globes, and Atlases from the American Geographical Society Collection," and part 2, "Cartographic Images in Contemporary American Art." A fourth exhibition, "Mapped Art: Charts, Routes, Regions," traveled between May 1981 and May 1983. A catalog is available from Independent Curators, Incorporated, New York.

2. Michael J. Blakemore and J. B. Harley, "Concepts in the History of Cartography: A Review and Perspective," *Cartographica* 17, no. 4, monograph 26 (Winter 1980).

3. Examples are James A. Welu, "Vermeer: His Cartographic Sources," *Art Bulletin* 57 (1975): 529–47, and Juergen Schulz, "Jacopo de' Barbari's View of Venice: Map Making, City Views, and Moralized Geography before the Year 1500," *Art Bulletin* 60 (1978): 425–74.

4. For example, Rudolf Arnheim, *Art and Visual Perception* (Berkeley: University of California Press, 1974); David Pye, *The Nature of Design* (London, 1964); and Michael Twyman, "A Schema for the Study of Graphic Language," in *The Processing of Graphic Language,* ed. P. A. Kolers, M. E. Wrolstad, and H. Bouwma, 1:117–50 (New York: Plenum Press, 1979).

5. "On Maps and Mapping," *ArtsCanada* 188–89 (Spring 1974); Marc Treib, "Mapping Experience," *Design Quarterly* 115 (1980).

6. Leo Bagrow, *History of Cartography,* rev. and enl. by R. A. Skelton (London: C. A. Watts, 1964), 22.

7. Ronald Rees, "Historical Links between Cartography and Art," *Geographical Review* 70 (1980): 60–78.

8. James A. Welu, "The Map in Vermeer's *Art of Painting,*" *Imago Mundi* 30 (1978): 9–30.

9. Thomas Munro, *Form and Style in the Arts: An Introduction to Aesthetic Morphology* (Cleveland: Case Western Reserve University Press, 1970).

10. Harold Osborne, *Aesthetics and Art Theory: An Historical Introduction* (New York: E. P. Dutton, 1970), 87–90.

11. A recent summary of this theory and its possible application to cartography is given in Phillip Muehrcke, "Maps in Geography," *Cartographica* 18, no. 2 (Summer 1981): 1–41.

12. Thomas Munro, *Scientific Method in Aesthetics* (New York: W. W. Norton, 1928), 97.

13. Barbara B. Petchenik, "A Verbal Approach to Characterizing the Look of Maps," *American Cartographer* 1 (1974): 63–71.

14. Geoffrey LaPage, *Art and the Scientist* (Bristol: John Wright, 1961). This stimulating work on the history of scientific illustration has several parallels with the technical history of cartography.

15. A parallel discussion of the links between the cartographer and the map printer is given in Arthur H. Robinson, "Mapmaking and Map Printing: The Evolution of a Working Relationship," in *Five Centuries of Map Printing,* ed. David Woodward, 1–23 (Chicago: University of Chicago Press, 1975).

CHAPTER ONE 1. For bibliography and further discussion of Leonardo's drawing *Man in a Circle and a Square,* see Carlo Pedretti, ed., *The Literary Works of Leonardo da Vinci Compiled and Edited from the Original Manuscripts by Jean Paul Richter* (Oxford, 1977), 1:244–51.

2. As translated by Elizabeth Livermore Forbes in Ernst Cassirer, Paul Oskar Kristeller, and John Herman Randall, Jr., eds., *The Renaissance Philosophy of Man* (Chicago, 1948), 224–25.

3. As translated by S. K. Heninger, Jr., in *The Cosmographical Glass* (San Marino, Calif., 1977), 144.

4. Leonardo, of course, would have known the relevant work of his friend Luca Pacioli, *De divina proportione,* eventually published in Venice in 1509. See Constantin Winterberg, ed., *Fra Luca Pacioli "Divina Proportione": Die Lehre von goldenen Schnitt.* Quellenschrift für Kunstgeschichte, n.s., 2 (Vienna, 1889); also Julius Schlosser, ed., *La letteratura artistica* (Florence, 1964), 141 ff.; also Derek J. de Solla Price, "The ✧, ✮, and ✿, and Other Geometric and Scientific Talismans and Symbolisms," in *Changing Perspectives in the History of Science: Essays in Honour of Joseph Needham,* ed. M. Teich and R. Young, 250–65 (Dordrecht, 1973).

5. Book 3, chap. 1. For an English translation of Vitruvius's famous passage on the proportions of the human figure, see Morris Hickey Morgan, ed., *Vitruvius: The Ten Books on Architecture* (Cambridge, Mass., 1914), 72–73. A few years before Leonardo, Francesco de Giorgio Martini experimented with a similar drawing after Vitruvius, but based more on the concept of "man in a modular grid." See, for example, his drawing in the Biblioteca Nazionale, Florence, Magl. II, I, 141, fol. 38v, as published and discussed in Corrado Maltese and Livia Maltese Degrassi, eds., *Francesco di Giorgio Martini Trattati di architettura ingegneria e arte militare* (Milan, 1967), 2:393. For more on Renaissance concepts of figural proportions as they evolved from classical antiquity, see Erwin Panofsky, "The History and Theory of Human Proportions as a Reflexion of the History of Style," in *Meaning in the Visual Arts* (New York, 1957). See also R. W. Wittkower, *Architectural Principles in the Age of Humanism* (New York, 1960), and also George Hersey, *Pythagorean Palaces* (Ithaca, N.Y., 1976).

6. For a thorough discussion of the fourteenth-century Greek-language Ptolemy manuscripts that first found their way to western Europe, see Joseph Fischer, *Claudii Ptolemaei Codex Urbinas Graecus 82,* 4 vols. (Leipzig, 1932). For further ideas on how these manuscripts were received in Florence after 1400, see Samuel Y. Edgerton, *The Renaissance Rediscovery of Linear Perspective* (New York, 1975), 91–124.

7. As translated in J.-P. Richter, ed., *The Notebooks of Leonardo da Vinci* (New York, 1970; reprint of *The Literary Works of Leonardo da Vinci,* London, 1883), 2:111. For further comments and bibliography on this passage, see Pedretti, *Leonardo,* 2:91 (see note 1 above) and Edmondo Solmi, *Scritti Vinciani: Le fonti dei manoscritti di Leonardo da Vinci e altri studi* (Florence, 1971; reprint of Turin, 1908), 271–73. Concerning Leonardo's ownership of Ptolemy's *Cosmography,* see Pedretti, *Leonardo,* 2:364 (note 1).

8. Most if not all of the maps in the Greek *Cosmography* manuscripts arriving in Florence and the rest of western Europe during the fifteenth century were based on Byzantine atlases of the tenth or eleventh century. Except for book 1 and perhaps book 8, the text of the *Cosmography* seems also to be a later compilation, gathered by some medieval author under the general rubric "Ptolemy." Just how much the real Ptolemy actually contributed to the Renaissance version of the *Cosmography* is not my concern here; it matters only that Renaissance scientists and artists like Leonardo da Vinci were convinced that it was an authentic, cohesive classical treatise on cartography. Concerning the dispute over Ptolemy's authorship, however, see Leo Bagrow (Lev S. Bagrov), "The Origin of Ptolemy's *Geographia,*" *Geografiska Annaler* 27 (1945): 318–87; Leo Bagrow, *History of Cartography,* rev. and enlarged by R. A. Skelton (Cambridge, Mass., 1964), 34–37; Otto Neugebauer, *The Exact Sciences in Antiquity* (Providence, R.I., 1957), 227, n. 89; E. Polaschek, "Ptolemy's Geography in a New Light," *Imago Mundi* 14 (1959): 17–37; and W. M. Stevens, "The Figure of the Earth in Isidore's *De Natura Rerum,*" *Isis* 71 (1980): 276–77, n. 27.

9. See, for example, Solmi, *Scritti Vinciani,* 272 ff. (note 7).

10. This passage is from book 1, chap. 1 of the *Cosmography.* Its implications are discussed in Edgerton, *Rediscovery,* 110–13 (note 6).

11. Robert Belle Burke, trans., *The Opus Majus of Roger Bacon* (Philadelphia, 1928 and 1962), 1:236. The original Latin is given in John Henry Bridges, ed., *The Opus Majus of Roger Bacon* (London, 1897), 1:214.

12. Edgerton, *Rediscovery,* 69 (note 6).

13. Pierre de Limoges (the work has also been attributed to John Pecham), *De oculo moralis* (Venice, 1496) (copy in Biblioteca Nazionale, Florence). Below follows my translation of a passage from chap. 3: "The authorities of optical science divide in three the visions of the eye. The first is by means of straight lines, the second by interrupted [refracted] lines, and the third by reflected lines. Of these the first is more perfect than the other two. The second is more certain than the third, and the third is least certain. In the same way we are able to assign in man three strengths of vision spiritually speaking. The perfect one will occur in the state of glory after the final resurrection. The other is in the soul separated from the body until the final resurrection, when it will contemplate the divine essence in the heavenly empyrean. This vision is weaker than the first. The third is the [vision] in the present life, weaker than both the others. The third vision is done by reflection, as one sees something in a mirror. . . . Hence this vision is called by the apostle 'mirror vision' when he says, 'We see in the present by means of a figurative mirror, but in glory we will see face to face . . . the full rectitude . . . and plenitude of the divine vision.'"

14. L. D. Ettlinger, "Pollaiuolo's Tomb of Pope Sixtus IV," *Journal of the Warburg and Courtauld Institutes* 16 (1953): 258–61.

15. Concerning Leonardo's optical theories and their application to Renaissance thinking about pictures, see James S. Ackerman, "Leonardo's Eye," *Journal of the Warburg and Courtauld Institutes* 41 (1978): 108–47, and Martin Kemp, "Leonardo and the Visual Pyramid," *Journal of the Warburg and Courtauld Institutes* 40 (1977): 128–50.

16. S. C. Leahy, A. Moskowitz-Cook, S. Brill, and R. Held, "Orientational Anistrophy in Infant Vision," *Science* 190 (1975): 900–902. See also Elaine Vurpillot, *The Visual World of the Child* (New York, 1976; originally published in French, Paris, 1972), 73 and passim.

17. Alexander Marshak, *Roots of Civilization* (New York, 1972).

18. Joseph Needham and Wang Ling, *Science and Civilisation in China* (Cambridge, 1959), 3:106–8. The ancient Chinese calligraphic character *ching,* meaning "a well," apparently derived also from the age-old image of a central water supply at the corners of four adjoining rectilinear fields.

19. Alfred Forke, *The World Conception of the Chinese* (London, 1925), 152.

20. Fernand Windels, *Lascaux: "Chapelle Sixtine" de la préhistoire* (Dordogne, 1948), 60–67.

21. E. H. Gombrich, *The Sense of Order* (Ithaca, N.Y., 1979), 75, 155–56 (note 21).

22. For another insightful discussion of the psychological and aesthetic effect of centrally focused design, see Rudolf Arnheim, *The Power of the Center: A Study of Composition in the Visual Arts* (Berkeley, 1982).

23. This quotation is from a personal letter sent to me by Professor Smith, dated 21 May 1980.

24. René Berthelot, *La pensée de l'Asie et l'astrobiologie* (Paris, 1949); Jorge E. Hardoy, *Pre-Columbian Cities* (New York, 1973; original Spanish edition 1964); and Paul Wheatley, *Pivot of the Four Quarters* (Chicago, 1971).

25. Douglas Fraser, *Village Planning in the Primitive World* (New York, 1968).

26. Sibyl Moholy-Nagy, *Matrix of Man: An Illustrated History of Urban Environment* (New York, 1968), 158.

27. Wheatley, *Pivot,* 308–9 (note 24).

28. James R. McCredie, "Hippodamos of Miletus," in *Studies Presented to George M. A. Hanfmann,* ed. D. G. Mitten, J. G. Pedley, and J. A. Scott, 95–100 (Mainz, 1971); R. E. Wycherley, *How the Greeks Built Cities* (New York, 1952), 20.

29. Moholy-Nagy, *Matrix,* 105–9 (note 26).

30. Giovanni Fanelli, *Firenze, architettura e città* (Florence, 1973), 1–3.

31. John Pinto, "Origins and Development of the Ichnographic City Plan," *Journal of the Society of Architectural Historians* 35 (1976): 35–50.

32. A number of these have been transcribed and published in the original Latin with commentary by C. Thulin, *Corpus Agrimensorum Romanorum* (Leipzig, 1913). Three of the known medieval copies have colored illustrations: the Arcerianus manuscripts in the Herzog-August Bibliothek, Wolfenbüttel, Germany (Aug. 8, 36, and 23), transcribed in the sixth or seventh century A.D., and *Palatinus Latinus* 1564 in the Vatican Library, Rome, of about the ninth century. See O. A. W. Dilke, "Maps in the Treatises of Roman Land Surveyors," *Geographical Journal* 127 (1961): 417–26; also idem, *Greek and Roman Maps* (London, 1985), 88–101; D. J. Price, "Medieval Land Surveying and Topographical Maps," *Geographical Journal* 121 (1955): 1–10; and H. Lyons, "Ancient Surveying Instruments," *Geographical Journal* 69 (1927): 137–43.

33. Wheatley, *Pivot,* 424 (note 24): "The Chinese processional way was of symbolic rather than visual significance. In fact, its full sweep was never revealed at any one time or from any one point. It was not so much a vista as a succession of varied spaces integrated into an axial whole, in a manner that inevitably recalls Chinese scroll painting. This axial design is superbly executed

in Pei-ching where the official visitor was formally confronted in his progress along the processional way by a seemingly interminable succession of gates and towers and walls."

34. Needham and Wang, *Science and Civilisation in China*, 2:279–303 (note 18).

35. Needham and Wang, *Science and Civilisation in China*, 2:290 (note 18): "Instead of observing successions of phenomena, the ancient Chinese registered alternations of aspects. If two species seemed to them to be connected, it was not by means of a cause and effect relationship, but rather 'paired' like obverse and reverse."

36. Needham and Wang, *Science and Civilisation in China*, 3:537–40 (note 18). Original Chinese gridded maps from this early date have not survived, but extant verbal descriptions of them leave no doubt. For instance, Needham translates from Phei Hsiu, minister of works for the Chin dynasty emperor in A.D. 267, who was instructed to inspect the imperial map archives. Phei's report to the emperor on the need for improving the current mapping system sounds almost like Roger Bacon writing to the pope nearly a thousand years later: "When the principle of the rectangular grid is properly applied, then the straight and curved, the near and far, can conceal nothing of their form from us."

37. Needham and Wang, *Science and Civilisation in China*, 3:548. The finest extant map of this period is the *Yü chi thu,* or "Map of the Tracks of Yü the Great," carved in stone about A.D. 1137 but probably after an earlier prototype. It shows central China fixed on a uniformly scaled grid with north at top. The whole map is about three feet square, and it is now in the Bei Lin Museum in Xian. Needham illustrates it in vol. 3, pl. LXXXI. He calls it "the most remarkable cartographic work of its age in any culture."

38. Needham and Wang, *Science and Civilisation in China* 3:106 (note 18).

39. Needham and Wang, *Science and Civilisation in China* 2:288 (note 18).

40. My translation of the Italian as published in Pasquale D'Elia, ed., *Fonti Ricciane: Edizione nazionale delle opere edite e inedite di Matteo Ricci* (Rome, 1942), 1:207–11.

41. Bagrow, *History of Cartography,* (note 8).

42. John Kirtland Wright, "Notes on the Knowledge of Latitude and Longitude in the Middle Ages," *Isis* 5 (1923): 76. For an excellent discussion of Islamic cartography, see also Needham and Wang, *Science and Civilisation in China,* 3:561–65 (note 18).

43. Lloyd A. Brown, *The Story of Maps* (Boston, 1949), 88–91.

44. On Isidore of Seville, see Jacques Fontaine, ed., *Isidore de Séville: Traité de la nature* (Bordeaux, 1960). On his cartographic influence, see W. L. Bevan and H. W. Phillott, *Mediaeval Geography: An Essay in Illustration of the Hereford Mappa Mundi* (London, 1873; reprinted in Amsterdam, 1969), xiii–xiv; and most recently, Stevens, "Figure of the Earth" (note 8). See also Arnheim, *Power of the Center,* 122–23 (note 22), for an aesthetic analysis of the T-O map.

45. Bagrow, *History of Cartography,* 48–50 and passim (note 8).

46. Burke, *Roger Bacon,* 2:416–17 (note 11).

47. But Bacon, of course, was quite familiar with Ptolemy's *Almagest* or *Handbook of Astronomy,* well known in the West at least since the twelfth century, which contained exacting mathematical means for determining longitude/latitude coordinates for heavenly if not earthly bodies. For further infor-

mation concerning the use of the grid as a tool of cartography as well as land measurement in Europe well before Ptolemy's *Cosmography* appeared in 1400, see Wright, "Latitude," 75–98 (note 42); Price, "Medieval Land Surveying," 1–10 (note 32); R. G. Salomon, *Opicinus de Canistris: Weltbild und Bekenntnisse eines avignonischen Klerikers des 14. Jahrhunderts,* Studies of the Warburg Institute (London, 1936); and Dana B. Durand, *The Vienna and Klosterneuburg Map Corpus: A Study in the Transition from Medieval to Modern Science* (Leiden, 1952).

48. Illustrated in Burke, *Roger Bacon,* 1:315 (note 11).

49. Burke, *Roger Bacon,* 1:232–34 (note 11); Bridges, *Roger Bacon,* 1:210–11 (note 11).

50. Needham and Wang, *Science and Civilisation in China,* 3:52, 105 (note 18).

51. Burke, *Roger Bacon,* 1:296 (note 11).

52. J. L. Myres, "An Attempt to Reconstruct the Maps Used by Herodotus," *Geographical Journal* 8 (1896): 605–29; see also William Arthur Heidel, *The Frame of the Ancient Greek Maps* (New York, 1976).

53. Needham and Wang, *Science and Civilisation in China,* 3:106–8 (note 18).

54. Ptolemy the polymath was also interested in art. Indeed, he described how to make a three-dimensional model of the universe in the very terminology of a Hellenistic painter; see K. Manitius and O. Neugebauer, eds., *Ptolemäus: Handbuch der Astronomie* (Leipzig, 1963), 2:72.

55. For the best explanation of Ptolemy's cartographic methods, see Hans V. Mžik and Friedrich Hopfner, "Das Klaudios Ptolemaios Einführung in die darstellende Erdkunde," *Klotho* 5 (1938): 1 ff.; also O. Neugebauer, "Ptolemy's Geography, Book VII, Chapters 6 and 7," *Isis* 50 (1959): 22–29, and his *The Exact Sciences in Antiquity* (Providence, R.I., 1957; New York, 1969), 220–27.

56. Neugebauer, "Ptolemy's Geography, Book VII," 22–29 (note 55).

57. Edgerton, *Rediscovery,* 106–24 (note 6).

58. O. Neugebauer, "The Astronomical Origin of the Theory of Conic Sections," *Proceedings of the American Philosophical Society* 92 (1948): 136–38.

59. Concerning perspective illusion in classical stage design, see Vitruvius's famous passages from *De architectura* quoted and discussed in Edgerton, *Rediscovery,* 70–72 (note 6). See also Filippo Coarelli, *Guida archeologica di Roma* (Rome, 1974), 141–44; also Decio Gioseffi, *Perspectiva artificialis: Per la storia della prospettiva spigolature e appunti* (Trieste, 1957), 31–47.

60. Gioseffi, *Perspectiva,* 60–73 (note 59); see also John White, *The Birth and Rebirth of Pictorial Space* (London, 1968), 60–89.

61. Robert Klein, "Pomponius Gauricus on Perspective," *Art Bulletin* 43 (1961): 211–30; Alessandro Parronchi, *Studi su la dolce prospettiva* (Milan, 1964), 468–532; review of Parronchi, *Art Bulletin* 49 (1967): 77–80.

62. Edgerton, *Rediscovery,* 115 (note 6).

63. On Alberti's mapping method, see Luigi Vagnetti, *La "Descriptio Urbis Romae" di L. B. Alberti,* Quaderno no. 1 (Università degli studi di Genova; Facoltà di Architettura, October, 1968), 25–81. Alberti also applied the disk-like instrument for mapping Rome to what we might call the mapping of the human figure for reproduction into three-dimensional sculpture. He referred to this process as *finitio,* or the recording of "variations in limbs . . . caused by movements and new dispositions of the parts." He would set his disk (he called it a *finitorium*) on top of the figure to be copied. After locating the relative di-

rections of all the parts of the figure, he would drop a plumb line from the end of the alidade, and by measuring perpendicularly from where this plumb passed the level of each body detail, he could reposition the same detail exactly in his copy. See Cecil Grayson, ed., *Leon Battista Alberti on Painting and Sculpture* (London, 1972), 120–42.

64. On Raphael's mapping method, see Vincenzo Golzio, *Raffaello nei documenti, nelle testimonianze dei contemporanei e nella letteratura del suo secolo* (Vatican City, 1936), 87–91.

65. Edgerton, *Rediscovery,* 40–49 (note 6). Alberti's text for constructing the *velum* is given in Latin and English in Grayson, *Alberti,* 68–69 (note 63).

66. On Dürer's perspective theory and its derivation from the Italians, especially Alberti, see Erwin Panofsky, *Albrecht Dürer* (Princeton, N.J., 1945), 1:242–73.

67. For an exhaustive list and brief description of all treatises published on perspective and perspective application from the fifteenth century through modern times, see Luigi Vagnetti, *De naturali et artificiali perspectiva,* Studi e Documenti di Architettura, 9–10 (Florence, 1979).

68. Elizabeth L. Eisenstein, *The Printing Press as an Agent of Change* (Cambridge, 1979), vol. 2. The author counters a commonly espoused view that printing, by paying so much attention to the Ptolemaic atlas in the early sixteenth century, actually retarded further advances in cartographic science. Not so, she avers, since printing made it possible for this system to be widely disseminated and studied: "It had to be assimilated first before it could be surpassed" (514–19). On the importance of printing to the spread of Renaissance art forms generally, see William M. Ivins, Jr., *Prints and Visual Communication* (London, 1953).

69. Erwin Panofsky, "Die Perspektive als 'symbolische Form,'" in *Vorträge der Bibliothek Warburg: 1924–1925,* 258–331 (Leipzig, 1927).

70. For further thought-provoking reading on the remarkable advances Western science was able to make simply by redefining and reapplying these ancient geometric devices, see Marshall Clagett, "Some Novel Trends in the Science of the Fourteenth Century," in *Art, Science, and History,* ed. Charles Singleton, 275–303 (Baltimore, 1967). Walter Pagel, "William Harvey and the Purpose of Circulation," *Isis* 42 (1951): 22–38; and Rocco Sinisgalli, *Per la storia della prospettiva (1405–1605): Il contributo di Simon Stevin allo sviluppo scientifico della prospettiva artificiale ed i suoi precedenti storici* (Rome, 1978).

71. This remarkable development in the ability to imagine complex but orderly geometric structures purely in the abstract, even without reference to diagrams, is stressed in Sinisgalli, *Simon Stevin* (note 70), leading in the seventeenth and eighteenth centuries to the founding of the science of descriptive geometry by Girard Désargues and Gaspard Monge.

72. Pius's commentary is in a lengthy section called *Cosmography* of his *Historia rerum ubique gestarum,* written in the 1460s and printed in Helmstedt, 1699–1700, under the title *Aeneae Sylvii Piccolominei postea Pii II Papae opera geographica et historica.*

73. Pius II (Eneo Silvio Piccolomini), *The Commentaries* ed. L. C. Gabel and trans. F. A. Gragg, in *Memoirs of a Renaissance Pope,* 282–92 (New York, 1959).

74. L. D. Ettlinger, *The Sistine Chapel before Michelangelo: Religious Imagery and Papal Primacy* (Oxford, 1965), 90–93: "The splendid centralized temple symbolizes by the combination of the perfect forms of circle and square the perfection of the church in accordance with the architectural principles of

Alberti and the other theorists. It is remarkable, however, that Perugino's building antedated all actual structures of such a centrally planned church."

75. Eugenio Battisti, "La visualizzazione della scena classica nella commedia umanistica," *Commentari* 8 (1957): 248; Richard Krautheimer, "The Tragic and Comic Scene of the Renaissance: The Baltimore and Urbino Panels," in *Studies in Early Christian, Medieval, and Renaissance Art,* 345–60 (New York, 1969).

76. Frederic R. White, ed., *Famous Utopias of the Renaissance* (New York, 1946). See also C. W. Westfall, *In This Most Perfect Paradise: Alberti, Nicholas V, and the Invention of Conscious Urban Planning in Rome, 1447–55* (University Park, Pa., 1974), and his "Chivalric Decorations: The Palazzo Ducale in Urbino as Political Statement," in *Art and Architecture in the Service of Politics,* ed. H. A. Millon and L. Nochlin, 20–46 (Cambridge, Mass., 1978).

77. Francis M. Rogers, *The Quest for Eastern Christians: Travels and Rumor in the Age of Discovery* (Minneapolis, 1962).

78. White, *Pictorial Space,* 46 (note 60).

79. Westfall, *Perfect Paradise,* 111 (note 76).

80. H. de la Croix, "Military Architecture and the Radial City Plan in Sixteenth-Century Italy," *Art Bulletin* 42 (1960): 263–90.

81. Samuel Eliot Morison, *Journals and Other Documents on the Life and Voyages of Christopher Columbus* (New York, 1963), 11–17.

82. Alexander's bull regarding the "demarcation line" is given in Anne Fremantle, ed., *The Papal Encyclicals in Their Historical Context* (New York, 1956), 77–81.

83. René Taylor, "Architecture and Magic: Considerations on the *Idea* of the Escorial," in *Essays in the History of Architecture Presented to Rudolf Wittkower,* ed. Douglas Fraser et al., 94 ff. (London, 1967).

84. Earl E. Rosenthal, "*Plus ultra, non plus ultra,* and the Columnar Device of Emperor Charles V," *Journal of the Warburg and Courtauld Institutes* 34 (1971): 204, and his "The Invention of the Columnar Device of Charles V at the Court of Burgundy in Flanders, 1516," *Journal of the Warburg and Courtauld Institutes* 36 (1973): 198–230.

85. Taylor, "Architecture and Magic," 81–102 (note 83). I am especially thankful to Marie Tanner for allowing me to expand on some of her own ideas and evidence concerning Philip II's Escorial, to be published in her forthcoming study of the subject.

CHAPTER TWO 1. Alfred Frankenstein, "The Great Trans-Mississippi Railway Survey," *Art in America* 64 (1976): 55–58.

2. The major examples in the field of Dutch art are the several studies by James A. Welu (cited below) and the exhibition catalog *The Dutch Cityscape in the Seventeenth Century and Its Sources* (Amsterdam, 1977). For a general study of cartographic material published in Amsterdam during the seventeenth century, with a fine eye for its cultural place and its relation to art and artists, see *The World on Paper* (Amsterdam, 1967), compiled by Marijke de Vrij on the occasion of the International Conference on Cartography. Both exhibitions were under the auspices of the Amsterdam Historical Museum, which has been in the forefront of showing the ties that bind art to society.

3. J. Wreford Watson, "Mental Distance in Geography: Its Identification and Representation" (paper delivered at the Twenty-second International Geographical Congress, Montreal, 1972).

4. Ronald Rees, "Historical Links between Cartography and Art,"

Geographical Review 70 (1980): 62. See also P. D. A. Harvey, *The History of Topographical Maps* (London, 1980). This book, which appeared after I had completed my own research, is interested in some of the same materials but differs because it still comes at it from what I would call a cartographic point of view.

5. On Vermeer's map as a source for cartographic history see James A. Welu, "Vermeer: His Cartographic Sources," *Art Bulletin* 57 (1975): 529–47, and "The Map in Vermeer's *Art of Painting*," *Imago Mundi* 30 (1978): 9–30. Footnotes 54 and 56 in the first article list the major studies on the map and on the interpretation of the painting itself.

6. To cite but a few from a great number of examples: Gemma Frisius titled his 1533 treatise on triangulation, *Libellus de locorum describendorum ratione . . .* , the Dutch rendering of which was *Die maniere om te beschrijven de plaetsen ende Landtschappen* (Amsterdam, 1609); Petrus Montanus refers to Jodocus Hondius as "De alder-vermaerste en best-geoffende Cosmagraphus ofte Werelt-beschrijver van onse eeuw" in his introduction to the first Dutch edition of the Mercator-Hondius atlas (1634).

7. Kurt Pilz has argued against the attribution of the map of Bohemia to Comenius. See Kurt Pilz, *Die Ausgaben der Orbis Sensualim Pictus* (Nuremberg, 1967), 35–37. For the previous attribution of the map to Comenius, see L. E. Harris, *The Two Netherlands: Humphrey Bradley and Cornelis Drebbel* (Leiden, 1961), 130, and Josef Šmaha, *Comenius also Kartograph seines Vaterlandes* (Znaim, 1892).

8. The circumstances of the making of this drawing were noted by I. G. van Regteren Altena in Victoria and Albert Museum, *Drawings from the Teyler Museum, Haarlem* (London, 1970), no. 39.

9. Antoine de Smet, "A Note on the Cartographic Work of Pierre Pourbus," *Imago Mundi* 4 (1947): 33–36, and Paul Huvenne, "Pieter Pourbus als Tekenaar," *Oud Holland* 94 (1980): 11–31. For more general studies see S. J. Fockema Andreae, *Geschiedenis der Kartografie van Nederland* (The Hague, 1947), and Johannes Keuning, "Sixteenth Century Cartography in the Netherlands (Mainly in the Northern Provinces)," *Imago Mundi* 9 (1952): 35–63.

10. Utrecht, Centraal Museum, *Catalogue Raisonné of the Works by Pieter Jansz. Saenredam* (Utrecht, 1961). Giuliano Briganti, *Gaspar van Wittel e l'origine della veduta settecentesca* (Rome, 1966).

11. Maria Simon, "Claesz Jansz. Visscher" (diss., Albert-Ludwig Universität, Freiburg, 1958).

12. Ernst Kris, "Georg Hoefnagel und der wissenschaftliche Naturalismus," in *Festschrift für Julius Schlosser* (Zurich, Leipzig, Vienna, n.d.), 243–53.

13. Quoted (in translation) in Johannes Keuning, "Isaac Massa, 1586–1643," *Imago Mundi* 10 (1953): 67.

14. For the Greek I have used Claudius Ptolemaeus, *Geographia,* ed. Karl Müller (Paris, 1883); for the Latin the *Geography,* trans. Bilibaldus Pirckheymer (Basel, 1552).

15. Evidence for this tradition of interpretation is readily available in the various translations of Petrus Apianus, *Cosmography,* whose text is based on Ptolemy. *Picture* is invoked in the subsection of chapter 1 entitled "Geographia quid." The editions consulted were in Latin (Antwerp, 1545), in French (Paris, 1553), and in Dutch (Amsterdam, 1609), all in the British Museum.

16. Apianus's rendering of Ptolemy's introductory words is "Cosmographia (ut ex etymo vocabuli patet) est mundi . . . descriptio" (Antwerp,

1545). The Dutch edition reads, "Cosmografie is een Cosnte daer-men de gheheele Wereldt mede beschrijft" (Amsterdam, 1609). The casual identity assumed between a picture in this mapping context is best brought out in Gemma Frisius's own French translation of a passage from Apianus in which geography is referred to as "une description ou paincture & imitation" (Paris, 1545), chap. 1, fol. 3v. The Latin so translated reads, "Geographia [est] . . . formula quaedam ac picturae imitatio."

17. See Ernst Robert Curtius, *European Literature and the Latin Middle Ages,* trans. Willard K. Trask (New York, 1953), 68 ff., for a succinct summary of the system of ancient rhetoric of which *ekphrasis* is part.

18. See the title of Frisius's treatise on triangulation, note 6 above.

19. Arthur H. Robinson and Barbara Bartz Petchenik, *The Nature of Maps* (Chicago, 1976), 16.

20. A. S. Osley, *Mercator: A Monograph on the Lettering of Maps . . .* (New York, 1969).

21. Samuel Y. Edgerton, Jr., *The Renaissance Rediscovery of Linear Perspective* (New York, 1976), chaps. 7 and 8, and above, chapter 1. John Pinto on the other hand has distinguished a nonperspectival mode of city representation—a vertical plan—that he also associates with Italy. This view, which specifically lacks a located viewer and instead assumes a plurality of views, is closer to the northern pictorial mode that I am defining. See John A. Pinto, "Origins and Development of the Iconographic City Plan," *Journal of the Society of Architectural Historians* 35 (1976): 35–50.

22. A subtle and original attempt to argue the mapping nature of northern images is found in John Harbison, *Eccentric Spaces* (New York, 1977), chap. 7, "The Mind's Miniatures: Maps."

23. Samuel van Hoogstraten, *Inleyding tot de Hooge Schoole der Schilderkonst* (Rotterdam, 1678), 7.

24. Kepler is quoted as commenting on the use of peasants as informants in mapmaking; see Egon Klemp, *Commentary on the Atlas of the Great Elector* (Stuttgart, Berlin, and Zurich, 1971), 19. Antoine de Smet, "Pierre Pourbus" (note 9) refers to Pourbus's use of fishermen and pilots.

25. Ernst Gombrich, "The Renaissance Theory of Art and the Rise of Landscape," in *Norm and Form,* 107–21 (London, 1966).

26. Edward Norgate, *Miniatura, or The Art of Limning* (1648–58) (Oxford, 1919), 45–46.

27. Jan de Vries, *The Dutch Rural Economy in the Golden Age, 1500–1700* (New Haven, 1974), provides the fullest evidence. See especially chap. 2.

28. Translated from the Latin *Epigramma in Duos Montes,* in *Andrew Marvell: The Complete Poems,* ed. Elizabeth Story Donno (Harmondsworth, 1972), 74–75. For a discussion of this problem in English poetry see James Turner, *The Politics of Landscape* (Cambridge, Mass., 1979); for the term "landscape" see the same author, "Landscape and the 'Art Prospective" in England, 1584–1660," *Journal of the Warburg and Courtauld Institutes* 42 (1979): 290–93.

29. Wolfgang Stechow, *Dutch Landscape Painting of the Seventeenth Century* (London, 1966), gives the standard account.

30. Georg Braun and Franz Hogenberg, *Civitates orbis terrarum* (Cologne, 1572–1617), vol. 3, introduction, fol. Av.

31. R. A. Skelton in his introduction to the reprint of Braun and Hogenberg, *Civitates* (Cleveland and New York, 1966).

32. Petrus Apianus, *Cosmographia* (Antwerp, 1545), chap. 19.

33. Braun and Hogenberg, *Civitates,* vol. 3, introduction, fol. B (note 30).

Geographical Review 70 (1980): 62. See also P. D. A. Harvey, *The History of Topographical Maps* (London, 1980). This book, which appeared after I had completed my own research, is interested in some of the same materials but differs because it still comes at it from what I would call a cartographic point of view.

5. On Vermeer's map as a source for cartographic history see James A. Welu, "Vermeer: His Cartographic Sources," *Art Bulletin* 57 (1975): 529–47, and "The Map in Vermeer's *Art of Painting*," *Imago Mundi* 30 (1978): 9–30. Footnotes 54 and 56 in the first article list the major studies on the map and on the interpretation of the painting itself.

6. To cite but a few from a great number of examples: Gemma Frisius titled his 1533 treatise on triangulation, *Libellus de locorum describendorum ratione . . .* , the Dutch rendering of which was *Die maniere om te beschrijven de plaetsen ende Landtschappen* (Amsterdam, 1609); Petrus Montanus refers to Jodocus Hondius as "De alder-vermaerste en best-geoffende Cosmagraphus ofte Werelt-beschrijver van onse eeuw" in his introduction to the first Dutch edition of the Mercator-Hondius atlas (1634).

7. Kurt Pilz has argued against the attribution of the map of Bohemia to Comenius. See Kurt Pilz, *Die Ausgaben der Orbis Sensualim Pictus* (Nuremberg, 1967), 35–37. For the previous attribution of the map to Comenius, see L. E. Harris, *The Two Netherlands: Humphrey Bradley and Cornelis Drebbel* (Leiden, 1961), 130, and Josef Šmaha, *Comenius also Kartograph seines Vaterlandes* (Znaim, 1892).

8. The circumstances of the making of this drawing were noted by I. G. van Regteren Altena in Victoria and Albert Museum, *Drawings from the Teyler Museum, Haarlem* (London, 1970), no. 39.

9. Antoine de Smet, "A Note on the Cartographic Work of Pierre Pourbus," *Imago Mundi* 4 (1947): 33–36, and Paul Huvenne, "Pieter Pourbus als Tekenaar," *Oud Holland* 94 (1980): 11–31. For more general studies see S. J. Fockema Andreae, *Geschiedenis der Kartografie van Nederland* (The Hague, 1947), and Johannes Keuning, "Sixteenth Century Cartography in the Netherlands (Mainly in the Northern Provinces)," *Imago Mundi* 9 (1952): 35–63.

10. Utrecht, Centraal Museum, *Catalogue Raisonné of the Works by Pieter Jansz. Saenredam* (Utrecht, 1961). Giuliano Briganti, *Gaspar van Wittel e l'origine della veduta settecentesca* (Rome, 1966).

11. Maria Simon, "Claesz Jansz. Visscher" (diss., Albert-Ludwig Universität, Freiburg, 1958).

12. Ernst Kris, "Georg Hoefnagel und der wissenschaftliche Naturalismus," in *Festschrift für Julius Schlosser* (Zurich, Leipzig, Vienna, n.d.), 243–53.

13. Quoted (in translation) in Johannes Keuning, "Isaac Massa, 1586–1643," *Imago Mundi* 10 (1953): 67.

14. For the Greek I have used Claudius Ptolemaeus, *Geographia,* ed. Karl Müller (Paris, 1883); for the Latin the *Geography,* trans. Bilibaldus Pirckheymer (Basel, 1552).

15. Evidence for this tradition of interpretation is readily available in the various translations of Petrus Apianus, *Cosmography,* whose text is based on Ptolemy. *Picture* is invoked in the subsection of chapter 1 entitled "Geographia quid." The editions consulted were in Latin (Antwerp, 1545), in French (Paris, 1553), and in Dutch (Amsterdam, 1609), all in the British Museum.

16. Apianus's rendering of Ptolemy's introductory words is "Cosmographia (ut ex etymo vocabuli patet) est mundi . . . descriptio" (Antwerp,

1545). The Dutch edition reads, "Cosmografie is een Cosnte daer-men de gheheele Wereldt mede beschrijft" (Amsterdam, 1609). The casual identity assumed between a picture in this mapping context is best brought out in Gemma Frisius's own French translation of a passage from Apianus in which geography is referred to as "une description ou paincture & imitation" (Paris, 1545), chap. 1, fol. 3v. The Latin so translated reads, "Geographia [est] . . . formula quaedam ac picturae imitatio."

17. See Ernst Robert Curtius, *European Literature and the Latin Middle Ages,* trans. Willard K. Trask (New York, 1953), 68 ff., for a succinct summary of the system of ancient rhetoric of which *ekphrasis* is part.

18. See the title of Frisius's treatise on triangulation, note 6 above.

19. Arthur H. Robinson and Barbara Bartz Petchenik, *The Nature of Maps* (Chicago, 1976), 16.

20. A. S. Osley, *Mercator: A Monograph on the Lettering of Maps . . .* (New York, 1969).

21. Samuel Y. Edgerton, Jr., *The Renaissance Rediscovery of Linear Perspective* (New York, 1976), chaps. 7 and 8, and above, chapter 1. John Pinto on the other hand has distinguished a nonperspectival mode of city representation—a vertical plan—that he also associates with Italy. This view, which specifically lacks a located viewer and instead assumes a plurality of views, is closer to the northern pictorial mode that I am defining. See John A. Pinto, "Origins and Development of the Iconographic City Plan," *Journal of the Society of Architectural Historians* 35 (1976): 35–50.

22. A subtle and original attempt to argue the mapping nature of northern images is found in John Harbison, *Eccentric Spaces* (New York, 1977), chap. 7, "The Mind's Miniatures: Maps."

23. Samuel van Hoogstraten, *Inleyding tot de Hooge Schoole der Schilderkonst* (Rotterdam, 1678), 7.

24. Kepler is quoted as commenting on the use of peasants as informants in mapmaking; see Egon Klemp, *Commentary on the Atlas of the Great Elector* (Stuttgart, Berlin, and Zurich, 1971), 19. Antoine de Smet, "Pierre Pourbus" (note 9) refers to Pourbus's use of fishermen and pilots.

25. Ernst Gombrich, "The Renaissance Theory of Art and the Rise of Landscape," in *Norm and Form,* 107–21 (London, 1966).

26. Edward Norgate, *Miniatura, or The Art of Limning* (1648–58) (Oxford, 1919), 45–46.

27. Jan de Vries, *The Dutch Rural Economy in the Golden Age, 1500–1700* (New Haven, 1974), provides the fullest evidence. See especially chap. 2.

28. Translated from the Latin *Epigramma in Duos Montes,* in *Andrew Marvell: The Complete Poems,* ed. Elizabeth Story Donno (Harmondsworth, 1972), 74–75. For a discussion of this problem in English poetry see James Turner, *The Politics of Landscape* (Cambridge, Mass., 1979); for the term "landscape" see the same author, "Landscape and the 'Art Prospective" in England, 1584–1660," *Journal of the Warburg and Courtauld Institutes* 42 (1979): 290–93.

29. Wolfgang Stechow, *Dutch Landscape Painting of the Seventeenth Century* (London, 1966), gives the standard account.

30. Georg Braun and Franz Hogenberg, *Civitates orbis terrarum* (Cologne, 1572–1617), vol. 3, introduction, fol. Av.

31. R. A. Skelton in his introduction to the reprint of Braun and Hogenberg, *Civitates* (Cleveland and New York, 1966).

32. Petrus Apianus, *Cosmographia* (Antwerp, 1545), chap. 19.

33. Braun and Hogenberg, *Civitates,* vol. 3, introduction, fol. B (note 30).

34. Keuning, "Sixteenth Century Cartography," 67 (note 9).

35. Norgate, *Miniatura,* 51 (note 26).

36. Haus der Kunst, *Das Aquarell, 1400–1950* (Munich, 1973).

37. Joan Blaeu, *Le Grand Atlas* (Amsterdam, 1663).

38. Apianus, *Cosmographia,* (note 32).

39. Kurt Schottmüller, "Reiseindrücke aus Danzig, Lübeck, Hamburg und Holland 1636," *Zeitschrift des Westpreussischen Geschichtsverein* 52 (1910): 260.

40. R. Joppien, "The Dutch Vision of Brazil," in *Johann Maurits van Nassau-Siegen, 1604–1679* (The Hague, 1979), 296. This publication on Prince Maurits includes thorough studies of the Dutch pictorial records (including their maps) of Brazil.

41. C. Koeman, *Collections of Maps and Atlases in the Netherlands* (Leiden, 1961).

42. Frederick Muller, *De Nederlandsche Geschiedenis in Platen* (Amsterdam, 1863–70), 1 : xiii–xviii.

1. Jodoco del Badia, "Egnazio Danti, cosmografo e matematico e le sue opere in Firenze," *Rassegna Nazionale* 6 (1881): 621–31, 7 (1881): 434–74, esp. 6:625, 7:447–63 (separately, Florence, 1881, 5:26–42). See further Roberto Almagià, *Le pitture murali delle Gallerie delle Carte Geografiche,* Biblioteca Apostolica Vaticana, Monumenta Cartographica Vaticana, 3 (Vatican City, 1952), 13–16; Detlef Heikamp, "L'antica sistemazione degli strumenti scientifici nelle collezioni fiorentine," *Antichità Viva* 9 (1970): vi, 3–25, esp. 3–13; and Ettore Allegri and Alessandro Cecchi, *Palazzo Vecchio e i Medici: Guida storica* (Florence, 1980), 303–13.

2. Giorgio Vasari, *Le vite de' più eccellenti pittori scultori ed architettori,* ed. Gaetano Milanesi (Florence, 1878–85), 7:633–36 (quoted by del Badia, Heikamp, and Allegri and Cecchi). The passage was written in the summer or fall of 1567; Wolfgang Kallab, *Vasaristudien,* Quellenschriften für Kunstgeschichte und Kunsttechnik des Mittelalters und der Neuzeit, n.s. 15 (Vienna and Leipzig, 1908), 128–29, nos. 437, 442.

The arrangement of the maps was devised in September 1563 by Don Miniato Pitti, an Olivetan monk learned in geography and other sciences who was a good friend of Vasari's. A month later Danti was engaged to execute the maps and set to work on their cartoons. In February 1564 the duke finally approved the program for the Guardaroba as a whole, and the same month Danti received his first payment and completed his first map (Indonesia, dated 1563; that year, by Florentine reckoning, ended on 24 March 1564). By 1568 he had completed the terrestrial globe. Discharged for obscure reasons in the autumn of 1575 by Cosimo's heir, Duke Francesco, Danti departed for Bologna, leaving just under half the cycle unfinished. He was succeeded by Stefano Buonsignori, whose latest dated map bears the year 1586. All the sources that speak of the progress of work in the Guardaroba, with the exception of the letters of Vicenzo Borghini, are digested by Allegri and Cecchi, *Palazzo Vecchio,* 309–12 (note 1). Borghini's letters may be found in his *Carteggio artistico inedito,* Scritti inediti, 1 (all publ.) ed. A. Lorenzoni (Florence, 1912), 174–84.

3. Cf. *Claudii Ptolemaei Geographiae Codex Urbinas Graecus 82 . . . ,* ed. J. Fischer, Biblioteca Apostolica Vaticana, Codices e Vaticanis selecti . . . , ser. major, 19 (Leipzig and Leiden, 1932), 1:3, 5, 105.

4. The division is Almagià's, *Galleria delle Carte Geografiche,* 14–15 (note 1).

5. Eugène Müntz, "Le musée de portraits de Paul Jove . . . ," Académie des Inscriptions et Belles Lettres, *Mémoires* 36 (1900/1901 [publ. 1908]): 249–343, esp. 266–68. Vasari inserted a list of the 254 portraits executed or being executed at the time his last volume went to press (1567) following that volume's indexes; *Le vite de' più eccellenti pittori scultori e architettori . . .* (Florence, 1568), vol. 3, unnumbered pages ††††, lv–3r. The list has been reprinted only once since then, by Allegri and Cecchi, *Palazzo Vecchio* (note 1), 310–12, but they unfortunately missed six portraits, so that one must still consult Vasari's original publication.

6. Vasari's report, that the globe was originally intended to descend from the ceiling, is borne out by correspondence of 1565, extracted in Allegri's and Cecchi's digest of documents, *Palazzo Vecchio,* 309 (note 1). The intention was apparently still the same when Vasari wrote in 1567, but no space for the globe or machinery for letting it down exists above the ceiling, and the plan seems never to have been carried out.

7. A mounting was made for it in 1571; Allegri and Cecchi, *Palazzo Vecchio,* 312 (note 1). For the instrument itself see Ugo Dorini, "L'orologio dei pianeti di Lorenzo della Volpaia," *Rivista d'Arte* 6 (1909): 137–44; Giuseppe Boffito, *Gli strumenti della scienza e la scienza degli strumenti* (Florence, 1929), 22.

8. Florence, Museo di Storia della Scienza, *Catalogo degli strumenti* (Florence, 1954), 37–39, 47–49; Maria Luisa Righini Bonelli, *Il Museo di Storia della Scienza a Firenze* (Florence, 1968), 160, no. 67.

9. Del Badia, "Danti," 30–32 (note 1); Francesco Bocchi, *Le bellezze della città di Firenze* (Florence, 1591 [reprinted 1971]), 50.

10. Thus Almagià, *Galleria delle Carte Geografiche,* 16 (note 1).

11. Wolfgang Liebenwein, *Studiolo: Die Entstehung eines Raumtypes und seine Entwicklung bis um 1600* (Berlin, [1977]), esp. 144–45.

12. The most complete treatment is that of Loren Partridge, "The Frescoes of the Villa Farnese at Caprarola," Ph.D. diss., Harvard University, 1969. For general accounts see also Italo Faldi, *Gli affreschi del Palazzo Farnese di Caprarola* (Milan, 1962), and Gerard Labrot, *Le palais Farnèse de Caprarola: Essai de lecture* (Paris, 1970). For the decorative program, see esp. Fritz Baumgart, "La Caprarola di Ameto Orti," *Studi Romani* 25 (1935): 77–179.

All these authors touch on the map cycle: Partridge, 216–20; Faldi, 37–38; Labrot, 68–73; Baumgart, 127–33. Special studies concerning it have been written by Roberto Almagià, "Sulle pitture geografiche del Palazzo di Caprarola," *Rivista Geografica Italiana* 59 (1952): 131–34, and George Kish, "The 'Mural Atlas' of Caprarola," *Imago Mundi* 10 (1953): 51–56.

13. Montaigne visited Caprarola on 30 September 1581 and noted: "Sale bellissime. Fra le quali ce n'è una mirabile; nella quale alla volta di sopra . . . si vede il globo celeste con tutte le figure. A torno alle mura il globo terrestre, le regioni e la cosmografia, pinta ogni cosa molto riccamente sul muro istesso"; Michel de Montaigne, *Journal de Voyage,* ed. Alessandro d'Ancona (Città di Castello, 1895), 529. See also the description of Gregory XIII, of 1578; J. A. Orbaan, *Documenti sul Barocco in Roma* (Rome, 1920), 381.

14. For the construction of the three sides of the Cortile, see Jakob Hess, "Le Logge di Gregorio XIII in Vaticano: L'architettura," *Illustrazione Vaticana* 6 (1935): 1270–75 (reprinted in his *Kunstgeschichtliche Studien zu Renaissance und Barock,* [Rome, 1967], 1:117–22, with addenda, 398–99); Jack Wasserman, "The Palazzo Sisto V in the Vatican," Society of Architectural Historians, *Journal* 21 (1962): 26–35; Dioclecio Redig de Campos, *I palazzi vaticani,* Roma Cristiana, 18 (Rome, 1967), 108, 159, 169, 189.

The decoration on the third floor of the complex has been studied as a whole by Hess, "Le Logge di Gregorio XIII in Vaticano: I pittori," *Illustrazione Vaticana* 7 (1936): 161–66 (reprinted in his *Kunstgeschichtliche Studien*, 1:123–28, with addenda, 399–400). The map cycle is dealt with by itself in great detail by Ladislao Holik-Barabás (under the nom de plume Florio Banfi), *L'immagine del mondo nelle Loggie di Raffaello* (Rome, 1951), and Roberto Almagià, *Le pitture geografiche murali della Terza Loggia e di altre sale vaticane,* Biblioteca Apostolica Vaticana, Monumenta Cartographica Vaticana, 4 (Vatican City, 1955).

15. The only full description of the entire decoration of the Terza Loggia is that of Agostino Taja, *Descrizione del Palazzo Apostolico Vaticano* (Rome, 1750 [but composed 1712; see the Prefazione, 25]), 229–67. The known acts and sources regarding its execution are summarized by Almagià, *Terza Loggia,* 3–5 (note 14). One notice that escaped him is the informative letter by Don Miniato Pitti to Duke Cosimo I de' Medici, of 10 April 1564, praising the duke's choice of one man (Danti) to design and execute the maps of the Guardaroba in the Palazzo Vecchio. The duke, he writes, "ne sarà contento e ben servito; molto meglio che Nostro Signore Papa Pio non sarà delle sue loggie di sopra del Palazzo di S. Piero di Roma che sono fatte et si fanno alla giornata dove sono di grandi sciarpelloni: ma solo un bene viè che essendo all'aria et dipinte a tempra, fra pochi di, bisognerebbe refarle et si correggeranno"; Borghini, *Carteggio artistico,* 175, doc. no. ii (note 2).

It is usual to give the whole west arm, with the exception of its planisphere, to the patronage of Pius IV, and the two planispheres and the whole of the north arm to the patronage of Gregory XIII. In the case of the walls, this division is borne out by the entirely Gregorian subject matter of the frieze in the north arm. In the case of the vaults, however, it is contradicted by the papal arms affixed thereon: those of the first three bays of the north arm are still those of Pius IV.

That a fire occasioned the early restoration of the west arm is shown by Holik-Barabás, *L'immagine,* 13 (note 14).

16. Almagià, *Terza Loggia,* 5–6 (note 14), provides a summary account of all restorations, with further references.

17. "Terminum posuisti quem non transgredient" (Psa. 103:9, 104:9 in the King James translation).

18. "Potestas eius a mare usque ad mare" (Zech. 9:10).

19. F. Gori, "Una delle più singolari processioni del sec. XVI in Roma," *Il Buonarroti,* ser. 2, 3 (1868): 41–50. For later literature, see Wolfgang Krönig, "Geschichte einer Rom Vedute," in *Miscellanea Bibliothecae Hertzianae* (Munich, 1961), 385–417, esp. 387 (republ. as "Storia di una veduta di Roma," *Bollettino d'Arte* 57 [1972]: 165–98, esp. 166–67).

20. They are transcribed by Taja, *Descrizione* (note 15). Holik-Barabás's and Almagià's accounts of the Terza Loggia (note 14) report only the inscriptions on the maps.

21. Roberto Almagià, *Galleria delle Carte Geografiche* (note 1). The gallery forms the fourth story of the west side of the Belvedere Courtyard and was built ex novo under Gregory between ca. 1578 and 1580; James S. Ackerman, *The Cortile del Belvedere,* Biblioteca Apostolica Vaticana, Studi e Documenti per la Storia del Palazzo Apostolico Vaticano, 3 (Vatican City, 1954), 103–7.

22. Almagià, *Galleria delle Carte Geografiche,* 10 (note 1); more fully, the same author's *L'opera geografica di Luca Holstenio,* Biblioteca Apostolica Vaticana, Studi e Testi, 102 (Vatican City, 1942), 104–19.

23. "Italia, regio totius orbis nobilissima, ut natura ab Apennino secta est, hoc itidem ambulacro in duas partes, alteram hinc Alpibus et supero, alteram hinc infero mari terminatas, dividitur, a Varoque flumine ad extremos usque Brutios ac Sallentinos, regnis provinciis ditionibus insulis, intra suos, ut nunc sunt, fines dispositis, tota in tabulis longo utrinque tractu explicatur. Fornix pia sanctorum virorum facta, locis in quibus gesta sunt, ex advorsum respondentia ostendit. Haec ne iucunditati deesset ex rerum et locorum cognitione utilitas, Gregorius XIII Pont. Max. non suae magis, quam Romanorum pontificum commoditati hoc artificio et splendore a se inchoata perfici voluit anno M.D.LXXXI."

24. I have explained the genre of moralized geography at length in Juergen Schulz, "Jacopo de' Barbari's View of Venice: Map Making, City Views and Moralized Geography before the Year 1500," *Art Bulletin* 60 (1978): 425–74, esp. 442–67. It was Richard Salomon who defined the genre and coined for it the term "géographie moralisée"; *Opicinus de Canistris,* Studies of the Warburg Institute, 1 (London, 1936): 78–79.

25. "Roma caput mundi regit orbis frena rotundi"; cf. Percy Ernst Schramm, *Kaiser, Rom und Renovatio,* Studien der Bibliothek Warburg, 17 (Berlin/Leipzig, 1929) 2:96. See also Schulz, "Jacopo de' Barbari's View," 448 (note 24).

26. Ernst Kitzinger, "World Map and Fortune's Wheel," American Philosophical Society, *Proceedings* 117 (1973): 344–73.

27. Gerald Roe Crone, *The World Map by Richard of Haldingham in Hereford Cathedral,* Royal Geographical Society, Reproductions of Early Manuscript Maps, 3 (London, 1954), and Leonardo Olschki, *Storia letteraria delle scoperte geografiche* (Florence, 1957), 147–50.

28. W. Rosien, *Die Ebstorfer Weltkarte,* Niedersächsicher Heimatsbund, Schriften, n.s., 19 (Hannover, 1952); A. Wolf, "Die Ebstorfer Weltkarte als Denkmal eines mittelalterlichen Welt und Geschichtsbildes," in *Geschichte in Wissenschaft und Unterricht,* Verband der Geschichtslehrer Deutschlands, Zeitschrift, 8 (Stuttgart, 1957), 204–15. Wolf was unfamiliar with the "Liber formularum spiritalis intelligentiae" of Saint Eucherius, which supplies an even more apposite text than the later writers; cf. J.-P. Migne, *Patrologia cursus completus . . . Series latina* (Paris, 1844–1905), 50:cols. 730–33.

29. Cf. Wallace K. Ferguson, *The Renaissance in Historical Thought* (Boston, 1948), 173–252. The works in question are Jules Michelet, *Histoire de France* (Paris, 1833–62), vol. 7; *La Renaissance,* esp. the introduction; Jacob Burckhardt, *Die Kultur der Renaissance in Italien* (Basel, 1860); Wilhelm Dilthey, "Auffassung und Analyse des Menschens im 15. und 16. Jahrhundert," *Archiv für Geschichte der Philosophie* 4 (1891): 604–51, 5 (1892): 337–400.

30. Tullia Gasparrini Leporace and Roberto Almagià, *Il mappamondo di Fra Mauro* (Rome, 1956). All inscriptions on the map are transcribed on 18–64.

31. Leporace and Almagià, *Fra Mauro,* 62, inscript. XL–49: "Unde se algun contradirà a questa [i.e., this map] perchè non ho seguito Claudio Tolomeo, sì ne la forma come etiam ne le sue mesure per longeça e per largeça, non uogli più curiosamente defenderlo de quel che lui proprio non se defende, el qual nel secondo libro capitulo primo dice che quele parte de le qual se ne ha continua pratica se ne può parlar corretamente, ma de quele che non sono cussì frequentade non pensi algun se ne possi parlar cussì correctamente. Però intendando lui non hauer possudo in tuto uerificar la sua cosmographia, sì per la cossa longa e difficile e per la uita brieue e l'experimento fallace, resta che'l

conciede che cum longença de tempo tal opera se possi meglio descriuer ouer hauerne più certa noticia de qual habuto lui. Pertanto dico che io nel tempo mio ho solicitado uerificar la scriptura cum la experientia, inuestigando per molti anni e praticando cum persone degne de fede, le qual hano ueduto ad ochio quelo che qui suso fedelmente demostro."

32. Leporace and Almagià, *Fra Mauro,* 26–27, inscript. XI-2: "Molto opinion e leture se troua che in le parte meridional l'aqua non circunda questo nostro habitabile e temperado çona, ma aldando molte testimoniançe in contrario e maxime queli i qual la maiestà del Re de portogallo à mandato cum le soe carauele a çercar e ueder ad ochio, i qual dice hauer circuito le spiaçe de garbin più de 2000 mia oltra el streto de çibelter . . . Unde se'l se uorà contradir a questi i qual hano uisto ad ochio, maçormente se porà non assentir ne creder a queli che hano lassato in scriptis quelo li non uedute mai ad ochio, ma così hano opinado esser."

33. Leporace and Almagià, *Fra Mauro,* 24, inscript. III-1.

34. Leporace and Almagià, *Fra Mauro,* 56, inscript. XXXIII-77.

35. Leporace and Almagià, *Fra Mauro,* resp. 32, inscript. XVIII-19, 34, XX-68, 36, XXII-12, 43, XXVI-66, 44, XXVII-4.

36. Leporace and Almagià, *Fra Mauro,* 53, inscript. XXX-99: "Sel parerà ad alguno incredibile de qualche inaudita cossa io ho notado qui suso, non conferisca que suso, non conferisca quela cum el suo inçegno ma tribuisca a li secreti de la natura, la qual adopera cosse inumerabile de le qual quele che sauemo son la minor parte de quele che ignoremo, e quele che sauemo per el suo continuo uso non sono extimade, etiam essendo admirabile, e quele che ne pareno inusitade non li demo fede e questo aduien perchè la natura exciede l'intellecto e queli che non l'ano sueluado nol può accomodar non tanto a le cosse insolite ma etiam a quele che assiduamente se pratica, e perhò queli che uol intendere prima creda azò le intenda."

37. Arthur O. Lovejoy, *The Great Chain of Being* (Cambridge, Mass., 1936), esp. 50–55.

38. The classic corpus of *mappaemundi* is that by Konrad Miller, *Mappae Mundi: Die ältesten Weltkarten* (Stuttgart, 1895–98). A fuller catalog of briefer entries is that of Marcel Destombes, *Mappemondes, A.D. 1200–1500,* Union Géographique International, Commission des Cartes Anciennes, Monuments cartographiques anciens, A.D. 1200–1500 (= Imago Mundi, suppl. 4) (Amsterdam, 1964). Neither author considers the function and meaning of these maps as a group.

39. Rodolfo Gallo, "Le mappe geografiche del Palazzo Ducale di Venezia," *Archivio Veneto,* ser. 5, 32 (1943): 47–89, esp. 51–52.

40. Giuseppe Zippel, "Cosmografi al servizio dei papi nel Quattrocento," Società Geografica Italiana, *Bollettino* 47 (= ser. 4, 11:2); (1910): 843–52, esp. 847.

41. Ignazio F. Dengel, "Sulla mappa mundi di Palazzo Venezia," in *Secondo Congresso Nazionale di Studi Romani: Atti* (Rome, 1931), 2:164–69.

42. Gallo, "Mappe" (note 39).

43. Sven Sandström, "The Programme for the Decoration of the Belvedere of Innocent VIII," *Konsthistorisk Tidskrift* 29 (1960): 35–75, esp. 37–47; 32 (1963): 121–22; Juergen Schulz, "Pinturicchio and the Revival of Antiquity," *Journal of the Warburg and Courtauld Institutes* 25 (1962): 35–55, esp. 36–38.

44. They were, respectively, Constantinople, Naples, Venice, and

Genoa and Rome, Florence, Cairo, and Paris. See Schulz, "Jacopo de' Barbari's View," 465–67 (note 24), where there is also a brief account of the Vatican cycle.

45. Kathleen Weil-Garris and John F. D'Amico, "The Renaissance Cardinal's Ideal Palace: A Chapter from Cortesi's *De Cardinalatu*," in *Studies in Italian Art and Architecture, Fifteenth through Eighteenth Centuries,* ed. Henry A. Millon, American Academy in Rome, *Memoirs,* 35 (Rome, Cambridge, Mass., and London, 1980), 45–119.

46. Paolo Cortesi, *De cardinalatu* (Castel Cortesiano, 1510), fol. 54r–v: "Nec item minus eruditae iucunditatis habet, aut mundi depicti pinax, aut eorum descriptio locorum, quae nuper sint nostrorum hominum audaci circumuectione nota, qualis ea modo iudicari quae est ab Emanuele Lusitanorum Regem de Indiae pervagatione facta: Eademque est zoographiae describendae ratio: qua diuersorum exprimitur animantium natura notatior: in qua eo est commenti saedulitas laudanda magis, quo minus nota animantium genera exprimi pingendi solent. Eodemque modo in hoc genere aenigmatum apologorumque descriptio probatur qua ingenium interpretanto (*recte:* interpretando) acuitur, fitque mens letterata descriptione eruditior." (This transcription and the translation above differ in small particulars from those of Weil-Garris and D'Amico, "Renaissance Cardinal," 94–97 [note 45]).

47. Schulz, "Jacopo de' Barbari's View," 468–72 (note 24).

48. Gallo, "Mappe" 55–58 (note 39).

49. Gallo, "Mappe" 59–63 (note 39).

50. The agreements of 8 January 1550 (st. circ.) and 6 August 1553, excerpted by Gallo, may be found published in full in Giambattista Lorenzi, *Monumenti per servire alla storia del Palazzo Ducale di Venezia* (Venice, 1868), 1 [all publ.]: documents nos. 573-A and 594.

51. There is no single well-rounded and annotated treatment of this complex period. For a general introduction without notes or bibliography, see the *New Cambridge Modern History* (Cambridge, 1957–79), vol. 3, esp. chap. 3. A series of specialized essays with recent bibliography appears in Eric W. Cochrane, *The Late Italian Renaissance, 1525–1630* (London, 1970), part 3, "Reformation and Counter Reformation." The effect of the Counter-Reformation, in particular the Council of Trent, on the fine arts is dealt with by Engelbert Kirschbaum, "L'influsso del Concilio di Trento nell'arte," *Gregorianum: Commentarii de Re Theologica et Philosophica* 26 (1945): 100–16; Georg Weise, "Il rinnovamento dell'arte religiosa nella Rinascita," *Rinascita* 4 (1941): 659–80; and Louis Hautecoeur, "Le Concile de Trente et l'art," in *Il Concilio di Trento e la riforma tridentina, Convegno storico internazionale, Trento, 2–6 sett. 1963* (Rome, Freiburg, and Basel, 1965), 1:345–62.

52. Maria Luisa Madonna, "La biblioteca: *Theatrum mundi e theatrum sapientiae,*" in *L'abbazia benedettina di San Giovanni Evangelista a Parma,* ed. Bruno Adorni (Parma, 1979), 177–94.

53. Marco Antonio Ciappi, *Compendio delle heroiche et gloriose attioni, et santa vita di Papa Gregorio XIII* (Rome, 1596), 103; Rodolfo A. Lanciani, *Storia degli scavi di Roma* (Rome, 1902–12), 4:97.

54. "Nell'entrata . . . u'erano al d'intorno bellissimi razzi, fatti di seta e d'oro: ne' quali si uedeua con grandissimo artificio ritratta Ferrara, Modana, Reggio, Carpi, e Bressello; città e luoghi principali del medesimo Duca: oue si scopriuano interamente e con bellissima arte di prospettiua le contrade e i palagi"; *La entrata che fece in Vinegia, l'illustrissimo et eccellentissimo S. Duca Alfonso II. Estense Duca V. di Ferrara* (Venice: Francesco Rampazetto, 1562), fol. 4v.

55. Allegri and Cecchi, *Palazzo Vecchio,* 275–82 (note 1).

56. Resp., Giulio Fasolo, "Notizie di arte e storia vicentina," *Archivio Veneto,* ser. 5, 22 (1938): 260–301, esp. 290–91, and Roberto Almagià, *Monumenta Italiae cartographica* (Florence, 1929), 43: col. 2.

57. Giovanni Battista Comelli, *Piante e vedute della città di Bologna* (Bologna, 1914), 32–42, 64–67; Almagià, *Terza Loggia,* 34–36 (note 14). The city view survives intact; the territorial map, which was painted on paper and then pasted on the wall, is partly torn away and otherwise barely legible.

58. Almagià, *Monumenta Italiae,* 44–45 (note 56); Almagià, *Galleria delle Carte Geografiche,* 36–37 (note 1).

59. Jodoco del Badia, "Pianta topografica della città di Firenze di Don Stefano Buonsignori dell'anno 1584," in *Terzo Congresso Geografico Italiano: Atti* (Florence, 1899), 2: 570–77, esp. 573–74; Heikamp, "Antica sistemazione," 5–6 (note 1). The murals are enlargements of printed maps by Stefano Buonsignori, to whom they were attributed before Heikamp published the record of Buti's payment.

60. Juergen Schulz, "Cristoforo Sorte and the Ducal Palace of Venice," *Mitteilungen des Kunsthistorischen Institutes in Florenz* 10 (1961/63): 193–208, esp. 202–6, and in the same journal, "New Maps . . . by Cristoforo Sorte," 20 (1976): 107–26, esp. 107–10. See also the exhibition catalog, Venice, Palazzo Ducale, *Architettura e utopia nella Venezia del Cinquecento* (Milan, 1980), 59–62.

1. R. A. Skelton, "Colour in Mapmaking," *Geographical Magazine* 42 (1966): 544–53. Other cartographic sources that discuss the history of color include Lloyd A. Brown, *The Story of Maps* (New York: Little, Brown, 1949), 151, 176–79; François de Dainville, *Le langage des géographes: Termes, signes, couleurs des cartes anciennes, 1500–1800* (Paris: A. et J. Picard, 1964); Edward Lynam, "The Development of Symbols, Lettering, Ornament and Colour on English Maps," *British Records Association Proceedings* 4 (1939): 20–34; and R. A. Skelton, *Decorative Printed Maps* (London: Staples Press, 1952), 19–20. A general neglect of color has also characterized artistic studies, as pointed out by Jonas Gavel, *Colour: A Study of Its Position in the Art Theory of the Quattro and Cinquecento* (Stockholm: Almquist och Wiksell, 1979), 9.

CHAPTER FOUR

2. Werner Horn, *Karten alter Meister* (Gotha and Leipzig: Haack, 1974).

3. The Blaeu map is reproduced opposite p. 174 in R. V. Tooley and Charles Bricker, *Landmarks of Mapmaking: An Illustrated Survey of Maps and Mapmakers* (Amsterdam and Brussels: Elsevier, 1968). Edward B. Espenshade, Jr., and Joel L. Morrison, eds., *Goode's World Atlas* (Chicago: Rand McNally, 1974), 204.

4. Lewis Mumford, *Art and Technics* (New York: Columbia University, 1952), 17.

5. Mumford, *Art and Technics,* 19 (note 4).

6. *Art à la Carte: Decorative Imagery on Maps, 1600–1800* (Ann Arbor: University of Michigan Museum of Art, 1979).

7. Mumford, *Art and Technics,* 81–82 (note 4).

8. Arthur Robinson, *Early Thematic Mapping in the History of Cartography* (Chicago: University of Chicago Press, 1982); and David Woodward, *The All-American Map: Wax Engraving and Its Influence on Cartography* (Chicago: University of Chicago Press, 1977).

9. G. Thomas Tanselle, "A System of Color Identification for Bibliographical Description," *Studies in Bibliography* (University of Virginia Bibliographical Society) 20 (1967): 203–34.

10. Gerald S. Wasserman, *Color Vision: An Historical Introduction* (New York: John Wiley, 1978), 1–2.

11. Three well-known color systems are those of the Commission Internationale de l'Eclairage (CIE), A. H. Munsell, and William Ostwald.

12. Anna-Dorothee von den Brincken, "Die Ausbildung konventioneller Zeichen und Farbgebungen in der Universalkartographie des Mittelalters," *Archiv für Diplomatik. Schriftgeschichte, Siegel- und Wappenkunde* 16 (1970): 328; and Daniel V. Thompson, *The Materials and Techniques of Medieval Painting* (New York: Dover Publications, 1956), 20.

13. Thompson, *Medieval Painting,* 131–33 (note 12).

14. Thompson, *Medieval Painting,* 88–89, 99–100 (note 12).

15. John Gage, "Colour in History: Relative and Absolute," *Art History* 1 (1978): 109–10; and Thompson, *Medieval Painting,* 60 (note 12).

16. Gage, "Colour in History," 107–8 (note 15).

17. Von den Brincken, "Ausbildung," 336–46 (note 12).

18. C. M. Danoff, "Pontos Euxeinos," in *Paulys Real-Encyclopädie der classischen Altertumswissenschaft,* suppl. 9 (Stuttgart, 1962): cols. 886–1175; about the name see cols. 950–55.

19. The first ones to suggest this were Max Vasmer, *Osteuropäische Ortsnamen,* Acta et Commentationes Universitatis Dorpatensis, ser. B., 1:3 (Dorpat, 1921), 3–6; and Emile Boisacq, "Le nom de la Mer Noire en Grec ancien," *Revue Belge de Philologie et d'Histoire* 3 (1924): 315–17. The Bulgarian Chr. M. Danoff (see note 18) and other scholars agree with their opinions, but still others hold different views; e.g., Viktor Burr, *Nostrum Mare: Ursprung und Geschichte der Namen des Mittelmeeres und seiner Teilmeere im Altertum* (Stuttgart, 1932), 31–35, and A. C. Moorhouse in discussion with W. S. Allen in *Classical Quarterly* 34 (1940): 123–28; 41 (1947): 86–88; 42 (1948): 59–60.

20. K. Tümpel, "Erythras," and H. Berger, "Erythraeum Mare," both in *Paulys Real-Encyclopädie der classischen Altertumswissenschaft,* Halbbd. 11 (Stuttgart, 1907): cols. 592–601.

21. H. T[reidler], "Erythra thalatta," in *Der kleine Pauly,* 2 (Stuttgart, 1967): cols. 336–37. Treidler dismisses the mythological interpretation (Mela 3, 72 and Plin. nat. 6,107) as worthless. It is notable that the ancient Egyptians seem not to have given the Arabian Gulf any name associated with color. Cf. W. Spiegelberg, "Die ägyptischen Namen für das Rote Meer," *Zeitschrift für Ägyptische Sprache und Altertumskunde* 66 (1930): 37–39. E. Zyhlarz, "Die Namen des Roten Meeres im Spätägyptischen," *Archiv für Ägyptische Archäologie* 1 (1938): 111–16.

22. F. Portal, *Des couleurs symboliques dans l'antiquité, le Moyen-Age et les temps modernes* (Paris, 1957; originally published 1837). D. A. Mackenzie, "Colour Symbolism," *Folk-Lore* 33 (1922): 136–69.

23. P. Grelot, "La géographie mythique d'Hénoch et ses sources orientales," *Revue Biblique* (1958): 33–69. In the Bible the prophet Zechariah (6:2–6) saw a vision of four chariots, symbolizing the four winds. Black horses were hitched to the chariot bound for the north, red ones for the east, white ones for the west, and roans for the south. The purport of this passage is discussed in G. Hölscher, *Drei Erdkarten: Ein Beitrag zur Erdkenntnis des hebräischen Altertums,* Sitzungsberichte der Heidelberger Akademie der Wissenschaften, Philos.-Hist. Klasse Jahrg. 1944/48: Abh. 3 (Heidelberg, 1949), 64 ff. L. G. Rignell, *Die Nachtgesichte des Sacharja* (Lund, 1950), 28–31.

24. A. Hermann and M. Cagiano de Azevedo, "Farbe," in *Reallexikon für Antike und Christentum,* 7 (Stuttgart, 1969): col. 376.

25. W. Eberhard, *Beiträge zur kosmologischen Spekulation der Chinesen der Han-Zeit,* inaug. diss., Berlin, 1933. S. Cammann, "Types of Symbols in Chinese Art," *American Anthropologist* 55 (1953): 201 ff. M. Porkert, "Farbenemblematik in China," *Artaios* 4 (1962): 154–67.

26. O. Pritsak, "Orientierung und Farbsymbolik: Zu den Farbenbezeichnungen in den altaischen Völkernamen," *Saeculum* 5 (1954): 376–83. A. von Gabain, "Vom Sinn symbolischer Farbenbezeichnung," *Acta Orientalia Academiae Scientiarum Hungaricae* 15 (1962): 111–17. O. T. Molchanova, *Toponimicheskiĭ slovar' Gornogo Altaĭa* (Gorno-Altaĭsk, 1979), the entries *kara, ak, kïzïl, kök.* In P. Pelliot, *Notes on Marco Polo,* vols. 1–2 (Paris, 1959–63), "Qaraqorum" (black boulder), "Aq-balïq" (white city), "Qïzïl-čai" (red stream), "Kök-yar" (blue [or green] ravine), are mentioned among other place-names.

27. K. A. Nowotny, "Beiträge zur Geschichte des Weltbildes, Farben und Weltrichtungen," in *Wiener Beiträge zur Kulturgeschichte und Linguistik,* 17 (Vienna, 1970). "The Colour Symbolism of the Cardinal Points in the Navaho Legends," in *Memoirs of the American Folk-Lore Society,* vol. 5 (Boston and New York, 1897).

28. Hermann and Cagiano de Azevedo, "Farbe," col. 391 (note 24); Mackenzie, "Colour Symbolism," 138–42 (note 22). H. Kees, "Farbensymbolik in ägyptischen religiösen Texte," *Nachrichten von der Akademie der Wissenschaften in Göttingen,* Philol.-Hist. Klasse (1943): 413–79.

29. Brent Berlin and Paul Kay, *Basic Color Terms: Their Universality and Evolution* (Berkeley: University of California Press, 1969).

30. Von den Brincken, "Ausbildung," 337–44 (note 12).

31. Hermann and Cagiano de Azevedo, "Farbe," col. 384 (note 24); and W. Kranz, "Die ältesten Farbenlehren der Griechen," *Hermes* 47 (1912): 126–40.

32. Hermann and Cagiano de Azevedo, "Farbe," cols. 358–447 (note 24).

33. Hermann and Cagiano de Azevedo, "Farbe," col. 430 (note 24).

34. P. Dronke, "Tradition and Innovation in Medieval Western Colour-Imagery," *Eranos* 41 (1972): 66–70. Gottfried Haupt, *Die Farbensymbolik in der sakralen Kunst des abendländischen Mittelalters* (Dresden: M. Dittert, 1941): 51–52.

35. Dronke, "Tradition," 67–69 (note 34), and Haupt, *Farbensymbolik* (note 34).

36. F. de Dainville, *Le langage des géographes* (Paris 1964), 332 ff.; and Pliny *Historia naturalis* 33.57–58.

37. Haupt, *Farbensymbolik,* 107–12 (note 34); and Louis Réau, *Iconographie de l'art chrétien,* vol. 1 (Paris: Presses Universitaires de France, 1955), 73.

38. *Art à la Carte* (note 6) and James H. Hyde, "L'iconographie des quatres parties du monde dans les tapisseries," *Gazette des Beaux-Arts,* ser. 5, 10 (1924): 253–72.

39. Von den Brincken, "Ausbildung," 335 (note 12).

40. Gavel, *Colour,* 26 (note 1).

41. Quoted from C. Gould, "Leonardo da Vinci's Notes on the Colour of Rivers and Mountains," *Burlington Magazine* 44 (1947): 240. See further: E. Oberhummer, "Leonardo da Vinci and the Art of the Renaissance in Its Relations to Geography," *Geographical Journal* 33 (1909): 540–69; Gavel, *Colour,* 103, 110–12, 122–23 (note 1).

42. H. Gautier, *L'art de laver; ou, Nouvelle manière de peindre sur le papier* (Lyons, 1687), 153.

43. Henry Peacham, *The Compleat Gentleman* (London: Francis Constable, 1634), 65.

44. John Smith, *The Art of Printing in Oyl,* 3d impr. (London: Printed for S. Crouch, 1701), 95–96.

45. William Salmon, *Polygraphice . . . ,* 3d ed. (London: Printed by A. Clark for J. Crumpe, 1705), title page.

46. Smith, *Art of Printing,* 110 (note 44).

47. Ibid., 104–5.

48. Ibid., 105–6.

49. Arthur M. Hind, *An Introduction to a History of Woodcut,* vol. 1 (New York: Dover Publications, 1963), 49.

50. Karen S. Pearson, "Lithographic Maps in Nineteenth-Century Geographical Journals," Ph.D. diss., University of Wisconsin, 1978, 145–47.

51. Wilhelm Worringer, *Die alte Buchillustration* (Munich: R. Piper, 1912), 29–33.

52. Hartmann Schedel, *Liber chronicarum* (Nuremberg: A. Koberger, 1493), in Herzog-August Bibliothek, Wolfenbüttel, fols. 12v, 13r.

53. Caspar Vopel, *Recens et Germana Bicornis ac uvidi Rheni omnium Germaniae amnium celeberrimi descriptio . . . auctore Caspare Vopelio—Coloniae Agrippinae* (Cologne, 1558), in Herzog-August Bibliothek, Wolfenbüttel (cat. no. R6, Alte Bibliothek).

54. Wilcomb E. Washburn, *Representation of Unknown Lands in Fourteenth-, Fifteenth-, and Sixteenth-Century Cartography* (Coimbra: Junta de Investigações do Ultramar-Lisboa, 1969).

55. *Claudii Ptolemaei Alexandrini Geographicae enarrationis libri octo. Ex Bilibaldi Pirckeymheri tralationae . . . Lugduni 1535: Trechsel,* in Herzog-August Bibliothek, Wolfenbüttel.

56. Walter J. Hofmann, *Über Dürers Farbe* (Nuremberg: H. Carl, 1971), 100.

57. Skelton, "Colour" (note 1), and Brown, *Story of Maps,* 115–17 (note 1).

58. Johann Hübner, *Museum geographicum, das ist: Ein Verzeichniss der besten Land-Charten, . . . Nebst einem Vorschlage, wie daraus allerhand grosse und kleine Atlantes können sortiret werden* (Hamburg, 1726).

59. Ruthardt Oehme, *Eberhard David Hauber (1695–1765): Ein schwäbisches Gelehrtenleben* (Stuttgart: W. Kohlhammer Verlag, 1976), 62.

60. Oehme, *Hauber,* 93–95 (note 59).

61. Pearson, "Lithographic Maps," 145–47 (note 50).

62. Ralph E. Ehrenberg, "Developments in Cartography and Printing Influencing the Publication of Geological Maps," unpublished paper presented at United States Geological Survey International Centennial Symposium, Resources for the Twenty-first Century, 14–19 October 1979, Reston, Virginia; H. Andrew Ireland, "History of the Development of Geologic Maps," *Bulletin of the Geological Society of America* 54 (1943): 1227–80; Martin J. S. Rudwick, "The Emergence of a Visual Language for Geological Science, 1760–1840," *History of Science* 14 (1976): 149–95; and Robinson, *Thematic Mapping,* 28–29, 52–54, 57–60 (note 8).

63. Pearson, "Lithographic Maps," 78 (note 50); W. A. Chatto and J. Jackson, *A Treatise on Wood Engraving, Historical and Practical* (London, 1839), 713–14. Chatto added a map of ancient Jerusalem to p. 715 as a proof of Knight's invention. The invention was also described in *Quarterly Review* 129 (December 1839): 27–30. David Woodward, ed., *Five Centuries of Map Printing*

(Chicago: University of Chicago Press, 1975), 50; and *Printed Patents: Abridgements of Patents Specifications Relating to Printing, 1617–1857* (London: Printing Historical Society, 1969), 204–7.

64. Karen S. Pearson, "The Nineteenth-Century Color Revolution: Maps in Geographical Journals," *Imago Mundi* 32 (1980): 13; and Pearson, "Lithographic Maps," 196 (note 50).

65. Pearson, "Nineteenth Century Color Revolution," 12 (note 64).

66. Pearson, "Lithographic Maps," 46–50 (note 50).

67. David Woodward, *The All-American Map: Wax Engraving and Its Influence in Cartography* (Chicago: University of Chicago Press, 1977).

68. C. Koeman, "The Application of Photography to Map Printing and the Transition to Offset Lithography," in *Five Centuries of Map Printing,* ed. David Woodward (Chicago: University of Chicago Press, 1975), 146–49; and Pearson, "Lithographic Maps," 52, 263–66 (note 50).

69. These include 3M Color-Key Proofing Film, General Color-Guide, Kwik-Proof, and the Cromalin process. They are described and compared in Arthur Robinson, Randall Sale, and Joel Morrison, *Elements of Cartography* (New York: John Wiley, 1978), 345–47.

70. Pearson, "Nineteenth-Century Color Revolution," 16 (note 64).

71. Josef von Hauslab, "Ueber die graphischen Ausführungsmethoden von Höhenschichtenkarten," *Mittheilungen der Kaiserlich-Königlichen Geographischen Gesellschaft* 8 (1864): 34.

72. Karl Peucker, "Zur kartographischen Darstellung der dritten Dimension," *Geographische Zeitschrift* 7 (1901): 22–41.

73. David C. Lindberg, *Theories of Vision from al-Kindi to Kepler* (Chicago: University of Chicago Press, 1976). Gavel, *Colour,* 25–26 (note 1).

74. R. Grob, *Geschichte der schweizerischen Kartographie* (Bern, 1941), 168–72. M. Eckert-Greifendorff, *Kartographie: Ihre Aufgaben und Bedeutung für die Kultur der Gegenwart* (Berlin, 1939), 93–115.

75. Hauslab, "Ausführungsmethoden," 33 (note 71).

76. Karl Peucker, *Schattenplastik und Farbenplastik* (Vienna: Artaria, 1898).

77. G. Grosjean, *500 Jahre schweizer Landkarten* (Zurich: Orell Füssli, 1971), 50–51.

78. John M. Herington and Terry R. Hardaker, "Atlas Revolution," *Geographical Magazine* 42 (1974): 192–96.

79. Grosjean, *Landkarten,* 51 (note 77); and Eduard Imhof, *Landkartenkunst: Gestern, heute, morgen* (Zurich: Neujahrsblatt der Naturforschenden Gesellschaft in Zürich, 1968). See also his article "Die Kunst in der Kartographie," *International Yearbook of Cartography* 7 (1967): 21–32.

80. Barbara Bartz Petchenik, "Cartography and the Making of an Historical Atlas," *American Cartographer* 4 (1977): 11–28.

CHAPTER FIVE

1. See, for example, R. A. Skelton, *Decorative Printed Maps of the Fifteenth to Eighteenth Centuries* (London: Spring Books, 1965), 1–28; R. A. Skelton, *Maps: A Historical Survey of Their Study and Collecting* (Chicago: University of Chicago Press, 1972), 26–61; and C. Koeman, *Collections of Maps and Atlases in the Netherlands: Their History and Present State* (Leiden: E. J. Brill, 1961), 19.

2. For a study of the contents of the *Theatrum* and its various editions and for additional literature on it, see C. Koeman, *Atlantes Neerlandici,* 5 vols. (Amsterdam: Theatrum Orbis Terrarum, 1967–71), 3:25–68.

3. This print is from Floris's *Veelderhande cierlyjcke compertementen* . . . (Antwerp: Hermann Müller, 1564). Engraved by Hans Liefrinck.

4. Technically some of the maps of the sixteenth and seventeenth centuries include both etching and engraving, but for simplicity's sake I shall use the terms engraver and engraving.

5. *Compertimentorum quod vocant multiplex genus lepidissimus historiolis poetarumque fabellis ornatum.* This series was engraved by Pieter van der Heyden and published by Hieronymus Cock. Ortelius also borrowed numerous designs from a series of wood engravings entitled *Varii generis partitionum, seu (ut italis placet) compartimentorum formae* . . . , attributed to Jacob Floris and engraved by Hans Liefrinck, 1555.

6. See L. Lebeer, *Catalogue raisonné des estampes de Pierre Bruegel l'ancien* (Brussels: Bibliothèque Royale Albert I^er, 1969), 113.

7. See J. van Beylen, "Schepen op kaarten ten tijde van Gerard Mercator," *Duisburger Forschungen* 6 (1962): 141–43.

8. *Variarum protractionum (vulgò compartimenta vocant)* See H. Mielke, "Hans Vredeman de Vries," Ph.D. diss., Berlin, 1967, no. 2. The upper portion of the same design was also used by Ortelius on his map of Utopia. See C. Kruyfhooft, "A Recent Discovery: Utopia by Abraham Ortelius," *Map Collector* 16 (1981): 10–14.

9. This cartouche comes from a set of thirteen prints: *Multarum variarumque protractionum (Compartimenta vulgus pictorum vocat)* . . . , published in 1555 by Gerard de Jode. Mielke, "Vredeman," 15, no. 1 (note 8), suggests that the set was engraved by Frans Huys, who engraved the other set of this year.

10. Both sets are untitled: Mielke 7 (numbered 1–20) and Mielke 8 (lettered A–Q).

11. This map was added to the Mercator-Hondius atlas in 1623.

12. The globe was designed by Emery Molineux. Copies are found at the Library of the Middle Temple, London, and the Hessisches Landesmuseum, Kassel. For a description and illustration of the globe, see. A. M. Hind, *Engraving in England in the Sixteenth and Seventeenth Centuries: A Descriptive Catalogue with Introduction,* 3 vols. (Cambridge: Cambridge University Press, 1952–64), 1:168–73, pl. 98.

13. For an illustration and discussion of this map, see. G. Schilder, "Wandkaarten der Nederlanden uit de 16e en 173e eeuw," *Kartografisch Tijdschrift* 5, 2 (1979): 29–30, no. 9a, fig. 6.

14. Ornaments 10 and 17 in Vredeman's untitled series of around 1560–63 (Mielke 7).

15. Ornament 16 in Vredeman's untitled series of about 1560–63 (Mielke 7).

16. Both parts come from Vredeman's untitled series of about 1560–63 (Mielke 7), the upper part from no. 20, the lower part from no. 3.

17. Mielke 8, print P.

18. For the dating and an illustration of de' Barbari's engraving, see J. A. Levenson, K. Oberhuber, and J. L. Sheehan, *Early Italian Engravings from the National Gallery of Art* (Washington, D.C.: National Gallery of Art, 1973), 349, fig. 17–10.

19. See, for example, the map of India (1670), which includes ships, sea animals, and mermaids, all taken from Gutierrez's map. For an illustration of Gutierrez's map, see C. Bricker et al., *Landmarks of Mapmaking: An Illustrated Survey of Maps and Mapmakers* (New York: Thomas Y. Crowell, 1976), 213.

20. This series contains twenty-eight prints, four of which include two cartouches each.

21. The graphic scale cartouche comes from one of Vredeman's untitled series of about 1560–63 (Mielke 7), and the third cartouche, in the upper left corner, comes from one of his 1655 series (Mielke 2).

22. Charles Claesen, *Kartuschen im Style der flämischen Renaissance: Ein Motivenwerk für Stein- und Holzbilderhauer, Kunsttischler, Decorationsmaler, Glasmaler, Kunstschlosser und Architekten. Aus dem Atlas des Abraham Ortelius, 1569* [*sic*] (Berlin: Charles Claesen, 1886).

23. Although most of the cartouches in Claesen's book are taken from several editions of the *Theatrum,* some come from other sources, including maps by Willem Jansz. Blaeu. The dates Claesen gives to the cartouches do not always correspond with the year in which they first appeared in the *Theatrum.*

24. The other cartouche (Battini 26) appears on Ortelius's map of Silesia.

25. I intend a future article that will list all the maps in the *Theatrum* and give the sources of all the borrowed ornaments.

26. In the preface to the *Theatrum* Ortelius lists the names of the cartographers and geographers whose maps he used in compiling his atlas. For the original 1570 edition, which consists of fifty-three maps, Ortelius drew from the works of eighty-seven different authors.

27. See W. Wegner, *Die niederländischen Handzeichnungen des 15.–18. Jahrhunderts,* 2 vols. (Berlin: Gebr. Mann Verlag, 1973), no. 1020, pl. 83, and G. Schilder, *The World Map of 1624 by Willem Jansz. Blaeu and Jodocus Hondius* (Amsterdam: Nico Israel, 1977), 5, fig. 3.1.

28. See E. Schaar, "Zeichnungen Berchems zu Landkarten," *Oud-Holland* 71 (1956): 239–43.

29. For an illustration of the original Hondius map, see E. L. Stevenson and J. Fischer, eds., *Map of the World by Jodocus Hondius, 1611* (New York: De Vinne, 1907).

30. F. W. H. Hollstein, *Dutch and Flemish Etchings, Engravings and Woodcuts,* vols. 1– (Amsterdam: Menno Hertzberger, n.d.), 21:88–90.

31. See James A. Welu, "Vermeer and Cartography," Ph.D. diss., Boston University, 1977, 98–102.

32. In fact, when Hondius's map was revised by the Visscher family about the middle of the century, the *vanitas* cartouche was replaced by one that features busts of Christopher Columbus and Amerigo Vespucci.

33. Hollstein 8:100–106. The two seated figures at the right were taken from Hendrik van Langren's large world map after Pieter Plancius; see F. C. Wieder, *Monumenta cartographica,* 5 vols. (The Hague: M. Nijhoff, 1925–33), 2:41.

34. For an illustration showing the cartouche, see. M. de Vrij, *The World on Paper* (Amsterdam: Theatrum Orbis Terrarum, 1967), no. 136.

35. See J. R. Judson and C. van de Velde, *Corpus Rubenianum Ludwig Burchard,* vols. 1– (London: Phaidon, 1967–), 21:240–44, figs. 190–91.

36. For the location of the Allart copies, see Schilder, "Wandkaarten," 31–32, n. 26 (note 13).

37. The map and its decorative borders are printed on eleven sheets, the text on two. The map, which was engraved by Jan van Troyen, is dedicated to William III, who ruled from 1689 to 1702.

38. This was not the case when several decades earlier Claes Jansz. Visscher revised another nine-sheet map of the Seventeen Provinces. As I demonstrated earlier ("The Map in Vermeer's *Art of Painting,*" *Imago Mundi* 30 [1978]:9–30), several of the allegorical figures that Visscher used for his title cartouche were taken from an Italian map in which the main figure, a woman,

symbolizes the subject of the map: Italy. By transferring this figure to the map of the Seventeen Provinces and endowing her with new attributes, Visscher managed a complete change of identity.

39. *Raccolta di varii cappriccii et nove inventioni de cartelle et ornamenti,* published by F. L. D. Il Ciartres. The series is illustrated in A. Baudi di Vesme and P. D. Massar, *Stefano della Bella: Catalogue Raisonné,* 2 vols. (New York: Collectors Editions, 1971), nos. 1027–1944. Three prints from this same set were used by Allart on another wall map: a six-sheet map of the British Isles dated 1657. The title cartouche on this map is a combination of prints 1 (title print) and 6 from the della Bella series, and the graphic scale cartouche is from print 17. Allart's map of the British Isles is included in the three Great Atlases published in Amsterdam about 1660. See the facsimile edition accompanied by E. Klemp's *Commentary on the Atlas of the Great Elector* (Stuttgart: Belser Verlag, 1971).

40. For the various editions and additional information on this work, see Koeman, *Atlantes,* 4:30, 31, 85–93 (note 2).

41. This set includes a third print, whose subject is Venus. See A. Bartsch, *Le peintre graveur,* 21 vols. (Vienna, 1803–21), 2–3, nos. 70–72.

42. The mask was taken from the framework on another print of Bacchus dated about 1600; Hollstein 134.

43. Bloemaert's composition was also engraved by Jan Theodor de Bry in 1608 (Hollstein 14, illus.). De Bry adapted the composition to a circular format.

44. Blaeu's map includes at the top a border of figures and town views and along both sides additional views of towns. A state in which these borders were eliminated appears in Blaeu's atlas from 1630 on.

45. Copy in the British Library, 30885(3).

46. For example the chin strap on Minerva's helmet and the indentation on the upper part of the central architectural unit were both added to Blaeu's design by van den Keere.

47. Koeman, *Atlantes,* 2:217 (note 2), notes that van den Keere engraved maps for Blaeu's *Het Licht der Zee-vaert.*

48. See Welu, "Vermeer and Cartography," 101–2 (note 31).

49. The 1617 map includes an outside border of figures and town views. Copy in the Landesbibliothek, Karlsruhe.

50. The fox comes from the title cartouche on chart 36, and the rabbit from the title cartouche on chart 19.

51. This map appears in volume 6 of Blaeu's new atlas, first published in 1655.

52. See the British Library's *Catalogue of Printed Maps, Charts and Plans,* 15 vols. (London: Trustees of the British Museum, 1967), 4:791.

53. Both the figures and the framework come from Blaeu's sea chart of the West Indies. For an illustration and further information on this chart, see J. Keuning and M. Donkersloot-de Vrij, *Willem Jansz. Blaeu* (Amsterdam: Theatrum Orbis Terrarum, 1973), 74–76, fig. 10.

54. The same three figures were incorporated into the title cartouche on Henricus Hondius's atlas map of Brazil that appeared in 1630.

55. For further information and an illustration of Blaeu's sea chart, see G. Schilder, "Willem Janszoon Blaeu's Map of Europe (1606): A Recent Discovery in England," *Imago Mundi* 28 (1976): 18, fig. 7.

56. On Blaeu's printer's mark, see Keuning and Donkersloot-de Vrij, *Blaeu,* 12, fig. 1 (note 53).

57. Copy in the Bibliothèque Nationale, Paris, Ge A.600.

58. J. G. Gregorii, *Curieuse Gedancken von den vornehmsten und accuratesten alten und'neuen Land-Charten . . .* (Frankfurt and Leipzig: H. P. Ritscheln, 1713), 73. That Danckerts's sea chart was still being used at the end of the seventeenth century can be verified by Michiel van Musscher's painting dated 1690 of an artist's studio, which includes Danckerts's sea chart on the back wall. See James A. Welu, "Vermeer: His Cartographic Sources," *Art Bulletin* 57 (1975): 538, fig. 11.

59. Royal Geographic Society Atlas, nos. 17, 18, 19. First to call attention to the map was Edward Heawood, *A Memoir to the Map of the World on Mercator's Projection by Jodocus Hondius, Amsterdam 1608* (London: Royal Geographical Society, 1927), 5.

60. Probably composed in the eighteenth century, the atlas consists of 118 maps, 45 of which are dated and range from 1573 to 1709. The known authors are chiefly Flemish, Dutch, or English.

61. Each sheet measures 37 × 50 cm. Since this paper was first presented, Günter Schilder of the State University of Utrecht has discovered a second copy of the Hondius map that includes all four sheets.

62. Heawood, *Memoir,* 5 (note 59), deduced from the paper the map is printed on that it was published about 1600. In the same year, Hondius issued a folio-size map of France (38.5 × 50 cm). Entitled *Gallia,* this map shows the same basic format as the wall map. In 1591 Hondius produced another folio-size map of France (26.5 × 29.8 cm) with an extremely ornate border. For a discussion of the decorative significance of this map, see Maria Simon, "Claes Jansz. Visscher" (diss., Albert-Ludwig Universität, Freiburg, 1958), 71–72.

63. These maps, their size, and the location of the only known copies are as follows: (1) Europe, 71.4 × 100.7 cm, sheet 4 missing, Rotterdam, Maritiem Museum "Prins Hendrik," no. 8; (2) America, 68.6 × 104.1 cm, sheets 3 and 4 missing, New-York Historical Society; (3) AFRICA/*pars orbis* . . . , 70.8 × 106.6 cm, sheet 2 missing, Rotterdam, Maritiem Museum "Prins Hendrik," no. 46; (4) GEO-GRAPHICA.XVII./INFERIORIS GERMANIAE . . . , 1602, 78 × 100 cm, Leiden, University Library, Bodel Nijnhuis Collection, P 1 N 54. The map of the Seventeen Provinces was drawn up by Hondius but engraved and published by Pieter van den Keere. For an illustration and discussion of this map and a copy of it, see Schilder, "Wandkaarten," nos. 4, 5 (note 13).

64. Apollo and Minerva were used on at least two other seventeenth-century maps of France, both of folio size: Willem Jansz. Blaeu's map of 1607 (copy in the University Library, Amsterdam) and Pieter van den Keere's map of 1608 (copy in the Library of Congress, Washington, D.C.).

65. For a discussion of this print, see A. Pelinck, "Goltzius' Portretten van de Scaligers," *Oud-Holland* 81 (1966): 259–63, 265. The same two figures were used in the title cartouche on a folio-size map of Gelderland by Joannes Janssonius and Jodocus Hondius, Jr. Here the figures are not reversed as in the map of France. For editions and locations of copies of the Gelderland map, see J. J. Vredenberg-Alink, *Kaarten van Gelderland en de Kwartieren* (Arnheim: Vereniging "Gelre," 1973), 36–37, nos. 33a,b,c,.

66. The figures of Urania and Mercury that frame the portrait of the younger Scaliger were incorporated into the title cartouche on Hondius's large map of the Seventeen Provinces (see note 63, no. 4 above). The figure of Urania and two putti from the same Scaliger print also appear on the upper left of

Hondius's four-sheet map of Europe (see note 63, no. 1 above). In both the map of the Seventeen Provinces and the map of Europe, all the figures are reproduced the same size as the original, but in reverse.

67. See note 5 above.

68. For example, the partially visible fish (?) in the English Channel is repeated (in reverse) on Hondius's four-sheet map of Europe (see note 63, no. 1 above).

69. I am indebted to J. van Beylen for the identification of the ships.

70. On his four-sheet map of the Seventeen Provinces (see note 63, no. 4 above), Hondius shows twenty-six different types of sailing vessels in the area of the North Sea, each accompanied by its name and size.

71. Bibliothèque Nationale, GeDD 5480; the sheets for the map are numbered by Visscher in the lower right corner, 1 through 4. The sheet of costumed figures, which bears the number 5, measures 37×52.1 cm; the sheet of town views, which bears the number 6, measures 39.7×50 cm.

72. "Vranckrijck van 4 Kaart en 2 Cieraat-bladen." This legal document and part of the list of works are reproduced in Koeman, *Atlantes*, 3:156–58 (note 2).

73. Visscher added the name of the Bristol Channel: "t'Canael van Bristol-genaemt het Verkeert." A recently discovered second copy of the map, which includes the fourth sheet (see note 61 above), confirms my conjecture that Visscher also revised the two decorative cartouches at the upper right, although in both cases the cartouche's inscriptions are unchanged.

74. See L. H. Wüthrich, *Das druckgraphische Werk von Matthaeus Merian d. Ae.*, 2 vols. (Basel: Bärenreiter-Verlag, 1966–72), 1:194–97, no. 629. Visscher also incorporated many of Merian's figures into his folio-size map of France published sometime before 1643. Copy in the Staatsbibliothek, Berlin (1:186).

75. The views of Rouen, Orléans, Tours, Angers, and Bourges were taken from drawings by Georg Hoefnagel and appeared for the first time in the *Civitates*. The source for the view of Rochelle is unknown. The views of Marseilles and Bordeaux, which are included in the *Civitates*, were published earlier, the view of Marseilles in Munster's *Cosmographia* and the view of Bordeaux in Antoine du Pinet's *Plantz, pourtraitz et descriptions de plusieurs villes et forteresses* (1564). The view of Paris appears to be from an engraving by Léonard Gaultier, which appeared on the title page of *Le théâtre géographique du royaume de France* (Paris, 1631).

76. As R. A. Skelton wrote in *Decorative Printed Maps*, 1 (note 1), "such formal qualities as letters and ornament . . . are sometimes in fact more reliable, as clues to the authorship and date of a map, than its geographical contents."

CHAPTER SIX

1. R. A. Skelton, Thomas E. Marston, and George D. Painter, *The Vinland Map and the Tartar Relation* (New Haven: Yale University Press, 1965), 8. Despite other evidence that this map is a twentieth-century fabrication, the identification of the lettering as genuine Upper Rhineland cursive, current in the 1440s, has still to be challenged in print.

2. Max Eckert, *Die Kartenwissenschaft* (Berlin: Walter de Gruyter, 1921–25), 1:347–48.

3. See, for example, Eckert, *Kartenwissenschaft*, 1:339–48 (note 2); A. G. Hodgkiss, *Maps for Books and Theses* (New York: Pica, 1970), 81–108; J. S. Keates, *Cartographic Design and Production* (London: Longman, 1973),

201–11; F. J. Monkhouse and H. R. Wilkinson, *Maps and Diagrams* (New York: E. P. Dutton, 1952), 41–46; and Arthur H. Robinson, Randall D. Sale, and Joel L. Morrison, *Elements of Cartography,* 4th ed. (New York: John Wiley, 1978), 321–36.

4. Wilhelm Bonacker, "Die Anfänge der Kursivschrift in Kartendrucken," *Petermanns Geographische Mitteilungen* 89 (1943): 246–51, and his "Fortschritt oder Ruckschritt in der Kartenschrift," in *Studien zur Kartographie* (Berlin: Fritz Haller, 1957); C. Koeman, "Kaarten zonder drukletters," *Kartografisch Tijdschrift* 2 (1976): 6–18; A. S. Osley, *Mercator* (New York: Watson-Guptill, 1969), and his "Calligraphy—An Aid to Cartography?" *Imago Mundi* 24 (1970): 63–75; Arthur H. Robinson, *The Look of Maps* (Madison: University of Wisconsin Press, 1952), 25–54; and David Woodward, ed., *Five Centuries of Map Printing* (Chicago: University of Chicago Press, 1975), and his *The All-American Map* (Chicago: University of Chicago Press, 1977).

5. The literature of paleography and calligraphy is vast, and as a result of the multiplicity of variations in letterforms, no one satisfactory style guide exists. A good start can be made by perusing the more than four hundred specimens of all the major scripts in use before the eighteenth century in Hermann Delitsch, *Geschichte der abendländischen Schreibschriftformen* (Leipzig, 1928). The reader wishing to identify more subtle variations in lettering style may then consult the appropriate specialized published collections of facsimiles, of which there are a bewildering number. Many will be found listed in Bibliothèque Nationale, Paris, Département des Manuscrits, *Listes des recueils de fac-similes et des réproductions de manuscrits conservés à la Bibliothèque Nationale* (Paris, 1935), supplemented by the lists in the journal *Scriptorium: Revue Internationale des Etudes Relatives aux Manuscrits* (Antwerp: Standard Boekhandel, 1947–). Also extremely useful are the facsimiles and descriptions in the still-standard work on the methods of Western paleography: E. M. Thompson, *An Introduction to Greek and Latin Palaeography* (Oxford, 1912; reprinted New York: Burt Franklin, 1964). Also recently reprinted is the excellent catalog to the exhibition Two Thousand Years of Calligraphy, organized by the Baltimore Museum of Art, the Peabody Institute Library, and the Walters Art Gallery in Baltimore in 1965 (Dorothy E. Miner, Victor I. Carlson, and P. W. Filby, *Two Thousand Years of Calligraphy* [New York: Taplinger, 1980]). The most comprehensive bibliography yet to appear on the subject of calligraphy is Claudio Bonacini, *Bibliografia delle arti scrittorie e della calligrafia* (Florence, 1953).

6. Of the approximately 930 manuscript maps listed in Marcel Destombes, ed., *Mappemondes, A.D. 1200–1500* (Amsterdam: N. Israel, 1964), only 18 were considered separate.

7. Excellent examples of these hands are found in Thompson, *Greek and Latin Palaeography,* 340–70 (note 5).

8. E. A. Lowe, *Handwriting* (Rome: Edizioni di Storia e Letteratura, 1969), 27–33.

9. Destombes, *Mappemondes,* 28 (note 6).

10. P. D. A. Harvey, *The History of Topographical Maps* (London: Thames and Hudson, 1980), 84–85.

11. S[tanley] M[orison], *"Black-Letter" Text* (Cambridge: Cambridge University Press, 1942), 19.

12. One scheme of nomenclature for the Gothic hands, by no means yet fully accepted, is found in B. Bischoff, G. I. Lieftinck, and G. Batelli, *Nomenclatures des écritures livresques du XIe au XVIe siècle* (Paris: Centre National de la Recherche Scientifique, 1954).

13. Morison, *"Black-Letter,"* 19–21 (note 11), and Marc Drogin, *Medieval Calligraphy* (Montclair, N.J.: Allanheld and Schram, 1980), 63. Drogin translates *prescisus* as "precise or exact," but it is more likely to come directly from the root word of "precise," *praescindere,* "to cut off."

14. Berthold Louis Ullman, *The Origin and Development of Humanistic Script* (Rome: Edizioni di Storia e Letteratura, 1960), 21–57.

15. Andrea Mantegna introduced careful renderings of such inscriptions into his frescoes; his friend Felice Feliciano compiled a collection of inscriptions and a treatise on the Roman alphabet about 1460 that includes diagrams and instructions for its formation. The first treatise on the Roman capitals to be printed was by Damiano da Moyle, published in Parma in 1480. The mathematician Luca Pacioli included an appendix on letter making in his *Divina proportione* (1509), Biblioteca Apostolica Vaticana, MS *Vaticanus Latinus* 6852.

16. A useful introduction to the writing manuals of this style is A. S. Osley, *Luminario: An Introduction to the Italian Writing-Books of the Sixteenth and Seventeenth Centuries* (Nieuwkoop: Miland, 1972), and his anthology *Scribes and Sources: Handbook of the Chancery Hand in the Sixteenth Century* (Boston: David R. Godine, 1980).

17. Edward Johnston, *Writing & Illuminating, & Lettering* (London: Pitman, 1906).

18. G. S. Holland, "The Part of the Royal Geographical Society in the Development of Private Cartography," *Bulletin of the Society of University Cartographers* 1 (1966): 4–10; examples of the use of calligraphy in maps serving as book illustrations may be seen in the work of Heather Child, *Decorative Maps* (London: Studio Press, 1956), Sheila Waters in David Chandler, *Campaigns of Napoleon* (New York: Macmillan, 1966), and Robert Williams in T. Bentley Duncan, *Atlantic Islands* (Chicago: University of Chicago Press, 1974).

19. Matthias Quad von Kinckelbach, *Teutscher Nation Herligkeit* (Cologne, 1609). I am indebted to Henk Nalis of the Gemeentelijke Archiefdienst van Deventer for this reference.

20. On the origin of the Roman letter, see Donald M. Anderson, *The Art of Written Forms* (New York: Holt, Rinehart and Winston, 1969), and Edward M. Catich, *The Origin of the Serif* (Davenport, Iowa: Catfish Press, 1968).

21. David Woodward, "The Woodcut Technique," in Woodward, *Five Centuries,* 25–50 (note 4).

22. Short but useful descriptions of these copybooks can be found in Miner, Carlson, and Filby, *Two Thousand Years* (note 5).

23. See Osley, "Calligraphy—An Aid to Cartography?" (note 4), for a discussion of the use of calligraphy in identifying a manuscript atlas apparently containing Mercator's handwriting.

24. [Carlo Pasero], "Giacomo Franco, editore, incisore e calcografo nei secoli XVI e XVII," *Bibliofilia* 37 (1936): 332–56.

25. The starting point for all research in this period of Dutch cartography is C. Koeman, *Atlantes Neerlandici,* 5 vols. (Amsterdam: Theatrum Orbis Terrarum, 1967–71).

26. R. A. Skelton, "Colour in Mapmaking," *Geographical Magazine* 32 (1960): 544–53; Erwin Raisz, *General Cartography,* 2d ed. (New York: McGraw-Hill, 1948), 32. See also Ulla Ehrensvärd's chapter in this book.

27. Stanley Morison, *Letter Forms, Typographic and Scriptorial* (London: Nattali and Maurice, 1968), 28–56.

28. André Jammes, *La réforme de la typographie royale sous Louis XIV, le Grandjean* (Paris: P. Jammes, 1961).

29. Miner, Carlson, and Filby, *Two Thousand Years,* 104 (note 5).

30. Bonacker, "Anfänge," 251 (note 4).

31. Joseph Sabin et al., *Biblioteca Americana: A Dictionary of Books Relating to America,* vol. 16 (New York: Sabin, 1884–91), reference no. 66470.

32. A[rthur] R. H[inks], "The Lettering of the Rome Ptolemy of 1478," *Geographical Journal* 101 (1943): 188–90.

33. Giacomo Gastaldi, *La Spaña* ([Venice], 1544).

34. Roberto Almagià, "Il globo di Livio Sanuto," *Bibliofilia* 48 (1946): 23–28.

35. R. A. Skelton, *Decorative Printed Maps of the Fifteenth to Eighteenth Centuries* (London: Staples Press, 1952), 14, n. 2.

36. Bonacker, "Anfänge," 248–50 (note 4).

37. Woodward, *Five Centuries,* 45–49 (note 4).

38. Elizabeth M. Harris, "Miscellaneous Map Printing Processes in the Nineteenth Century," in Woodward, *Five Centuries,* 113–36 (note 4).

39. Woodward, *Five Centuries,* 46–48 (note 4).

40. Woodward, *All-American Map* (note 4).

41. Karen Severud Pearson, "Lithographic Maps in Nineteenth Century Geographical Journals" (Ph.D. diss., University of Wisconsin, 1978).

42. J. J. Delalande, "Typolithographie," *Lithographe* 2 (1840): 234–35.

43. C. Koeman, "The Application of Photography to Map Printing and the Transition to Offset Lithography," in Woodward, *Five Centuries,* 137–55 (note 4).

44. Alfred Grandidier, "Les cartes et les appareils de géographie . . . ," *Rapports du jury international, Paris, Exposition Universelle, 1878* (Paris: Imprimerie Nationale, 1882), 372–73.

45. In 1920 the use of stickup lettering for the titles is mentioned by John Livesy Ridgway, *The Preparation of Illustrations for Reports of the United States Geological Survey* (Washington, D.C.: Government Printing Office, 1920), 54–55. A commercial variation on the technique was the float-lettering method of Colin Landin in the 1930s, for which see Woodward, *All-American Map,* 38 (note 4).

46. Michael Kleper, *Understanding Phototypesetting* (Philadelphia: North American Publishing Company, 1976), 23–25.

47. Wellman Chamberlin, *The Round Earth on Flat Paper* (Washington, D.C.: National Geographic Society, 1950), 7–15.

48. A. Amiel and E. Thibaut, "Die Verwendung der Schriftsetzmaschine NOMAFOT bzw. BIBETTE bei der Herstellung einer neuen Michelin-Karte . . . ," *Nachrichten aus dem Karten- und Vermessungswesen,* part 9 (1958): 14–21; C. W. Westrater, "Procedural and Performance Analysis of the 'Staphograph' and a Placement Process," *Nachrichten aus dem Karten- und Vermessungswesen,* part 5 (1959): 21–26.

49. Eduard Imhof, "Die Anordnung der Namen in der Karte," *International Yearbook of Cartography* 2 (1962): 93–129, translated as "Positioning Names on Maps," *American Cartographer* 2 (1975): 128–44.

50. Pinhas Yoeli, "The Logic of Automated Map Lettering," *Cartographic Journal* 9 (1972): 99–108. Work is in progress by several researchers, including Stephen A. Hirsch, "An Algorithm for Automatic Name Placement around Point Data," paper presented at the annual meeting of the American Congress on Surveying and Mapping, February 1981, Washington, D.C.;

John H. Garlow, "Automated Type/Symbol Placement Developments," Technical Report no. ETL-TR-74-9, U.S. Army Engineer Topographical Laboratory, Fort Belvoir, Va., 1975; and Ümit Başoğlu, "An In-Depth Study of Automated Name Placement Systems" (Ph.D. diss., Department of Geography, University of Wisconsin–Madison, 1984).

51. J. G. Withycombe, "Lettering on Maps," *Geographical Journal* 73 (1929): 429–46.

52. Withycombe, "Lettering," 438–42 (note 51).

53. Withycombe, "Lettering," 442–43 (note 51).

54. C. B. Fawcett, "Formal Writing on Maps," *Geographical Journal* 95 (1940): 19–29.

55. Fawcett, "Formal Writing," 26 (note 54).

56. David Woodward, "Map Design and the National Consciousness: Typography and the Look of Topographic Maps," in *Technical Papers of the American Congress on Surveying and Mapping,* annual meeting March 1982 (Falls Church, Va.: American Congress on Surveying and Mapping, 1982), 339–47.

57. Personal communication from James Darley, National Geographic Society, based on internal memorandums and reports.

Index

Miletus, plan of, 18
Militär-Geographisches Institut, Vienna, 141
Miniatura (Norgate), 80–81
Mix, John Stanley, 52
Miyata, Masako, 5
Modern art, and mapping, 1–3, 5, 51
Modern lettering, transition to, 190–94
Modo di scrivere cancellaresca moderna, Il (Franco), 189
Moholy-Nagy, Sibyl, 17
Monconys, Balthasar de, 81
Monotype, 204
Montaigne, Michel de, 101
Moors, 126, 127
More, Thomas, 44, 45
Morison, Stanley, 195
Morris, William, 206
Mosto, Alvise da, 118
Mountains, coloring of, on maps, 130–32, 143–44
Mount McKinley, map of, 145
M. R. (engraver), 195
Muller, Frederick, 94
Mumford, Lewis, 123–25
Munro, Thomas, 6, 7
Münster, Ortelius map of, 155–56
Museion, 20
Museum geographicum (Hübner), 3,138
Musi, Agostino, 195
Musicians, The (Ochtervelt), 56

National Geographic Society, 205, 208–10, 212
Needham, Joseph, 23–24
Neoplatonists, 6
Netherlands, 134; color in cartography of, 131, 141–42; *Germania inferior* map of, 164; lettering on maps in, 189–90; lithography in, 204; mapping concept in landscape painting of, 4, 5, 51–96; ornamentation in cartography of, 3, 147–73. *See also* Vermeer, Jan
Neudörffer, Johann, 186
New Spain maps, 149, 151
Newton, Isaac, 143
Niccolì, Niccolò, 180
Nicholas V, Pope, 45
Nomaphot/Bibette, 205
Norden, John, 81
Norgate, 80–81, 88
Normal engraved cursive alphabet, 193–94
Normandy, 163

Ochtervelt, Jacob, 56
Oikoumene, 36, 37, 46, 49
Oldenburg, Claes, 5
Old style lettering, transition from, 190–91
Omphalos, 12, 17, 26–27, 37–38
Open-window negatives, 142
Optics (Newton), 143
Optics, Ptolemy on, 14, 36–37
Opus majus (Bacon), 29–31
Ordnance Survey of England and Wales, 192–93, 206
Orientation preference, 15
Ornamentation, on maps, 2, 199: color in seventeenth-century, 137–38; etching in, 183; in Netherlands, 3, 54, 147–73
Orsini, Fulvio, 100
Ortelius, Abraham, 48, 63, 76, 99, 189; map of Scandinavia, 137; *Theatrum orbis terrarum,* 88, 148–57, 161, 169
Orthophotomap,7
Osborne, Harold, 6
Osley, A. S., 187

Pacioli, Luca, 183
Palatino, Giovambattista, 186, 194
Palazzo Ducale, in Urbino, 44
Palazzo Farnese, murals in, 97, 99–101, 111
Palazzo Vecchio, 121; murals in, 97–98, 101, 107, 111, 120
Palazzo Venezia, 116
Paleography, 175
Palestine, Ortelius map of, 155–56
Papermaking, 126
Parchment, 126
Paris, 173; Merian plan for, 172; Raulin map of area of, 141
Paris serif, 191
Parma, Italy, San Giovanni Evangelista in, 119–20
Patenir, Joachim, 71
Paul II, Pope, 116
Pavimento, 40
Peacham, Henry, 134
Pearson, Karen Severud, 204
Peep box, 92–93
Penn, William, 46
Persia, 129
Perspective: Alberti system of, 4–5, 39–40, 43; in Assisi frescoes, 38–39. *See also* Cartographic grid
Perugino, 43

Petchenik, Barbara, 7, 69
Petermann, August, 138
Petermanns Geographische Mitteilungen, 136, 138
Peter the Hermit, 29
Peucker, Karl, 144
Philadelphia, plan for, 46
Philip II of Spain, 48
Photography, in color comparisons, 126
Photomechanical methods: in color printing of maps, 140, 142; of map lettering, 204–12
Photon-Lumitype, 205–6
Phototypography. *See* Photomechanical methods
Picardy, 163
Pico della Mirandola, Giovanni, 10
Piero della Francesca, 43–44
Pierre de Limoges, 14
Pigments, manuscript illustration, 127
Pillars of Hercules, 29, 46, 48
Pindar, 128, 160
Piso, Willem Pies, 94
Pissarro, Camille, 64
Pius II, Pope, 43, 115–16
Pius IV, Pope, 102–7
Pius V, Pope, 104–5
Plancius, Pieter, 163
Plato, 6
Pliny, 131
Pollaiuolo, Antonio, 14
Polo, Marco, 101, 118
Portolan charts, calligraphy on, 177, 179
Portugal, 46; Ortelius map of, 153, 155
Positional attenuating design, 15–16, 22, 50
Positional enhancing design, 15–16, 24, 27
Pourbus, Pieter, 60–62
Poussin, Nicolas, 6, 81
Preuschen, August G., 199
Printing of maps. *See* Engraved maps; Typographic maps
Process-color printing, 142, 146
Profile Views of Leiden and Haarlem and Two Trees (Saenredam), 75–76
Proverbs (Bruegel), 76–77
Ptolemy, 20, 32, 39, 143–44, 148; *Almagest,* 30–31; color symbolism of, 130; and grid cartography, 11, 16, 21, 24, 39, 50; and Palazzo Vecchio murals, 98. See also *Geography* (Ptolemy)